AGNES MARTIN

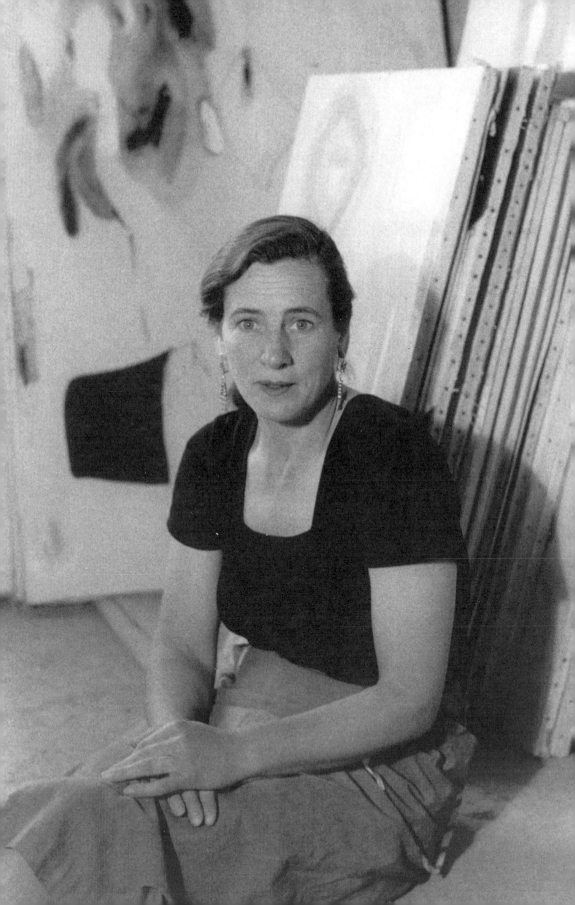

NANCY PRINCENTHAL

AGNES MARTIN

HER LIFE AND ART

A LYON ARTBOOK

First published in 2018 in paperback in the United States of America by
Thames & Hudson Inc., 500 Fifth Avenue, New York, New York, 10110

Reprinted in 2023

Library of Congress Control Number: 2018934143

ISBN: 978-0-500-29455-0

Published in association with Lyon Artbooks
Design & typesetting by Mark Melnick
Cover design by Debra Morton Hoyt

CONTENTS

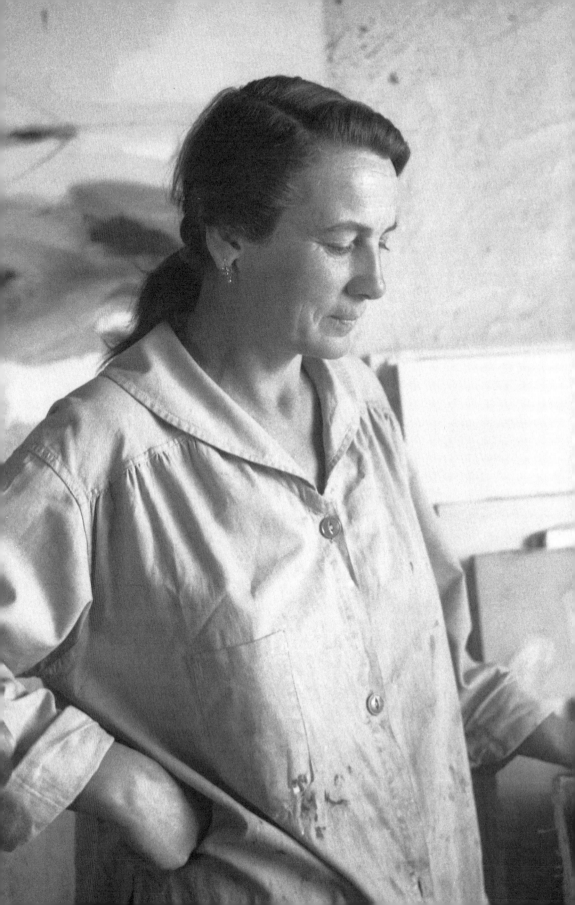

ABSTRACTION

T o be abstracted is to be at some distance from the material world. It is a form of local exaltation but also, sometimes, of disorientation, even disturbance. Art at its most powerful can induce such a state, art without literal content perhaps most potently. Agnes Martin, one of the most esteemed abstract painters of the second half of the twentieth century, expressed—and, at times, dwelled in—the most extreme forms of abstraction: pure, silencing, enveloping, and upending.

Martin's mature paintings (she destroyed most of her early work) are incontrovertibly right, in the sense that they convince us that not a single preliminary decision or incident of execution could have been changed without damage. Composed of the simplest elements, including ruled, penciled lines and a narrow range of forms—grids, stripes, and, very occasionally, circles, triangles, or squares—and painted in a limited palette on canvases that are always square, they reveal an esthetic sense that is, as her friend Ann Wilson said, the visual equivalent of perfect pitch.[1]

Martin called her creative source "inspiration," and she said that the paintings came to her as visions, complete in every detail, and needed only to be scaled up before being realized. (This scale shift generally required bedeviling computation; sheets densely covered in calculations attest to the trouble it caused.) It is possible to think of such a refined esthetic sense as savant-like or akin to a religious vocation: an attunement to qualities

commonly imperceptible. Such acute sensibility is not rare, but many art-ists who have a refined visual sense find it a liability, threatening to equate the practice of their art with the design of their homes or the selection of their wardrobes, all elegant and graceful. Martin wasn't like that. She was capable of the most robust gaucheries. Even when she was wealthy, her choices of domestic furnishings and personal attire seem to have been utterly free of the standards that guided her artwork. But she was a ruthless judge of her own painting, discarding the many examples that failed her vision, and her acuity allowed her to see concatenations of line and color to an order of exactitude, surpassing common perception with ease, that can only be called transcendent.

That is not to say that her motivation, or her world view, were mystical. Martin's ruled lines resonated with the hum of the physical world, and while she resolutely denied that her paintings contained references to the landscape, seascape, weather, or natural light (notwithstanding the many titles of her works that suggest such associations, most of which she later attributed to well-meaning but misinformed friends), her work is inarguably grounded in visual experience. Moreover, the work is meant to express universal emotional and existential states—emphatically not those corrupted by lived, personal events. The states she represented—and these in later years increasingly provided titles, unquestionably of Martin's choosing—are rarefied, ideal conditions: happiness, joy, and, especially, innocence. These titles, and the paintings they name, guard against the vulgarities of everyday life. Martin's work, then, not only channels the visual and psychic abundance of the world but also filters it, relieving it of impurities.

As she stated often in the talks and lectures she started to deliver in the 1970s, many of which have since been published, the sense of self to which she aspired was egoless and devoid of pride, and her paintings can be seen to reflect that commitment in their refusal of either bravura execution or centered composition. At the same time, and again paradoxically, much of Martin's work suggests a system of boundaries. In more cases than not, the

penciled lines don't go to the canvas's edge, and the earliest grids were set off by framing lines that echoed the canvases' edges. And yet, exhibiting one's artwork, to which Martin was firmly devoted, is sure to breach such boundaries—it is a public act, requiring pride and confidence. She made art to be seen by a wide audience, and she believed it was incomplete without the viewer's response.

If it is hard to reconcile conflicting aspects of Martin's work and character, it is because her internal life was deeply fragmented. By adulthood, she had been diagnosed with paranoid schizophrenia; she was hospitalized several times and was treated for the illness, with both talk therapy and medication, throughout much of her life. Admiring accounts of her capacity for extended periods of preternatural calm might also point to the catatonia from which she occasionally suffered. As is often the case with schizophrenia, Martin was subject to auditory hallucinations, and although the voices she heard didn't tell her what to paint—they seemed to steer clear of her work—the images that came to her through inspiration were fixed and articulate enough to suggest a relationship between visions and voices: she heard and saw things that others didn't.

The pencil that was always in her hand when she began a painting, calculating its rhythms and transcribing her vision, may also be said to have transcribed her thought; in a sense she wrote her work. Born into a generation trained in penmanship (she was for many years a teacher of young children) and much given to handwritten letters, homilies, speeches, and poems, Martin carried that graphic impulse into her painting, where it met the geometric structures and color harmonies shaped by visual inspiration. The sense of hyper-connectedness that is a feature of paranoia may also be seen in Martin's formal choices, the grid in particular. Representing the structure of interconnection, the grid in common parlance names an international communication system and a map of power. At once electric, alive, and dangerous, it is also supremely orderly and harmonious.

Without question, such speculation is hazardous. Creativity and active psychosis are incompatible; common sense tells us it is nearly impossible

to work when you're seriously ill, and luckily Martin was not acutely ill often enough to prevent her production of a very substantial body of work. Just as it would be wrong to call her a mystic, it would be a gross error to see in her work symptoms of illness. Even less was it a cure. Moreover, mental illness is a moving target. In the 1960s, under the reign of orthodox psychoanalysis, schizophrenia (like all forms of mental illness) was treated, literally, as narrative. It was understood to be the result of a person's circumstances, and it was believed to be curable by telling the story of those circumstances, with honesty and feeling. At the same time—in the sixties—art was stripped of personality, of narrative, of expression, indeed of any information extrinsic to an exploration of art's own boundaries, of its function as a "language." Fifty years later, these positions have flipped. Psychosis is now treated most successfully (or so says current wisdom and healthcare policy) with medication; early life experience and parental failure are not widely believed to be the most important contributing factors to schizophrenia. On the other hand, artists have lately been urged to get out in front of their work, to talk about its meaning and its sources, and their own origins as well.

But Martin was unyieldingly, and successfully, opposed to talking about her life, withholding details even from those who considered themselves good friends. As she saw it, art was impersonal and universal—and mental illness was something that didn't need to be discussed at all. In any case, friendship was a complicated undertaking for her, subject to firm constraints and beset by unpredictable lapses. She seems to have had the gift of mirroring back to people their own best self, while guarding her own identity. That doesn't mean she wasn't capable of engaging deeply with others, and her impact on people was often enormous. Martin could be compassionate, inquisitive, astute, and extremely generous. She was often voluble and funny. She was certainly courageous. Most of her friends note her love of the outdoors, of camping and, later, picnicking, of walks and drives, of travel. And for some periods, she forswore all of these pleasures.

Her public persona, too, was at once tightly controlled and distinctly eccentric. Increasingly described as a sage and an ascetic, attributes that didn't suit her and which she explicitly rejected, she wanted most of all to let her work speak for her. If she was not the mystic saint some took her for, neither was she altogether averse to exploiting that reputation. "Tell them I'm a hermit," she said to Suzanne Delehanty,[2] director of the Institute of Contemporary Art in Philadelphia, to avoid appearing at events there connected to the opening of her first major solo museum exhibition, in 1973. And Martin was, indeed, a student of Buddhism, as well as of other spiritual systems, including Christianity. She advocated humility, celibacy, and above all egolessness, and she suffered fairly extreme poverty with little protest. Even when she became wealthy, she lived simply. Her discipline in all things was prodigious.

The religious practices Martin explored, Buddhism in particular, offered not only guidelines for ethical behavior and glimpses of sublimity but also protocols for resisting physical appetites. In its recommendations for rising above the body's demands, Zen, it has been argued,[3] is particularly appealing to those whose sexual inclinations run counter to what is socially permissible. At the same time, by its determined openness and egalitarianism, and its abrupt detours into precepts and stories that seem inexplicable, absurd, or bawdy, Zen licenses the forbidden. Martin's romantic attachments, if that is the right term—she was not given to sentiment and preferred living alone—were largely with other women. But she refused the label lesbian (as she did the term feminist when it was applied to her). In her life, as in her work, renunciation was as important as embrace.

•

Martin was born in rural western Canada in 1912, and she died in New Mexico in 2004. A contemporary of the Abstract Expressionist painters, with whom she identified, Martin was long associated with the younger Minimalists. She participated actively in a number of richly complicated

artistic communities, from Taos, New Mexico, in the 1940s, a proving ground for modernism as well as various non-Western spiritual systems, to the riverfront Coenties Slip area of Manhattan in the 1960s, where her neighbors included Ellsworth Kelly, Robert Indiana, and Jasper Johns, and where both hard-edge abstraction and Pop Art took form. Like any artist of genuine interest, she was both keenly alert to cultural developments and averse to simply accepting them. Her apprenticeship was long; Martin was in her late forties when she produced the grids that, she felt, represented her true vision and that first won her acclaim. Her work has seldom been out of the public eye since.

Any effort to reconcile Martin's paintings, character, and life faces the challenges of the many contradictions they present. A portrait drawn by Rosamund Bernier in 1992, on the occasion of Martin's first major retrospective, which originated at the Whitney Museum of American Art, begins, "On a country road not far from Santa Fe, a white BMW sedan came flying. . . . There was a glimpse of close-cut gray hair, a strong jaw, cheeks the color of a McIntosh apple, a face for all weathers. Hardly had the visitor passed than a friend said, 'Who on earth was that? She looked like Beethoven's sister.' 'Not at all,' I replied. 'That is Agnes Martin, the painter.'" Bernier continues, "Visitors who come in awe, and almost in terror, are surprised to find that in the right company she likes to party. . . . But it is also true that there are few people who can use a single syllable to greater effect. Did she have any memorable experiences with fellow students or teachers when she was a student at Columbia? No. Has she kept up with her friends from Coenties Slip? No. Or with her friends from Taos? No." These dismissals are "often accompanied by an abrupt sideways motion of her well-trimmed hand, as if she was brushing a fly away." But Bernier shifts into mythmaking mode herself in describing Martin's gifts in drawing people out. "On the other hand, she is a great listener. She turns her head toward the speaker. Half thinker, half seer, she focuses her all-seeing gaze upon eyes and lips. A deep silence, born of attention, envelops her. It could be disconcerting, but the speaker—old friend or new acquaintance—feels

drawn into a magic space in which anything can be said without hesitation and will be heard without prejudice."[4]

In her later years, Martin gave interviews rather freely, and she spoke with considerable frankness, which did little to dispel the confusion. To the filmmaker Mary Lance, who produced a sensitive documentary about her in 2003, Martin proclaimed, with refreshing satisfaction, "I was born in the north of Canada, just like being born in Siberia. The land of no opportunity, that's where I was born. And still, I have had every kind of opportunity and been every place and done everything I ever wanted. And I'm rich and famous. God knows I'm rich."[5] Indeed, she has come to represent a certain kind of triumphant success. In Michael Cunningham's popular novel *By Nightfall*, we are led through a wealthy collector's perfectly appointed Connecticut home to its inner sanctum, where we find "on the one windowless wall the Big Kahuna, the Agnes Martin, presiding over the room like the visiting god it is, satisfied, it would seem, by these offerings of sofas and tables created by geniuses, by these stacks of books and this gaggle of glass-eyed wooden saints and these Japanese vases full of roses..."[6] Martin's painting plays a similar cameo role in Donna Tartt's best-selling novel, *The Goldfinch*. A recent volume of critical essays about Martin's work, its cover showing an enlarged detail of a grid painting, served in 2013 as an accessory on a table of shirts in a J. Crew store in Manhattan: a quick emblem of educated taste and elegance, an elusive promise of insider chic to the masses. On Martin's birthday in 2014, Google used a detail of one of her paintings from the 1980s as the banner for its search page.

Perhaps anticipating just such promiscuous dissemination of her work and image, Martin late in her life elicited pledges from friends that they wouldn't talk about her after she was gone. Whether or not sworn to secrecy, many have honored her wish—a wish that is also plainly apparent in her deeply reticent work and even more explicit in her writing. Her paramount injunctions, against pride and ego, have continued to shape attempts to bring her life into focus. A champion of rigor, she elicited great feats of

tact. In the context of sketching an "Aesthetics of Silence," Susan Sontag wrote, "what any work of art supplies is a specific model for meta-social or meta-ethical *tact* [the emphasis is Sontag's], a standard of decorum. Each artwork indicates the unity of certain preferences about what can and cannot be said (or represented)."[7] Martin clearly established such a standard, in both her character and her art. My qualms about violating her privacy, which have grown in the writing of this volume, are a little allayed by unintended consequences of her success in guarding it. Richard Tuttle, a younger artist who had an exceptionally long friendship with Martin, and who steadfastly resisted my shameless badgering for his insights about her, finally gave me this: people often ask him whether he misses Agnes, he said, but he (and his wife, the poet Mei-Mei Berssenbrugge) live with her paintings, and everything of her is in them. There is, he said, nothing to miss.[8] But certainly she gave abundantly in her friendships, and in the example of her life, just as she did in her work—even to those whose attachments to her were less enduring.

As Tuttle suggests, the paintings are the most reliable sources of information. I first saw one when I was a teenager, and I first wrote about her when I was in college; at that time, we exchanged letters, and hers to me, a long handwritten note in which she firmly encouraged me to dismiss "intellect" and "ideas" in favor of "true feelings," was a puzzle that I worked at for years. It wasn't what I wanted—I was writing an academic paper and had asked for her opinions of various critical responses—but its deep generosity provided a story I've told students more than once. The more I've come to know about her life and work, the more I've come to respect her essential unknowability and to beware of her many inconsistencies. She was a student of Plato and Saint Teresa of Avila, of Lao Tzu and Daisetz Suzuki, and of Gertrude Stein; by the end of her life, her favorite author was Agatha Christie. She was a fan of the director Akira Kurosawa and equally of big-budget Hollywood Westerns.

Help in sorting out these disparate clues is offered by Martin's own written words; those seldom quoted are often the most revealing. Similarly,

her paintings require discriminating attention and a fair amount of time. They are notoriously difficult to reproduce; as with live performance, you have to be there. Like the horizon between sea and sky, the drawn lines that organize her work are both firm and fluid, and they seem to change with our changing perspective on them; so do the contours of her life.

---- Chapter 1 ----

NORTHWEST PASSAGES

Starting from scratch, working hard and alone with the simplest of tools until the job—however exorbitant its demands—is done, keeping your own counsel, and staying tuned to the earth's glory: these principles were all Agnes Martin's birthright. Whatever the crosswinds of material circumstance and prevailing opinion, they guided her development of a body of painting as rigorous as it is, for the many viewers who try and fail to account for its enchantments, ineffable.

The same principles guided new arrivals to the Western Canadian prairie that was her first home, where life—like her work—was plain but far from simple. Some of Martin's recollections of her early years seem borrowed from *Little House on the Prairie*. "My family were pioneers," she said in a 1989 interview for the Archives of American Art. "My grandparents on both sides came from Scotland, and they went on to the prairie in covered wagons. My paternal grandfather was a rancher and a fur trader and my maternal grandfather was a wheat farmer. My parents were also pioneers; they proved up a homestead in northern Saskatchewan, but my father also managed a wheat elevator and a chop mill,"[1] where livestock feed is produced. Others of Martin's memories reflect the difficulties, some of them daunting, that she and her family faced.

Agnes Bernice Martin was born on March 22, 1912. An auspicious year, it also saw the birth of Jackson Pollock and John Cage, and, in November,

the incorporation of Martin's hometown, Macklin, in the Canadian province of Saskatchewan. As it happened, 1912 was also the year when New Mexico, where Martin would spend roughly half her life, gained statehood. Poles apart culturally as well as geographically, yet strikingly alike in many ways, Saskatchewan and New Mexico would have formative roles in her work. Similarly poles apart, Pollock and Cage would come to represent critical aspects of Martin's sensibility, the former connected with the vaulting expressive aspirations of Abstract Expressionism, the latter with disciplined submission to fixed procedures, which the practice of Zen Buddhism helped to support. Like both these artists, Martin was a lifelong child of the North American West, bred into self-reliance and wired to spring hard on the world, to make do with little if she had to, and to invent herself as freely as circumstances required.

The year 1912 was propitious for art as well, one of several sometimes named as birth dates of abstract imagery and of modernism itself. Duchamp's Cubist *Nude Descending a Staircase* was painted that year, before scandalizing a New York audience at the Armory Show the following February. Picasso's *Still Life with Chair Caning* introduced real-life objects (a frame of thick rope around the oval canvas, a fragment of shelf paper attached to its surface) into a painting. The first abstractions of Mondrian and Malevich were in the works. The era of empire-building was ending in Britain and continental Europe, as the "settling" of the West concluded in North America. In the United States, the Gilded Age, its chasm between wealth and poverty strikingly like that of our own day, had reached its climax. The Titanic sank in one of the last years of peace before a half a century of nearly continuous global war.

In Macklin, though, 1912 was effectively still the nineteenth century. The town sits at the western edge of Saskatchewan's central prairie, which was (and remains) home to the once-nomadic Cree, Assiniboine, and Saulteaux nations; in 1876 they were signatories, with representatives of other regional indigenous peoples, to Treaty 6, which appropriated their land in return for concessions fitfully and partially provided. The western

territories would only later be established as Canadian provinces, when they were acquired from the Hudson Bay Company by the government in Ottawa, which was concerned about the expansionist ambitions of the United States; Saskatchewan became a province in 1905.

White homesteaders first arrived in the prospective Macklin township in 1906, part of an enormous wave of emigrants that largely originated in eastern Canada, the United States, and Great Britain. Martin's father, Malcolm, was among Macklin's earliest settlers, filing his first claim, for 320 acres (a half section) in 1908, using scrip he obtained for his service, as a British citizen, in the Boer War in South Africa; he eventually acquired a total of a full section (one mile square). Rail lines had been laid across Canada by the 1880s, and 20,000 homestead entries were registered in Saskatchewan in 1903 alone. One E. M. Macklin, general manager of the *Winnipeg Free Press* and a member of the survey crew for the area, lent the hamlet his name; hence, a local history proudly records, "our town still stands unique in Canada in having streets named after outstanding newspapers and periodicals,"[2] as in Times, Herald, and Post Streets, crossed by Express Avenue. The first baby born in the newly established settlement, in 1910—the year the railroad reached the town—was, inevitably, christened Macklin; in the same year, the first street was graveled. The village's first recorded homicide, also in 1910, was originally attributed to a Saulteaux native; the charge proved false. Other firsts—the building of a church (for an itinerant minister) and a schoolhouse, the arrival of a doctor—had not yet taken place.

The decades between 1897 and 1929 have been called, in some regional histories, the "golden years for Saskatchewan's rural economy." The population of the province grew tenfold, reaching nearly a million by 1931.[3] (It has scarcely changed since.) The great majority of the province's residents were farmers, with wheat the predominant crop; the prairies of Saskatchewan served as "the granary of the British world."[4] In this vast breadbasket, even the biggest "urban centers," Moose Jaw and Regina, were towns of only a few thousand souls.[5] Unlike modern agricultural communities, the

farming towns of that era were largely self-sufficient. Macklin, favored by the intersection of two rail lines, boasted the handful of stores and services—grain elevators, a lumber yard, meat market, furniture store, church, and schoolhouse—that provided for its residents.

But rosy summaries are belied by local accounts. The type of wheat initially planted on the prairie wasn't suited to the climate, which had a growing season barely one hundred days long (more regionally appropriate seed, which matured a scant week or two earlier, was introduced only decades later). Farmers lured west by the promise of free land were often sorely disappointed. Requisites for holding title included clearing ten acres and making "improvements" to the homestead: the minimum was a single structure per quarter-section, built within three years of staking a claim. Those built by the Martin family were "a frame house, twelve by fourteen" and "a stable, fourteen by sixteen," each valued at $100 in 1914. Modest though these dimensions are, a wooden home was much preferable to the sod houses in which some homesteaders dwelt; wood for building was a luxury on the nearly treeless land, and it was particularly scarce in these years, which followed a devastating prairie fire.

Thirty-five years old when he arrived in Macklin, Malcolm Martin was by the standards of the time no longer young, and the physical challenges of the prairie were considerable. More than a few men quit the land to work on the railroad, leaving their wives and children behind. Many families arrived with treasured belongings from the East—a piano, sets of best clothes, or good china—to find conditions on the prairie a cruelly disappointing surprise. Susan Conly, a local historian born in Macklin in 1919, recalls a homestead wife sitting regularly on her porch in her single silk dress, for which she would never have a proper occasion. Conly also remembers improvised emergency surgery being performed on her family's dining table, and the occasional overnight visits of Canadian Mounted Police, whose patrols took them through Macklin not more than once a month.[6] Survival in these circumstances depended on substantial reserves of resilience and resourcefulness. The temperate months, harvest times

in particular, brought people together, and small prairie towns of the era had periodic cultural events (as they had periodic doctoring, policing, and religious services): opera houses for itinerant companies were built and halls for Chattauqua-style lectures. But in the long winters, isolation was nearly complete; even schools—officially, built not more than four miles apart, as children were not supposed to walk more than two miles each way—closed in the coldest months.

Martin recalled, of her mother, "She always thought that if she ever got a chance socially, that she would be a knockout. She would be a charming hostess and all that, and when she got married, she thought, oh, now it's my chance, but then they went up north, way up north, 'cause the government was giving away land, and my father was the manager of a grain elevator.... He was like the biggest businessman in town. But my mother was out on the farm and she had three children in three years and she really didn't like children, and I was the third."[7] The family grew to have four children: Ronald, Maribel, Agnes, and then a second boy, named Malcolm after his father. Martin's maternal grandfather was a successful farmer and later a builder, and she suggested that her mother, Margaret, labored hard to sustain the prosperity in which she'd been raised. Agnes's recollection also hints at a curious distance between her parents (as does the historical record, of which more below).

To be sure, like most people, Martin was hardly altogether consistent in her recollections. On some occasions she said that she had no memories of Macklin,[8] and on others that she recalled it vividly. In a documentary made when she was in her eighties, she declared, "I do remember it. It was so flat you could see the curvature of the earth." And, recalling how far across the planet one's gaze could take you, from there: "When you saw a train at nine a.m., it was still leaving at noon."[9] Whether a memory from childhood or a later reconstruction, it is a vivid evocation of the prairie—and it suggests, perhaps, sights trained on escape. Historian John Archer describes the deeply satisfying visual rhythms of the land at harvest time: "The bull wheel of the binder traced geometric patterns on stubble fields. The

marching rows of stooks gave some assurance to hurrying farmers. The hum and dust and fury of the threshing machine gave a vicarious thrill to the onlooker and a deep, profound satisfaction to the participant."[10] The novelist Wallace Stegner, who was born in 1909 and grew up on the south Saskatchewan plains, wrote lyrically of its "winter wheat heavily headed, scoured and shadowed as if schools of fish move in it; spring wheat with its young seed-rows as precise as combings in a boy's wet hair; gray-brown summer fallow with the weeds disked under; and grass, the marvelous curly prairie wool tight to the earth's skin." But he also called it—suggestively, with respect to Martin—"a country of geometry," one that was "flat, empty, nearly abstract." And as if conjuring the spirits with which Martin would long wrestle, Stegner proclaims, "It is a country to breed mystical people, egocentric people, perhaps poetic people. But not humble ones."[11]

On an unseasonably balmy day in October 2014, Macklin (the current population is approximately 1,400) greeted visitors with a sign promoting farming, drilling for oil, and bunnock, a local sport traditionally played with bovine or equine anklebones (there is also a giant replica of a horse anklebone). The town remains fairly isolated and mainly agricultural, though now visibly affected, in some streets, by oil money; surviving from its frontier past is a hotel that once faced the train station. The Martin homestead, still farmed though now otherwise vacant (the house and stable are long gone), is not perfectly flat, but rather billows slightly, and on a bright autumn afternoon it is bristly with cut grain and sun-warmed, like a big cat's pelt. Its emptiness gives way here and there to hollows with small stands of trees and shrubs, as welcome as people would be. Above, the air is crystalline and in constant motion—the wind, which residents confirm is nearly ceaseless, produces a sound that ranges between a hum and a roar. As so many observers say, the land does seem limitless, a vast convex disc, but it is the size of the sky that overwhelms—just as in New Mexico, where Martin would later live. As in New Mexico, too, extreme variation of temperature in a single day is common, and night comes down like a knife. Perhaps most tellingly for Martin's mature painting, notoriously so

difficult to reproduce, the Saskatchewan prairie is perfectly impossible to photograph. The camera simply makes it disappear. One must experience at first hand its irreconcilable visual aspects: its fine-grained texture and soul-gulping immensity, its featureless planes and fully four-dimensional grasp of the senses.

However nourishing to the future painter's visual appetites, the frontier idyll didn't last long; Agnes Martin's father was gone by the time she was three years old, leaving his young family to an uncertain future. In the 1993 profile for the *New Yorker*, Benita Eisler wrote that he died as a result of injuries sustained in the Boer War.[12] By another account, he contracted syphilis while there, which Martin's mother experienced as an intolerable disgrace.[13] The Boer War ended in 1902, so if Malcolm's death twelve years later can be attributed to his engagement there, illness seems a likelier cause than injury. A third competing explanation for his departure from the family is that he sold his homestead and skipped town; in a local history, there is an account by a neighbor born in 1913, who reports that Malcolm Martin "left the country for Black River Falls, Wisconsin, U.S.A.," selling his property to his neighbor Walter Henderson.[14] But Saskatchewan homestead records show the property passing rather less scandalously—if still murkily—to his wife, Margaret. These records also indicate that in 1910 Malcolm Martin made his wife his legal representative; another document, from the local Surrogate Court and dated October 26, 1916, states that he died, intestate, "on or about June 22, 1914" at Swift Current, 225 miles southeast of Macklin (one historian believes that Swift Current is where Malcolm and Margaret met[15]). What particularly complicates the story are documents showing that Margaret had already taken ownership of the property by late June 1914. Some of the signatures on these documents are date-stamped June 30 (a scant week after the ostensible and approximate date of her husband's death); one signature, however, is dated, rather suspiciously, June 23, and another, even more so, June 15. In other words, Margaret may have assumed title to the homestead before Malcolm's (dubiously dated) death. The appearance of Margaret's name on these records

is in any case unusual.[16] Inheritance by a widow of her husband's land was hardly inevitable at that time; women had few legal rights (and no vote). There are no feminine pronouns on any of the homestead records; they were added by hand, as was "Madam" for "Sir."

Whatever the particulars were of Malcolm's passing, Margaret Martin raised the four children (the last arrived soon after he departed) alone and in considerable bitterness. Her husband's demise came at a particularly difficult time. In 1914 the prairie boom years ended in a sharp economic downtown caused by an exceptionally poor crop, disruption of trade following the outbreak of war in Europe, and tightening of London capital markets.[17] Margaret thus seems to have come into possession of a good deal of land from which it would have been hard to draw a profit even with an intact family headed by an able-bodied man. (In 1916, she stated that, while no acreage had been cleared in 1914, '15, or '16, forty, thirty, and seventy acres, respectively, were "cropped"—considerable numbers by comparison with their first years on the farm. By this time, the house had grown to 16 by 20 feet.) Margaret also claimed that she remained on the homestead "continuously" until 1916. If these declarations are accurate (she would have had reason to falsify them, since residence on the homestead was required to retain ownership), Agnes was on the prairie until she was roughly five years old—a school-age child, instead of the toddler she later said she was when she left Macklin.[18] In any case, both census and homestead records show that by 1917 the family was residing, for at least part of the year, several hours east of Macklin in the town of Lumsden, where Margaret's parents lived; her mother had died in 1913, but her father, Robert Kinnon, survived until 1936, as the couple's shared tombstone in the Lumsden cemetery attests. Malcolm Martin is buried in the Lumsden cemetery, too, somewhat to the rear of his father-in-law's grand stone in the Kinnon family plot and behind shrubbery. Nevertheless substantial, the grave marker for Agnes's father, dedicated to him "in loving memory," adds simply that he has "gone home." No space was left on his stone for his wife.

It is generally said that sometime after leaving Macklin, Margaret took the family to Calgary. Their residence in Calgary would have followed the year or two in Lumsden, and it had to have been brief. By 1919–when Agnes was seven–the Martin family had moved again, to Vancouver, where Robert Kinnon had already established himself, in a very substantial Craftsman-style house at 1147 Faithful Street (it still stands).[19] In her childhood and adolescence, Agnes spent considerable time with her grandfather Kinnon, whom she remembered with some warmth. "I felt 'first' with my grandfather," she recalled. "I've never felt first with anybody else. He was a Scotsman, first of all, and he was a man who tried to be virtuous, *really* tried.... He influenced me tremendously."[20] On another occasion, Martin added, "He tried to be a good man. He believed in not interfering with children. He didn't talk to them. But you knew that he liked you.... my grandfather believed that God looked after children. And that it was none of his business. Anyway, it made for a good life, I can tell you. Freedom."[21]

Distantly affectionate though this relationship may have been, it stands in marked contrast to most of Martin's remembrances of her mother. According to Eisler, "Maternal authority was maintained by strict discipline, and self-reliance was expected from an early age. When she was about six, Martin recalls, she had to have her tonsils removed. Her mother put her on the streetcar with carfare and instructions about where to get off for the hospital. No one had told her that the operation meant staying overnight. The next morning, she was sent home on the streetcar, alone. 'I wasn't the least bit scared,' she says."[22] In another even darker recollection, Martin said her mother "didn't like children, and she hated me, god how she hated me. She couldn't bear to look at me or speak to me–she never spoke to me.... When I was two, I was locked up in the back porch, and when I was three, I would play in the backyard. When I came to the door, my sister would say, 'you can't come in.'" Further, Martin explained, "My mother hated me because I interfered with her social life." At this point in the reminiscence, Martin laughed, with characteristic disjunction, then continued, "She's a fierce, fierce woman. She enjoyed seeing people hurt."

Later, when her mother had a television, Martin said, "Her favorite television program was boxing, and she got right up close to the television."

To Arne Glimcher, whose Pace Gallery represented Martin's work starting in 1974, she said that "she loved her father," and that "he was the only person who ever had faith in me,"[23] although it is hard to know on what she based this belief, having known him only for her first two years. But "she hated her mother for her sternness" and was relieved when she died. "Glad to be rid of her," Glimcher reports her saying. On the other hand, Martin told writer and friend Jill Johnston "all about how she died, how it took two years and how happy she was when it happened, i mean how happy her mother was, and agnes's final pronouncement on death was that you go out either in terror or in ecstasy and clearly her mother was ecstatic."[24] Perhaps the most pungent of Martin's memories of her mother is her earliest, recorded in Mary Lance's documentary: "I can remember the minute I was born. I thought I was a small figure with a little sword and I was very happy. I thought I would cut my way through life victory after victory. Then, they carried me into my mother and half my victories fell to the ground."

If this vivid—and mordantly funny—vignette has the shape of myth, its emotional truth is well supported; many of her friends have testified to Martin's difficulties with her mother. But though daughter struggled with mother, sword in hand, the two also shared characteristics that Martin was grateful for inheriting. Describing her mother as "a tremendous disciplinarian," Martin continued, "My mother never said a word. . . . She had a strong sense of duty, and of justice." Noting that she, too, had often worked in one way or another as a disciplinarian, Martin conceded—or boasted—"I never said a word either."[25] And she proclaimed, "I have great respect for my mother," a sentiment also expressed many times. Discipline served Martin not only in her extensive work with children and young adults, in her early life, but in every aspect of her career as an artist. And while insisting on having been loathed by her mother, Martin claimed some warm feeling for her nonetheless, "Because she worked so hard. She

made a good house clean, she was a good cook, she sewed, and I felt sorry
for her making my clothes when she hated me so much." Clearly, living
with formidable levels of conflicting emotion was a lesson learned early.

In Vancouver, Martin's mother supported the family by buying, reno-
vating, and reselling houses. The city, which had been incorporated only in
1886, had grown almost 300 percent in the first decade of the new century,
to roughly 100,000 in 1911; by 1931 it had more than doubled again, to nearly
250,000. Housing was surely in high demand, and Martin's mother arrived
at what seems a resourceful, and demanding, solution to the challenge of
single-handedly supporting a family of five. The physical and emotional
stresses of the work she did must have been considerable. Her choice of
work also suggests that Margaret Martin had a better-than-average design
sense and an interest in the visual aspect of things, although Agnes later
remembered little early art instruction and no family interest in it at all.
But she did recall doing a lot of drawing at home with her brother. She
told Mary Lance that she drew all the time as a child, using "anything she
could get her hands on." She also told friends that she was especially close
with her younger brother, Malcolm.[26] But, in a reminiscence that evokes a
early inclination toward solitude, she said, "when I was a child I wouldn't
walk home from school with my brother and sister because that would
distract me from my state of mind."[27]

As evidence of her childhood interest in art and of occasionally warm
associations with her siblings, Martin recalled that at eight or nine she
saved pocket money to buy postcard-sized prints of famous paintings,
which came in a series, and which she and her older brother would copy.
The first print in the series, which made a strong impression, was Jean-
François Millet's *The Angelus*.[28] Martin's response to this sentimental
mid-nineteenth-century image of two peasants pausing in a potato field
at dusk, clasping their hands and bowing their heads in the titular prayer,
speaks not only to a love of painting but also to the deep roots in her life
of Christianity (though she was to become an admitted agnostic). As is
clear from her comments about her devout grandfather, Martin grew up

in "an atmosphere of stern Scotch Presbyterianism"[29] that left an indelible impression.

But as a teenager she was certainly not averse to pleasure, nor much constrained by propriety. "When I was in high school," Martin recalled, referring to her years in Vancouver, "I don't know what struck me. I was, I guess I was promiscuous. But I got over it."[30] A similar recollection was recorded by the artist Harmony Hammond, who befriended her in the late 1970s: "We laughed, drank a little too much, and Agnes told us stories, such as the one about when she was sixteen and was into seeking degradation in speakeasies but she couldn't do it, she couldn't succeed at degradation because 'There just aren't enough people in the world who want to prey on innocence.'"[31] Moreover, she became the object of nasty teasing, "And so I stopped dating." She concluded that the behavior "was just absentminded of me."[32]

More chaste—and lifelong—satisfaction was to be found in athletics, swimming in particular, but also sailing and hiking. Vancouver is on the Pacific, and Martin spent a good deal of time fishing and sailing as she grew up, relishing the area's beauty and bounty. "She spoke about oysters two-feet deep on the British Columbia coast," her friend Ann Wilson reported.[33] Late in life, Martin admitted, "I was brought up on the ocean and I tried to convince myself that I like the mountains as much as the ocean but I don't. I like the ocean better." In fact, Martin became a Provincial medalist in swimming and in July 1932 got notices in the *Vancouver Sun* and the *Saskatoon Star-Phoenix* for placing fourth in the women's 440-yard free-style race, part of that year's Olympic trials.[34] She did not make the team; had she won, she would have participated in the notorious 1936 summer Olympics in Berlin, documented by Leni Riefenstahl. Nonetheless, Martin was a highly successful athlete and loved being in the water. (Late in her life, she endowed a public swimming pool in Taos, one of many philanthropic gestures. She continued to relish sailing.) The rigors and routines of competitive swimming and, perhaps most strikingly, its combination of ambition and solitude, are all habits Martin would sustain. More than

in any other organized athletic pursuit, swimmers, even when part of a team, are profoundly alone when they practice and compete.

Looking back, she said she found racing uncongenial. "I used to be an athlete many years ago," she recalled. "If you're thinking about…winning, …it tightens up your muscles," a condition she said she opposed in every way.[35] But she also later compared painting to competitive sports: "The canvas is like an athletic field [laughter]…I have to almost climb it."[36] As described by Canadian writer and visual artist Leanne Shapton, who, like Martin, nearly won a spot on her country's Olympic swim team when she was a teenager, the sport has a distinct phenomenology: "Brief cheering at an intake of breath, collapsing into bubbles as her head, aligned and steady, dips back and under again at the turn. This is followed immediately by quiet.… As her head breaks the surface, the roar of the crowd is, with each breath, loud then quiet, loud then quiet."[37] That beat, loud then quiet—the solitude, while in the water, contrasting with a roaring audience that is heard only intermittently, as a kind of percussive background music—is strikingly like the rhythms that would play out, in longer measure, throughout Martin's life. They can also be seen expressed quite clearly in her work. Notable, too, is Shapton's description of her body in water, which "immersed, feels amplified, heavier and lighter at the same time. Weightless yet stronger."[38] One thinks of the rather abstract relationship to her physical self that Martin would later express: often treating her body's exigencies with some contempt, or at least impatience, she seems to have had her most fulfilling experience of embodiment in her painting. One thinks, too, of Max Ernst's *The Blind Swimmer*, 1934 (The Museum of Modern Art, New York), in which concentric series of ripples, regular as the amplified beat of breath heard underwater, bring sharp focus to a subject that isn't there.

•

By the time she swam for the Canadian Olympic team's tryouts, Martin was no longer a full-time resident of Vancouver. Having graduated from King George High School there in 1928, she left Canada in 1931 for Bellingham

in Washington State, joining her sister Maribel there, despite what she recalled as a terrible relationship with an intellectually inferior sibling. There are unanswered questions about the momentous relocation, including why Martin began high school again in Washington State, graduating at twenty-one; whom she stayed with during these years; and, most perplexingly, what really impelled her to leave home in the first place. Martin said later that Maribel had become ill during a difficult pregnancy and that she had come down "to take care of her."[39] It is an odd explanation, with conspicuous holes. (Where was Glen Sires, whom Maribel married in 1930? How precisely could Agnes, still a teenager, have been of help?) There are also explanations having to do with the opportunities, educational and otherwise, of living in the United States. That is, Martin "noticed the difference in American people and the Canadian people and I decided I wanted to come to America to live, not just to go to college but actually to become American."[40]

And there is evidence that the trip to Bellingham had at least one detour. At some point in 1930 or 1931, she took a job in Los Angeles offered by an employment agency—in another version of the story, she saw a sign offering a position while on a bus back to Vancouver[41]—as household cook to a woman named Rhea Gore, and she wound up serving as driver for Gore's roughly 25-year-old son, John Huston. Soon to become a famous film director, Huston was then a budding screenwriter and miscreant (he'd been arrested for drunk driving a few times). Having been involved in a fatal car accident that was "something of a scandal," according to his son, Tony Huston—he'd struck a pedestrian—John Huston's license was suspended, and during the trial that ensued, Martin drove him to court each day. Tony, a Taos resident who knew Martin in her later years, conjectures that his father might have had an influence on her because he had wanted to be an artist himself and was "an excellent draftsman."[42] Be that as it may, the stint in California didn't last long.

For her part, Martin explained that she had come to the U.S. "Because I liked the kind of higher education that we have here. . . . I think it

contributes more to self development. . . . In a British school [as in Canada], if you're studying Socrates—you'd memorize what Socrates said, but in American schools you find out what Socrates thinks and then you find out what you think."[43] (The precocious attention to Socrates is notable; Martin would later call herself a classicist.) She spoke with appreciation of freedoms, not only academic, offered in the United States. But she also expressed surprise at its laxities: "I found out how easy it was here, compared to Canada. In high school [there], I learned in one year . . . as much as I did in four at college, at Columbia. . . . In Canada, we took 10 subjects—10! Not four like they do here." As a result, she declared, "I was a good student."[44] The record doesn't altogether support that assessment.[45] She seems to have taken a single art course in her second high school, a drawing class; her grade is not recorded.

Perhaps, given her adolescent experiences in Vancouver, the most appealing freedom on offer in the United States was from her own reputation. Certainly Bellingham was a good place to start fresh; even more raw than Vancouver, the area constructed its first high school only in 1890, in nearby Sehome, serving 33 pupils. Bellingham Bay, first settled by migrating Americans and Europeans in the 1850s, was surrounded by old-growth trees of colossal proportions that bore down on the land in such profusion that clearing was prized not only (or even mostly) for the resulting timber, but for providing space, air, and, above all, light. As described by Annie Dillard, Puget Sound, gray with perpetual rain, was "the rough edge of the world, where the trees came smack down to the stones. The shore looked . . . as if the corner of the continent had got torn off right here, sometime near yesterday, and the dark trees kept on growing like nothing happened."[46] At the same time, at the water's edge, when the clouds lift, the light can be transcendent. But nothing could be further from the landscape of her earliest childhood, so like the one in which she eventually settled.

For some time in these years, Martin was going back and forth between Vancouver and Bellingham, swimming in Canada, attending school in the United States, and living a rather uprooted life—another pattern that would

be sustained for many decades. Her later petitions for naturalization indicate that she first entered the United States in 1936; perhaps she couldn't admit having attended a Washington State school while still a citizen of Canada—and, because of Canada's status, a British national. But no lack of security or confidence is recorded in the photograph of Martin in her second high school's yearbook, the 1933 Kulshan of Whatcom High School. It shows a beautiful young woman, her hair pomaded into a fashionably short, sleek bob, her small smile lively and eyes strikingly bright.

In the fall of 1933 Martin enrolled at Washington State Normal School in Bellingham, a teachers college, which she attended for three years. (Until that year, a teaching certificate had required only a single year of study; perhaps the much more rigorous standards reflected the competition facing prospective teachers in the depths of the Depression.) Martin's college application gives her address as 1454 Ellis Street in the working-class York Neighborhood of Bellingham, where she lived as a tenant in the home of Mrs. Cora Johnson (Martin listed her as "guardian" on the application). A recently widowed middle-aged woman—like Martin's mother—Mrs. Johnson had a daughter Bernice, four years Martin's senior, who would become a teacher too; also living at the house were another daughter and her family. (Built in 1910, the house is now part of a historic district; it was originally a modestly genteel neighborhood, Martin's last for some time.) In her first years at the Normal School, Martin's academic record was again uneven. Some semesters she got mostly Bs and a few As, excelling in English and History (although at other points she drew poor grades in both). Math seems to have been a source of consistent trouble; one thinks of the pages of crammed mathematical notations she later created in preparation for her paintings. She took four courses in teaching and its techniques, and received two Bs and two Ds. For her work in her single art class (Art I), she got an A.

Despite her apparent indifference to problems of pedagogy, on June 10, 1937, Martin received a teaching certificate, a license that was valid for elementary and junior high schools (she returned to have the certificate

renewed in 1942). Her extended career as an educator indicates that she found considerable satisfaction in working with young people. During the following four years, she taught at various schools in rural Washington, including the Livingston School of Clark County (1937-39), the Country School in Hanson Ferry (1937-38), and the Burley School of Kitsap County (1939-1941). At least some of these seem to have been one-room schoolhouses, since on the document where she described this work history, she entered "all grades 1-6" under the heading "title or type of work."[47]

The long list of jobs she said she'd taken in early adulthood would also come to include several stints at lumber yards, where she was (as elsewhere) a cook; she remembered baking twenty-five pies each morning at one lumber camp. But she returned, regularly, to working with children and recalled having taught in a one-room schoolhouse in Idaho, a country school "in the forest," as she described it much later to her friend David McIntosh. "I believe she was completely alone," McIntosh said, and to the remark that that sounded rather magical, he replied, "Much of her life was magical. It could be described as difficult and crude but it was magical."[48] Perhaps it is that quality that drew her to children—and, in turn, drew them to her. Although she is not known to have had any children of her own, her interest in them was lifelong, exceptionally sympathetic, and surprisingly reciprocal. But they entered her art only in 1976, in the form of an anomalous project, the film *Gabriel*, which features a young boy. Said Kristina Wilson, who was a close friend for decades, "Agnes often said she wished she had a batch of kids."[49]

•

This sketch of an outdoorsy adolescence and lonely, itinerant early adulthood, living in boarding houses and teaching children at a succession of schools in the deep woods of the Pacific Northwest, gives no hint of engagement with progressive culture in the 1930s. But as a teenager Martin may have come across some of the livelier artists active in Vancouver: the renowned Canadian modernist Emily Carr, for instance, lived near Martin's grandfather. She has been described as a "wildly conspicuous eccentric,"

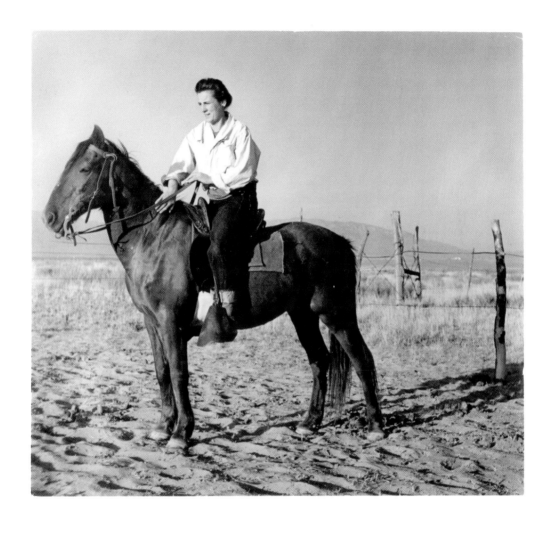

1

Agnes Martin in New Mexico, late 1940s.
Courtesy Peyton Wright Gallery, Santa Fe

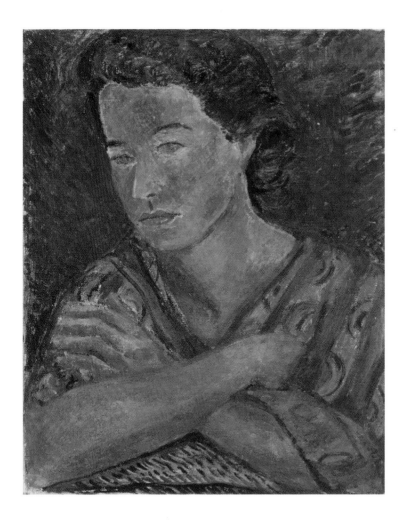

2 (ABOVE)
Portrait of Daphne Vaughn, ca. 1947-49.
Encaustic on canvas, 20 × 16 in.
Courtesy Peters Family Art Foundation, Santa Fe

————

3 (RIGHT)
Self Portrait, late 1940s. Oil on canvas, 26 × 19 in.
Collection Christa Martin

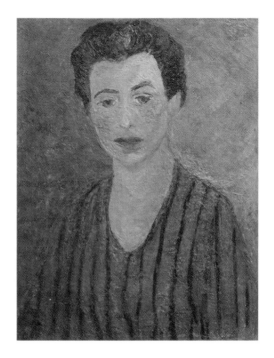

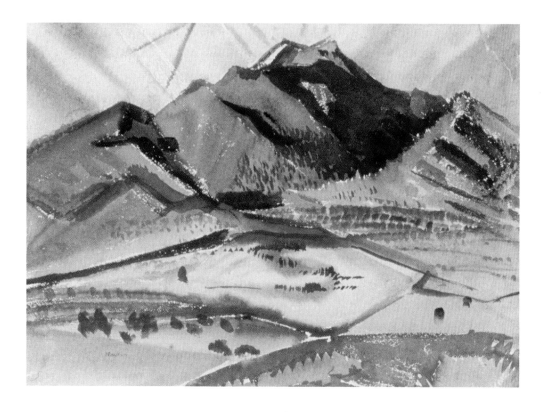

4 (ABOVE)

New Mexico Mountain Landscape, Taos, 1947.
Watercolor, 11 × 15¼ in.
University of New Mexico Art Museum,
Albuquerque, Raymond Jonson Collection.
Gift of Mercedes Gugisberg

5 (BELOW)

Agnes Martin painting in
New Mexico, late 1940s.
Courtesy Peyton Wright Gallery,
Santa Fe

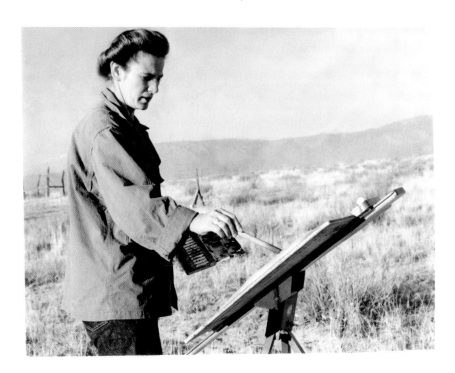

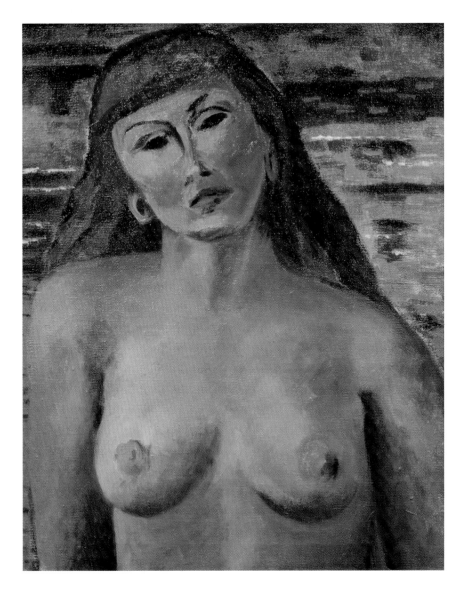

6 (ABOVE)
Nude, 1947. Oil on canvas, 20 × 16 in.
The Harwood Museum of Art
of the University of New Mexico, Taos.
Gift, John Schaefer

————

7 (RIGHT)
Agnes Martin displaying *Nude*, 1947.
Courtesy Peyton Wright Gallery, Santa Fe

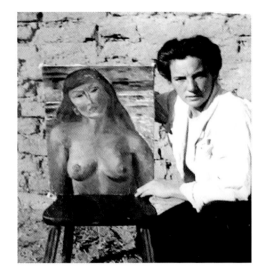

8 (ABOVE)

Untitled, 1949.

Oil on masonite, 14 × 21 in.

Collection Scott K. Stuart

9 (BELOW)

The Bluebird, 1954.

Oil on canvas, 28¼ × 40 in.

Roswell Museum and

Art Center, Roswell

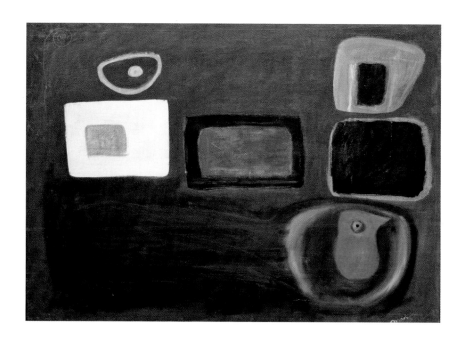

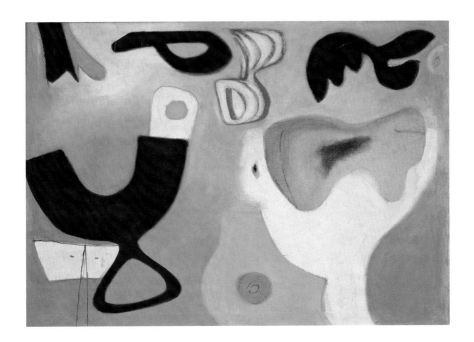

10

Untitled, 1953.

Oil on canvas, 33 ⅝ x 47 ½ in.

The Harwood Museum of Art

of the University of New Mexico, Taos.

M. A. Healy Family Foundation

Purchase Fund

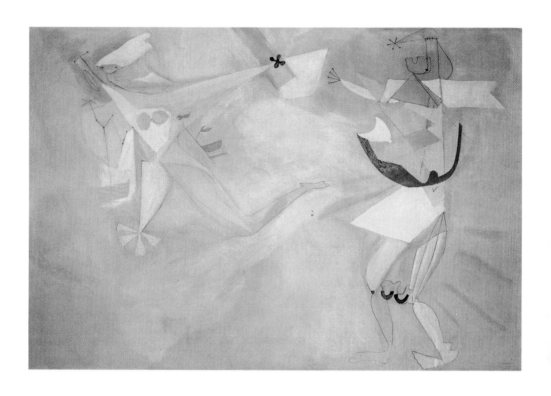

11

The Expulsion of Adam and Eve
from the Garden of Eden, 1953.
Oil on board, 48 × 72 in.
Private collection, Denver

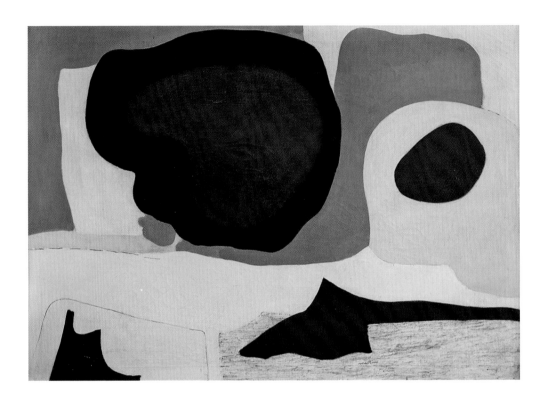

12

Mid-Winter, 1954.

Oil on canvas, 33 × 48 in.

Taos Municipal Schools

Historic Art Collection, Taos

who often walked through the neighborhood with her pet monkey and half a dozen sheepdogs—a commanding single woman, she might well have drawn Martin's attention. The painter Lawren Harris, who later lived in Taos, was from Vancouver as well.[50] It is also possible that Martin was aware of, and perhaps even directly engaged in, the animated art scene taking shape in northern Washington State at the time she was there. Bellingham, while conveniently (for Martin) close to Vancouver, is also only eighty miles from Seattle, which in the late 1930s was a substantial city of 365,000. The small but energetic Cornish School of Music, founded there in 1914 by Nellie Cornish, was a hub of activity: vanguard dancers, actors, musicians, and painters, all established professionals, were drawn to it.

The painter Mark Tobey, who was at the Cornish School in the middle 1920s, traveled widely in China and Japan, studying calligraphy and Buddhism—he spent a month in a Zen monastery in Kyoto in 1934. He returned to Seattle in 1935, and that year the Seattle Art Museum showed Tobey's Eastern-influenced paintings. *Broadway Norm*, a small canvas that was his first abstract, calligraphic work, dates to 1935, and from this point forward, his work was generated by line. Writing in 1962, MoMA curator William Seitz (who would later champion Martin) praised Tobey's "white writing" as an integration of two "related innovations: 'multiple space' and 'moving focus.' They lie behind—and often within—the over-all calligraphic picture."[51] The intimate relationship in Martin's mature work between handwriting and painting, as well as its mobile and multiple focal points, make it tempting to imagine she saw this prominent local painter's pioneering work.

The pull of Asian influences and of Zen, so much more pronounced on the West Coast in these years than in New York, was also evident in the work of Morris Graves, another Seattle-based artist. He had shipped out, as a very young man, on a merchant vessel to Shanghai, Kobe, and Yokohama (as well as Honolulu and San Francisco), and on a second trip returned to Japan, China, and Hawaii, besides visiting the Philippines. He, too, studied Zen in the early 1930s. Known for images of birds and other

small animals drawn with spidery, mist-shrouded lines, Graves met Tobey in 1939, a year after having befriended John Cage, who began teaching at the Cornish School in 1938. Merce Cunningham had recently arrived there too; Cage and Cunningham's lifelong professional and romantic partnership stemmed from this encounter. Cage and others at the school organized several exhibitions at Cornish of paintings and watercolors by such leading European modernists as Paul Klee, Vassily Kandinsky, and Alexei Jawlensky. In addition to Klee, the Bauhaus figures László Moholy-Nagy and György Kepes appeared at the school in the 1930s. Dance was a particular focus of the school; Martha Graham taught a summer class at Cornish in 1930. Among the modernist disciplines pioneered there was puppetry, and the first marionette course in the country was offered there; later, at Teachers College, Martin took such a class.

One can see affinities with Graves's bird imagery, and with his delicate, skittish line, in some of Martin's early paintings. Likewise, Klee's darkly playful and unflaggingly inventive paintings and works on paper influenced her early work. But among the artists in Seattle when Martin was in the area in the 1930s, only Cage would be engaged with Martin's circle of friends and colleagues when she was later in New York. His importance for her work came largely through his promulgation of Zen Buddhism, which he had learned about from Tobey.[52] Even if Martin had no occasion to visit the Cornish School for a public presentation by Cage, she might have seen one of his several lecture recitals at the Seattle Artists League, the local Pro Musica society, and elsewhere in the area.[53] It is possible that Martin's years in the Pacific Northwest were spent in unremitting rural isolation. But it is hard to imagine that she would have headed to New York City with the intention of being an artist if she had not had a taste, in Seattle, of what the country's cultural capital offered.

At this point as at many others in Martin's life, there are lacunae in the record, and some may be explained by the onset of illness. Schizophrenia generally emerges in early adulthood, and though there are no reports of Martin suffering a breakdown or undergoing hospitalization until the

1960s, it is likely that the illness had affected her long before that. If that is true, her achievements in the face of it are the more remarkable; initial episodes are often severe. What is known is that by the turn of the decade, with the country still in the grip of the Great Depression and the Second World War already raging in Europe, Martin had decided to pull up stakes in the Northwest and take on bigger challenges.

—— Chapter 2 ——

STUDENT / TEACHER

Like many of the momentous choices Martin would make, her decision to leave Washington State for New York City in 1941 has the shape of myth, at once dramatic and blunt. "When I found that I could work my way through college, I asked everybody what was the best college; I thought I'd go for that. They said Columbia University. So I went to New York." She also had decided to be an artist. "I thought if I could make a living painting, that's what I would like to do."[1]

The move, which propelled Martin from small-town teaching in the remote Northwest to studying in a preeminent cultural center, was a crucial turning point, but looking back, she would have absolutely nothing to say about her schooling in New York, her teachers, or her classmates. She did mention having seen paintings in quantity, but she gave no information about what they were. Moreover, some details of Martin's account are slightly fudged. She enrolled not at Columbia, but at Teachers College, which is affiliated with Columbia but is a separate institution. And the road to becoming a self-supporting painter proved unexpectedly long.

It is worth noting, moreover, that Teachers College was not the only school she considered; four months prior to applying to Teachers College, Martin's transcript from Washington State Normal School had been sent to UCLA.[2] A few friends report that she received and accepted a swimming scholarship at the University of Southern California, and that she

attended but did not stay; one said she tried a few sororities there, "but didn't care for them at all."[3] Neither of these California schools has any record of Martin's enrollment. Martin stayed at Teachers College for a single academic year during the first of two periods there; she returned to the school a decade later, finally completing her formal education in 1954, at the age of forty-two.

Teaching remains the most common day job for artists. But it was not as reliable a fallback in the 1930s as it is today. When Martin began teaching, the post-World War II explosion of art education, both in independent art schools and, especially, in the fine arts departments of liberal arts colleges, was more than a decade away. The prewar options for an art teacher were largely restricted to elementary and secondary schools. Classes in non-matriculating atelier-based programs, like New York's Art Students League or the National Academy of Design, were led mostly by established artists; independent studio-schools, such as Hans Hofmann's, were another option.

In the depths of the Depression, any teaching position—any paying job at all—was both hard to come by and, even by the standards of the time, poorly paid. Writing about Barnett Newman, a painter seven years Martin's senior who would become an important friend to her in the late 1950s, Thomas B. Hess recounts, with some mirth, that "to earn a bit of money," in 1930 Newman and fellow painter Adolph Gottlieb

> both decided to look for work as high school art teachers; they took the Board of Education examination and to their blank astonishment flunked.... In the spring of 1938, after seven years of intermittent [substitute] teaching, [Newman] took the regular teacher's exam again and again flunked. Outraged, he took a copy of the test to his near-neighbor on Martha's Vineyard, Thomas Benton (who was a conspicuous presence at the Art Students League) and got him to state in writing that he would have flunked it, too. Then Newman wrote a letter to the newspapers exposing the scandal: America's most famous artist states

that he couldn't pass a test given by the New York Examiners Board. It was published in the *Tribune*, made a local furor; the results of the exam were canceled.... When a new test was given, Newman and his friends took it—and they were all flunked again![4]

Undeterred, Newman did some public-school substitute and adult-day-school teaching between 1931 and 1945, for which he earned not more than $7.50 per day; for comparison, though, the Federal Arts Program of the Works Progress Administration, which supported many artists during the Depression, paid an even skimpier $87.60 per month in the years 1937-41.

These are the circumstances under which Martin had begun teaching in the Northwest; her chances elsewhere would surely have been slim. In other words, Martin had many reasons to want to boost her qualifications—and, of course, to go to New York. She also had some basis for confidence. When she arrived "with advanced standing" at Teachers College, she was already furnished with a teaching certificate from Western Washington State University, and her teaching experience distinguished her from many of her classmates. (After the war, the GI Bill supported a vast expansion of enrollment in colleges across the country, a shift that transformed society. As one consequence, it made it easier after the war for qualified teachers, including Martin, to find work.)

Similarly, she benefited, on her arrival at Teachers College, from the precipitous drop in enrollment that resulted from the advent of World War II. Indeed, the war abroad loomed large even at the outset of Martin's time at Teachers College. According to a report in the *Teachers College Record* of 1941,[5] by the summer of 1940, the faculty had developed a "Creed of Democracy" in which every department was called upon to enter into the spirit of defense. Faculty and staff engaged in defense work were asked to suggest services that "teachers everywhere can render to promote community stability and welfare at present and also the protection and improvement of the position of America on into the post-emergency period." The

language of this report may seem, for its time, both vague and alarmist as well as stridently nationalist; Japan had not yet struck Pearl Harbor. Yet, "Throughout the latter part of 1939 and 1940, there was a steady development of 'defense-mindedness' at the College," which included, in addition to preparing for civil defense and campus protection, activities like "organizing entertainment in the event of air raids" and "a fine arts course on Posters in the War Effort"; this impulse was "perhaps at its peak during the early months of the war."[6]

Martin may well have been sympathetic with the school's call to arms. Although her political commitments would never be strong or clear, she became an enthusiastic patriot and declared herself in solidarity with the country's military efforts. She first petitioned for U.S. citizenship in 1946 and attained it in 1950. She took considerable pride in being a U.S. citizen, as she did in her younger brother's military service during World War II. But whatever advantages the war years may have afforded Martin as a student and prospective teacher, she did not have an easy ride in New York. In the winter, spring, and summer sessions of 1941-42 she had a heavy course load. Each term she enrolled in at least one class devoted strictly to teaching skills;[7] her other courses were in studio art. They included Marionette Production and Stage Design, and Letter and Advertising Art, as well as classes in Drawing and Painting, Figure Drawing, and Clay Modeling. Overall, in studio coursework—her strongest subjects—she maintained a steady B+ average. She received a Bachelor of Science degree in October 1942, with a double major in Fine Arts and Fine Arts Education.

Martin was ruthless in destroying artwork that she considered immature, which for her included anything made prior to the late 1950s. None of her student production from Teachers College is known to exist, so it is hard to determine what she was exposed to or absorbing. The earliest of her paintings to have survived her purgative efforts, from the middle 1940s, suggest that she was reluctant to adopt the lessons of modernism, to the extent they were on offer; presumably she'd seen examples both in

Washington State and in New York City in the early 1940s. Her character suggests that a will to understand and to excel battled with a resistance to ostentatious experimentation.

Teachers College seems to have offered a range of possibilities for such experimentation. Its faculty and program were progressive enough to have lured promising students such as Ad Reinhardt, whose radically reductive "Black Paintings" would make him an important link between New York School painters and a succeeding generation of abstractionists during the 1950s and 1960s, when he was a good friend of Martin's. Reinhardt was at Columbia from 1931 to 1935, and he went next door to Teachers College for instruction in painting; one teacher he remembered there was Elise Ruffini, who would also be among Martin's teachers in 1941, for a class called Color and Design. The elementary-grades curricula Martin and her fellow students were being trained to teach are suggested by the series of instructional booklets called *New Art Education*; volume 9, of 1947, is co-authored by Ruffini (then acting head of the Fine Arts department at Teachers College) and Harriet Knapp,[8] and begins, "Art means selecting and arranging," as in shopping for clothing and furnishings, or advertising. Succeeding subjects, each addressed summarily with a captioned image, include flower arranging, historic costume and textile design. "Color" is the tenth such subject, painting the twelfth (it follows greeting cards). Career opportunities in the applied arts are touched upon. Three-quarters of the way through the book is a page headed "How to Look at Painting," with a color reproduction of the sunny 1930 townscape *Le mur rose* by André Derain, "one of the important modern French painters"; the painting is deemed "an excellent example of design in painting. The artist has used only essentials to express his idea and these he composed with sensitive feeling." Ruffini, who also wrote the catalogue essay for a 1948 exhibition of the work of Hilla Rebay, founding director of what became the Guggenheim Museum, was evidently a committed modernist and more sophisticated than this booklet suggests, but it seems likely that the teaching classes, at least, were not especially progressive.

A 1951 essay by Arthur Young, under whom Martin studied for four of the six semesters she ultimately spent at Teachers College (he taught two of her courses in two separate terms), provides more insight into the program's ideology at the time, if little indication of what actually went on in its classrooms and studios. Civic-mindedness, American exceptionalism, and, above all, a commitment to the principles of democracy are expressed in nearly every paragraph of Young's bromide-filled essay. The arts, Young wrote, were to be a social good; each child should be encouraged to develop his or her creativity; the popular and applied arts (with the wary inclusion of advertising) must be celebrated along with the fine arts, which were to be supported despite their occasional elitism and perverse difficulties. Immigrants were welcomed, but the special character of American culture, conceived in explicitly populist terms, must be upheld. "The social structuring of a nation devoted to democracy does not encourage nor accept an imposed critical hierarchy expressing the opinions and standards of wealth, social position, or prestige," Young wrote.[9]

Though his remarks on the avant-garde were strenuously polite, Young's feelings were evidently conflicted. He warned that avant-garde criticism exploited "highly personal and often obscure and esoteric dimensions of the individual," yet he allowed that such criticism was the most enlightened of the day. Likewise, rebellious young artists had "opened up a wealth of expression exploring all of life's dimensions," but were also "guilty, at times, of a perverse obscurantism."[10] If Martin had come seeking unqualified affirmation of an inclination toward vigorous experimentation with challenging new ideas in art, she would not have found it under Arthur Young, unimpeachable social progressive though he was.

Among the handful of cultural authorities Young cites, including Bertrand Russell and Lewis Mumford, none had a more powerful impact on Teachers College than the philosopher, psychologist, and educational reformer John Dewey, who had been a lecturer there (although his primary appointment was at Columbia) from 1906 until his retirement in 1930. (He also figures among the thinkers cited, approvingly, in Reinhardt's

acid, erudite cartoons.) A leading Pragmatist, along with William James and Charles Sanders Peirce, Dewey believed, according to a history of Teachers College, that "education should be active rather than passive; that to prepare the child for a democratic society, the school should be social rather than individualist; and that to enable the child to think creatively, experimentation rather than imitation should be encouraged."[11] *Art as Experience* (1934), Dewey's most important work on the arts, commenced with an appeal "to restore continuity between the refined and intensified forms of experience that are works of art and the everyday events, doings, and sufferings that are universally recognized to constitute experience." Coining a striking metaphor, he continued, "Mountain peaks do not float unsupported; they do not even just rest upon the earth. They *are* the earth in one of its manifest operations. It is the business of those who are concerned with the theory of the earth … to make this fact evident in its various implications. The theorist who would deal philosophically with fine art has a like task to accomplish."[12]

Dewey's emphasis on continuity between the fine and applied arts might have initially appealed to Martin, a practical woman to her bones. She would have found less congenial his social ambitions for painting, as in his claim that when "art exercises its office," it urges "the community in the direction of greater order and unity."[13] Ultimately she became firmly committed, like Reinhardt and others of the Abstract Expressionist generation, to an absolutely impermeable boundary between art and everything else. Moreover, Dewey was not an advocate of pure abstraction: "lines, even when we try to ignore everything and gaze upon them in isolation, carry over the meaning of the objects of which they have been constituent parts," he wrote.[14] But he did believe in the vitality of form, and resisted simple narrative realism: "If all meanings could be adequately expressed by words, the arts of painting and music would not exist."[15] Dewey found continuity among disciplines; indeed, he believed in a unity of all creative impulses. Expanding on the implications of the book's title, he wrote, "In short, art, in its form, unites the very same relation of doing

and undergoing, outgoing and incoming energy, that makes an experience to be an experience."[16] In its affirmation of a connection between music and painting, and, particularly, of the experiential essence of art, Dewey's beliefs and Martin's coincided perfectly.

It is possible to see the legacy of Dewey's fervor for civic action in Teachers College's strong commitment to the war effort. But the conflagration in Europe had another, more consequential effect for fledgling artists in New York in the early 1940s. Hostilities had been raging for two years when Martin arrived there, and many of the Continent's leading artists had found their way to the city. Among the artists in New York by 1942 were the Surrealists André Breton, Salvador Dalí, Max Ernst, André Masson, Roberto Matta, and Yves Tanguy; also in the city were Piet Mondrian, high priest of geometric abstraction, and the mercurial proto-conceptualist Marcel Duchamp. And there was, too, a sizable contingent of the painters who would constitute the expressive abstractionists of the New York School: Pollock had first arrived in 1930; also present, along with Reinhardt, Newman, and Gottlieb, were Mark Rothko, Clyfford Still, and others. Cage came to New York in 1942. Relations among these groups were not simple. Writes Lucy Lippard, the cultural critic who was later Martin's neighbor in New Mexico, "When the Surrealist exiles arrived, around 1940, there were already members of the struggling avant-garde who wanted nothing to do with them on the grounds that 'we'll work things out ourselves.' Eventually such an attitude would spawn the jubilant chauvinism that attended Abstract Expressionism's triumph in the mid-to-late fifties."[17]

There had already been considerable resistance in the United States to European modernism in the interwar period, when regionalist painters such as Grant Wood and Thomas Hart Benton, along with more left-leaning representational artists like Ben Shahn, gained prominence. In its support of artists, most conspicuously through the WPA, the federal government tended to promote distinctly American tendencies, through murals that celebrated domestic history and achievements. On the other hand, European modernism's public visibility in New York was enhanced by nascent

local institutions, principally the Museum of Modern Art, founded in 1929, and the Museum of Non-Objective Painting (later the Solomon R. Guggenheim Museum), founded in 1939. Among exhibitions of note when Martin was first at Teachers College was MoMA's 1941 survey devoted to Joan Miró: his influence on Martin's work in the early 1950s would be pronounced. The progressive young dealer Sam Kootz organized a large exhibition at Macy's department store in January 1942; it included the early, quasi-figurative work of Mark Rothko, whose later paintings would strongly affect Martin's work. But if the Europeans' investigations of abstraction, and of chance operations and unconscious processes, drove experimentation by artists in the United States, venues for seeing the Europeans' work remained limited. Many of the most notable local exhibitions of the new art, both European and American, occurred after Martin's departure from Teachers College in the summer of 1942. The galleries that would pick up these artists and, eventually, provide crucial support for the New York School painters would open only after the end of the war.

In short, New York, during Martin's first year there, was a place of both great ferment and manifold contradictions; like Zurich during World War I, it sustained a level of international concourse that would dissipate in peacetime. And like all historic cultural conjunctions, its competing forces gain a misleading coherence in retrospect; in reality, the various artists and their circles intersected without finding common cause. In any case, Martin was busy with schoolwork and tied to an institution located on the Upper West Side, miles away from the centers of artistic activity. Yet she said that when she was a student in New York, "I saw all the paintings in the museums."[18] And again, "Before I went to New York I had very little contact with art and then, when I got there, I mean, it seemed to me there were so many people interested and so many museums and it just seemed like—I thought for the first time of the possibility of being an artist, when I went to Columbia"—this despite her declaration that she'd come to New York to launch a career as a painter.

Her reasons for leaving New York at the end of this first year of stud-
ies are similarly uncertain. Perhaps she was overwhelmed by competing
claims on her attention, or found herself outside the center of activity.
Other factors may have come into play. She has said that her younger
brother, Malcolm, whom she described as "brilliant," was killed in bat-
tle, while fighting (as his father had done) for the British, in this case the
Royal Air Force in World War II. In one telling, Martin said of her younger
brother, "He was a pacifist. And when the British declared war, he went
straight to bed and he went to sleep. And when he woke up he went and
enlisted. The first Canadian to enlist, I think. (Pause) Then he flew over
Germany every day for three and a half years. Can you imagine? Going
to meet the enemy every day for three and a half years? (laughs)."[19] In this
recollection, her brother's death is a fable of heroic combat, solitary and
unyielding, told with gleeful relish; little about it seems plausible. Later,
she boasted to her dealer Arne Glimcher, with characteristic gender ambi-
guity, "We Martins are military men."[20] And to her late-life friend David
McIntosh, she said her younger brother, whom she talked about with great
warmth—McIntosh believed they must have been close as children—died
of high blood pressure.[21] To sift through these accounts is to find a scanty
residue, with traces of pride, bafflement, and narrative ingenuity put in
the service of reshaping misfortune.

•

Whatever other reasons Martin had for leaving New York after the 1941–42
academic year, financial hardship was one. She later said that while she was
in school (without specifying which of her two stints at Teachers College
she was referring to), she worked three jobs at a time: "riding the school
buses as a disciplinarian, working as a disciplinarian for 45 waiters in a
big dormitory" for first-year law students, and running the elevator in the
boys' dormitory.[22] With these references to serving as a disciplinarian, Mar-
tin introduces a theme. If it is not clear what this work involved—and she

always insisted that fulfilling its responsibilities involved not much more than a raised eyebrow and stern silence—it is evident that she felt herself well suited to it. Connecting the impulse to her working methods, to her character, and above all to the nature of her mature work, is irresistible; the geometries of her paintings are nothing if not firmly governed—with the lightest possible touch and with absolutely unrelenting vigilance.

"Sounds like bragging but I think the best work I've done is as a disciplinarian," she said. "I don't have to be a strict disciplinarian, you know. I think I inherited it from my mother. I'm just a natural."[23] In the fall of 1942 Martin took a job at the Delmare School in Delmare, Delaware, teaching high school art. The following year, 1943-44, she was back in Washington State, teaching first grade at a school in Tacoma. In 1944-45, she was teaching art at a school in Bremerton, Washington. In addition to working as a teacher, Martin was, during this period, a tennis coach, a waitress, a baker's helper, and a dishwasher. She spoke of having cared for children in a shipyard, where boats were built as part of the war effort.[24] "Whenever I was really starving I always washed dishes because I got closer to the food," she recalled.[25]

This period of itinerancy ended in 1946, when Martin arrived in New Mexico, where she stayed—with interruptions—for more than ten years. When she did finally settle down, it would be in this state, where she would ultimately spend roughly forty years. And it was in New Mexico during this decade that she made the first paintings that have survived, despite her best efforts to suppress them. Though she would later postdate the moment when her life as a painter commenced, her career as an artist had unquestionably begun.

Her progress remained halting. Once again, she enrolled in school, at the University of New Mexico (UNM) in Albuquerque in 1946, and in the summer of 1947 she was a student in its Summer Field School of Art in Taos, a program that had been launched in 1929. Unlike the curriculum at Teachers College, this course of study was entirely devoted to producing art. But it was only fitfully progressive by the cosmopolitan standards of

the day. Its instructors inclined toward representational work, landscape painting in particular.[26] The Field School was housed in the Harwood Museum, founded by Lucy and Burt Harwood in 1923 (it is now part of UNM); students lived and worked there. There was much *plein air* painting (plate 5). Photographs show the young artists setting out on horseback with canvases, paint, and brushes at their sides. Sometimes departure was before dawn: "We got up at five o'clock in the morning and went out and painted before breakfast,"[27] Martin recalled.

Fellow student Earl Stroh remembers the decisive impact of seeing East-Coast transplant Andrew Dasburg's Cézannesque *Still Life with Mandolin and Vegetables* at a gallery in Albuquerque in the spring of 1947 (he says it was the "first real painting" he'd seen in New Mexico). Stroh further records, "That summer at the Harwood, Dasburg was one of the Taos artists who gave Saturday morning group criticisms to the students. I was impressed by his ability to spot a student's possibilities right through the surface of other artists' influences." Martin spent that summer at the school and, Stroh writes, "She was then working in a figurative style variously influenced by German expressionism, very much by Rouault, and perhaps a touch by other French post-impressionists."[28] A show of student work that summer was reviewed anonymously in the local newspaper; it noted, "Among the more advanced students, Agnes Martin and Earl Stroh have turned out some excellent work."[29]

During her enrollment at UNM, Martin was in her mid-thirties, and her seniority and experience were evidently recognized by the faculty; the university hired her as an instructor for the year 1948-49. The teaching was conventional: "We'd paint the Indians. And I painted flowers and landscapes,"[30] she reported. In addition to the limitations of the curriculum, there were financial constraints; because her income from teaching was very low, Martin took a job in the fall of 1948 at the John Marshall School in Albuquerque, teaching writing and art to young boys considered to have disciplinary problems.[31] In Martin's account, she persuaded these "illiterate and delinquent boys"–"criminal boys" she also called them–to

"act out stories that she made up for them. Later they made up stories of their own, in one of which a donkey had a major role."[32] And, again, she was a dorm monitor. In both roles, her approach was decidedly idiosyncratic.

The relative isolation of New Mexico had its drawbacks, but it also contributed to the appeal of Santa Fe, Taos, and their environs, which remain a magnet for artists and writers. No visitor fails to remark on the area's physical beauty; its culture, too, is distinctively rich, and still strongly influenced by Spanish and Indian traditions (at present, less than half the state's population is non-Hispanic Caucasian). The high desert in the northern part of the state features both vast open vistas and precipitous canyons and mountains, and its surprisingly abundant vegetation bursts into spectacular color in spring and fall. As in the prairie of Saskatchewan, extremes of weather, from day to day and even hour to hour, are commonplace, and the light has remarkable brilliance and clarity.

"Elsewhere the sky is the roof of the world; but here the earth was the floor of the sky," Willa Cather wrote of the New Mexico desert in *Death Comes to the Archbishop* (1927). A novel set in and around Santa Fe in the second half of the nineteenth century—Cather had visited the area in 1925—it vividly portrays the period's intimate exchanges among Spanish-speaking ranchers, Catholic missionaries, Native Americans, and westward-forging emigrants from the eastern United States and Europe.[33] D. H. Lawrence was among the literary figures who spent time in New Mexico early in the twentieth century; Georgia O'Keeffe arrived in 1929. The art colony at Taos was born when two urban artists, Ernest Blumenschein and Bert Geer Phillips, set out from Denver on a painting trip to Mexico and foundered twenty miles north of the town, where their wagon broke down. They arrived on horseback in Taos in September 1898 and, enchanted by what they saw, exhorted other artists to join them. By 1915, just three years after New Mexico gained statehood, the Taos Society of Artists had been formed. Among those to become affiliated with it and spend time there were the New York painters Robert Henri and John Sloan, who, in the 1910s, attracted other representatives of their style of vigorously expressive

figuration. The Museum of Fine Arts in Santa Fe opened in 1917, showing both traditional realists and modernist abstractionists (as it still does).

Modernist doyenne Mabel Dodge (later Luhan) arrived in Taos in 1917, with painter and sculptor Maurice Sterne, to whom she was then married. The Taos she settled in was a frontier town with roughly two thousand residents. "From the very first day I found out that the sunshine in New Mexico could do almost anything with one," she later wrote.[34] (It is not an uncommon reaction, a century later.) In New York, Dodge's salon had drawn John Reed (who would later found the Communist Labor Party in the United States), Upton Sinclair, Leo and Gertrude Stein, and Alfred Stieglitz; painters John Marin, Marsden Hartley, and O'Keeffe became part of Dodge's circle too. In 1913 Dodge had been among the promoters of New York's Armory Show. Dasburg, a veteran of that landmark exhibition, came to Taos at Dodge's invitation in 1918 and stayed for more than sixty years.

Along with the European-derived modernism that reached New Mexico through these emissaries, there was a distinctive local interest in various nontraditional spiritual practices. In 1938 Raymond Jonson, who had come to Santa Fe fourteen years earlier, founded the Transcendental Painting Group there with Emil Bisttram, a Taos resident since the early 1930s. The Taos group included Agnes Pelton, Lawren Harris, and others who, under the influence of Vassily Kandinsky, studied the Theosophy promoted by Helena Blavatsky, a portmanteau religious philosophy integrating various esoteric, arcane Eastern and Western spiritual traditions. "Compared with the art of Mondrian's followers in New York, the paintings made by the group in Taos appear striking spiritual—amazingly cosmic and symphonic," Maurice Tuchman wrote in the catalogue for an exhibition affirming the links between spiritualism and abstraction.[35] Indeed, the group's paintings seem precociously New Age; spacey visions of sharply defined, Deco-ish forms soaring through the cosmos, they are harbingers of an ethos alive in Taos to do this day. Bisttram, an eager advocate of these alternative spiritualities, believed that the moment of creation was of surpassing importance; he admired the geometry of Native American design for

its process as much as its formal satisfactions.³⁶ (Before dissolving in 1941, the Transcendental Group had a period of renown that led to two New York exhibitions in 1940, at the Guggenheim Museum and the Museum of Modern Art.³⁷) Later, Jonson invited Josef Albers to Albuquerque, and also Dore Ashton, who came in 1950. Ashton would be one of the first New York critics to write about Martin's work, in the *New York Times* in the late 1950s, although she did not remember meeting Martin in New Mexico at this earlier point.³⁸ Ad Reinhardt was in Taos in 1952 and did meet Martin while there–a momentous if largely undocumented encounter.

Non-Western spiritual beliefs were also propounded by Mable Dodge and her circle. Among her friends was the poet Witter Bynner, who settled in Santa Fe in 1922, and who in 1944 translated and introduced an edition of the writings of Lao Tzu that Martin is known to have admired. Bynner, like Bisttram, made connections between Eastern mysticism and the belief system of the Pueblo Indians of New Mexico–links that had considerable credence among the artists in Taos. So did work by anthropologists active in New Mexico at the time (notably, several were women), who compared Pueblo songs to Hindu ragas; the researcher Natalie Curtis, for instance, observed that the "rhythm of [the Indians'] grinding stones kept time with the 'turning of the planet,'" expressing a mystical ideal.³⁹ These interests were far from parochial; in 1925, André Breton called attention to Native American art of the Southwest in his magazine *The Surrealist Revolution*.⁴⁰ It is a publication–or at least an interest–of which Dodge may well have been aware when she wrote two years later, with a lofty presumption typical of the time, "The Indian has the gift of seeing organized form so clearly because he has cultivated his senses instead of the faculty of analysis. His perceptions are direct. He sees instead of thinking about what he sees."⁴¹

Favoring perception over analysis would become a cornerstone of Martin's approach to painting (as would analogies between music and painting). Dodge continued, "We find that [the Indian] has discovered the law of form which states that all life is manifest geometry, that every concrete expression of art or nature has a determinable mathematical structure."

The patterns woven into Pueblo textiles reflect, in this argument, the order and symmetry inherent in the natural world. As art historian Sharyn Udall writes, "Plato's notion, admired by Emerson, that 'God geometrizes' echoes clearly in [Dodge's] interpretations, as it does in much painting produced by mystically-inclined artists."[42] These inclinations, too, are close kin to Martin's and all would be reinforced by further contact with artists interested in Buddhist thought when she lived in New York in the 1960s.

Along with unconventional spirituality, the Taos community was open to social and personal choices that were effectively prohibited elsewhere (including in New York). Dodge, who in Taos married the Pueblo native Tony Luhan, was among the many women in Taos (and Santa Fe) at the time to have had romantic relationships with other women, as did O'Keeffe. According to David Witt, a curator in the 1980s and '90s at the Harwood Museum and a historian of the art community in the area, "you could be lesbian in Taos in the 1940s and 1950s and not have to hide it, not be afraid. You could be an openly gay man and a respected member of the community," as was Marsden Hartley, for instance.[43] That remains true today, although of course enormous changes in social tolerance have made such refuges less crucial than they were then. It has been said that for Dodge Luhan, O'Keeffe, and their friend Rebecca James, this sexual freedom was partly a prerogative of class—that, especially in the freewheeling 1920s when they were young, the wealthy subscribed to a different, more lenient set of standards than everyone else.

The same could be said of Betty Parsons, the art gallery owner who was in New Mexico several times in the 1950s, and whose 1957 visit to Taos would prove pivotal for Martin. Parsons was born into a family of considerable wealth and social prominence; even when her fortunes declined, she continued to live among the similarly fortunate—and, before and after her brief marriage, to enjoy frank relationships with women. Martin's sexuality, like much about her, was anything but open. There is conjecture that Martin had affairs with a few women in Taos in her early years there.[44] Unquestionably, she had chosen to live, not for the last time, in a community

where single women were not uncommon, where homosexuality was more acceptable than elsewhere, and where independent spirits were welcome.

Important in connection with the social tolerance characteristic of Taos (and to some extent of Santa Fe) is that despite Martin's emotional difficulties, which would repeatedly lead her to choose prolonged isolation, and despite her poverty, which would remain intractable for many years, she had an uncanny ability to befriend people of every kind, including those representing the full spectrum of inherited and acquired privilege. When Martin was in Albuquerque, she became acquainted with O'Keeffe, and visited her in her home in Abiquiú, then new and (especially by Martin's standards) quite lavish. Evidently, they discussed traveling around the world on a freighter. Martin recalled that the discussion of the trip made O'Keeffe increasingly, and finally exhaustingly, enthusiastic: "Georgia was like that—very intense and exciting to be with, but she drained me. When I left the room for a few minutes, I just had to lie down, right then and there."[45] (Martin and O'Keeffe did not take this trip together, although Martin would later take many ocean voyages, including at least one on a freighter.)[46] In another recollection of O'Keeffe, Martin said, "Once, when I came from New York, I went to visit her in Abiquiú. The trouble with it, when I went to visit O'Keeffe, I found her over-stimulating.... She liked to make fun of young men ... When we left, we went to Santa Fe and we went in the first bar we could find and we just drank. (laughing) Glass after glass of beer. To recover."[47] But if she remembered O'Keeffe as an exhausting companion, she also remained grateful for her encouragement, which continued after Martin had gone back to New York and her career had gained traction.[48]

•

Martin's retrospective evaluation of the artwork she made during her initial years in New Mexico was categorical: "At Taos I wasn't satisfied with my paintings and at the end of every year I'd have a big fire and burn them all."[49] Indeed, the works of the forties that escaped the annual auto-da-fé are uneven and, by the standard of advanced art at mid-century,

often cautious in subject matter and form. (It has been suggested that the surviving landscapes, still lifes, and portraits include a few that were made for classes, and for applications for scholarships or teaching positions.[50]) Nonetheless, these early works are fascinating, both as tantalizing precursors and on their merits, which are considerable.

The oeuvre begins modestly, with several small watercolor landscapes strongly reminiscent of John Marin; they could be among those of which she said, "I used to paint mountains here in New Mexico and I thought my mountains looked like ant hills."[51] This is not necessarily a failure of representation. The clarity of the atmosphere in New Mexico does make distant mountains look deceptively close, hence oddly small, and Martin's depictions are spritely and fresh, capturing the regal blue sky and hurrying clouds so characteristic of the high desert. In their fidelity to the odd experience of a miniaturized, or compressed, landscape, and to the razor-sharp details that the atmosphere in the desert produces, these landscapes evoke the biblical quality of the terrain. *New Mexico Mountain Landscape, Taos,* 1947 (pl. 4), for instance, is a confident sketch of deeply shadowed mountains in bright sunlight, rendered with quick, precise strokes. The subject of *Untitled (Landscape South of Santa Fe, NM),* 1947 (Peters Family Art Foundation, Santa Fe), another small watercolor, is more arid, the sparse vegetation lending itself to staccato graphic representation. There were also early still lifes, including a very animated example of 1948 (private collection).[52] The blooms shown, all past their prime, are rendered in a range of vivid reds, from deep, bluish rose to earthy brick, the blown petals exposing the fecund pistils; the paint is applied loosely and energetically. The flowers are held within a perfunctorily sketched blue vase that sits on a green table, and both vase and table seem to be spinning; the whole composition, crammed into the small canvas, bursts upward with great vivacity and sensuality.

This still life's liveliness stands in stark contrast to a handful of early portraits, which are guarded in execution and affect. In an undated self-portrait, painted in oil on canvas, and modest in size (26 by 19 inches) (pl. 3),

Martin gives herself huge blue-gray eyes that, although downcast, dominate her face; the cheeks are very ruddy and heavily worked, but the animation they might evoke is countered by a slope-shouldered torso—so unlike the vigorous woman shown in early photographs—and a narrowly striped shirt that further flattens the form of her body; her hair is swept up in an old-fashioned, businesslike style. Conventionally pretty but not delicate (and bearing little resemblance to the young Martin), the face is bluntly drawn. An absence of highlights and an undifferentiated, scumbled brown background make it hard to determine the source of illumination. It is a melancholy, implacable picture. Equally adamantine is the 1947–49 portrait of Daphne Vaughan (pl. 2), who was a friend of Martin's; they had lived together in Albuquerque.[53] Thick encaustic renders Vaughan's skin a lightless adobe red. Her arms are crossed over her chest, which is thereby again neutered; flattening it too is a deep-dyed red background. The head is shown in a three-quarters profile and the eyes are downcast and powerfully strange: there are no irises and no whites; instead, the open lids are carefully filled in with pencil, lending the subject something of the look of a Greek kouros. This early appearance of pencil marks amid paint feels like a beacon, shining (literally, as the graphite adds the faintest glint) toward the future penciled grids.

On the other hand, a nude half-length portrait of a woman from 1947 (oil on canvas, 20 by 16 inches) (pl. 6) is frankly appealing, although also markedly odd. Pressed close to the painting's surface, the subject's body has a brassy glow, its highlights a warm ocher and shadows brick red. The very wide shoulders, one hitched up a little defensively, span the small canvas like a rampart; from the sunlit chest, plump breasts thrust forward, nipples rosy. Tilted slightly to one side, the subject's commanding head is crowned with flowing brown hair, cut in blunt bangs across the forehead and falling heavily behind her shoulders. Big gold hoops dangle from her ears. The high arched eyebrows seem artfully tended, and the mouth, too, beneath a barely indicated nose, seems cosmetically enhanced. Her eyes, however, are again lightless voids, this time painted a pitchy black. If this

nude does not lack sensuousness and a certain degree of deliberate exoticism (the sitter may have been Mexican, or perhaps Native American), the gouged eyes are deeply sinister. (This painting was included in the 2010 exhibition "Hide/Seek: Difference and Desire in American Portraiture," which took a long view of homoeroticism as a factor in American and European art; the context promoted the sensuality of the image, but its address could hardly be called alluring in any uncomplicated sense, and in any case the painting, like the other portraits, may have been an academic exercise.)

Two further paintings from this period, one known only by Martin's description, point in very different directions. A small untitled oil-on-Masonite painting dated 1949 (pl. 8) anticipates a radical change to come: it is dominated by an irregular red lozenge that serves as the ground for three black vignettes, each bearing a cipher-like figure scratched into the paint: they represent, in rudimentary form—as if in a code for recording motifs that will soon be discarded—a mountain range, a tree, and a rectangular contour that might be a lake, or a house, or a pure abstraction. Of a painting that won first prize at a Taos Art Fair in around 1951, the critic Lizzie Borden reported, "Martin has indicated that the subject of the painting is a father worrying that his son is not masculine enough, forgetting that sons are not born manly."[54] It isn't easy to picture this lost painting, nor to reconcile it with others that exist from the period. But it is clear that Martin had a good deal on her mind.

·

By the turn of the decade, Martin's impatience—with her work, with the Taos community, and with her professional status—again led her to move on. In the fall of 1951 she returned to New York, spending three more semesters at Teachers College. This time, she was not a newcomer to New York, nor to painting. (She was also securely American, having become a U.S. citizen the year before.) And this time she succeeded easily in school, taking a mix of academic and studio courses (including advanced painting,

lithography, studio problems, and figure drawing and composition), and excelling in the studio work. Enrollment had rebounded,[55] but the tide of veterans that had vastly swollen classes in the immediate postwar years had subsided. In June 1952, shortly after she turned forty, Martin was awarded an MA in education with a concentration in fine arts from Teachers College. It was her final degree and for the next year she took no classes as a matriculating student. In the fall of 1952 she taught for one semester at Eastern Oregon College in La Grande. The following year she returned to Teachers College for a final academic experience, taking a "Seminar in Social Living" in 1954 at PS 125, an elementary school in Harlem.

In these years, several pivotal cultural events took place at Columbia University, and at Teachers College as well. Daisetz Suzuki, an enormously influential Japanese scholar of Zen Buddhism, gave three lectures at Columbia in March 1951.[56] Suzuki's lectures drew overflowing crowds and reached many more through hearsay. Although Martin wasn't in New York in time for Suzuki's lectures, his teachings were certainly in the air and came to be reflected in her thinking. John Cage also lectured at Teachers College at around this time and gave two lectures at the Eighth Street "Club," an important forum and meeting place for New York-based artists, on the subjects he designated "something" and "nothing"; he had spoken at the Club more than half a dozen times by 1955.[57] While Martin had already been exposed to Eastern spiritual teachings through their currency among the artists in Taos (and may have become aware of them in Seattle in the 1930s), her time in New York allowed her to engage with them to a much greater extent.

Just as Asian thinking was gaining a foothold in certain New York cultural circles, European influence on the East Coast was being eclipsed by rising American painters, the more so as most of the wartime Continental expatriates had returned home. Pollock had made his first drip painting in 1947, Newman his first "zip" composition in 1948. Betty Parsons opened a gallery under her name in 1947; the artists to whom she gave one-person shows, between 1951 and 1953, included Pollock, Reinhardt, and Theodoros

Stamos. During these years, Parsons was also representing Barnett New-
man, later a pioneer of hard-edge, big-field painting who, like Reinhardt,
would come to play a significant (if short-lived) role in Martin's career.
Sam Kootz and Charles Egan both opened important showcases for van-
guard art in 1945, Sidney Janis in 1948, and Eleanor Ward founded the
Stable Gallery in 1953. Dorothy Miller's "Fifteen Americans" exhibition of
1952, one in a series of pioneering shows she organized for the Museum
of Modern Art, featured work by William Baziotes, whose atmospheric
biomorphism had some relationship to Martin's early work; by Bradley
Tomlin and Richard Lippold, whose linear abstractions would be relevant
to her as well; along with work by Pollock, Rothko, and others. The range
of art available to her in these New York years was enormous and she was
well prepared to absorb it.

Following her last stint at Teachers College, and during the time when
she was not enrolled there (nor teaching elsewhere), Martin returned to
New Mexico and stayed until 1957. During her previous residence in the
state she had alternated between Albuquerque and Taos, but this time
she remained in the latter, and "although it was hard to hide out in such a
small town," Witt writes, she "maintained a relatively low profile."[58] Mar-
tin's living conditions in Taos were rustic, even by local standards of the
time. For a period, she shared her small house next door to the Harwood
with the artists Kit and Ted Egri—it had neither heat (aside from a small
wood stove) nor indoor plumbing (there was an outdoor privy). "I had a
good studio behind the Harwood for fifteen dollars a month, but I almost
starved to death a couple times," Martin said.[59] And although there were
intervals when she withdrew from social contact altogether, she did not
decline companionship or opportunities for professional advancement.

Among her neighbors was Clay Spohn (who taught at the California
School of Fine Arts in San Francisco in the late 1940s with Clyfford Still, a
painter of craggy abstractions born in Western Canada, and Rothko, who
was a guest faculty member in 1947 and 1949; Richard Diebenkorn was
among their students). But she was closest in the early 1950s to Beatrice

Mandelman and her husband Louis Ribak, who lived a block away and had come to Taos from New York in 1944. Martin went to see them "just about every night," she recalled; art was a not a subject they discussed.[60] Also living in straitened circumstances, especially at first, but more comfortable than Martin, Mandelman, who was Martin's exact contemporary and shared many of her artistic inclinations at this time, had already been associated with a number of the vanguard New York artists, including Stuart Davis, Willem de Kooning, Arshile Gorky, Louis Lozowick, and Pollock. Ribak, too, had a wide acquaintance among New York artists and had first shown there in 1931.

Martin was included in exhibitions at Mandelman's and Ribak's open studio, Gallery Ribak, including its inaugural show in 1955, which featured only her work and theirs. "Agnes Martin, long-experienced as a teacher, is a less-experienced painter who shows great integrity and seriousness of purpose," *El Crepusculo*, a Taos newspaper, reported. "After having taught art in both public schools and the U. of New Mexico, Miss Martin decided to strike out on her own for a career as an artist. Dedication to her ideals is apparent in her work." At least once she also showed work at the Stables gallery in Taos—where, she said, "everybody squabbled"[61]—and at the Ruins Gallery in Ranchos de Taos, a few miles north of Taos, although she said she had hesitated about joining it, feeling her work was "different" from that of the other artists.[62] In addition, she recalled, "Another boy and I rented a storefront in Ranchos [de Taos] for nine dollars a month. We had one-man shows there, one after another."[63]

Inevitable frictions notwithstanding, relations among the Taos artists were close and lively. "When I lived here in the fifties there were 100, 150 artists," she said in a late interview conducted in Taos. "I knew everyone. They had such good parties. The parties in New York were dull after that. Parties every week, with dancing. Sometimes we'd have a program where each one would recite or sing."[64] But she does not appear in the photos (or the records) that survive of receptions at other Taos galleries, including the Heptagon, which had opened in the early 1930s. Determined to succeed and

selectively convivial, Martin was nonetheless often leery of social engagement. On the other hand, her appetite for vigorous outdoor activity was uncomplicatedly enthusiastic. Mildred Tolbert, a local photographer, wrote that toward the end of this period in Taos, Martin's "social circle began to widen.... And when Joan and Erik Erikson [the psychologist] were in Taos for a time, Agnes invited me to climb Wheeler Peak with her and Joan Erikson.... As we were descending the mountain beside a roaring stream, Agnes called out, 'I like your plumbing Lord.'"[65] It's clear why her company was cherished.

•

Whatever the hesitations and hardships that marked Martin's life during this period, these were productive years. And although she would later be dismissive of her efforts in Taos—"I worked hard in Taos, but in New York I just painted and threw them away and painted and threw them away until I got at the place where I felt I was doing what I felt I should," she'd say[66]—the work of the early 1950s was crucial in her development. During this time, she turned decisively toward abstraction, and there was at last a considerable quantity of paintings that—at least for the moment—met her expectations. In a letter of January 3, 1956, to Helene Wurlitzer, she states that in the previous year she had painted "one hundred canvases of which I had a good opinion and sold seven."[67] Her long apprenticeship was drawing to a close.

Hovering between figuration and abstraction, the work of the second Taos period reveals the clear influence of a number of leading modernists, particularly Joan Miró, Arshile Gorky, Paul Klee, William Baziotes, and Adolph Gottlieb. In some of the surviving works of the early 1950s, biomorphic and star-shaped figures float on, or spring across, grounds blocked out in softened geometric shapes, as in a small untitled print of 1952 (private collection). Two small ink drawings of the same year, executed on both sides of a single sheet, feature sketchy, saucer-headed totems with fright-mask eyes towering over inky vegetal forms (private collection). The title of *Personnages*, a lithograph from this time, may indicate familiarity with

Louise Bourgeois's totemic sculptures, shown in 1949 and 1950 in New York; Alberto Giacometti's influence is evident too.

More robustly narrative, *Expulsion of Adam and Eve from the Garden of Eden*, tentatively dated 1953 (pl. 11), is, at 4 by 6 feet, a very large painting by Martin's standards at the time (her financial resources were limited enough to severely restrict purchase of materials). It is executed in oil on board, and in feeling is decidedly graphic, with delicate contours, executed in finely drawn, ink-black lines, and vaporous washes of color. The biblical narrative is given a sharp twist into what clearly seems, not the exodus of two mortals fallen from a state of grace, but the escape of a terrified woman from a powerful if irresolute man. Adam's head, outlined in profile, faces up, howling; a star shoots across the sky above him. Though reaching forward, he seems immobilized, perhaps by the horseshoe-like shapes that link his slightly bent knees. His upright form spans the surface, an anchoring column. Eve, by contrast, is in chaotic flight. Facing us, her arms wide in appeal, she is lifted up by a graceful, bounding leg, and also by a spinning, propeller-shaped foot; she appears as well to be supported by wings. Windswept green leaves adorn her back. The colors, thinly applied, are mostly pale shades of pink, blue, and white, though a bright red form scythes across Adam's midsection; flying toward his chest is what seems to be a disembodied breast. For all the inscrutability of its symbolism, the composition is powerfully integrated; its emotional register is of baffled panic, as in a dream from which the sleeper desperately tries, without success, to scream herself awake.

An untitled oil painting also dated 1953 (pl. 10), slightly smaller and on canvas, is both more frankly sensual and more abstract. A swelling, pink form at bottom center is unmistakably a breast, centered on a brown nipple as plain as a target. Above and to the right, an ambiguous fleshy form has a furry brown patch of paint at its center. But the other crisply drawn shapes that bounce around this canvas, in shades of black, white, and gray, are hard to identify as even allusively human. The drama here is formal. By contrast, *The Bluebird*, 1954 (pl. 9), is a painting that combines

simple charm with a sense of lurking menace and evokes the quiet hum of nocturnal activity in Klee's nighttime gardens and seas. In a lunar, silvery nimbus at the lower right corner of Martin's painting, a pert, sketchy bluebird perches uncertainly, its thickly impastoed eye vigilantly alert; Morris Graves's birds seem to lurk here too. Stacked above and to the left are various nested frames, most in a midnight range of grays and blacks, though a white square to the left is topped with a light gray oval, echoing the bird and its moonlit halo. Sweeping behind the bluebird is a scarcely visible, deep blue tail, blurred with silent movement. The loosely rectilinear compartments into which this painting is divided constitute, like the penciled eyes of the early portrait, a strikingly premonitory note, pointing toward the grids to come. Another steady balance of naturalism and abstraction can be found in *Mid-Winter*, 1954 (pl. 12), in which traces of landscape, evocative of Milton Avery's work, form the armature for a study in shades of gray. A big brown cloud, ringed with black, barrels down towards thickly scumbled fields of brownish white, sharply evocative of well-worn snow and gripping cold.

The fairly stable and calm organization of these canvases is starkly opposed by an untitled painting of 1954 (University of New Mexico Art Museum, Albuquerque), its jangled, wiry lines vibrating with tension. At top center is a pair of dotted circles—eyes? breasts? Beneath them, a wild scrawl, drawn in black on white, frames a yawning void. At bottom is the residue of two flattened figures, one of them vaguely boatlike, which makes the central form appear to be a sail. The ground is brown, earthy. Did Martin, living in the desert, miss her days of sailing off the coast of Canada? Both playful and melancholy, *Dream of Night Sailing*, 1954 (private collection) sets a round-bottomed black vessel afloat in a sea of moonlight-striped gray. There is no certain horizon. Tattered clouds, or waves, run uphill. Paint-strokes circle a tiny boat, buoying it, provisionally. Much more settled, and more structurally complicated, is *Autumn Watch*, 1954 (private collection), a substantial work in shades of black, white and gray that feels as tightly constructed as *Night Sailing* is dreamy and fluid.

Irregular flat forms are puzzled together, interlocking and overlapping: blacks advance, grays recede, with a confident sense of rhythm. In another substantial (33 by 53 inch) untitled painting of c. 1955 (private collection), clearly executed by a painter with much experience of winter light and blankets of snow, shades of white are differentiated by the merest breath. A pale, yellowish saucer-shaped disk above is neither quite solar nor lunar; beneath, barely visible lines, which appear to have been drawn in ink (and possibly crayon, in places), hint at a horizon, and perhaps crude dwellings. The unusual conjunctions of graphic and painterly materials; the counterpoint of fine line and broadly washed, pale fields of paint; and, particularly, the forms that hover at the limits of coherence and visibility, are all features that look forward to the kinds of abstraction Martin was feeling her way toward and would in a few years begin to inhabit fully.

These surviving early works are a tease, pointing in several directions. Color is almost always suppressed, likewise drama, which, while not absent, is strongly muffled; indeed the dynamism of the paintings comes largely from the effort to resolve conflict. Throughout this second period in New Mexico, Martin's influences remain European and American modernism, and also, perhaps native textiles of the Southwest. The local landscape, its seasons and its light, are inarguably present. But by the middle 1950s, the reference points for progressive painting in New York were shifting radically, toward homegrown modes of both hard-edged abstraction and figuration based in commercial imagery. As would become clear only belatedly, both had strong European counterparts and even precedents, although in the 1950s American painters turned their backs on the culture that had so long dominated visual art. Visitors to Taos would have brought this news; magazines were broadcasting it too.

However halting her progress, Martin's work was changing radically, and her efforts to gain attention and support in New Mexico were not without success. She secured a grant from the Helene Wurlitzer Foundation, in Taos, in 1954, the year it was established. It was not a princely sum: as she put it, "I was the first one to receive a Wurlitzer grant. All I asked for was

$25 a month to buy supplies. And so they gave it to me right off."[68] The references she listed in her request were the artists Lez Haas (who'd also been a Field School student), her neighbor Clay Spohn, and Betty Parsons; the date of Martin's first acquaintance with Parsons, which this mention implies, is not clear. In the application essay, she wrote, "I would like to say that my efforts and interests as an artist are directed toward assisting in the establishment of American Art, distinct and authentic, that I feel we, myself and other artists, will very soon succeed in making not only a successful but an acceptable representation of the expression of the American people. I feel that it is very thrilling to be 'in' at the beginning as we are."[69] Her cultural patriotism is as clear in this statement as her ambition. According to David Witt, "None of the other Taos artists then seemed to experience the overwhelming drive to become famous" that Martin did.

In the summers of 1956 and 1957, Parsons and the Japanese-born painter Kenzo Okada went to New Mexico, staying with Aline Porter, a friend of Parsons (and wife of photographer Eliot Porter), in Tesuque, near Santa Fe. They'd been to Taos frequently, also visiting there with Parsons's friend Dorothy Brett. Parsons had seen Martin's work in New York before 1954 and was encouraged to handle it by Okada, whom Parsons represented and whose soft-colored, subtly biomorphic abstractions bore some resemblance to Martin's at that time.[70] Parsons had approached Martin about possible representation, and by the summer of 1957 Martin was ready. In Martin's recollection, "Betty Parsons came to visit Dorothy Brett and I knew Dorothy Brett so I called on them and asked her to look at my work and she did," viewing it in the space Martin rented next to the Ruins gallery north of Taos. Martin continued, "She bought enough of my paintings"–five–"so that I could go to New York and she promised to show my work,"[71] on the condition that Martin live there. Once more, then, Martin gathered herself for the bracing plunge into an art world whose intensity she found both nourishing and ultimately insupportable.

REACHING HARBOR

M artin came back East in 1957, beginning a period—at the age of forty-five—when she at last embraced the vocabulary she would work with for the rest of her life. Indeed, nothing she made before this time ultimately qualified, in her mind, as art at all.

Martin could hardly have chosen a more transformative decade to be in New York, her first and last as a resident member of a major city's cultural community. When she had left the city a scant five years earlier, Abstract Expressionism was still headline news; by the time she returned, Pollock had been dead for a year, and while most of the painters with whom he was associated remained active—at least for a few years more, as this generation was notoriously short-lived—and highly visible, the tide was turning against the highly expressive forms of painterly abstraction they had pioneered. Pop art, on the one hand, was elevating everyday objects and images into art. On the other, and more important for Martin, a handful of New York School painters, including Reinhardt, Newman, and Ellsworth Kelly, were picking up a trail left by Piet Mondrian and Josef Albers to help forge a movement toward hard-edged abstraction.

Martin would be recognized as a progenitor—however reluctant—of this movement, which came to be called Minimalism, and which helped cement New York's central place in an explosively active new art world. By the time she left the city in 1967, the small, insular, and deeply introspective

cultural scene of the 1950s had given way to the stunningly centripetal and famously uninhibited sixties, with its celebrated art stars and roaring market, all avidly tracked by news media happy to find parallels between commercial and highbrow culture.

Betty Parsons's support for Martin when she arrived was crucial. When Martin first arrived in the city, she briefly lived with Parsons in her studio at 143 East Fortieth Street. Parsons would present Martin's first New York exhibition in 1958 and introduce her to the artists among whom she would soon be living in lower Manhattan. But Martin didn't stay long at the Betty Parsons Gallery, and her daily life, as always dominated by work, was quickly caught up in the distinctive rhythms of the Coenties Slip community in lower Manhattan where she settled.

Dating to 1699, Coenties Slip—the term "slip" refers to an inlet created as a boat landing—originally extended from the East River as far inland as Front Street, several blocks from the current edge of the island. It lent its name to a section of the oldest and once the busiest waterfront in Manhattan. By the 1880s it had been filled in, and during the late nineteenth century, the neighborhood's buildings served as warehouses, gas works, and ship supply shops, including stores for ropes, tackle, and netting.[1] Many of the buildings retained pulley systems for hauling up goods, and many remained unchanged through the middle of the twentieth century, when activity in the area centered on the seaport's wholesale Fulton Fish Market. But this part of New York had once been a cultural and, particularly, a literary center too, drawing Herman Melville, Walt Whitman, and Edgar Allan Poe to its streets and providing subjects for their writing.

New York, which prides itself on being a forward-looking city, has not celebrated (nor marketed) its history as aggressively as have other East Coast cities such as Boston, Philadelphia, and Baltimore, and the commercial development of the South Street Seaport, which dates to the early 1980s, has been less ambitious (and less successful) than other urban waterfront restoration projects. Nonetheless, the area's current chain stores and tourist sites successfully obscure the outlines of the old, pre-development

seaport. When visual artists began to congregate there in the 1950s, it was profoundly isolated from the rest of the city; the disjunction between the towers of the adjacent financial district and the waterfront's tumbledown nineteenth-century buildings was a visual, cultural, and economic contrast so jarring as to be uncanny. In one of a series of long articles that Joseph Mitchell wrote about the seaport at midcentury for the *New Yorker*, he described with great relish "the fish smell, the general gone-to-pot look, the trading that goes on in the streets, the roofs over the sidewalks, the cats in corners gnawing on fish heads, the gulls in the gutters, the way everybody's on to everybody else, the quarreling and the arguing."[2]

If the narrow, crooked, windswept byways of Wall Street, so often described as canyons, were utterly deserted at night, the small riverfront enclave to the east, where the smell of the sea is strong, was hardly less desolate. It offered nothing like the fractious conviviality of the Abstract Expressionists' "Club" on Eighth Street, which hosted lectures and discussions (including Cage's, mentioned earlier); the Waldorf Cafeteria, where they often met in the early days for coffee; or the Cedar Bar, where they convened later, for more fortifying beverages—and more aggressive exchanges. (In fact, from the perspective of Coenties Slip, there were several uptowns, including the Greenwich Village and Union Square areas, the blocks around Fifty-seventh Street where the major galleries were situated, and, for the more successful artists, the apartment buildings on the Upper East and West Sides of Manhattan.)

Painter Jack Youngerman, who moved to the seaport in 1957—like Martin, he came to New York at the urging of Betty Parsons—recalls an aversion to those now legendary Abstract Expressionist meeting places, and he refers fondly to a local spirit that was both warmly congenial and decidedly less collective than the one prevailing a little further north. "The Tenth Street crowd, and the influence of Greenberg, was oppressive," he said, referring to Clement Greenberg, the pugnacious critic who championed Jackson Pollock, David Smith, and other artists of the New York School's first generation. "No one on Coenties Slip went to the Tenth

Street meetings," he has said. "We all knew that we weren't part of the de Kooning/Pollock legacy in art which was centered around Tenth Street."[3]

While the Slip produced a powerful and distinctive sense of community, which transcended differences between abstractionists such as Martin—who vigorously maintained that her work was close in spirit to the Abstract Expressionists, whatever her social distance from them—and Ellsworth Kelly on the one hand, and figurative artists like Johns and Rauschenberg on the other, it was hard to define its character. "'Crowd' and 'scene' don't quite describe what I remember about living there," Youngerman recalls.[4] It was, perhaps more accurately, a group of artists who'd washed ashore and were glad to find others similarly bivouacked, but who shared most of all a profound respect for privacy.

The buildings surrounding the seaport, with floors that tilted and splintered, and walls that didn't always meet ceilings, offered big, river-facing lofts that lacked not just kitchen fixtures but often heat and hot water; the great majority were not legal residences, so beds were hidden, and unwelcome visits from the housing authority were routine. But there were distinctive comforts and rewards. Youngerman, who, like Kelly, arrived from Paris (they'd become friends there), said the two cities, as viewed from the perspective of New York's seaport, shared a comfortingly melancholy tonality that he remembers as "pigeon gray."[5] The Seamen's Church Institute, then located at 25 South Street, provided a much-needed cafeteria with mounds of cheap food and, just as welcome, hot showers.[6] Occasionally, the artists would meet at Sloppy Louie's, an inexpensive local restaurant, and at each other's openings. But the feeling of the neighborhood was curiously non-urban. Charles Hinman, who arrived on the Slip in 1960, recalls, "It was, on the weekend, like a country village."[7] Ann Wilson, who, like Martin, settled there in 1957, remembers Coenties Slip at the time as "a very tender place."[8] For a brief—and now legendary—time, it wove a powerful spell.

Indeed, by 1958, a year after Martin arrived, the community was the subject of a feature article in *Cue*, which billed itself as "The Magazine of

New York Living." Titled "Bohemia on the Waterfront," it hailed "A New Shangri-La" being created at the East River's edge. Explaining that Greenwich Village had become "fashionably expensive and self-consciously 'arty,'" the article noted that, by contrast, "Seriousness is the keynote of the waterfront group" of painters, poets, actors, and weavers, who favored the area despite—or because of—its lack of bars or restaurants; in fact, there was "nary a coffee shop in sight."

Of the handful of artists named in the article, only a few were quoted, and among those, Martin's voice predominates—a considerable surprise, since she was a newcomer, and never known for seeking media attention. "Being down here reminds me of Taos," she told the author, Faye Hammel. "You feel as if you've climbed a mountain above the confusion." Hammel notes that Martin was preparing for a show at Betty Parsons Gallery "sometime in 1959"; in the event, it opened in December 1958: Martin hit the ground running. And she emphasized, in these first published comments, a commitment to work, and to solitude. "Painters must live together because other social contacts are barred to them," Martin said, but "when you paint, you don't have time to get involved with people, everything must fall before work. That's what's wonderful about the Slip—we all respect each other's need to work. The rest of New York? Everybody groans about going into the city and sings when he comes back home." The reference to "the city" as a place apart is striking (Youngerman used the same locution in this article); so are Martin's rather formal and poetic habits of speech, discernible in an unattributed quote that seems unmistakably hers: "You can shut yourself up in your studio for three days," Hammel says "a painter" told her, "and when you come out again into the Slip it's like stepping into cool water."[9]

Later, Martin expanded on this picture. "We all did the same thing, like we went to Prospect Park, and rode on the ferry, and things like that," she said, "but we went alone, we didn't go together. . . . Because it's better not to get involved and argue and talk if you're really seriously moving ahead. . . . The best thing to do when you stop painting . . . is cross the

Brooklyn Bridge."[10] Another thing that made it "a great place to live" was that "you could go on the Staten Island Ferry before breakfast"—the terminal was just a block away.[11] But again, she added, "We all knew enough to mind our own business—even when we stopped painting. If, when you stop painting, you go and meet people and try to have a good time and everything, you get off the track. When you're really painting, you don't want to interrupt yourself."[12] To the era's preeminent art historian, Irving Sandler, she recalled, "We all lived the same kind of life and we all had the same kind of velocity, you might say." Completing the portrait of this heterogeneous but harmonious community, Martin concludes, "There was no resistance, there was no competition."[13]

Among the earliest to settle in the seaport area were Rauschenberg and Johns; they were on Pearl Street by 1954. They were the most successful, in the 1950s, of the local artists, but Robert Indiana remembers them as also being among the more aloof.[14] (Indiana arrived in 1956, living first at 31 Coenties Slip and then at 25.) Newman had a studio nearby, on Wall Street (although he didn't live there). When Kelly returned to the United States in 1954 from France, where he had lived since 1948—he came back, he said, because he'd seen a reproduction of a very reductive painting by Reinhardt in *Art News* and felt his own then grid-based work might find a warm reception in New York[15]—he visited Fred Mitchell, a Mississippi artist who was the Slip's pathfinder. Mitchell had taken a place at 26 Water Street in 1951, and he helped Kelly find his first loft, at 109 Broad Street, near the Seamen's Institute.

There was a good deal of movement within the seaport, as personal circumstances changed and buildings were demolished to make way for development. When Youngerman arrived, he took up residence at 27 Coenties Slip, where Martin lived until 1960 as his tenant. Youngerman also rented space to artists Ann Wilson and Lenore Tawney, with both of whom Martin formed strong attachments. It was because number 27 was torn down that Wilson and Martin relocated to 3-5 Coenties Slip, joining Kelly, who had moved there by 1957 (James Rosenquist and Charles Hinman

would live there later). Martin took the second floor, Kelly was on the top floor, and Wilson was on the first, above a bar at street level. (Because 3–5 Coenties Slip shares a block with the historic and landmarked Fraunces Tavern, it still stands; the other buildings in which artists lived have mostly been replaced with corporate towers.) Martin's final loft at the seaport was at 28 South Street, directly facing the river.

Ann Wilson says, "Agnes had an old Acorn cast-iron kitchen stove on which she made marvelous muffins";[16] her homemade muffins and other baked goods, and a similar stove, would turn up throughout her life. Similarly, the sparse furnishings included, always, a rocking chair. "I had a hundred-foot-long loft," Martin reported. "It had two skylights and fourteen-foot ceilings with great beams, and at the end of every beam you could see daylight." As a result, of course, it was cold. "So I had a big heater blowing that used to be in a garage. It was quite economical. When you moved into a loft, you had to put everything in—the plumbing, the kitchen stove. But on the Lower East Side you could buy anything you needed real cheap, because it's so hard to throw things away in New York. I found a bathtub with long legs and claws. I had to put it somewhere so I put it in the bedroom."[17]

Among the activities at 27 Coenties Slip was, briefly, an art school on the first floor, run by Indiana and Youngerman in an attempt to earn a little money; life drawing was offered but, Indiana said, it was impossible to heat adequately for nude models;[18] in any case they often took their drawing materials out of doors. *Cue* described the students as "a polyglot group ranging from a barge captain to a businessman from Wall Street," and the article said in good weather they sketched river traffic. Ann Wilson remembers that events at the drawing school included artists' slide shows of places they'd been, like Machu Picchu—a homier version, perhaps, of the evening lectures "uptown" on Eighth Street, which similarly often included firsthand encounters with non-Western art.

Martin found sympathetic company among this varied group of artists, and her inclination to solitude distinguished her perhaps more in degree

than kind. Like Martin, Kelly (born in 1923) has Scottish-Irish forebears (his on his father's side), and like her, too, he is inclined to quiet discipline and renowned for incisive intelligence. Mildred Glimcher, who organized an exhibition of the seaport artists in 1993, writes, "Although intensely private while making his work, Kelly's presence on the Slip was important for many other artists there."[19] Also like Martin, Kelly hesitated before settling briefly in New York and has long kept a wary distance, having left the city for rural Spencertown, New York, in 1970. At a formative stage for both, they exchanged ideas and support. Martin said Kelly was the person she was "closest to" on the Slip,[20] and remembered that he "used to come for breakfast. He came every day for a year and a half to have breakfast. Then he stopped all of a sudden. Didn't come back."[21] (The abrupt break is in all likelihood attributable to Martin, in whose friendships it was a recurrent feature—or, more often, a terminal point.)

Their regard was mutual. Kelly recalled, "My early work—no one else, except Parsons, could appreciate what I was doing then. Agnes appreciated it right away." He explained that they shared a "love of the anonymous, of doing the work. The work itself is what's important. We don't want our personality in the art." Unlike Picasso, or the gestural Abstract Expressionist painters, he continued, "we were trying to get away from the 'I,' as in 'Look how well I do it.' Then, there's a stillness that we appreciate in each other's work, as in a common destiny."[22] Kelly's first freestanding sculptures, made while he was living at the seaport, resulted directly from a conversation with Martin. He has recalled, "When I thought of the first piece, I happened to be having breakfast with Agnes Martin in her studio... I made a model for the piece called *Pony* [1959] from the top of a coffee container we used at breakfast.... Another piece was a sketch from an envelope. It still has her name on it. It's called *Gate* [1959]."[23]

Like many artists at Coenties Slip, Kelly considered Martin a source of comfort and good counsel. "Agnes was always the earth mother, a kind of sage," he said. "When you're in your creative period, between twenty and thirty-five, you go through a lot of crises. She was very much a healer. You'd

go to talk to her and she'd soothe things. Sometimes she would correct us because of our follies, like a parent would in a way."[24] He was impressed by her courage—or, perhaps more accurately, her imperturbability. "I was struck by the way she never locked her door," he told Benita Eisler. "The Seamen's Church Institute was on the Slip. There were lots of drunken sailors around at night—many of them weren't working. It wasn't that safe. I remember thinking, Boy, she's very brave, never to lock her door." Kelly was drawn as well to Martin's cool-headedness. "Artists can be very aggressive and competitive, and they can be loners—hard to get close to—except for confrontational occasions. Bob Indiana, for example was a good friend, and amusing, but he could be very caustic. Agnes wasn't like that." Their shared need for escape from urban life led them to take occasional excursions together. "She was a nature lover, and I was, too. So we went around together. With the first pictures I sold, I bought a little VW, and we would go to Jacob Riis Park," which is on the Brooklyn shorefront. Another favorite destination was the Jersey shore, where several of the artists, Martin and Kelly included, sometimes slept in tents or on the beach.[25]

Kelly was also struck by a quality of Martin's personality that he termed spiritual, and that others have noted as well, with more specificity. In Youngerman's words, "We were all a bunch of Protestants from the hinterlands, as opposed to warm New York Jewish people, like Rothko and Newman"[26] and the rest of the garrulous "uptown" crowd. Youngerman believes that Martin's connection with Parsons was strengthened by the similarity of their religious backgrounds, describing Parsons as having a "kind of upper-class Protestantism which she shared with some of us. In the case of Agnes it was an important factor." Youngerman later elaborated, "I think of Agnes as the ultimate Protestant. That's not a put down at all. What Betty and she had in common was a Protestant soul. That's a very particular thing. I think of [Richard] Tuttle," a younger artist whom Martin befriended while at the seaport—and with whom she maintained an unusual lifetime connection—"in that sense."[27] Taking a slightly different perspective, David Witt, the Taos curator and resident who knew Martin

later in her life, described her as a fundamentalist, "Not a religious person, but strict with herself in an unforgiving way." He continues, "Agnes's relationship to art was along Calvinist lines of being absolute. Her friends were secondary."[28] At the seaport, these priorities seem to have been widely shared, or at least accepted.

In addition to this rather loose but notable affinity, the Slip, like Taos, was distinguished as a place where homosexual men and women could be comfortable, even if the constraints of the time prohibited the openness acceptable today. In fact the tension between gay and straight artists during the years Martin was in New York erupted, at times, into open hostility. Morton Feldman, a musician who was a close associate of John Cage, "recalled the 'raving heterosexual' Pollock's verbal assaults on Cage for being gay ... Feldman thought ... 'there was an anti-homosexual bias' against not only Cage but also Rauschenberg, Johns, poets John Ashbery and Frank O'Hara, and the painter Cy Twombly, among others."[29] Friends of Martin's whose homosexuality has been acknowledged also include Indiana and Kelly; during her New York decade, Martin is said to have had romantic relationships with two women artists: Chryssa (who used a single name) and Lenore Tawney. Indisputably, she had close associations with both.

A weaver, fabric artist, and collagist, Tawney had moved to the Slip from Chicago, arriving shortly before Martin. She was five years older than Martin (and thus among the senior artists at Coenties Slip) and, like Martin, had gotten a late start. Before coming to New York, she'd been married (to a psychologist who died within two years of their wedding), traveled widely, and studied at the School of the Art Institute of Chicago; her instructors had included the Ukrainian Cubist Alexander Archipenko, from whom she also received instruction at a school in Woodstock, New York, and at whose encouragement she went on to the Penland School of Crafts in North Carolina. Unlike Martin, Tawney embraced the seaport's austerity by choice—"I know I'm more fortunate than many because I didn't have to think about making my living out of [art]," she said[30] —and her commitment to the

seaport's material hardships had some qualifications. She'd driven from Chicago in her Daimler, she reported, with sufficient funds that she was able to help Martin by buying her work in the 1960s.[31]

As photographs make clear (and friends affirmed), the attractive and stylish Tawney had a gift for creating gracious interiors, a disposition that Martin didn't share. Says Kristina Wilson, a friend from Taos who visited Martin in New York and met Tawney there, "Lenore was a sprite, very sophisticated and beautiful, and her loft was perfect, orderly and elegant. Utterly different from Agnes's."[32] Finding that the first space she took, at 27 Coenties Slip, was "oh, a terrible loft,"[33] and "needed everything—painting, heating, but first, cleaning out,"[34] Tawney moved around the corner eight months later to 27 South Street, where she occupied three 25-by-80-foot floors of a sailmaker's loft, with cathedral ceilings, a skylight on the top story and a view of the river—and with hot and cold running water, amenities Martin's several residences lacked. The floors were sanded so they "were like a dance floor."[35] Tawney recalled the South Street loft as "an island, really, with the water always," and, at night, boats that "were like Venetian glass."[36] Applying her gift for composing graceful spaces, Tawney presented her work in dramatic installations that were ground-breaking in their challenge to the boundary between art and craft. The best-known examples are majestic hangings of open-weave textiles, often totemic in configuration although fundamentally abstract. Tawney also created a significant body of collages, assemblages, and small works on paper, including hand-worked postcards, in which personal mementos are integrated into formal schemes of great delicacy and wit.

Of Irish descent and raised a Catholic, Tawney was well educated and erudite, and she shared her interests with Martin. Together they read Alban Butler's *The Lives of the Saints*, as well as the writings of Saint John of the Cross and Saint Teresa of Avila. "Of course, we couldn't hope to emulate them," she said, "but we could be inspired."[37] One testament to their friendship is the statement Martin wrote for Tawney's 1961 exhibition at the Staten Island Museum, her first major solo show—and Martin's first

published text. Clearly choosing her words carefully, she praised the work's "directness and clarity" and its "complete certainty of image, beyond primitive determination or any other aggressiveness, sensitive and accurate down to the last twist of the smallest thread." Gathering steam, Martin wrote, "the expression in one square foot of any piece cannot be hinted at. But it can be said that trembling and sensitive images are as though brought before our eyes even as we look at them; and also that deep, and sometimes dark and unrealized feelings are stirred in us." The text ends with three sentences separated by line spaces: "There is penetration. / There is an urgency that sweeps us up, an originality and success that hold us in wonder. / Art treasures indeed, this work is wholly done and we can all be proud." It was signed, with some satisfaction, "Agnes Martin, Painter, Parsons Gallery, New York."[38]

Borrowing equally from the rhythms of the Bible and Gertrude Stein, this statement has a fervor and lyricism that would be developed and sustained in Martin's later substantial body of published writing and public lectures. But this brief essay's fulsome acclamation of collective accomplishment—"we can all be proud"—would not be repeated. Nor was a return favor welcome. Martin avoided catalogues and their attendant critical essays whenever she could and would always remain suspicious, if tactically tolerant, of critics. In an undated letter to Arne Glimcher, Martin cited a Zen koan on the deceptions of words as her reason for prohibiting the production of catalogues for her exhibitions;[39] it was a theme to which she would return often. It has been stated that Tawney titled some of Martin's paintings at the time. But when asked about it many years later, Martin replied, "No. I had one show when I was ill, and Lenore put it on, and she named the drawings." And when the interviewer suggested that the grid works have an affinity with weaving, Martin became angry: "Oh, don't give me that," she retorted.[40] Obviously it was not a subject on which she chose to dwell.

While Martin maintained some contact with Tawney after leaving New York, in 1967 she severed relations with Chryssa, who by all accounts had a

stormier personality.[41] "She arrived in New York in 1955, an ambitious and beautiful twenty-two-year old Greek girl stunned by the electric energy and visual stimulation of Manhattan,"[42] Critic Barbara Rose gushed (rather uncharacteristically) in a recent appreciation. "Chryssa's imagination is like a *ouija* board: she is a transmitter of signals from another realm of consciousness."[43] Others, writing earlier, paint a less rosy picture. The historian Sam Hunter begins a 1974 monograph by declaiming, "The artist Chryssa is a dark and mercurial woman," and says it is difficult "to reconcile her theatrical personal style with the cool, controlled objectivism" of her work.[44] He goes on to say that she "can make strong workmen and artisan assistants blanch by her eruptions of cold fury . . . apocrypha and legend seem to collect around her name." Similarly, the prominent French critic Pierre Restany writes, "Chryssa is famous in New York for her towering cold rages";[45] he, too, mentions technicians who disappoint her. Even allowing for the conspicuousness, at the time—plainly galling to some—of a woman ordering men around, Chryssa stood out.

Born in Athens, Greece, in 1933, Chryssa, like Martin, grew up with a widowed mother, her father having died shortly before Chryssa's birth; she reported that his death sent her mother into months of wailing.[46] She left Greece at the age of twenty for Paris, where she studied briefly at the Académie de la Grande Chaumière and said she met Surrealists André Breton and Max Ernst. Chryssa spent a brief period in California, which she recalled dimly and reluctantly: "I don't really want to remember my time there. I do remember I drove my Austin every day across the Golden Gate from Sausalito, where I shared the houseboat of [Agnes] Varda. The best part about being there is the decision I took to go to NY."[47] The reference to the flashy car is strikingly like Tawney's to her Daimler. Martin, too, loved to drive—"like a race-car driver,"[48] says the artist Pat Steir, who later knew her well—and, after she became successful, also favored expensive automobiles. Her last was a white Mercedes, which she piloted herself until very near the end. There was no stronger emblem of independence, power, and prestige in postwar America than the car, and all three of these

women took possession of it with gusto. Although it would be some time before Martin could match their brands for luxury, driving great distances on short notice for sheer pleasure—or powerful need—was a leitmotif in her life from very early on.

By the mid-fifties, Chryssa was in New York, taking up relatively comfortable residences in neighborhoods ranging from Gramercy Park to the Union Square area to the Upper East Side—where she lived in what has been described as "a minor temple," which suited her beautifully[49]—and winding up, in the late seventies, in SoHo; she never resided at Coenties Slip. An associate of her later years writes in an e-mail, "she seems to have been a loner for a lot of the time she was working [in New York]. But Agnes Martin was a close friend," as was Ursula von Rydingsvard.[50] Von Rydingsvard, a sculptor who met Chryssa when she arrived in New York in the mid-1970s, notes that Chryssa, like Martin, was deeply troubled and hospitalized several times, and, also like Martin, she resisted mightily talking about those experiences. But, as von Rydingsvard observes as well, an equally important bond between Chryssa and Martin, and one they shared with Tawney, was the challenge of succeeding as a woman in an art world dominated by men. Martin and Chryssa, von Rydingsvard says, "were in kind of the same boat—in this huge city that could devour any sort of aspiring artist, especially women, in those days."[51]

In that respect, Martin, twenty years Chryssa's senior and by the late 1950s well into her development of a radically reductive way of painting—and established among a very lively community of groundbreaking artists—likely commanded considerable professional as well as personal attention (at least initially) from the younger artist, who was not shy about seeking out successful mentors. In later reminiscence, Chryssa says that on her arrival in New York she met with such iconic figures as Pollock and de Kooning;[52] she also pursued connections with Rauschenberg and Warhol. Martin evidently fell into that category. Sam Hunter, seeing an affinity between Chryssa's sensibility and Martin's, writes, "Chryssa herself brings up the name of the painter Agnes Martin as one of the first New

York artists whom she knew and respected."[53] And if, as von Rydingsvard believes, Chryssa wasn't capable of true friendship, Martin's relationship with her (as with Tawney) surely involved mutual professional support.

Chryssa's ascent was meteoric. Dorothy Miller, the influential curator at the Museum of Modern Art, acquired her work for the museum and included it in a "Recent Acquisitions" exhibition of 1960–61; in late 1961, Chryssa had a solo exhibition at the Guggenheim Museum. She was still in her twenties. But her first solo show, at the Betty Parsons Gallery, earlier in 1961, resulted from an introduction by Martin. Says Chryssa of Parsons, "I met her thru Agnes Martin who had spoken to Betty about my work. Betty then came to visit my studio and immediately gave me an exhibition."[54] On the other hand, Chryssa continues, "When I had my one man show at Guggenheim, Arnold Glimpser [sic] visited the show and then came to my studio and asked me to work with Pace." (She had solo shows there in 1966 and 1968.) Notably, Glimcher does not credit Chryssa with his introduction to Martin, who joined his Pace Gallery in 1974; the gallery continues to represent Martin's estate. He relates in a monograph, "it was at one of the parties in Jack Youngerman's loft that I met Agnes Martin [in 1963]. Ellsworth Kelly, Robert Indiana, Lenore Tawney, Sam Green and Sam Wagstaff were also there." But Glimcher does note, "Agnes had a close friendship with the Greek artist Chryssa." He continues, "Agnes had always suffered from schizophrenia and from time to time required hospitalization, yet Chryssa was much more violently psychotic than Agnes." He means this literally; rumor has it, Glimcher reports, that during an argument Chryssa broke Parsons's arm.[55]

Parsons, of course, was a powerful force herself. Because her privileged social circle was strongly at odds with Martin's, some who knew Martin feel that a liaison between them is unlikely. "My grandfather was a businessman," Parsons said by way of explaining her background. "He made quite a lot of money." And, she hastened to add, "My father spent his life losing money. He had a gift for that." But she stressed the blueblood nature of her background, noting that she was a descendent of Alexander Hamilton, and

concluding that "nobody could be more American" than she.[56]

Jack Tilton, a gallery owner who was Parsons's longtime assistant and then gallery director, has said that "everyone" knew that she and Martin were lovers briefly in the fifties. Parsons had property in Southold, on the south shore of Long Island, and, Tilton says, "They spent time there. There was a house and a tent on the property. Agnes cut a trail through the brush and Betty called it the Agnes Martin trail." And if their backgrounds were worlds apart, Tilton says, they shared a love of nature that helped cement a relatively enduring friendship.[57] During the unsettled years after Martin's departure from New York, Parsons is one of the people with whom Martin spent time and corresponded. Ann Wilson also believes that "Lesbianism played a part in her [Martin's] relationship with Betty Parsons."[58] Yet in the long interview conducted with Parsons for the Archives of American Art in 1969, Agnes Martin's name does not come up.

Thus even among the artists on the Slip, with whom she had so many affinities, Martin was an outlier. Older by ten years or more than almost all the other artists there, Martin differed from them, too, in her preference for being associated with the Abstract Expressionists, who were her coevals, and whose passionate commitment to achieving transcendent expression matched her own. But in many ways the seaport, as a physical, social, and professional environment, seems to have been ideally suited to her disposition and her artistic interests.

In 1958 the photographer Hans Namuth, perhaps best known for his portrayals of Pollock, was commissioned to photograph Kelly as part of a pictorial essay about the artists who were to participate in the Brussels World's Fair,[59] and of the pictures that resulted, one has become iconic. It shows Indiana, Kelly, Martin, Youngerman, Delphine Seyrig (an actor and Youngerman's wife), and their young son Duncan, on the roof of 3-5 Coenties Slip. The gray masonry of old office towers is massed behind them; the tar-papered rooftop they share is by comparison low and old-fashioned. At the center of the image, the three men form an attentive group around the child, who alone looks at the camera. Seyrig sits off to one side. Opposite

her is Martin, hands in her coat pockets, perched atop the inside slope of the roof's cornice. Smiling serenely down on the scene, she seems a cross between the dorm matron she so often had been and a local deity, and in either case both integral to the group and distinctly apart from it.

•

In New York, Martin's work evolved rapidly, and if the influence of other artists is evident, in it her own voice at last becomes fully, resoundingly clear. During the first few years, there are soft-edged rectangular fields strongly evocative of Rothko, though Martin minimizes color in favor of pure light and the infinitely variable ways it can be muted and veiled. In *The Spring*, 1957 (pl. 17), two horizontal rectangles in shades of grayish light brown, the one on top lighter, occupy a canvas that, at 70 inches square, is very close to the 6-foot-square format she would use for the great majority of her mature work. The painting's simplicity, symmetry, and rectilinear organization are also templates for what would follow: a tightly controlled sensuality, pulsing with a quiet, luminous force. All appear again in *Window*, 1957 (Dia Art Foundation), a smaller (38 inches square) painting featuring a quartet of vertical rectangles, the two above a cool, bluish dark gray, and the pair below warmer and lighter; the ground is nearly white. Here, the penciled edges of the rectangles are visible, if just barely, pointing to the characteristic penciled scaffolding of later, more insistently abstract paintings, while the title pulls this image toward representation, and a specific condition of daylight.

The Spring, 1958 (Dia Art Foundation), 50 inches square, is a more complicated composition than *The Spring* of the previous year. Its two open horizontal rectangles rest near the canvas's top and bottom; between are three horizontal bands, and their relationships establish a subtle tension between planes that slip fractionally under and over each other. A small (25-inch-square) untitled painting (Dia Art Foundation), possibly made the following year is more atmospheric: its two vertical rectangles, which don't quite meet at the center, are each layered in soft triads of brownish gray, the

contours all yielding and slightly irregular, with forms running together at their borders and tilting a little up to the right. The effect is of faintly illuminated fog. As in much of the work of the early New York period, it is hard not to see harbor light, morning damp, and the saline, gray-green mists of the seaport. The same inclinations can be felt in *Harbor I*, also painted in about 1959 (pl. 15), a portrait-format (rather than her by then more commonly square) canvas, whose asymmetrical composition looks back to earlier work, with circular forms and a single diamond-shaped quadrilateral all bouncing gently around a bent and forked band that juts across the gray field. The round shapes anticipate compositions soon to come in which circles fall into regular rows; here, with shadowed contours lending them a subtle volumetric presence, they strongly evoke the gently jostling forms of piers, buoys and water, and the cool, drizzly atmosphere of Manhattan's southern tip.

At the same time, Martin produced a handful of canvases that recall the prairie and her earliest, inland life. In *Wheat*, 1957 (Dia Art Foundation), 49 inches square, fields of grain are evoked by a pair of stacked rectangles in subdued gold, just slightly deeper on top, fractionally more lemony below; they are framed by a gray perimeter, while a band of neutral pale brown bisects the canvas vertically. *Desert Rain* (private collection), a smaller painting of the same year, shares *Wheat's* gray/yellow color scheme, with even subtler distinctions between yellows and bordering grays and whites. *Cow*, a bigger (69-inch-square) painting of 1960 (pl. 18), is centered on a large, brushy brown disc, which is held within nested, Josef Albers-style squares of pale grayed browns. The sense of bovine steadiness and implacability is strong. (So, for some viewers, is an association with Buddhist symbolism, as will become clear.)

Yet it is perhaps more appropriate to accept this painting—and all the others of this period—as fully non-referential. Tempting though it may be to rely on titles to suggest the associations Martin intended, she often reused them, and the willingness with which she accepted ones proposed by friends and colleagues suggests a certain amount of indecision—or,

perhaps, indifference. Without question she would come to resist, in the most vigorous terms, any suggestion that her work represented landscape, water, weather, light, or any other natural conditions or forms. But the natural allusions in titles persist for some time, ultimately to be replaced by the nomination of universal experiences (innocence, happiness). What is arguably clearest, in these works of the late 1950s and early '60s, is the difficulty of giving up such references to landscape and water, of turning away from the kind of natural beauty to which she was so clearly alive, and which offered so much in the way of painterly, and emotional, resources.

In any case, the progression was not steady and had its share of digressions and reversals. There were ongoing Surrealist drawings, such as *Night and Day*, 1958 (private collection), a small casein work featuring a bright yellow, egg-shaped form that is encroached upon by a sperm-like brown element, while a pair of bouncy Miró-esque forms—a star and pink kite—hover above. At the same time, Martin was experimenting with reliefs and fully three-dimensional constructions made from materials found around the seaport. *Kali*, 1958 (private collection), is a small (11-inch-square) wooden object into which wooden boat spikes are driven in a checkerboard pattern, their heads painted alternately black and white. *The Laws*, 1958 (pl. 16), consists of a tall, narrow, wooden board (it is 93½ by 18 by 2 inches) that is painted gray below and black on top; a gridded pattern of boat spikes is driven into the black field. In the small (roughly 10-inch-square) *Little Sister*, 1962 (pl. 19), each rectangular unit of a grid lightly inked onto the white-painted canvas is occupied by two brass nail heads; these glistening points of punctuation form vertical columns, as of a patiently kept ledger. Similarly, in *The Wall #2*, of the same year (National Museum of Women in the Arts, Washington, DC), the heads of hundreds of tacking nails foreshadow the glint of the graphite grid. These seem not only to echo the glint of the graphite line, but also to satisfyingly integrate texture and line in their own right. One can't help mourning other, evidently grander, examples that do not survive; in a letter of the early 1970s, Martin wrote of her constructions, "The best ones made with thousands of

nails (heads out) were destroyed."[60] Despite her use of the passive voice, she surely disposed of them herself. The ambition—and labor—these lost works reflect, and the fierce discipline involved in destroying them, are as striking as her later assessment of their merit.

An anomalous construction that did survive, *The Wave*, 1963 (private collection), is a small board-game-like object in which a few dozen wooden beads are distributed on a grooved wooden surface beneath a Plexiglas lid; they are meant to be reconfigured by viewers tilting the object from side to side.[61] While *The Wave*'s closest link is to the kinds of game boards constructed in the 1920s by such Surrealists as Jean Arp and Alberto Giacometti, the time-based element of this work, meant perhaps to evoke marine movement, also hints (if distantly) at Martin's later experiments with film. And if, as sculptural objects, these works represent roads not taken, the invitation to active viewer involvement would remain on offer, if less openly, throughout her career. "The life of the work depends upon the observer, according to his own awareness of perfection and inspiration,"[62] she wrote. And, "if we can *know our response*, see in ourselves *what we have received* from a work, that is the way to the understanding of truth and all beauty."[63] And, most simply, "The observer makes the painting."[64] Though she would not again make physically interactive work, she remained deeply concerned with the viewer's response.

Another line of inquiry Martin undertook at this time—one that led directly to the later, grid-based paintings—was a small series of untitled white paintings of 1959 that are scored with pencil marks. Digging deep into heavy applications of oil paint on medium-sized canvases (two such paintings are 47½ by 23¾ inches), she inscribed rows of small triangles separated by horizontal lines or, even more significantly, for succeeding developments, grids with slightly wavering lines on horizontal canvases. The deliberate effort of pushing the pencil through the paint is evident. Similarly, in an untitled painting of 1959 (Solomon R. Guggenheim Museum, New York), four vertical rectangles occupy a waxy white surface, their lightly penciled outlines stopping short of some corners and exceeding

others; the interiors of these rectangles are a little (very little) lighter and brighter than their ground. During this period, Martin also executed a number of black and dark gray paintings, a palette to which she would repeatedly return throughout her career. *Lamp* (private collection) and *Earth* (Dia Art Foundation), both 1959, are square paintings composed of evenly spaced rows of circles, in the former gray on black, in the latter black on black. From the same year are dark canvases featuring gray rectangles or nested circles of white. But there are also such single-motif works as a 34-inch-square painting of a black diamond vertically bisected by a pale gray stripe, of about 1957, which is as bold and graphic as a stop sign. A few works of the following year appear to look back to the landscape, as in two paintings featuring paired circles, centered at top and bottom of the canvas and separated by horizontal bands; both paintings strongly evoke a sinking sun or rising moon, hovering above a distant horizon and reflected in still water.

This period of experimentation with format and composition was soon to end. The rectilinear grid that would become Martin's best-known format had appeared by 1958. At this time, she also made a commitment to the square canvas internally organized by straight lines, from which she would not depart, though the variations she would strike on this simple paradigm were prodigious. Sometimes there were parallel horizontal lines rather than grids; as an almost unvarying rule, the grids formed rectangles, not squares. (After 1974, the grids were generally replaced by stripes.) In 1958 she was four years shy of 50 and had been, as she saw it, an apprentice for two decades, a span more common in monastic traditions than in what was becoming an increasingly youth-centered world of contemporary art.

The skeletons of the grids that had appeared in the incised white paintings were also prefigured in numerous drawings. In these works on paper, Martin explored variations on the weight of closely spaced parallel or gridded lines and the distances between them. Sometimes the lines were bounded by regular forms, such as the rhombus of the distinctly

mesa-shaped *Mountain*, 1960 (pl. 21) or the simple squares of *Stone* and *Wood*, both 1964 and both ink, roughly 10 inches square. A small, untitled ink drawing of 1960 features little semicircular humps rising in regular repetition along the delicate horizontal lines; this skeleton of penmanship is telling. *Red Bird*, 1964 (pl. 27), is a drawing in pale red ink of only horizontal lines, so faint they register not much more strongly than the air stirred by a bird's wing, although in her note on the museum's acquisition form for this work Martin cautioned that it is "a bird in the mind, just by itself. A personal experience not about attributes."[65] The colorless drawing *The City*, 1966 (The Cleveland Museum of Art), was executed with gum arabic (the medium in which the pigments of watercolor are suspended), which Martin used to create a grid of relatively open rectangles that pucker the paper like a quilt, or seersucker—or like urban streets.

In some drawings, the close, parallel lines extend past the grid in irregular patterns, as in fringed rugs, and occasionally the lines are doubled. All these works were drawn with straight-edged guides whose placement occasionally seems to have been guided by sight: at one point in working her way through the fine, closely drawn horizontals of *Mountain*, Martin let the lines begin to drift slightly up; she corrected this asymmetry as she went. But as in the paintings, she generally worked with guide marks beyond the field of the finished work—ink or pencil dots that she did not intend to be seen.

Martin's method for executing the grid paintings, once established, did not vary. Two tapes would be measured off in the increments separating the lines to be drawn, and they would be attached vertically to the canvas. Then she would use a short—generally eighteen-inch—T-square ruler or other straight-edge, placed across the marked tapes, to guide her pencil or brush; on her 6-foot-square canvases a longer line would be impossible to control, she explained, because the pressure of the drawing tool would cause the fabric to give a little and hence cause the line to curve. The tapes were repositioned as she proceeded. Graphite, colored pencils, and paint were the mediums for executing the lines. Having long used

oil paint, Martin switched to acrylic by the middle of the 1960s, and in succeeding work its amenability to dilution, as well its relative flexibility (because its medium is a plastic, it doesn't tend to crack when it dries), would add to its appeal for her. In the first grids on canvas, the delineated fields are centered on the supports and bordered with internal frames and/ or unmarked fields. In works made in 1963 and 1964, the grids extend to the edges, "making a single undifferentiated tremor of form, or a plateau of non-form, across the whole surface," as Lawrence Alloway wrote in 1973.[66]

Among the earliest grids is *White Flower*, 1960 (plates 22 and 23).[67] On a ground of dilute gray-brown paint, which imbues the canvas like stain and gives it the appearance of menswear fabric, a grid is drawn in thin white lines; the medium is oil paint, though the lines are controlled enough to suggest chalk or ink. Inside each of the horizontal rectangles created by the grid are two pairs of white telegraphic paint strokes, exactingly executed, as any error would be apparent: viewed closely, it is possible to see the rounded points where the brush touched down, and the tails, pointed inward, of the stroke that followed. The grid extends beyond this marked field, creating a border of empty rectangles framing the central image: an incremental bloom, a field of petals.

White Flower is similar to *The Islands*, ca. 1961 (private collection), an acrylic and graphite painting, 72 inches square, in which a penciled grid is centered on a square canvas. The regularly spaced horizontal lines are closer together than half the vertical ones, making the units alternately square and rectangular. Each rectangle is again occupied by two dashes of white paint, which form columns. The canvas is stained a rich brown, as in *White Flower*, and this grid too extends several inches beyond the field of dashes, forming a net within which they are held. Up close, they form a code, a community, a hive. From a distance, the effect is of diffuse, atmospheric presence. The penciled net gives the white field at its center the slightest degree of play. The whole is chaste, pure; it has a devotional feel, and the sense of an ordering: a book of hours, a map of a perfectly ordered world, each island in its place. A white line that frames the painting near

its edges forms a rather formal, almost heraldic border around the whole, which exudes quiet triumph—an announcement, perhaps, of a problem distinctly apprehended, if never conclusively resolved.

The primed and painted field that grounds the oil painting *Milk River*, 1963 (pl. 26), stops short of the canvas's border, leaving a margin of raw linen—a field within a field. And there is a further internal border: a frame roughly 3 inches wide of paint just a little more pink than the white that grounds the field of horizontal lines (this is not a grid) drawn in red pencil and quite close together (roughly one-quarter of an inch apart), as if the ground has been raked, or combed. Most of them seem to double a very faintly applied first draft, and some waver slightly, lending a very gentle billow to the field. And most pick up the weave of the canvas, which turns some into minutely dotted lines; viewed very closely, these blood-red beads are slightly menacing. From a few feet away some lines disappear, and from around six feet, the whole becomes a shimmering field, the pinkish border seeming more beige; the blush of the central field, which now seems a tender pink, leaches the frame's color and restores the sense of unblemished innocence. But there is nothing saccharine about this painting and, if "milky" (as the title suggests), it seems, from certain angles, just faintly soured. Indeed, the instability of the impression *Milk River* makes—the viewer's sense of never quite capturing its essence, of no one viewing position being summary—is an important and much-remarked component of all of Martin's painting.

Friendship, 1963 (pl. 24), is a grid of horizontal rectangles incised into gold leaf. Another painting of this year, *Night Sea* (The Doris and Donald Fisher Collection, San Francisco), also features gold leaf, but *Friendship* is alone in presenting an entire field of gold, and the impression it makes is of dazzling—and, for Martin, anomalous—opulence. The grid is scored into the leaf, the horizontal lines heavier, going to the whitish ground; the vertical scoring is freer, and seem to reveal a reddish underlying layer of paint. *Friendship*'s luster evokes the gold of saris, of shantung silk, of—powerfully and surprisingly—the sixties; it participates in the era of Kennedy's

Camelot and of the shimmery gold-brown façade of the then new Seagram building.[68] Gold is also a symbol of transcendence in many cultures; it is central to Greek Orthodox icons and to pre-Renaissance Western Christian imagery as well. Any of these connections might have been in Martin's mind. But perhaps, as the title suggests, this painting's gold is simply the coin of personal affection. *Friendship* offers something of a slant perspective on the many experiments in which Martin engaged at this time.[69] Gold leaf is devilishly tricky to apply and even more unforgiving than her usual mediums. The challenge may itself have been part of its appeal. A never-repeated trial, it is nevertheless fascinating and instructive, not least because, in its extravagance, it goes against the grain of Martin's reputation for unyielding modesty.

And in fact, a mineral, faintly metallic gleam would also be a recurrent element in Martin's succeeding works. More predictive of what would follow, and among Martin's most breathtaking and best-known paintings, are the penciled grids on white grounds that soon followed *Friendship* and its counterparts. The penciled line is refractory, in the sense that it is visibly hard—it requires from the viewer the effort, at the very least, of steady concentration—and also in the sense that it creates, barely visibly, a chromatic shimmer under strong illumination. Even in Martin's very late paintings this mineral glint is there, guiding the broad bands of lightly stroked layers of color, so habitual it scarcely registers.

Although all of the gridded compositions described above (and others of the early 1960s) preceded *The Tree*, 1964 (pl. 25), it is this painting, in the collection of the Museum of Modern Art, that Martin more than once described as her first grid, the origin for all that followed. Her initial statement about it, made for the museum's Collection Record of 1965, was fairly cautious. Answering a final question about its general "significance," she replied, "All my paintings are about joyful experiences"; in response to a previous question, "Has the subject any special personal, topical or symbolic significance?" she replied, with scrupulous honesty, "I don't know." And to the question of whether it was "a representative example of your

work in this medium and of this period," she replied, "Yes." But in 1989, she proclaimed, "When I first made a grid I happened to be thinking of the innocence of trees and then this grid came into my mind and I thought it represented innocence. And so I painted it and then I was satisfied. I thought, this is my vision."[70] By 2000, she had described it as "the first really abstract painting," and said, proudly, that she gave it to the Museum of Modern Art and they accepted it.[71] (In fact, it was acquired from the Elkon Gallery with funds from the Larry Aldrich Foundation.)

The Tree is composed of twenty-four horizontal bands of narrow, vertical penciled rectangles, drawn over washes of white oil paint; bands of empty rectangles alternate with those occupied by quartets of faintly tingling vertical lines. At the bottom, the canvas rests on a band of empty rectangles; the topmost band is filled. The main vertical lines of Martin's *Tree* are slightly heavier than the horizontal ones and the more so when the small rectangles' internal verticals overlap the canvas-spanning ones, which they do irregularly—this is visible only on very close inspection—adding to the perceived vitality of the whole. This variety in the drawn elements' weight contributes, perhaps, to its grid's faintly prismatic character, perceptible only as a kind of optical ghost. And in the simple rhythm of the alternating bands, there is something of the beat of respiration, an evocation, perhaps, of the upward-flowing sap of a growing tree. Its roots—as, arguably, in all of the grids, but more explicitly here—are in Mondrian's progressively abstracted trees, and in his pier and ocean series. But Martin insists that her *Tree* is about joy and innocence, the latter especially a key term in the vocabulary she was to develop in the extensive body of writing that began in the mid-1970s; often, she misspelled it as "innosense." (It is tempting to see this spelling as expressing a rejection of reasoned logic—a rejection that she would later formulate in her lectures and published texts.) In this key painting, she bases her intuited geometry in the architecture of trees, which is, as her own use of the grid would prove to be, both fundamentally stable and infinitely variable.

The penciled grids on white grounds vary in size, emphasis, and effect.

In *The Beach*, 1964 (Lannan Foundation), a very small-bore grid, in hard
pencil, causes the white ground to appear slightly shadowed. Its fine net-
work of lines goes wonky if viewed too closely; at this range, the graphite
wavers; as one steps back, it disappears quite quickly into a glary haze,
like the white sky of a summer day near the ocean. In *White Stone*, 1964
(Solomon R. Guggenheim Museum, New York), another close-knit grid
appears to be a violation of Martin's prohibition against grids that produce
squares, although in fact the interval between vertical lines is fractionally
smaller. As with *The Beach*, this grid dissolves quickly, as one steps back,
to a gray veil shadowing—or, as in stone, veining—a slightly uneven, milky
surface. In several other paintings of this period, including *Garden*, 1964
(Hirshhorn Museum and Sculpture Garden, Washington, DC), the grid is
drawn in colored pencil, here red and green, on a white-painted canvas
that has a fair amount of tooth (that is, the weave of the canvas is evident).
The grid forms narrow vertical rectangles (¾ by 2½ inches) and is very
delicately drawn; its component lines are all doubled, with the red lying
infinitesimally to the top and left of the green. A subtle emphasis occurs
in places where lines (accidentally, one presumes) overlap, which causes
some rectangles to seem to aggregate into blocks; the adjacency of the lines
also lends the surface the faintest bloom. If this painting is a garden in the
sense of floral profusion, it is so only remotely; more resonant is the faint
but insistent buzz it generates, as of heat rising from a field in sunshine.

 Garden's combination of colors gives the white ground, at a distance,
a slight creaminess. As with *Milk River*, the colored pencil substitutes a
warm glow for the fractional glitter of graphite. There are several other
paintings of the mid-1960s in which Martin dispensed with the penciled
lines she would favor for the rest of her career. In *Play*, 1966 (Hirshhorn
Museum and Sculpture Garden, Washington, DC), the vertical rectangles,
in two sizes, are painted in cool white over a neutral, light tan ground that
suggests balsa wood. This white net goes to the canvas edge but falters in
some places, slightly, making it seem to hover above the ground. Its vertical
lines appear to be freehand and, at points of intersection with horizontal

ones, what may have been occasional pauses of the brush produce very small pools of white. Gossamer and spidery, this grid is, within the parameters of Martin's mature work, surprisingly irregular—perhaps that is the playfulness of the title.

The grid-based paintings and drawings of the 1960s constitute a discrete body of work and are still bracingly radical, as gripping today as they were more than half a century ago. By the end of this period, Martin was already reaching toward later preferences, for instance, stripes rather than grids. Amply evident in the paintings of the sixties is the formidable discipline that ran so deep in her temperament, now implicit not just in her work habits but also in the very structure of her work. Also foregrounded is Martin's willingness to risk failure. In distinction to the Abstract Expressionists with whom she identified, who agonized over the decision to say work could be called finished and whose works were often visibly painted and repainted, Martin's methods were like scripted performances (athletics might also serve as a comparison): each undertaking involved the execution of a predestined program from which there was no turning back, and no salvaging unsatisfactory efforts. Each canvas was a new test. Many—possibly most—paintings didn't succeed and were discarded. It is hard to imagine any of them, whether the sparest small drawing or most lavish gold-leaf painting, emerging from the rough and haphazardly appointed studios in which Martin worked and lived.

But stubbornness, sheer persistent determination, is perhaps the single essential characteristic of a groundbreaking artist. And for Martin, that necessary conviction in having one's way was balanced by an absolute refusal to be concerned with her inner self. Of the many paradoxes inherent to her work, this one is central: she was unyieldingly committed to her vision and, with equal fervor, to refusing the claims of personal experience. Ultimately she was able to formulate a way of regarding the two as comfortably separable. It took her a long time to reach the point of allowing these contradictory impulses to coexist.

Chapter 4

LINES OF THOUGHT

The question of how Martin arrived at the grid, and what she drew from those around her, seems easy to answer: several pioneers of pared down, rectilinear abstraction were near at hand, and ideas were exchanged freely. But to get at the particular quality of Martin's paintings from the 1960s on, it is necessary to look beyond her neighbors at the seaport—and, at the same time, more deeply at what they shared.

Martin's work compels attention because it reflects impulses that were as irresistible to her as her paintings are to so many viewers. She said she composed her work following the dictates of inner visions, which arrived as complete images that she executed just as she saw them, but bigger. To take her at her word is to call her creative process a kind of psychic automatism—that is, to see a link between the kind of geometric abstraction she developed and the Surrealism with which so many of her Abstract Expressionist peers (and Martin herself) wrestled early on.[1] Seeing a connection between Martin's creative process and earlier literary as well as visual stream-of-consciousness production helps us see, as well, that the hand-drawn lines in her paintings are tied to handwriting and to verbal language. The grids and later works do not so much represent conditions in the material world—light, shape, form—as states of mind or, more precisely, lines of thought. Various spiritual teachings shaped Martin's thinking, and her immersion in both Eastern spiritual teachings

and mystical Christianity deepened when she was in New York. They significantly affected the way she approached painting and also how she conducted her life (though she would sometimes later deny these influences). But mostly, she tuned in to the harmonics of an inner voice and to the visions appearing before her mind's eye.

In the many accounts she gave of her working process, Martin invariably used the word "inspiration." She had visions of paintings, which appeared to her fully formed and exactingly precise in composition and, in later works, in color.[2] At first, they were a challenge and a surprise: "When I had the inspiration for the grids, I was thinking of innocence and the image was a grid. That was it. I thought, 'My god, am I supposed to paint that?'"[3] While her transcriptions sometimes succeeded and sometimes failed, the visions themselves were unerring in every detail, requiring no internal adjustments. As she explained it, "I have a vision in my mind about what I'm going to paint before I start... When I make a mistake, I make a mistake in scale, then it's no good at all.... See, I have a little picture in my mind and I have to make it into a six-foot canvas."[4]

Often she referred to inspiration as a gentle spirit: "That which takes us by surprise—moments of happiness—that is inspiration."[5] At other times, she experienced it as more peremptory: "Inspiration is a command. While you have choice that is not inspiration. If a decision is required that is not inspiration and you should not do anything by decision. It is simply a waste of time."[6] Infallible though the visions were, they didn't always arrive punctually. "I don't get up in the morning until I know exactly what I'm going to do. Sometimes, I stay in bed until about three the afternoon, without any breakfast. You see, I have a visual image. But then to actually accurately put it down, is a long, long ways from just *knowing* what you're going to do.... First, I have the experience of happiness and innocence. Then, if I can keep from being distracted, I will have an image to paint," she reported.[7] Discriminating visions from wayward thoughts wasn't always easy. "When you look in your mind you find it covered with a lot of rubbishy thoughts. You have to penetrate these and hear what your mind is

telling you to do."[8] At the same time, inspiration required a certain relaxation of control. "At night the intellect goes to sleep and gives inspiration a chance. When people have a decision to make, they say they will sleep on it; that is the part of the mind that's responsible for artwork. It's not an intellectual process," Martin told Irving Sandler. When he noted that she often discarded paintings, she continued, using one of her more homespun analogies, "Well, inspiration doesn't always turn out because, even if inspiration is the black corn in the bottom forty, the weather has a lot to do with it!"[9]

Finally, inspiration, as Martin saw it, is not unique to gifted artists; on the contrary, it is a universal faculty:

> Inspiration is there all the time.
> For everyone whose mind is not clouded over with thoughts, whether they realize it or not...
> Inspiration is pervasive but not a power.
> It is a peaceful thing.
> It is a consolation even to plants and animals.[10]

Such statements may sound uncomfortably mystical. But Martin also spoke of inspiration as an altogether pragmatic tool, handy in avoiding the trap of overthinking a problem. To a student audience, she offered this advice: "I used to be pretty intellectual.... But I think I've got it out of my system. You don't have to worry about your inner eye. It is working. It's on the job."[11]

These descriptions of her work's source, which she began to offer in the mid-1970s, leave much unaccounted for and not a little that invites skepticism (as do most artists' accounts of their work's development): her reported experience acknowledges no connection with other artists pursuing similar goals with similar means. Considering Martin's "inspirations" to be a kind of automatism—a channeling of an impulse over which she ceded (or suppressed) conscious control—helps place them in an art-historical

lineage. It could be said that she did so herself by finding merit in Pollock's work, which she deemed "terrific. I think he freed himself of all kinds of worry about this world" and "managed to express ecstasy."[12] (For de Kooning, on the other hand, she had no use at all.) But to invoke automatism is also to introduce associations Martin rejected. In fact, there is a sharp distinction between the extra-conscious mental states that produced her visions and the personal, subjective experiences most automatists sought to express. "Personal emotions are emotions that apply to a person—like the soap opera," she responded to a question from the audience following a 1989 lecture. "They are anti-art.... I hope that's clear—personal emotions as against other kinds of emotions.... Happiness is not a personal emotion, it is a universal."[13] Martin's subjects are states that transcend the particular conditions of an individual life.

On the face of it, no simple connection can be made between Martin's painstakingly ruled penciled lines and automatism as it is commonly understood: a kind of cursive, meandering script that has served, in the hands of such artists as André Masson, Henri Michaux, Roberto Matta, and (most famously) Pollock as a visualization of the term "stream of consciousness." This liquid metaphor for the spontaneous expression of mental activity that originates *un*consciously, coined in 1890 by the American psychologist William James, is strongly associated with the literature first written with its assistance, including that of Virginia Woolf, James Joyce, and Gertrude Stein. Also undertaken in its name are the departures from narrative logic sought in literary exercises by the Surrealists André Breton and Philippe Soupault, who made "pure psychic automatism" the cornerstone of the First Surrealist Manifesto in 1924.[14] (Under the influence of Freud, they expected the unconscious creative voices thus liberated to speak largely of sex.) Automatism is strongly associated as well with the irrational figuration and dreamlike narrative that Surrealist visual artists produced.

But there is another way of thinking about automatism, in which there is a perhaps surprising link with Ellsworth Kelly, who entered into

consciousness-evading experiments while in France (where he lived from 1948 to 1954), experiments that led to his color grids of the early 1950s. In 1949 Kelly had spent two weeks vacationing in France with an American friend, Ralph Coburn, an excursion on which they engaged in various kinds of automatism, including, as described by art historian Yve-Alain Bois, "scrawls and *cadavre exquis*: Coburn was well up on Surrealist procedures."[15] The same year, in the spring, Kelly made several visits to Jean Arp, a founding Surrealist who had long been engaged with chance procedures. During this period, Kelly also tried drawing various subjects—trees, for instance—without looking at the paper, and made drawings with his eyes closed. The use to which Kelly put his automatist "scrawls" has led later observers to challenge their claims to psychic immediacy. Notes fellow art historian E. C. Goossen, in an earlier discussion of Kelly's work, generally such efforts achieve "results which are often very startling to the drawer, but which, more often than not, are similar in character to all other such drawings."[16] Yet the finished works that followed Kelly's automatist exercises departed vigorously from the technique's conventions. While one is a loosely meandering composition, and another exploits serendipitous little blooms of ink atop vertical strokes leaning this way and that, several of Kelly's automatist exercises, including those executed on graph paper, led to linear compositions. Jack Cowart writes, "The artist made doodles, connecting random lines into rectilinear constructions, and in Paris *Sketchbooks 11* and *14* [1949], produced a number of 'automatic' drawings made with a ruler for random straight lines, but with his eyes closed. Curiously, some of the resulting drawings still arrange themselves in gridded patterns, proving the point that the grid remained for him a ubiquitous subconscious design."[17] The parallel with Martin's work is powerful.

There is also a strong connection between Kelly and Martin in their shared reluctance to let go of the landscape—and, to a lesser extent, the cityscape—as creative touchstones, even when their paintings became fully abstract. During the same period that Kelly was investigating various ways to circumvent expressive intent, he traveled with Ralph Coburn to Monet's

home and garden at Giverny, which they found shockingly rundown. The return of cultivated flora to the chaos of unregulated growth, like the nearly, but never entirely, abandoned dispersion of paint across a canvas in the leading Impressionist's late paintings, both had lessons for Kelly (as they did for many of his Abstract Expressionist elders). Back in Paris, Kelly made grid-based paintings involving relatively large blocks of vivid colors, in sequences that appear random. In fact, they are derived, however distantly, from observation, including light skittering across water, which lent itself first to a small black-and-white ink drawing of 1950 that was in turn "subsumed and redeployed" across the grid-like surface of *Spectrum Colors Arranged by Chance I*, 1951 (Philadelphia Museum of Art), "using a preconceived and arbitrary distribution system."[18] As its title indicates, the pixelated black-and-white *Seine*, 1951 (also in Philadelphia), is similarly drawn from observing light on water;[19] other sources for the grids included, more predictably, window mullions and floor tiles.

Even while creating these sharp-edged geometric abstractions, Kelly has depicted plant life throughout his career, often in contour drawings that trace stem, leaf, and bloom with an immediacy and concision that has made them legendary. Sometimes bordering on abstraction in their simplicity, and revealing awareness of Asian calligraphy in their graceful shorthand, these drawings find order in nature's complexity, and tremendous richness in a single line, the subtlest turn of which creates the volume of a furled leaf, or suggests the surface tension of water, or the lift of breeze. And although these drawings are not at the center of Kelly's practice, even the most reductive of his abstractions are grounded in observed shapes: the silhouettes of forms both natural and man-made. Thus during the 1950s and '60s, both Kelly and Martin were actively negotiating the relations between natural, urban, and abstract form, and exploring ways to relinquish figurative painting without forgoing expressive depth.

Martin continued to channel geometry as inspiration—and resist the appeals of landscape—throughout the period when she was distilling her vision of a grid from the entirety of the visible world. But however appealing

Martin may have been found Kelly's reconciliation of plane geometry with spontaneous mark-making, and despite her early work's wealth of Surrealist-influenced imagery, automatism was not a term she embraced. It was freighted with what seemed to her self-indulgent introspection.

In her effort to enforce boundaries between art and personal expression—to maintain a firm line between art and everything else—she could have found no better guide than Ad Reinhardt. Like Kelly, Reinhardt (born in 1907 and thus closer in age to Martin) was a bridge between the generation of the Abstract Expressionists and the younger Minimalists who drew so much from his example. Reinhardt was not a Coenties Slip resident, but he was a gallery mate of Martin's at Betty Parsons, first showing there in 1947 and every year thereafter until 1960, with a final show in 1965. (Unlike most of her artists, he remained with Parsons, although not exclusively, nearly until his death, in 1967.)

There are other points of biographical connection with Martin: Reinhardt attended Columbia University, on a scholarship, from 1932 to 1935; he, too was from a working-class background, a circumstance that helped to shape his deep and abiding political commitments.[20] While at Columbia, Reinhardt enrolled in painting classes at Teachers College and, as noted above, both he and Martin—who arrived five years after Reinhardt left—studied with Elise Ruffini. Among Reinhardt's first exhibitions were two at the Teachers College gallery, in 1943 and '44, by which time Martin was in New Mexico, where they met briefly in 1951. When asked whether she was good friends with him during her seaport years, Martin replied, "Yes," adding that they didn't talk about painting together, but they "supported each other.... He thought I was a good painter, and I thought he was a good painter."[21]

Although Reinhardt's work of the 1940s was calligraphic, grid-like armatures structured its allover weave, and he was scathing in his judgment of Surrealist automatism. "Artists who peddle wiggly lines and colors as representing emotion," he said in 1960, "should be run off the streets."[22] In 1943 Reinhardt wrote, "the main current of Surrealism is chaos, confusion,

individual anguish, terror, horror... an abstract painting stands as a challenge to disorder and disintegration."[23] Later he revisited this judgment in more colloquial terms, claiming that the Surrealists "were anti-art. They were involved in, I don't know, life or love or sex or I don't know what.... Well, the abstract painters were always dull in that sense."[24] It was a dullness—and also, implicitly, a devotion to higher, better things—that he endorsed.

Some of Reinhardt's antipathy to Surrealism was simply a symptom of the widespread resistance, among postwar American painters, to European influence.[25] As Dore Ashton writes, in connection with Rothko, "For most artists who would become New York School abstract painters, the Surrealist lunge into the unconscious was somehow shameless"; instead, they pursued grand, transpersonal themes.[26] Martin's 1957 Wurlitzer Foundation application had reflected the same anti-European, universalizing enthusiasms. While Reinhardt deplored the "sublime," he too embraced—in what is arguably a hair-splitting distinction—the conception of art as an expression of absolute emotions. Martin made the same distinction when she wrote, "I think that personal feelings, sentimentality and those sorts of emotions, are not art but... universal emotions like happiness *are* art."[27]

Equally close in spirit to Martin's thinking was much of the aesthetic program that was so forcefully defined by Reinhardt. In the spring of 1958, in *It Is*, he wrote a "Statement" called "25 Lines of Words on Art." Written entirely in capitals, it included these pronouncements: "1. Art is art. Everything else is everything else. / 2. Art-as-art. Art from art. Art on art. Art for art. Art beyond art. / ... / 6. Painting as 'not as a likeness of anything on earth.' / ... / 10. Painting as absolute symmetry, pure reason, rightness. 11. Painting as central, frontal, regular, repetitive. 12. Preformulation, preformalization, formalism, repainting."[28] In her newly symmetrical, frontal, regular, repetitive, preformulated, and purified painting, Martin subscribed to—or possibly helped shape—many of Reinhardt's tenets.

Ideology aside, their work also shared formal features. By the late 1950s Reinhardt was making monochrome paintings, including entirely white

ones which, Thomas Hess wrote, had an effect like "the sound snow makes falling on snow."[29] The description would perfectly suit much of Martin's work of the late 1950s. And by 1960 Reinhardt had committed himself conclusively to what are generally called his "black" paintings: the square canvases, 5 feet on a side, trisected into nine squares of close-valued, very dark gray. "No other American painter was interested in a combination of invisibility, purity, and the end of painting until at least 1960,"[30] Lucy Lippard claimed. Similarly, Michael Corris writes, "In Reinhardt's post-historic universe, 1960 symbolizes year zero of the project to construct an artistic practice that embodies the performance of negation in modern art."[31] The timing is almost exactly coincident with Martin's commitment to her own unvarying format, the 6-foot square canvas organized by horizontal and vertical lines, and to her own pursuit of near invisibility. Reinhardt described his black paintings in 1966 as "squares of time, colorless intersection [between] memory, forgetfulness; signals from the void, grid-lines between future [and] past."[32] Achieving these voided images required that Reinhardt make ruthless denials—of subjects, of subjectivity, of visibility itself: "Only a standardized, prescribed form can be imageless, only a stereotyped image can be formless, only a formula-ized art can be formula-less.... Everything into irreducibility, unreproducibility, imperceptibility."[33]

Like Reinhardt's black squares, the lineaments of Martin's grids are only visible at close range and can disappear entirely when photographed. And their execution requires similar feats of patience and care. "The work of producing a 'black' painting was painstaking, delicate and, above all, tedious,"[34] writes Corris, who also says, "Reinhardt favoured labour-intensive studio methods, which he described in various manifestos as a kind of *ritual*."[35] This involvement in process, in repetitive and demanding—or, it could also be said, meditative—work for its own sake, characterizes Martin's paintings as well.

Even equating the scale of the painting and the artist is an interest Reinhardt and Martin shared. The "black" paintings, it is often said, conformed

to the span of Reinhardt's outstretched arms—limbs that are implicit in the equal-armed cross that divides each canvas—and had the advantage as well of being easily moved around the studio. The same is true of Martin's paintings (although, until near the end of her life, they were a foot bigger than Reinhardt's; her physical strength was considerable and her rejection of assistants adamant). For her part, Martin said of the scale she committed to at this time, "It's a good size [when] you can just feel like stepping into it. It has to do with being the full size of the human body."[36]

Martin's paintings differ from Reinhardt's in essential ways. The distinction is not mainly between paintings that tend more often to fade to white than black—in 1955 Reinhardt, like several of his peers, including Newman and Kelly, and also Robert Rauschenberg, had made white-on-white paintings, and Martin's paintings could be quite dark—but between Reinhardt's many renunciations and Martin's abiding spirit of affirmation; he chose not to promote the universal emotions of joy and innocence that she celebrated. Just as important, Martin parted company with Reinhardt on the issue of political engagement. (Reinhardt, who had been a member of the Communist party in the 1930s, remained a lifelong activist—perhaps surprisingly, he was Vice President of the Student Non-Violent Coordinating Committee in 1963, a group associated with student protests of the sixties. These affiliations had led early on to FBI surveillance and to habits of wariness that conformed with Martin's own.)

But the differences between Martin and Reinhardt are outweighed by shared commitments, primary among them the defeat of ego. While Martin did not faithfully practice any organized religion ("I quote from the Bible because it's so poetic, though I'm not a Christian," she once said[37]), she, like Reinhardt, was drawn to several varieties of quietism. While at Columbia, Reinhardt began a lifelong friendship with Thomas Merton, who would become a Trappist monk and scholar of both Buddhism and Christian mysticism; Merton encouraged these interests in his friend and called Reinhardt the "dean of the Great Quiet."[38] In something of the same spirit, Lippard calls Reinhardt a moralizing art-for-art Protestant.[39] The

Protestant ethos that Martin shared with Betty Parsons has already been noted, although the character of Parsons's religious identity was more social than spiritual. On the other hand, both Lenore Tawney and Ann Wilson encouraged in Martin a searching interest in Christian mysticism. Like Tawney, Wilson, who in 1977 would produce an operatic performance based in part on Alban Butler's *Lives of the Saints*, read the eighteenth-century volume with Martin during their seaport years, along with the life and teachings of Saint Teresa of Avila.

Saint Teresa's appeal to Martin was manifold, and the artist would have had no trouble heeding her advice, "The necessities of the body should be disregarded," and at times she accepted (if only by necessity) "the good that comes from poverty." Even Teresa's praise of "the great blessing that shunning their relatives brings to those who have left the world"[40] would have resonated with Martin, whose relations with her family were strained at best. But it was Teresa's visions that must have attracted Martin most, both as a model for her own inspiration and, perhaps, for affirming psychological experiences that could be isolating and frightening. The sixteenth-century Teresa, by her own description "too giddy and careless to be trusted at home," was sent to be educated by Augustinian nuns, but she challenged Church authority by embracing the visions that began visiting her in early adulthood.[41] In "The Prayer of God," Teresa's most influential writing, she explained to her "daughters" that there is "a supernatural state" in which "all the faculties are stilled." Those who achieve this state, doing so by grace rather than by effort, "seem not to be in the world, and have no wish to see or hear anything but their God; nothing distresses them, nor does it seem that anything can possibly do so."

Parallels have often been noted between such mystical states and the internal experiences of individuals who, like Martin, have a history of breaking from reality. And Teresa used a striking metaphor for this state of sublimity: "The soul is like an infant still at its mother's breast: such is the mother's care for it that she gives it its milk without its having to ask for it so much as by moving its lips. That is what happens here. The will

simply loves, and no effort needs to be made by the understanding." There is a connection here to Martin's curiously staunch belief that mothers know instinctively just how to best serve their infants and do so without doubt or exception: "Our most heartfelt and anxious obedience is a mother's obedience to the infant, and her slavish obedience to her children as long as they are in her care," she wrote. The child, reciprocally, is perfectly obedient to the mother; this "authority-obedience state" is "a continuous state of being." But, Martin goes on to say, "the obedience of children is generally worthless because they are inattentive and desultory."[42] The oblique perspective such statements throw on Martin's childhood, and on her experience as a teacher, is tantalizing, not least for its final touch of mordant humor. But most salient, for Martin, in Saint Teresa's advice is her celebration of a state of rapture, her affirmation of vision as a creative resource, and, not least, her recommendation to disregard thought—which, Teresa says, is to be laughed away, a recommendation Martin took to heart.

Martin also drew on Old Testament prophets, as is clear from such passages in her writing as, "From Isaiah, about inspiration / Surely the people is grass." The biblical passage in question reads, "The grass withers, the flower fades; because the spirit of the Lord blows upon it: surely the people is grass" (Isaiah 40:7). Martin's association from this citation to inspiration is elliptical; Isaiah is speaking of mortality. Generally, though, the teachings of the prophets, like Teresa's, are concerned with humility, devotion, and modesty. And perhaps Isaiah (or Second Isaiah, as the author of this section of the book is generally identified) appealed to Martin as well by twice having God compare himself to a woman: "Now I will cry out like a woman in travail, I will gasp and pant," the prophet has God say (Isaiah 42:14), and "Can a woman forget her suckling child, that she should have no compassion on the son of her womb?" (Isaiah 49:15). Again the innocence of children, and also the immutable loving kindness of mothers, are invoked. And the radical anomaly of the image lends urgency to the prophet's statement. As biblical scholar Abraham Heschel observes, "The allusion to the Lord as 'a woman in travail' [is] the boldest figure used by

any prophet."[43] But Second Isaiah is also distinguished by his concern for the vulnerable and by his mission to give "power to the faint."[44] Equally important, the Old Testament prophets were, like Teresa, by definition the beneficiaries of transcendent knowledge that arrived in moments of dissociation from ordinary life, experiences from which they drew their teachings.

Important though these sources were to Martin, Eastern spiritual systems, Buddhism in particular, are much more commonly cited as an influence on her thought and artwork. This, too, was an interest she shared with Reinhardt and Kelly—and with Tawney, Wilson, and many others. Like Christian mysticism and quietism, Buddhism—which is notoriously difficult to define, and comprises a range of traditions and spiritual practices—provided Martin with a model of humility, egolessness, and patient devotion. Among the Buddhist teachings that would have particularly recommended themselves to Martin are emphases on innocence and modesty; on the immanence of spirit in the natural world; and on a precise balance of rigorous discipline and fundamental anti-authoritarianism—of discipline without a disciplinarian. Preferences for receptivity and silence, and for acknowledging stillness and void as active and creative forces, are all reflected in her quietly animated work. Late in her life, she spoke of a daily meditation practice, and of her belief in reincarnation, for both of which Buddhism lends support. Perhaps appealing to her as well were the profound absurdity of many Zen parables—attractive, arguably, to a woman sometimes plagued by bouts of unreason—and Zen's admonitions against yielding to the body's appetites. Transcending one's self by submission to a greater, trans-subjective whole may have seemed to her an eminently sound determination.

The influence of Buddhism and other Eastern spiritual systems was widespread in the New York culture of the 1950s and 1960s, and, as discussed earlier, it had taken an at least equally strong hold earlier on the West Coast. While Martin's exposure to Buddhism in Washington State in the 1930s is speculative, her engagement with such ideas in Taos in

the 1940s and again in the 1950s is almost certain. But Martin's contact in New York with artists avowedly engaged with Eastern thought, including Kelly and Reinhardt, is confirmed. In 1949, the year Kelly met with Arp and began to experiment with automatism, he also met in Paris with John Cage, who was already deeply engaged with the *I Ching* and chance-based compositional strategies.[45] Reinhardt, who after Columbia went on to study Asian art history, in which he completed a master's degree in at New York University's Institute of Fine Arts in 1951, had attended Japanese scholar Daisetz Suzuki's seminars on Zen at Columbia in the early 1950s. Reinhardt himself became a proponent of Zen, and he lectured on it at the Abstract Expressionists' Eighth Street "Club" (of which he was a somewhat reluctant member).[46] In addition to learning of these teachings through Kelly and Reinhardt, Martin might also have come across Zen teachings through Rauschenberg, who learned of Suzuki's teaching from Cage.

Martin's statements about Buddhism are not consistent and, especially later in her life, she expressed great disappointment and even anger that her painting was considered by some to be an expression of Eastern spiritual beliefs. In fact she was cautious about embracing spiritual beliefs from the start.[47] Reported Martin's friend Jill Johnston, "she hates magic and fetishes and superstition and the i ching" and was "a zen sort of person who never studied zen."[48] To an audience of students, Martin had this rather earthy advice: "When you're in life drawing, you're really thinking of all the women you've ever seen, and all the gestures they've ever made. That's what brings life into the drawing. It's your experience of life. It's not spiritual, it's really in this life. You sort of underestimate the human being when you say that every least thing that is an abstract experience is spiritual. It isn't. It's just your real self. You can be capable of fantastic abstract experiences, right in this life."[49] Nonetheless, she often proclaimed the importance of practices and beliefs belonging to Taoism and certain schools of Buddhism. "My greatest spiritual inspiration came from the Chinese spiritual teachers, especially Lao Tzu," she wrote. "My next strongest influence is the Sixth Patriarch Hui Neng.... I have also read and been

inspired by the sutras of the other... Buddhist masters."[50] Lao Tzu, who dates to roughly the sixth or fifth century B.C.E. and thus was probably a contemporary of the Buddha, taught that happiness depends on living in harmony with the Tao–the void from which reality emerges. While it is only one school of the many Buddhism comprises, Taoist-influenced Zen Buddhism, which is what many Americans think of when they think of Buddhism, had the greatest impact on Martin. The critic Holland Cotter reports that Martin read Suzuki and attended lectures by Krishnamurti, and that she said, "One thing I like about Zen, it doesn't believe in achievement. I don't think the way to succeed is by doing something aggressive. Aggression is weak-minded."[51] Martin's friend David McIntosh says, "She often referred to Lao Tzu, the *Tao te Ching*. She had meditated for a long time when I met her, continued to do it in the eighties. She would sit for long periods of time. I don't know whether she was in meditation, or just listening to her mind, as she would call it."[52] At the end of her life, she was still often urging Witter Bynner's translation of the *Tao te Ching, The Way of Life According to Lao Tzu*, on friends and acquaintances, insuring that a local bookstore in Taos kept it in stock.[53]

First significantly promoted in this country by Ralph Waldo Emerson (in whose journal, *The Dial*, a translation of the Lotus Sutra appeared in 1844), Henry David Thoreau, and their fellow Transcendentalists, Asian spiritual teachings were associated from the start with reverence for nature–a reverence that is expressed in starkly different ways in Western and Eastern culture. The distinction was taken up in the writings of the indefatigable Suzuki, who was the foremost ambassador to the United States for Zen in the first half of the twentieth century; his *Introduction to Zen Buddhism*, published in 1934 with an introduction by Carl Jung, and his *Manual of Zen Buddhism*, published by Grove Press in 1960, were both widely read by artists. In the former, Suzuki contrasts the canonical Victorian poem by Alfred, Lord Tennyson that begins, "Flower in the crannied wall, I pluck you out," with a verse by the Japanese poet Basho, who discovered a flower by the roadside and simply looked at it, absorbed in thought.[54] The pious

and Romantic Tennyson feels compelled to pick (and hence, of course, kill)
the flower—"hold you here, root and all, in my hand"—write an ode to it,
and construct an allegory around it; his Buddhist counterpart admires it
where it grows and moves on.[55] For Martin, as for Basho, the natural world's
bounty is best expressed in gestures that make no attempt to appropriate
it or speak in its name. A passage from Martin's "The Untroubled Mind,"
a text of 1973, seems to offer a resolution of Basho and Tennyson: "When
the rose is destroyed we grieve / but really beauty is unattached / and a
clear mind sees it."[56] She returned to the motif, adding a touch of Platonic
idealism, in the 1989 lecture, "Beauty is the Mystery of Life": "When a
beautiful rose dies beauty does not die because it is not really in the rose.
Beauty is an awareness in the mind."[57]

Such awareness is easier to attain if intellect does not corrupt one's
ability to perceive; Zen teachers warned against allowing the intellect to
prevail, at the cost of "sense-experience" and, even more damaging, "the
loss of 'innocence.'"[58] This teaching compares closely with that of Cage,
whose "Lecture on Nothing" offers this epigram: "Putting the mind on it
takes the ear off it."[59] And it is even closer to Martin's thinking, as when
she wrote, "We constantly pursue perfection ... the danger is intellectual
interference,"[60] a danger she warned against as frequently as she praised
innocence. Moreover, Zen teaches that generosity should be extended
without looking for recognition; rather than seeking such gratification,
one should pursue selflessness, to the extent of allowing the self to be
absorbed into oneness, or allness. Having reached this state, however, is
not an uncomplicated achievement, since "the idea of oneness or allness
is" itself "a stumbling block ... which threatens the original freedom of the
spirit."[61] Again, a passage from Martin's writing makes a striking compari-
son in its radical self-abnegation: "Thinking leads to pride, identification,
confusion and fear. Work is a function in which we seem to be identified.
[But] In *the great process*, in the sum total of the outward being of all liv-
ing things, our work is insignificant, *infinitesimal and insignificant. This
must be realized.*"[62]

The italics were Martin's caution to herself; work indeed was everything to her. But she believed that it achieved its importance only through being seen by others. Her conviction that art's value for both artist and viewer was in its expressive utility can be linked to John Dewey—and, in turn, through him to Zen. Although he didn't address Buddhism in his writings, Dewey was in contact with Suzuki early in his career, and when the educator traveled to Japan in 1919, Suzuki served as his translator;[63] the connection was consolidated when Suzuki lectured at Columbia, Dewey's academic seat. As art historian and Buddhist scholar Jacquelynn Baas observes, Buddhism is experiential (unlike Christianity or Judaism, which are based in revelation), an emphasis that ties the school of Zen Buddhism to Dewey's Pragmatism—and, in turn, to the values Martin affirmed in her own work.

Just as Martin's paintings are committed to the practical good of communicating with viewers, they are visibly reliant on her own manual labor; the slow inscription of precisely drawn and painted webs and bands can be compared, with not too big a stretch, to Zen acolytes' sweeping of monastery floors. The humility of the practice is its own reward. Suzuki could be firm on this point: "Morally, any work involving an expenditure of physical force testifies to the soundness of its ideas."[64] At the same time, "Life is an art, and like perfect art it should be self-forgetting; there ought not to be any trace of effort or painful feeling. Life, according to Zen, ought to be lived as a bird flies through the air."[65] As this pair of conflicting teachings suggests, "Zen is decidedly not a system founded upon logic and analysis. If anything, it is the antipode to logic."[66] The many tales of monks' irrational, and sometimes rather brutal, answers to supplicants' pleas for wisdom or clarity are ample evidence of its contradictory nature.[67] It is easy to imagine the appeal, to Martin, of such mutually opposing and even frankly irrational precepts.

Zen also calls for the practitioner to submit to fate, which relates directly to the non-introspective variant of automatism that attracted Kelly and Martin. Fickle in its attentions, the inspiration that produced her visions was unerring in its wisdom, and she followed it unequivocally.[68] Just as

Cage's applications of the *I Ching* were determined by guidelines as arcane and arbitrary as they were rigid (an explanation of his methods that may cause the mind to wander begins: "Three coins tossed once yield four lines: three heads, broken with a circle; two tails and a head, straight; two heads and a tail, broken; three tails, straight with a circle"),[69] so did the translation of Martin's visions onto canvas rely on fixed but bewildering calculations. Her faith in the formal structures the visions provided was immutable. As explained with winsome grace by Cage, in his legendary 1949 "Lecture on Nothing," "structure," whatever its seeming difficulties, offers "those rare moments of ecstasy, which, as sugar loaves train horses, train us to make what we make."[70] And what Martin appreciated best in Cage was not his promulgation of spiritual precepts, nor his reliance on chance, but his respect for nature's sense of humor. "Agnes loved Cage," Ann Wilson says. "She would go to his performances and laugh and laugh."[71]

Another aspect of Zen Buddhism that likely appealed to Martin was its opposition to European styles of thought, including the bleakly Existentialist and, especially, the libidinously Freudian, which by the 1950s had both taken deep root in progressive American culture—not least in Abstract Expressionist circles. Commonly understood to underscore the fundamental meaninglessness of life, Existentialism ran counter to Martin's exertions to affirm the universal states of happiness and innocence. It could be said that her commitment to these states was something of a rebuke to the irremediably depressive character of the Abstract Expressionists whom she otherwise respected, and with whom she generally identified. And the introspective thrust of Freudian psychoanalysis, combined with the priority its orthodox practice places on exploring sexual conflict, would have struck someone of Martin's disposition as wrong and intrusive. Moreover, Freud was notoriously unsympathetic to homosexuality, a bias not lost on the many gay artists with whom Martin associated; it is perhaps no coincidence that they largely turned elsewhere for insight. The connection between Zen and homosexuality has been noted by Jonathan Katz, who writes, "Only in retrospect does it make sense that the zenith

of Zen Buddhism's influence in American cultural life was probably the mid-1950s. . . . a period when more homosexuals than Communists lost their jobs" and were persecuted; the self-liberation offered by Zen was, Katz suggests, a form of personal salvation and a refuge.[72]

Along with all these parallels between Buddhist practices and Martin's sensibility, it should be noted, too, that certain of her paintings have been understood by some viewers as examples of very particular forms of Zen imagery, which she assiduously denied. Says Baas, "Zen influence is read-ily apparent in Martin's *Cow*, a painting from 1960. Its brown circle could almost represent the 'Both Vanished' episode from the Zen Oxherding Pictures about the taming of the mind." Such "Oxherding Pictures" fea-ture broken circles drawn in ink. Baas continues, "I am not suggesting that Martin's intention was so literal. . . . Martin's ultimate subject was perfection of which the circle is symbolic . . . Still, Martin did entitle this painting *Cow*," which "is surely related to the 'meaning of the Oxherding pictures.'"[73] Despite the combination of motif and title, it seems an unwar-ranted reduction to account for the circle, always completed (and not, as in the Oxherding Pictures, broken) in Martin's paintings of this time, as a Zen pictogram. Martin didn't live to contradict this particular interpreta-tion, but she did oppose such readings in more general terms, as when, in response to a question about the place of spirituality in her art, she said heatedly, "I think that the spiritual community is encroaching on the art field. . . . People say, you're painting Zen, or you're painting Taoism, or something like that. And that's not right."[74] In any case, she soon repudi-ated all her circle-based paintings as well.

•

Inspiration, certain aspects of Surrealism, and spiritual practices of both the East and the West all played important parts in shaping Martin's work. But perhaps no source was more important to her than the pressure of language, whether oral, written, or internal. To the extent that her paint-ing can be called automatist, it can also be identified with unspoken and

not fully articulated writing. The lines of thought along which her mind ran can be said to find literal expression in the penciled lines that course throughout her work. And in the years when Martin was in New York, she could look to many other artists who were cross-wiring the verbal and the visual.

Of course, written language had long been hybridized with visual art. Ever since the Futurists' *parole in libertà* ("words-in-freedom")–or since Mallarmé or medieval illuminated manuscripts–the shape of a verse, its typography and arrangement on the page, as well as the rhythms of speech it shapes, have all functioned as supplements to its semantic content. In traditional Asian art the relationship between image and text is especially intimate; the calligraphy that accompanies pictorial representation in scroll painting is a form of expression both equal to figuration and integrated with it. Neither alone is sufficient in accounting for material reality: "Existence is beyond the power of words / To define," writes Lao Tzu. "In the beginning of heaven and earth there were no words / ... The core and the surface / Are essentially the same / ... If name be needed, wonder names them both."[75] The contrast with the first Gospel's origin story is striking.

The legacy of European experiments in marrying image to text can be seen in some of Cage's writing, in which it is further linked to music. His "Lecture on Nothing," first delivered at the Club around 1950 and published ten years later, is organized on the page by a scaffold of lines, columns, and spaces (they indicate pauses for the speaker, and the reader), which together strongly resemble a grid. Cage was not alone, at the time, in considering text as a musical score and both music and score as forms of drawing; Morton Feldman's scores of the 1950s and later have an independent life as visual works and in fact also took the form of grids. For the musical avant-garde in the postwar era, words were read as sound just as ordinary sound was music, and notations were images as well as instructions.

The connection to Martin's work is made explicit in Richard Landry's *Quad Suite (Six Vibrations for Agnes Martin)*, 1972, a black-and-white video

in which the camera frames a section of a guitar's neck as it is strummed and picked by the unseen musician; the instrument's four visible frets form the vertical components of a grid completed by its six vibrating strings. With the deadpan whimsy characteristic of the time, Landry (a Louisiana-born musician best known for playing the saxophone–and for his involvement with the cooperative restaurant Food) thereby makes literal the internal hum of Martin's work: the visual vibrato that several observers have noted.

For Martin, the connections between instruction and image are unusually complicated. A generous correspondent and at times an active author, Martin almost always wrote by hand, and her penmanship was careful. Here again there is a connection to Reinhardt, in the elegantly penned calligraphy of his written statements (and also, more distantly, the careful lettering of his political and cultural cartoons). But Reinhardt kept writing separate from painting, which, it can be argued, Martin did not. The penciled line in her artwork is not just the record of a straight edge as it is moved over the surface of the canvas, laying down the structure of a grid or the breadth of a stripe. It is also a line of measure and deliberation. Implicitly, it is a line of language, not in the sense of discrete meaningful words but as the minimal structure, the onward flow, of all rumination. Whatever else surrounded or accentuated it, whether blank canvas or precise strokes of oil paint or dilute washes of acrylic, that penciled line runs beneath and beside.

Among the many authors Martin is known to have read, including the spiritual guides noted above, Gertrude Stein looms large at the nexus between the visual and textual. For Martin, Stein seems to have represented liberating candor and, perhaps even more agreeably, the freedoms offered by concealment. Robert Indiana, a seaport resident, recalls that Martin reintroduced him to Stein's *To Do: A Book of Alphabets and Birthdays*, which she had in her loft, and he says Martin admired Stein's writing for its simplicity and its density.[76] She was hardly alone. Stein's legacy was important enough to Kelly that he (and Ralph Coburn, during the busy

summer of 1949) found time to pay a visit to Stein's partner Alice B. Toklas at Bilignin. Cage notes having mentioned Stein to Suzuki, "who had never heard of her. I described aspects of her work, which he said sounded very interesting."[77]

The scholar Brendan Prendeville has drawn attention to a quotation from Stein printed inside the foldout card for Martin's December 1959 exhibition at Betty Parsons Section Eleven gallery: "In which way are stars brighter than they are. When we have come to this decision. / We mention many thousands of buds. And when I close my eyes I see them." Prendeville observes that the explicitly romantic lines following those Martin excerpted are "among the most overt and declaratory in Stein."[78] They read, in part:

> If you hear her snore
> It is not before you love her
> You love her so that to be her beau is very lovely....
> She is sweetly here and I am very near and that is very lovely
> She is my tender sweet and her little feet are stretched out well which
> is a treat and very lovely....
> She is very lovely and mine which is very lovely.[79]

These citations and exchanges are points of solidarity for a necessarily self-protective homosexual community of the 1950s and early '60s, and it is heartening to imagine the reticent Martin sharing in this encrypted round of personal communication.

There is also a kinship linking the measured, repetitive beat of Stein's writing and its insistent materiality to the rhythms of Martin's grids. Obdurate to the point of impenetrability, Stein's prose and poetry push against comprehension in something like the way Martin's work (and Reinhardt's) pushes against visibility. The dispersion of attention across the field of the page that Stein's prose and poetry often invite is comparable to the dispersion of attention across the expanses of Martin's paintings.

In creating text that tends to be both syntactically negotiable and, at its most difficult, semantically inaccessible, Stein made the act of reading come close to that of looking. (As Prendeville points out as well, Stein had studied with the philosopher and psychologist William James, and she "was stimulated by James's notion of the stream of consciousness"; she also "clearly drew on James's philosophical pragmatism."[80] Similarly, Martin was educated under the influence of James's Pragmatist colleague Dewey; the relevance to her of stream-of-consciousness procedures has already been suggested.)

The formal parallels between Stein's writing and the work of artists in the 1960s attracted attention at the time, notably in a key essay of 1965 by Barbara Rose, "ABC Art," which proposed that term as one among the many competing names for what would come to be called Minimalism. One section of Rose's essay is titled "A Rose Is a Rose Is a Rose: Repetition as Rhythmic Structuring," and she includes a quotation from Stein's "Portraits and Repetition": "the kind of invention that is necessary to make a general scheme is limited in everybody's experience, every time one of the hundreds of times a newspaper man makes fun of my writing and of my repetition he always has the same theme, that is, if you like, repetition, that is if you like the repeating that is the same thing."[81] Stein's writing is clearly relevant to the serial, formulaic, reductive visual artwork then emerging. Just as important, there are present in Stein's writing—as with other poets connected to the art world in which Martin participated: Frank O'Hara, John Ashbery, Joe Brainard, James Schuyler, and such elders as Wallace Stevens and William Carlos Williams—accounts of everyday things occurring in everyday lives, observed closely and dispassionately. "Not ideas but facts," Cage wrote,[82] echoing Williams's famous "No ideas but in things." That insistence on primary experience is felt in Martin's work, too.

At the same time, many of the visual artists with whom Martin associated at the seaport were reconciling the written and the painted. For instance, in Robert Indiana she found not only a friend who shared her

interest in Stein but also an artist whose work integrated word and image. During his downtown years, Indiana began making sign paintings that combine words and geometric figures into imperative statements of noisily mixed meanings, in which a blunt form of dark poetry often lurks—as do, occasionally, references to leading poets, including Williams.[83] One of Indiana's earliest sign paintings, *The Slips*, 1959-60 (private collection), features the names of various slips-turned-streets at the seaport: Coenties, Old, Peck, Pike. And he notes that at the time he was developing work involving equidistantly spaced orbs—the names in *The Slips* are inscribed in circles—he went to see what Martin was working on and found that she was doing something similar, which was, he said, naturally discouraging.[84] (Ironically, Martin would soon discard circles herself, and, as noted previously, she later repudiated all paintings in which they appeared.) In addition to the similarity between these compositions, the bisected black diamond in an untitled painting of 1956-57 (Dia Art Foundation), with its powerful graphic simplicity, strongly evokes Robert Indiana's sign-based paintings of the time.

Far more lyrical, hence closer in sensibility to Martin, are the canvases of Cy Twombly. His paintings of the early 1960s make classical allusions in large, unsteady, intermittently legible script that loops across pale expanses of paint; works of the later sixties simulate chalk drawn across classroom blackboards. Martin, too, considered herself a classicist, although her references were to Plato, while Twombly's were to Homer. Of this cohort of painters, the artist making work closest to Martin's was Jasper Johns, a taciturn Southerner who was eighteen years her junior and not as personally close to her as Kelly, Reinhardt, or Indiana. In the 1950s Johns was introducing the regular grids of letters and numbers for which he would become so well known. Examples include *Gray Alphabets*, 1956 (The Menil Collection, Houston) and *White Numbers*, 1958 (The Museum of Modern Art, New York), both of which are richly textured encaustic paintings featuring ghostly stenciled figures set in tidy rows. Compounding looking

and reading, the prosaic and the poetic, Johns was developing a language that had much in common with Martin's. Rauschenberg's use of newsprint in his transfer paintings, starting in 1958, is also relevant, as are the white paintings in which numbers appear. Rauschenberg's white paintings of 1950 and 1951 have striking similarities to Martin's small white paintings of the late 1950s in which pencil lines push through thick paint. For instance, his *The Lily White*, ca. 1950 (private collection), consists of a mazelike pattern penciled into white oil paint. Within the maze are inscribed numbers, facing up and down and, in one case, sideways, as well as the title and the word "free," both upside-down. Comparisons with Martin's work are highly suggestive.

To the extent that Martin's grids resonated to spiritual harmonics, they also find company in the contemporaneous work of Alfred Jensen, who by the late 1950s had begun to make heavily painted grids, the internal squares and framing margins of which bore characters relating to various numerical systems, including Arabic and Mayan counting procedures and symbols from the *I Ching*.[85] In these years, Mark Tobey was deploying a delicately calligraphic white line in compositions that suggest a fine Northwest rain of writing, skittering across his work's generally dark surfaces. Neither painter, though, was personally connected to Martin.

On the other hand, two artists with whom Martin surely interacted while she was in New York, Lenore Tawney and Chryssa, were at the time using in their work written language—including letter forms and newsprint—integrated with grids. In 1961, around the time of her solo show at the Staten Island Museum, Tawney stripped her work of color, creating fiber hangings with knots that reflect her nautical setting at the time and with braids that make reference to (among other things) ancient Egyptian headdresses. By the following year, Tawney's work had become fully three-dimensional, as seen in the floor-to-ceiling hangings included in the landmark 1963 group show organized by Mildred Constantine and Jack Lenor Larsen at the Museum of Contemporary Crafts (now the Museum of Art and

Design), titled *Woven Forms* (after Tawney's series of the same name).[86] The delicate lines of Tawney's *Woven Forms*, dominated by vertical threads in close parallel, as well as the closely woven wall works they followed, lend support to the many claims by critics that Martin's grids reflect a concern with textiles—and, by extension, that Martin made deliberate reference to domestic handcraft and its traditional association with women's labor (a claim that, as noted above, she vigorously denied).

In any case, the closest point of contact between the two women's work is not Tawney's textiles but instead the drawings in ink on graph paper that she began to make in 1964 and the collages she made in the same period. Tawney said of the drawings, which consumed her for a year, "They were like a meditation, each drawing, each line,"[87] suggesting a familiarity with mindfulness practices she shared with Martin. Executed on graph paper, often in red and/or blue ink, these drawings are not themselves grids. Fanning out to form mirrored or overlapping triangles and circles, often creating moiré patterns where they cross, the vanishingly thin lines are organized into compositions that are at once aerodynamic and vaporous.

Tawney's small collages, a significant number of them made on the backs of postcards sent to friends, are as painstaking as the drawings. Among those from the mid-sixties are some involving delicate inked lines in close parallel, occasionally crossing to form grids; a few are overwritten with lines of script perpendicular to the first, resulting in illegible grids of cursive penmanship. Strips of newsprint, with both text and numbers, alternate with rows of small pebbles and vertically inked lines in a 1966 postcard to Jack Lenor Larsen. In another postcard of 1966, horizontally drawn lines are crossed with strips of text in old French, their direction alternating, making it even harder to read; in the center is a circle of vertical lines. This one was addressed to the two proprietors of a sewing shop on Manhattan's Upper East Side called Tender Buttons—another Stein reference. In later years, Tawney's collages included elements—feathers and petals, images of animals—that Martin likely would have found dismayingly

sentimental. But the collages held an important place in Tawney's work; a 1990 retrospective included as many collages and assemblages as weavings. They intersect directly with Martin's work and thinking: in the delicacy of Tawney's gridded lines—alive with language that, teasingly, is almost but not quite legible—and in the touch of a hand that is evident but disciplined, it is easy to see the lineaments of Martin's paintings.

Ann Wilson, too, was making textile-based work in the sixties, hers comprising partially painted patchwork quilts composed in grid-like patterns. Some incorporate passages from her extensive writings.[88] But a far stronger commitment to the integration of image and text was made by Chryssa, whose initial body of work in New York was a plaster and clay series, *Cycladic Books*. Relatively small abstracted forms, they are each bisected vertically by a subtle spine that suggests the gutter of an opened codex, although a horizontal form generally spanning the top (these "books" were made from casting the inside of flattened cardboard boxes) evokes instead the brow of a highly abstracted face and thus the Cycladic figures to which the series title refers.

From 1955 to 1960, Chryssa was engaged with compositions of multiple letters, some of which take the form of raised type on bronze plaques suggesting press plates, as in the *Bronze Tablets* of 1956 and '57. Others are plaster reliefs, the letters either lined up in regular rows or more freely distributed. There are also reliefs featuring large, solitary uppercase letters, and others composed from rows of projecting elements that simulate the incandescent light bulbs of the period's older commercial signs; these elements also resemble, rather strongly, the boat spikes that appear in several of Martin's assemblages in those years. Between 1958 and 1962, Chryssa turned to newsprint—news stories, classified ads, stock prices, crossword puzzles, from the *Herald Tribune* and the *New York Times*—for repeated rectangular units that were formed into grids. There were seven large paintings in this body of work, 8 and 10 feet on a side, as well as a number of smaller studies, some stamped in ink on paper and/or newsprint; in 1963 the newspapers became sculptures.[89]

Neither the language Chryssa visualized nor its alphabet was native to her, and her work reflects an absorption by all that was new and exclamatory in the city's visual (and textual) landscape. As early as 1957 she was already conceiving sculptures dedicated to Times Square, iconic destination of all first-time visitors to New York, and in 1961 she began to use electric lights. By 1964 she had commenced work on the mammoth neon *Gates of New York*, which monopolized her time and resources for two full years (it was shown at both Grand Central Station and the Pace Gallery). "For two years, I'd had no desire to see anyone,"[90] she said, testifying to the depth of her commitment to her work—as well as, perhaps, to the volatility of her character.[91] And if she was alive to the lyricism lurking in her new environment—"I saw Times Square with its light and its letters, and I realized it was as beautiful and as difficult to do as Japanese calligraphy"[92]— she was also keenly alert to the flavor of a city changing at warp speed: by the late sixties she was using rheostats to make her glowing neon sign sculptures turn themselves on and off, and black lights to enhance their impact.[93]

In Chryssa's uninhibited drive to make her work literally shine forth, she and Martin stood poles apart, and nothing seems further from Martin's sensibility than Chryssa's monumental neon extravaganza. By the same token, it is hard to imagine work further in spirit from Tawney's than Chryssa's of around 1967; to put the comparison in terms of the era's popular culture, think of love beads and macramé in comparison with light shows at acid rock concerts (or, taking fewer liberties, the artists' own points of reference: Gertrude Stein at her most tender as compared with Sophocles at his most savage). But in Chryssa's newspaper-grid paintings especially, which are shadowed and whispery by comparison with her better-known light-based sculptures, the three women find common ground. And, as time would tell, Martin's quiet determination would far surpass Chryssa's drive in securing public visibility and critical acclaim.

It would be wrong to discuss these points of commonality between Martin and a range of artists all finding their varied voices, from Kelly and

Reinhardt to Tawney and Chryssa, without noting the perhaps obvious point that the influences they reflect were all reciprocal. Martin's annoyance—"Oh don't give me that"—at being associated with Tawney's weavings may have less to do with a reluctance to confirm their intimacy, or the reliance of her paintings on textiles, than with legitimate resentment of an attribution of influence going in the wrong direction. As was noted by Sam Hunter, "The faint intelligibility of Martin's repeated markings and formalized graffiti do have a bearing on her [Chryssa's] own forms and content."[94] During the years that Martin spent in New York, her eyes were wide open, and she absorbed a great deal. But she arrived as a full-grown adult—she was roughly twice Chryssa's age—with considerable experience and exposure to modern art. There is plenty of evidence—one thinks of her documented conversations with Kelly and Reinhardt, and also with Tuttle—that she was a deeply compelling presence whose thoughts were taken seriously, no small matter for a woman in a world of men. Her many years as a teacher had not, it seems, gone to waste. At the same time, she was, at least in the first few years, very plainly still learning from those around her.

Still, like most artists, Martin mainly listened to herself. Art historian Briony Fer, who notes the intimacy in Martin's work between drawing and painting, writes powerfully of its reflexive inner language: "Repetition sets in train a self-reference so intense that it is like an interior monologue. No dream of camaraderie, but a dream of solitude."[95] It matters, in considering Martin's work, that reading silently to oneself is something like listening to a voice inside your head, and—habitual and commonplace though it may be—is devilishly hard to define. The closest analogy to silent reading is thought. Or spending time with one of Martin's paintings. A fair amount of scientific and philosophical attention has been paid to the history and phenomenology of reading and writing, in all their variants, including reading aloud to an audience and noiselessly in private. "Thought requires some sort of continuity. Writing establishes in the text a 'line' of continuity

outside the mind," explains Walter Ong in his classic study *Orality and Literacy*.[96] That is, writing lends persistence and substance to mental activity that may have neither.[97]

As is intuitively clear, reading text aloud doesn't offer the imaginative flexibility associated with silent reading. While it hardly needs saying that writing comes much later in history than spoken language, it is less well known that reading silently to oneself also emerged only gradually, long after the development of written language.[98] As the literary scholar Alberto Manguel explains, it is only with silent reading that words "could exist in interior space."[99] In a jeremiad proclaiming (in 1987) the imminent death of written language, Vilém Flusser summarized, "As the score of a spoken language, the alphabet permits us to stabilize and discipline a transcendence of images that has been won, with effort, through speech. One writes alphabetically to maintain and extend a level of consciousness that is conceptual, superior to images, rather than continually falling back into pictorial thinking, as we did before writing was invented."[100] Flusser believed that we are in danger of just such a regression. For Martin, whose illness included aural hallucinations, and whose healthy imagination provided her with extraordinarily clear visions, negotiating relations between vision and thought, thought and image, inner voices that came unbidden and those over which she had control, was central to her mental life and her art. The line that runs through her work, from drawings to paintings, from one artwork to the next, and one decade to the next, can be seen as the contour of those negotiations.

Shaping thought is one thing art does for everyone, artist and viewer alike. The natter of both inner speech and public language can be intrusive for anyone; sometimes both make unwelcome demands. Talking back is one effective response. In the early 1960s Chryssa (who was plagued by mental illness, too) made audio recordings of letters pronounced at various regular intervals, progressively extended: it was an exercise in disarming language by radically slowing it down. In her public speech, Martin stilled

the private clamor with a contravening voice that tended toward the incantatory. The rhythms of her texts are often those of a sermon. But they are not that way consistently, and in recordings you can hear her listening both to her own words and to the audience, chuckling to herself at her remarks and laughing along when her listeners got her jokes: she had a quick wit, dry and laconic, as in proverbial Yankee humor. But it is in her artwork that she succeeded best in bending sometimes wayward private thought to public image.

Chapter 5

AS SHOWN

A ccounting for how an artist's work developed—describing the internal and external pressures that shaped it—is a different matter from relating how it was seen at the time it was made. More than half a century later, it takes some effort to bring into focus the context in which her work was first shown.

By the middle of the 1960s Martin was firmly established among a rising generation of young Minimalist painters who were taking the path first trodden by Reinhardt, Kelly, Newman, and a few others of their generation, a path that led away from gestural abstraction and toward hard edges and smooth surfaces. Being new to New York galleries and museums, Martin was often presumed to belong to this generation—that is, to be younger than she was. Amusingly, her birthdate is transposed to 1921 in biographical material in the catalogue for *The Responsive Eye*, an important exhibition organized in 1965 by William Seitz at the Museum of Modern Art, which promoted what is most often termed Op Art. Similarly, Michael Corris, in his careful recent study of Ad Reinhardt, includes Martin among the "younger artists" who sensed an affinity with Reinhardt's "black" paintings, though Martin was Reinhardt's senior by a year.[1] But the Betty Parsons Gallery, where Martin first showed her paintings in New York, was not only the context that initially defined her work, it also provided the associations with which she remained most comfortable throughout her career.

Parsons, who opened a gallery under her own name in September 1946, inherited the group of artists Peggy Guggenheim had exhibited at Art of This Century, which closed in 1947. Guggenheim knew both Parsons and Barnett Newman socially, and Newman became an important advisor to Parsons. Her biographer, Lee Hall, writes, "'Barney' became a touchstone in Betty's life, a friend with whom she discussed virtually every aspect of the gallery and of her own progress as an artist; above all, Barney was both the theorist and artist by whom Betty measured all others."[2] Parsons credits Newman's encouragement with her decision to inaugurate the gallery with a show of Northwest Coast Native American art. Newman's interest in that art was shared with many of his colleagues, including Martin, who had firsthand knowledge of the region. Indeed, one wonders if Parsons was listening not only to Newman but also to Martin when she chose the gallery's first show. (This interest has also been cited as a link between Martin and Tawney, who also deeply admired Native American art of the Northwest.[3])

At the outset, Parsons's artists included Newman, Pollock, Rothko, and Still, a group she would come to call the Giants and also, less amiably, the Four Horsemen. The caustic yet loyal Reinhardt became very important to her as well. Unlike the Giants, he retained her as his dealer until he died and, Hall reports, "He wrote notes and postcards to Betty as if she were his diary."[4] With coverage in *Time*, *Life*, *Vogue*, and other popular magazines, and critical support from such writers as Thomas Hess, Clement Greenberg, and Harold Rosenberg, the gallery was celebrated in the fifties as a bellwether for new art.

But Parsons's moment as the New York School's chief dealer was brief, and it was waning by the time Martin arrived. An artist herself, Parsons was notoriously distractible and generally short of funds. In 1951 most of her best-known artists defected to Sidney Janis, who was subletting a portion of her space at 15 East Fifty-seventh Street. She said he "just took them away. He could offer them stipends. I couldn't."[5] The help Parsons continued to offer newcomers was nonetheless invaluable. Jack Youngerman expresses

the protective feelings she elicited from some. "At the time I felt defensive toward Betty because she had a modest income," he recalled "But she had a generous soul. Betty was supportive, had a quiet confidence, a social confidence, that a lot of us didn't have."[6] Martin recalled that Parsons was "very social" and threw lots of parties—which Martin remembered enjoying.[7] Youngerman's first solo show there was in 1958. Kelly had come on board in 1956. Says Youngerman, "Ellsworth's first show at Parsons was a bombshell. It was so assured. It countered, totally, the art atmosphere at that time,"[8] which was dominated by Pollock and de Kooning.

While Parsons's relationships with the artists she represented were often close and complicated (as is commonly the case between dealers and artists), her ties to Martin were perhaps uniquely complex, even setting aside the question of romantic involvement. According to Newman's wife, Annalee, "Barney had a terrific eye for new young talent, and he recognized Agnes's possibilities. But he wouldn't have done all that if Betty hadn't made it clear how important Agnes was to her."[9] Newman had a studio on South Street, but he didn't live there, and he wasn't as close to Martin as Reinhardt and Kelly. Nonetheless, Martin was grateful to him. "I considered that I was very good friends with Barnett Newman, or he was a very good friend to me I should say, because he used to hang my shows for me," she later told Irving Sandler.[10] Although the paintings in Martin's first show at Parsons, in December 1958, were not those Parsons had bought in Taos but ones Martin made in New York, they were consistent with the biomorphic abstractions in bleached shades of sand and sky that she had been doing in New Mexico. In her next show, one year later, the palette deepened, and small circles and rectangles dominated the compositions; titles included *Wheat*, *Tideline*, *Earth*, and *Buds*. Her third and final exhibition at Parsons, in 1961, featured the early grid works.

Crucial though it was, Parsons's representation of Martin lasted only these three years, during which Martin was still groping toward the work with which she would be identified, and she later discarded much of what she showed there. (In a letter of the early 1970s, Martin wrote, "All

the paintings in the [December 1959–January 1960] show at Betty's have been destroyed except *The Ages* at Santini's [a storage facility] and *White Flower* at the Guggenheim."[11]) And despite Parsons's invaluable support at a critical moment, her record as a promoter and salesperson was decidedly mixed. "She was a very good dealer from the standpoint of artists," Martin said; "she took so much interest in them and encouraged them." At the same time, Martin conceded, "She didn't make so much money as some other dealers. She didn't price up art as high. She was just a real friend."[12] Even following a successful show in terms of sales, Martin would get quarterly statements from Parsons indicating, "after expenses for moving, storage, publicity, et cetera, I owed *her* money . . . I just couldn't live on what I was getting from Betty."[13]

The one-year contract Martin signed in 1958 stipulated, "The dealer will, during this period, be responsible for promotion of the artist and the artist will have the use of the gallery free of charge. The artist will be responsible for any additional expenses such as advertising, catalogues, photographs, etc." It was not by any standards a generous arrangement. Initially, Martin's smaller works were priced at $450 and larger ones around $650; by February of 1959, Parsons had had sold seven drawings and small paintings by Martin, for a total of $1,183.35, and Martin had incurred expenses of $630.14 (for transporting works, stamps for announcements, photographs of works and advertising, and advances totaling $308.34). Following the year's end, Parsons paid her $553.21. (In 1961, on the other hand, one painting sold for $1,500.)[14]

Martin later said she brought legal complaints against several dealers, but, she said, "I couldn't sue Betty . . . You'd ask her for your money and she'd say you owed her for storage and transportation. She didn't believe in artists having money." But looking back, Martin was nothing if not a realist about the relationship. "Lots of dealers won't pay up until artists make a fuss," she said. "Artists are so anxious to show their work they put up with anything. Betty, she'd wait until you were starving, then reduce the prices and buy them up herself." At the same time, she maintained, "I

owed her a lot, though. She came to Taos and bought enough so I could get to New York and start up. She put me up until I found a place to stay."[15]

If similar financial accountings could have been made by many of her serially disappointed gallery-mates, Martin's decision-making process was her own. As she remembered it, "Every morning for two and a half years, I asked my mind if I could change galleries, and for two and a half years it said, 'No, no, no.' Finally, it said 'Yes.' I leaped out of bed, went uptown, and told Betty Parsons I was leaving."[16] (In another recounting of this attenuated inner debate, she added, "It doesn't usually take that long."[17]) Also characteristic was her choice of going straight to the top: "When I left Betty Parsons I went to [Leo] Castelli." She was pragmatic about the outcome: Castelli told her "that he was filled up, you know, had all the artists, but that there was the Robert Elkon [sic] that had opened a gallery and it was brand new and he didn't have any artists and so I thought I'd go someplace where there was no competition."[18]

Robert Elkon, who was in his early thirties, had just established the gallery in 1961, on Madison Avenue, where he showed a mix of European and American painters, ranging from Picasso, Magritte, and Kandinsky to Pollock, Kline, and Rothko, as well as some younger Pop artists. In 1962 Martin had her first exhibition with him, and he remained her dealer until 1974.[19]

Martin was fortunate from the start in the critical response to her work, which has mostly remained remarkably sympathetic. Dore Ashton reviewed her first exhibition at Parsons for the *New York Times*, writing, "Miss Martin offers an evanescent, infinitely simplified communication—one that is quite apparently the result of many years of refinement." Responding in suitably lyrical fashion to the "poetic expression" she saw in Martin's paintings, "all in pale, floating keys," Ashton identified allusions to the landscape: "The warm glow and the carefully controlled optical illusions in these delicate paintings seem to be the observed and deeply felt benign essences of the mesa country so long Miss Martin's home,"[20] country of which Ashton had recent firsthand experience.

Notable in this auspiciously alert and favorable review is the reference to optical illusions, which—oddly, it now seems—would be ascribed to Martin's work for some time, as well as to the natural environment, a connection Martin would always denounce. Ashton reviewed Martin's next show at Parsons, which opened in December 1959, this time quoting the artist, to underline a connection between her art and the environs of her youth and early adulthood. "I guess I am really an American painter," Martin said. "I've never been to Europe. Never thought about it, and I suppose the only other place like Vancouver is the Russian tundra." (She must have been thinking of Saskatchewan; Vancouver is nothing like the tundra.) Of New Mexico's high desert, Ashton quotes Martin as saying, rather uncharacteristically, "The land is effective there. Isn't there something ecological about painting?"[21] The 1959 show was also reviewed in *Art News*, by Lawrence Campbell, who introduced Martin, in the short notice's patronizing first sentence, as "a specialist in teaching children creative activities." Campbell, too, saw optical illusions in the paintings, which he described as centered on "color disks—like buttons on a card—or small rectangles—like light through a Venetian blind," which produce "a strange, spoofing, kinetic experience. The disks and rectangles seem to swell, jump or skip.... The total effect is unsettling and entertaining."[22]

On the other hand, two early reviews by the soon-to-be-renowned Minimalist sculptor Donald Judd, both of exhibitions at Elkon featuring grid paintings, are surprising for their wealth of associative links. In 1963 Judd, in somewhat hesitant praise ("the paintings are simply attractive, a word which is usually, and is here, used both as a derogation and a compliment"), noted, "Most of the paintings are composed of a large square, within an empty border, of rows of small dashes.... A small painting that really works has horizontal rows of dash-dot-dashes (every iconologist should know that this is 'K' in Morse)." While perhaps overestimating the cryptological literacy of most viewers, Judd tellingly implies that there is something in the paintings to *read*, as a written message. He ends by noting that the work he favors has "a tightly quilted surface."[23]

Probably unaware of (or unconcerned with) Martin's deep aversion to this analogy, Judd returned in the next year's review to the theme of textiles. This time, writing about paintings and drawings in which grids are filled with dashes, he began approvingly ("These paintings are much better than last year's") and applauded the work's quiet force. There was no mention of code; instead, he stated emphatically, "The field is woven."[24] Also writing in 1964, Barbara Rose compared "these quiet works" to "Reinhardt's black paintings"; both "are reticent and retiring. They inspire contemplation rather than empathy." But Rose hastened to dispel any notion that such modesty indicates a limitation. "They are related to the most important painting being done today,"[25] she asserted.

By 1965, Martin was being written about as someone with whom the reader might be expected to be familiar ("Agnes Martin [Elkon; April 10-30] continues to make extraordinarily lyrical geometric paintings"). In fact, she was already being quoted, familiarly, by Jill Johnston, a writer who would become a good friend. While observing that "the all-over rectangular schemes... are absurdly simple," Johnston praises them for achieving "the quiet intensity of a perfectly contained image." The result is that "The pictures are, as the artist says, like tranquilizers."[26] A paraphrase, the analogy is a striking anomaly. It is hard to picture Martin speaking openly of psychotropic drugs, even harder to imagine her recommending her paintings as simulating their effects. That doesn't mean she didn't; it just indicates the variability with which she presented herself to—or was understood by—her many, very varied friends.

In a longer piece for the *Village Voice* in 1973, Johnston recalled her first acquaintance with Martin. "i think it was 1964 when i stopped in at the elkon gallery and saw all these six by six foot paintings washed out whites and tans crossed by close vertical and horizontal lines muted and irregularly perfect... a little later... i was knocking on her door to review her most recent show for art news... her hair was long then and she had lots of it and when i came in it was all loose and she was busying herself putting it back up." They had tea, and, Johnston continued, "looking at

agnes's paintings with agnes was a quiet concentrated ceremonious ritual... she traversed from the point in her loft where the paintings were stashed to the spot right next to the door where she showed them... when she reached the showing place next to the door there would be a certain gesture of hiking the work with her foot under the canvas up into position on the nails sticking out of the wall. then she would sit down next to you and contemplate the work with you and wait."[27] It is a vivid evocation of a first encounter between artist and critic, and the extended moment of quiet sitting is notable. Others would later often remark such encounters.

Another friend who wrote about Martin early on was Ann Wilson, a neighbor at the seaport and, like Johnston, one of the few to maintain a relationship with her after she left New York. In a feature-length article of 1966, Wilson touches on many aspects of Martin's work, sometimes contradicting herself but casting revealing light. She begins by claiming that Martin's paintings "imply the sound of pencil lines drawn on canvas above a tape measure,"[28] and she returns several times, curiously, to auditory associations. Wilson observes the artist at work: "There are measuring tapes, which she herself has made for each painting, hanging on a nail on her painting wall beside a T-square. These marked canvas tapes, the rulers she makes for each canvas, are clear in their simplicity."[29]

Wilson's language can be richly lyrical—she refers to Martin's penciled lines as "dry bones, taking away... whatever time, soap, hard use might take way, leaving... a painting that might survive in a desert." She refers to the "absolute symmetry" that Martin pursues, and she notes, "Classic form has always been difficult, austere, and impersonal."[30] The subtle trace of her hand's fallibility is noted, an early example of an observation that critics would make again and again. And not unlike Johnston, Wilson asserts, "These paintings can evoke a trance." It is possible that Wilson had experience of Martin's tendency to fall into such a state; if so, she quickly averts any suggestion of a psychological symptom, claiming the trance denotes a "spiritual quality," one which "is related to the work of Mark

Tobey and Morris Graves, who share with her a deep connection with the Pacific Northwest heritage of strong Indian presence and immense wilderness."[31] (Again, one wonders if Parsons was listening to Newman or to Martin when she inaugurated her gallery with an exhibition of Northwest Indian art.)

Wilson discusses Martin's early connection to farming—she compares Martin, shamelessly, to Daniel Boone—and provides what is evidently (there are quotation marks but no footnotes) an account by Martin of a family farm: "They planted navy beans half a mile across a field near Flint, Michigan. They put 40 acres in potatoes, an eye in each square of a chequerboard field, all by hand." This suggestive reminiscence, with clear implications for Martin's grid paintings, continues, "The land was a dollar an acre and Uncle Pete had 2,000 acres. There were big pine trees on the land. They dragged the trees to the field edges and stood them up, roots out along the roads. The roots would stand twelve to fourteen feet high in the air along the roads running straight as a die for miles and miles to the horizon." This Flint farm, at considerable distance from Saskatchewan and even further from British Columbia, is unlikely to have been a place Martin often visited; nevertheless, her evocation of it is sharp, and it has the shape of a strong childhood memory, or perhaps of a story often heard, everything outsized and interminable. Wilson quotes it with obvious relish; an embellisher (and powerful writer) herself, she is determined to frame Martin with distinctly different language from Ashton's, or Judd's, and to mythologize her character. But Martin's own voice is clear in the often-cited "statement about her work" with which Wilson concludes her article. It begins, "When people go to the ocean they like to see it all day. They don't expect to see, to find all that response in painting.... There's nobody living who couldn't stand all afternoon in front of a waterfall. It's a simple experience, you become lighter and lighter in weight, you wouldn't want anything else. Anyone who can sit on a stone in a field awhile can see my painting. Nature is like parting a curtain, you go into it. I want to draw a certain response like this ... that quality of response from people

when they leave themselves behind. My paintings... [are] about merging, about formlessness, ... A world without objects, without interruption."[32]

It would be several years before Martin's words began to be published at any length, and this early quotation is important. It sets out a preferred perspective, and demonstrates that Martin was keen on controlling—or at least shaping—discussions of her work. Not that critics have altogether complied, but they can't entirely ignore her statements either. She was hardly alone among artists of her generation (or any other) in hoping to manage viewers' responses. As the statement quoted by Wilson suggests, Martin invoked the experience of nature often, but only as a state comparable to the response she sought, never as subject or theme for her work. She fought for this distinction for the rest of her career, often in vain. She would not generally insist that people leave themselves behind in the act of viewing and tended later not to dwell on such images as sitting on a stone in a field. But she retained hope that a viewer might engage with her paintings as if walking into water, or a field of wheat, and with a similar kind of release and submission.

By the time Wilson's article appeared, Martin's work was being included in important museum exhibitions and positioned by the theories they advanced, not all of them consonant with her own. She is silent in the catalogue for the Museum of Modern Art's 1965 exhibition *The Responsive Eye*, and her work is neither referred to in curator William Seitz's text nor illustrated. Nonetheless, her inclusion in the show is important and revealing. It was one of the first of many exhibitions and essays in the middle 1960s that aimed to reground abstraction in terrain free of emotion, religion, politics, and even the vocabulary of formalism—indeed, the tension between verbal and visual language is a leitmotif in these attempts, and nearly every one proposes new terminology meant to support the works in question without compromising their freedom from words.

Seitz's effort was unusual in its focus on perception, although not in its impatience with the fogs of spirituality or the swamps of Existentialist angst. The "perceptual abstraction" he defined with his exhibition (and

catalogue essay) is work "stripped of conceptual association, habits, and references to previous experience." Though it shares with the abstraction of the early twentieth century "areas of color or tone… applied flat and hard edged,"[33] it avoids asymmetry and part-to-part composition. In comparison to, say, Mondrian, many perceptual abstractionist works, Seitz wrote, "have a stronger family resemblance to mechanical patterns, scientific diagrams, and even to screens and textured surfaces than to relational art."[34] In short, while old-style nonobjective painting and sculpture defined "a work of art as an independent object as real as a chair or a table," perceptual abstraction, in contrast, is dematerialized by uniform surface treatment, reflective or transparent materials, and a battery of optical devices; its primary purpose is to challenge perception. It is equally unproductive to approach these new works from a conceptual angle: "Ideological focus has moved from the outside world… and entered the incompletely explored region area [sic] between the cornea and the brain."[35] Where once there were hazy esthetic concepts grounded in soft disciplines (introspective psychology, philosophy, theology), now there was biological science.

As with many other such manifesto-like essays of the period, Seitz's goes on to outline a taxonomy of the field: his categories include "The Color Image" (chromatic investigations by painters ranging from Josef Albers to Frank Stella), "Black and White" (various kinds of optical illusions), and "Moiré Pattern"; his core interest, though, lies in "'Optical' Paintings," which combine the color and pattern provocations of all three. Although Seitz doesn't specify the heading under which Martin's work falls, the category it best fits is "'Invisible' Painting," which is illustrated in the catalogue with a red painting (in black-and-white reproduction) by Reinhardt. Seitz's brief account of this category concludes with the admission, "It is easy to associate these large paintings with religious and mystical states. The contemplation of nothingness, which they invite while retaining their identity, quickly goes beyond purely visual sensation." Defended with little passion (a "harried… visitor can easily dismiss these 'invisible' works"), such paintings gain admission to his exhibition, Seitz says, because of the

particular quality of visual attention they require, demanding that the eyes accommodate to them "as they do to a dimly lit room."[36] One suspects that Seitz also values them for defining, by opposition, the rackety paintings of artists like Bridget Riley and Victor Vasarely: optical exercises that are tough, loud, and shiny new.

Op Art would not seem to be a lasting association for Martin's work. Yet in Thomas Crow's 1996 book *The Rise of the Sixties*, she is still linked with Riley: "It is striking that two women artists, operating on opposite sides of the Atlantic, should have drawn parallel lessons from the all-over compositions of Pollock and de Kooning,"–this despite Martin's dismissal of de Kooning, with whom she felt no kinship whatsoever–"should both have seen the finely controlled, abstract grid as the next logical step for painting, should both have seen emotionalized rhetoric and self-expo-sure as superfluous to the task at hand, and should both have opted for pure tone over color." While Crow goes on to concede crucial differences, he concludes that "Both Riley and Martin ultimately appeal alike to the authority of nature… the latter's sensual concreteness plays on the divide separating human subjective faculties from the underlying natural order."[37] For many observers, the only solid defense for Martin's "modest" work would always be in firm dismissal of emotion and fixed attention on the abutment between subjectivity and the "natural order."

The year after MoMA's *The Responsive Eye*, Lawrence Alloway's *Systemic Painting* appeared at the Guggenheim. Alloway begins his essay by claiming, "The painting that made America famous" was associated with a "lore of violence." Certain outliers, however–Newman and Rothko among them–were "clearly not offering revelatory brushwork with autobiograph-ical implications." We would expect to find Martin among the outliers, but the essay's only reference to her suggests, rather oddly, that she is a maker of hard-edged shapes, rather than delicately drawn lines. Just as in *The Responsive Eye*, she is linked with Reinhardt.[38] And, drawing a com-parison with abstractionists of the early twentieth century who "universal-ized their art by theory," including Malevich, Kandinsky, and Mondrian,

Alloway insists, "What seems relevant now is to define systems in art, free of classicism, which is to say free of the absolutes which were previously associated with ideas of order." The key innovation, Alloway argues, is reconciling rule-based esthetics and human values: "A system is as human as a splash of paint, more so when the splash gets routinized,"[39] he writes. While the larger philosophical framework seems to accommodate Martin, it is very hard to find in his essay the particular contours of her art or her thinking—not because he was unresponsive to her work (seven years later he would write a sensitive feature article on it), but because his rather tendentious argumentation marshaled her painting for a scholastic battle in which, unlike some of her younger colleagues, she had no interest at all.

While these maneuvers (and many others, including those by Judd, Robert Morris, and Richard Wollheim) went on in the demarcation and defense of what would be called Minimalism—with explicitly martial language, as in Michael Fried's famous declaration, "there is a war going on between theatre and modernist painting"[40]—other writers were beginning to pay close attention to Martin's work on its own terms. As with her earliest reviews, many of those most sympathetic were women, which remains true today. From 1967, Martin's last year in New York, come a number of such responses, including a short feature by Annette Michelson in *Artforum*. Michelson begins by defining an opposition between "younger painters and sculptors" and "their Constructivist and neo-Plasticist precedents," and then names Martin as an example of those artists who "invoke historical precedents, only to bracket or negate them in the interest of fresh departures." Quoting Mondrian at length, especially on the achievement of unity and the abolition of particular form through the mutually neutralizing interactions of rectangles, Michelson concludes that the neo-Plasticist's theories actually fail "to wholly account for what [Martin's] paintings are or do." Another historical marker she uses is the "destruction of the surface's hierarchy which, originating in Pollock and Tobey, developed through the painting of the 40s and 50s." By "repressing the suggestion of any spatial depth, Miss Martin attains an 'annihilation of the existence of forms as

entities' [quoting Mondrian] typical of the sixties." If this kind of stylistic categorization recalls the essays by Seitz and Alloway, Michelson differs by describing in some detail the way the paintings are made–the T-square and stretched, shifting string; the hand-ruled line–and writes of a "visual tremolo," a phrase taken up by other critics; Michelson raises as well the "question of optimum viewing distance" that also becomes a staple of critical writing about Martin. In concluding, Michelson points to the work's fundamental resistance to words–its "ultimate ineffability"[41]–a term also often applied, understandably, to Martin.

In a review later that year of an exhibition at Nicholas Wilder in Los Angeles, Jane Livingston notes the paintings' subtleties and remarks on their "asceticism"– another that term would become a mainstay for describing Martin's work and her character–and observes qualities, such as vague, shadowy inflections of the surface, that are "visible only from some distance." Again the T-square is mentioned, as is a yardstick: critics were increasingly paying attention to the transparency and integrity of the artist's process. But unlike other writers in this period, Livingston insists that "there is virtually no adequate precedent or comparison by which one can measure" Martin's paintings: they "undermine the relevance of historical or stylistic analogy." While explaining that Martin destroys many of her works, she writes, "the works present have an almost incredible air in themselves of being culminations. Confronted with these canvases, one simply does not argue intent, or resolution, or lack of it."[42] It is an early ascription to Martin of an identity beyond the reach of ordinary measure.

The same year, Lucy Lippard organized an article for *Art in America* titled "Homage to the Square" (itself, of course, an homage to Josef Albers's series of paintings of the same title), in which a handful of artists were invited to make statements about their work. In her introduction, Lippard began by quoting Plato, a source dear to Martin. "To the ancients," Lippard wrote, the square "was a source of ideal proportions–endowing a structure with permanence and stability, making it a constant factor in a transient and corruptible world."[43] Perhaps not surprisingly, several of the

artists represented in the article demurred in one way or another. Wrote Donald Judd, "I don't think there's anything special about squares, which I don't use, or cubes. They certainly don't have any intrinsic meaning or superiority. One thing though, cubes are a lot easier to make than spheres. The main virtue of geometric shapes is that they aren't organic, as all art otherwise is. A form that's neither geometric nor organic would be a great discovery."[44] Sol LeWitt agreed: "The best that can be said for either the square or the cube is that they are relatively uninteresting in themselves … [they] lack the expressive force of other, more interesting forms … [and hence are] better used as grammatical devices."[45] On the other hand, Kelly wrote, "To me the square is sufficient because of its exact quality. The rectangle and the curved form are dictated by sensibility. The square is in the present tense, unchanging."[46]

Also included were Tony Smith (represented by the cube-shaped sculpture *Die*, 1962), Dan Flavin (fluorescent light), Claes Oldenburg, Marcel Breuer, and Albers: a markedly heterogeneous group variously associated with Pop sculpture, functional design, and reductive abstraction new and old. Nonetheless, Martin stands out. Paired on a page with LeWitt and illustrated with her *The Rose*, 1966 (Philadelphia Museum of Art), Martin's statement—the shortest of the group—reads, in its entirety: "My formats are square, but the grids never are absolutely square; they are rectangles, a little bit off the square, making a sort of contradiction, a dissonance, though I don't set out to do it that way. When I cover the square surface with rectangles, it lightens the weight of the square, destroys its power."[47] The only woman in this cohort, she declines the studied nonchalance of LeWitt and Judd, and, unlike her peers, admits some space between what she sets out to do and what she accomplishes. What she describes is a process in which she contends, vigorously, with the forces at work in visual expression, defying the power of the square, achieving a satisfying imbalance. It is evident that for her this struggle is not allegorical, but real. Later statements would smooth over the dissension, the instability. But it is always clear that when she is doing battle for her work, for her vision, it

is with forces—pride, envy, the enchantments of nature—both more funda-
mental and more intractable than the power of art historical precedents.

Among other group shows of more or less like-minded artists in which
Martin found herself at this time, none was more important than *10*, a
landmark October 1966 exhibition at the Dwan gallery. Curated by Robert
Smithson, it featured—in addition to Martin, who was separately brought
to Dwan's attention by Reinhardt—work by Carl Andre, Jo Baer, Dan Fla-
vin, Don Judd, Sol LeWitt, Robert Morris, and Michael Steiner, along with
Reinhardt and Smithson. (The abbreviated, working-stiff first names—Dan,
Don—were those favored by the artists at the time.) The installation was
spare, interpretive material nonexistent. Andre was represented by a
square field of ceramic magnets, Judd by six equal-sided galvanized steel
boxes, LeWitt by nested cubes, Morris by a square plywood box, Reinhardt
by a square black painting. Martin's contribution was the 1966 painting
Leaves (private collection). The catalogue, with a glossy white cover, was
square (like the newly ascendant *Artforum*). The number "10" appears on
the title page, and the table of contents lists the artists in alphabetical
order; black and white images of each work follow. The preponderance of
squares (in paintings, sculptures, and the catalogue documenting them)
is almost comical. And the staple-bound publication's taciturn, just-the-
facts-ma'am presentation, in newsprint-y black and white, consolidated
the sense (also then gaining ascendance) that less—whether of explana-
tory text, in the catalogue, or of the slightest personal inflection, in the
work—was immeasurably more.

Afterward, the question of how Martin felt about having been included
was raised many times. Looking back, she said, "They asked me to show
with them, and I was flattered. They were all so young. I considered myself
to be an abstract expressionist but they considered me a minimalist. I
couldn't do anything about that." She went on to explain that they were
classicists, in the sense that "they followed perfection in their minds. You
can't draw a perfect circle, but in your mind there is a perfect circle, that you
can draw towards.... That's the Greek ideal." She subscribed to classicism

in that sense herself, she admitted. "But they insisted more than I did on being impersonal. They wanted absolutely to escape themselves . . . they didn't even allow people to put their names under their pictures." After some discussion, she continued, they were persuaded to put their names in the back of the catalogue, with numbers identifying which work belonged to each. But "They even had to be talked into that."[48] And, further, "we all make mistakes. I mean, when I exhibited with the minimal artists at the Dwan Gallery, I was much affected by my association with them. . . . They want to minimalize *themselves* in favor of the ideal. Well, I just can't. . . . I rather regretted that I wasn't really a minimalist. It's possible to regret that you're not something else. You see, my paintings are not cool."[49] (Later still, she said, with the candor of advanced age, "I don't know why I ever showed with those boys . . . I've regretted it ever since."[50]) Virginia Dwan herself admitted that Martin was an imperfect fit with this group, in a letter to the *New York Times* addressing a review by John Canaday. After apologizing for not producing a press release or manifesto, she offered, by way of compensation, the explanation that the artists shared a commitment to "stillness," and that their work is, "Above all, . . . non-expressionistic, and, with the possible exception of Agnes Martin, impersonal."[51]

One reason the Dwan show continued to preoccupy Martin was its undeniable importance in advancing her career. Hardly alone among artists, Martin had conflicted feelings about success. While she went all out for recognition, she also feared it, as attested by her preoccupation, in her later writing, with the sin of pride. The same ambivalence lodges at the heart of her work, in the difficulty it presents to reproduction, a characteristic that had been remarked from the outset.

Michelson notes that the paintings display a "resistance to photographic reproduction almost as obdurate as that of Reinhardt's or Robert Irwin's painting."[52] Addressing the same issue, Michael Corris wonders, "Is there a political lesson to be extracted from the level of un-reproducibility of Reinhardt's work? Might we assume provisionally that 'un-reproducibility' is a marker for withdrawal?"[53] The politics to which he refers, of aversion

to the machinations of capitalism as manifest in the art market, were more clearly of concern to Reinhardt than to Martin, though the two artists may have talked about such issues. They played a role in Martin's life-long but selectively enforced opposition to exhibition catalogues, which at times inhibited her career. In any case, Michelson's observation that "The threshold of perception... is pitched so high" in Martin's work, places them in a category very similar to the one in which Seitz put them when he accommodated Martin under the heading "Invisible Painting." A resis-tance to reproduction—to visibility itself—can certainly be, at least in part, a resistance to distracting or distorting forms of promotion and packaging.

At the same time, the glare of attention against which Martin was defending herself cast an unreliable light. Despite her increasing public presence and critical favor, her opportunities for exposure weren't the same as those offered her male peers. Reinhardt, for example, had three simultaneous gallery shows in 1965 (of blue paintings at the Stable gallery, red ones at Graham, and black ones at Parsons), and a retrospective at the Jewish Museum in 1966. Chryssa, too, had a higher public profile in the middle 1960s than Martin. Even, or perhaps especially, for someone actively struggling against vanity, it must have been frustrating. To Jill Johnston, Martin later deadpanned that in New York, "i had 10 one-man shows and i was discovered in every one of them. finally when i left town i was discovered again—discovered to be missing."[54]

By the late 1960s, the art world in New York was transforming itself with unprecedented speed and force. An unlikely number of first-generation Abstract Expressionists had died (Kline, Newman, Reinhardt, and Rothko, along with Pollock, were all gone by the end of the decade, none of them older than 65), and a rising cohort of Pop artists were looking to bright new modes of consumer culture, while others were shaping a rarefied world of Conceptual and Minimalist art. The press was avid for all of it, and the acclaim that came unevenly to Martin's friends was a source of tension for all. Mildred Glimcher writes of:

a change in the atmosphere on the slip. It began to replace Tenth Street for those in search of the avant-garde. Kelly remembers a visit from [Michelangelo] Antonioni and Monica Vitti at the time of the opening of [Antonioni's] *L'Avventura*. The visit was arranged by Sophia Loren's secretary because Antonioni expressed an interest in meeting some artists. Whereas Betty Parsons and Eleanor Ward [director of the Stable Gallery] were the earliest dealers to visit the slip, after 1960, as more artists began to settle in the area, it became a destination for dealers and the hungry new collectors hot on the trail of the "new art."[55]

Thomas Hess's 1965 response to *The Responsive Eye* provides a vivid picture of changes affecting both artists and viewers. His review begins with arch hyperbole: "In an exemplary display of what Harold Rosenberg called 'the Premature Echo,' some forty or fifty-thousand Op-Art group shows in 1963–65 strewed flowers in front of the band-wagon of the Modern Museum's recently opened smash survey of the mode à *la mode*."[56] With iciest sarcasm, Hess adds, "One striking thing about Op-Art: its return to modesty."[57] This exhibition's dialogue, he says, is "with the audience and through the audience to a responsive, indeed glad-handing Society." Finding an incoherent diversity among the works shown, Hess narrows in on its core group of eye-tingling paintings, at once "very clean" and possessed of a "decorous violence."[58] Martin's incontestably pacific *The Tree* is illustrated in the article, although Hess does not mention the artist; his argument is with the more aggressive work and with the bridge it creates between fashion design, graphic arts and traditional painting, leading to an unhealthy commodification of the latter. In his most pointed assault, Hess contends, "There is an invisible but crystal-hard wall between the viewer and a Franz Hals or a Franz Kline." This is as it should be. By contrast, "Op will actually come down off the walls and shake your hand." Concluding on the same note with which he began, he writes, "I see no reason why collectors should not keep Op in racks, like wine in cellars."[59]

Martin, too, was deeply dismayed by the commercialization of art and vulgar preening of its audience, as is clear from her praise, several years later, for Lee Seldes's scathing book, *The Legacy of Mark Rothko*, which reviews in great detail the sordid financial and legal dealings that followed Rothko's death in 1970. Martin told her friend Donald Woodman in the late seventies that Seldes's book contained "everything you need to know about the art world."[60] Among its contents is this notorious account, by Calvin Tomkins, of the reception for the Metropolitan Museum of Art's exhibition *New York Painting and Sculpture: 1940-1970*:

> The stately, black-tie world of the Metropolitan trustees found itself mingling with tribal swingers dressed as American Indians, frontiersmen, Cossacks, Restoration rakes, gypsies, houris, and creatures of purest fantasy. The see-through blouse achieved its apotheosis that night, and spectators lined up three deep to observe the action on the dance floor—there was a rock band in one gallery and a dance orchestra in another, to say nothing of six strategically placed bars. Works of sculpture acquired festoons of empty plastic glasses, the reek of marijuana hung heavy in the air, and at one point late in the evening, while the rock group blasted away in a room full of Frank Stella's paintings and David Smith's sculptures, a tall woman and a lame sculptor wrestled for fifteen minutes on the parquet floor, untroubled by guards, spectators or a century of Metropolitan decorum.[61]

The arch tone of Tomkins's reportage, no less than the assaults against propriety it describes, capture a spirit of violent cultural collision that whiplashed participants of every inclination. It is impossible to imagine Martin in the scene Tomkins details so vividly (and indeed she had left New York two years earlier); it is not much easier to picture her at the opening of *The Responsive Eye*, which she may well have attended. And the over-familiarity with—or disrespect for—artworks that both Hess and Tomkins observed on these occasions seems, understandably, to

have infuriated and alarmed the artists whose work was ostensibly being celebrated.

In the chronology of his life that Reinhardt assembled for the catalogue of his Jewish Museum survey, he give particular emphasis, in these years, to vandalism of his notoriously vulnerable work ("1963 Six paintings in New York and six paintings in Paris get marked up and have to be roped off from the public. 1964 Ten paintings in London get marked up."[62]) Similarly, Martin complained throughout her life of paintings being defaced. "Somebody took an ice cream cone and went around and around on one of my paintings," she reported. "Then there was one that was destroyed with a green crayon.... And in Germany there was a nationalistic group that threw garbage at the paintings at Documenta Five."[63] By way of explanation, she offered, "You know, people just can't stand that those are all empty squares. And the vandalism that happens, you wouldn't believe how many of my paintings have been destroyed.... Once some vandals just took an india ink fountain pen and they just opened it right across the painting and that one wasn't restored. They wanted to fill in the squares.... It's a narcissistic type that would do that... In San Francisco, a woman gave one to the Museum and people started coloring in the squares."[64]

In addition to its portrait of a changing art world, there were many aspects of Seldes's book—and of Rothko's life story—that would have caught Martin's attention. Born in 1903 in Russia, Rothko (then Marcus Rothkowitz) emigrated with his family to Portland, Oregon, in 1913. His father died soon after, leaving the family in straitened circumstances. Rothko went East to Yale, in 1921, but its social restrictions made him uncomfortable and he dropped out, becoming a part-time teacher. All these experiences—moving from a fatherless family with little education or means into a world of wealth and power, coming to New York from the still rough-hewn Northwest, and supporting himself at times as an educator—would have resonated with Martin, entirely apart from the kinship she felt with him as an artist. Rothko was among the artists Betty Parsons represented when she opened her gallery (he left in 1954 for Sidney Janis);

he was one of her Giants. Martin and Rothko hardly knew each other: "I only had lunch with Rothko once, but I enjoyed it; he talked about the difference between the life of an artist and a layman—very amusingly. That's the only time I met him,"[65] she recalled. But his influence on her work of the early 1950s in particular is inarguable.

Seldes's book opens with Rothko's suicide and is concerned primarily with legal challenges to the disposition of his estate, managed by the Marlborough Gallery, which represented Rothko in his last years. His survivors charged, in a case that ultimately proved successful, that they and a foundation Rothko had established to protect his work and his legacy had been defrauded. Seldes addresses all of the tangled financial and legal particulars in great detail; they are both bleak and numbing, but Martin was evidently engrossed. Shell companies in Liechtenstein, offshore tax shelters, double bookkeeping, and the minutiae of sale prices and court proceedings are all part of this modern-day tragedy involving greed, power, deception, and despair.[66] Not least alarming, for an artist, was Seldes's exposure of a then new form of investment, in which international banks hold valuable artwork—unseen, in vaults—as elements of a species of mutual fund in which investors could own shares. Those who see Martin as an otherworldly mystic uninterested in the fine points of financial legerdemain miss her astute awareness of the social and cultural environment, her acumen, and her practicality.

Martin was not only predisposed, like Rothko, to a dim view of the commercialization of the art world and to a similar dismay over the money and glamour that came to dominate it, she was also prey, often and enduringly, to similarly deep depression. And the paranoia to which Martin was subject finds ample support in *The Legacy of Mark Rothko*. Seldes goes so far as to cast suspicion, tacitly but clearly, on the untimely deaths of two interested parties: Rothko's young widow and would-be heir, Mary Alice (known as Mell), and an esteemed art historian appointed by Rothko as a director of his foundation, Robert Goldwater. Both proved uncooperative with Marlborough's schemes.[67] (Goldwater's demise, in 1973, left another

widow, the sculptor Louise Bourgeois.) In fact, Seldes's speculation extends to dark doings in the death of Rothko himself—although, she admits, he had threatened to kill himself and was extremely unhappy and physically unwell at the time of what she suspects was his murder.

In a second edition of her book, she finds support for her hypothesis in none other than Agnes Martin: "Years afterward, the possibility of foul play occurred not only to the conspiracy-minded, but some of those who had known Rothko well and thought him incapable of suicide. Finally the speculation was voiced publicly in a 1976 *Art News* interview by painter Agnes Martin: 'I wish you could publish that I don't believe for a minute that Rothko committed suicide. Nobody in that state of mind could. He was done in, obviously ... by the people who have profited or have *tried* to profit.'"[68] Seldes was wrong about Martin knowing Rothko well (her quoting of Martin tactically cuts before the discordant concluding estimation, "Why, Rothko might have been the happiest man in this world, because his devotion was without mark or stain. He just poured it out, right from his heels!"[69]); neither was Martin an exception to the conspiracy-minded. But she was clearly deeply affected by the results of Seldes's own sleuthing (whence, surely, the conviction Seldes so gladly cited). Indeed, looking back at the New York art world from New Mexico in the late 1970s, Martin might have felt lucky to have gotten out alive, figuratively if not literally.

To be sure, those who knew her have recalled occasions on which Martin not only enjoyed, with gusto, the professional and personal associations she had made, but also entered into the spirit of the period with considerable abandon. Jill Johnston, by the later sixties a good friend, recalls an "incredible evening in '66 i think it was when i brought five or six people over to her loft and we sat around in a vague circle in a sort of a trance as though it was a séance although nobody mentioned it and there was at one point this great overhead crash ... whatever it was she didn't bat a lash she went right on talking," inviting her guests to participate in various exercises for the imagination (if you picture a body of water, would you cross it, for example).[70]

"Trance," the word that Martin's friends (including Ann Wilson) some-times used to describe her periods of profound dissociation, seems to have been taken, by her guests, if not by Martin herself, as an experience of more or less voluntary mental levitation in keeping with the era's growing embrace of psychic travel. Johnston reports, in the same essay, that on an excursion during this period to rural upstate New York, "for a little two-day cook and sleep-out next to a crick river and 20 yards in from the macadam," Martin kindly refrained from observing "what an elementary tourist trip it was" for an experienced outdoorswoman like herself; instead, Martin "seemed happy tearing off her clothes yelling at last one with nature."[71] Though Johnston doesn't favor exclamation points, one is clearly implied here—as when, under similar circumstances, Martin had praised the Lord for his plumbing. Even during her urban decade, nature was a reliable source of pleasure.

But in the end it seems the occasional weekend outing didn't suffice. The circumstances of Martin's departure from New York in the summer of 1967 remain hazy. It is worth noting that she was far from alone in leaving the seaport. Recalling the breakup of the community, Jack Youngerman stressed the urge to solitude that was, paradoxically, the thing that drew the artists there together. He pointed out that for the most part, they left for remote places: Kelly moved to upstate New York, Indiana to an island off Maine, Martin to New Mexico, and so on. But Martin's move was unlike the others', precipitous and surrounded by mystery. The several reasons given for her sudden exit, at the cusp of fame, include the death of Ad Rein-hardt, the end of her relationship with Chryssa, and the loss of her final seaport loft, at 28 South Street; the last is the one Martin herself affirmed. In 1996, she recalled: "They tore down my building. I had a perfect loft. It was 125 feet long, 30 feet wide. Windows right across on the river. And up the side it had two skylights. A beamed ceiling that was 14 feet high.... I could see the expressions on the faces of the sailors, it was so close to the river."[72] Three years later, she claimed it had "20-foot ceilings, 135 feet long and 45 feet wide, two big skylights, windows right on the water."[73]

Whatever its true size, she would never again have a workspace with the lambent, riverfront light, or the ecclesiastical dimensions, of those she had at the seaport. Losing it, and the community of which it was a part, was a hard blow.

It is also the case that shortly before leaving New York, she had had a psychotic episode; it was not the first, but it was apparently quite severe. These events are hard to reconstruct. The closest she came to referring to her emotional condition as a reason for her departure was in a 1983 statement: "I left New York in 1967 because every day I suddenly felt I wanted to die and it was connected with painting. It took me several years to find out that the cause was an overdeveloped sense of responsibility."[74] She'd put her reasons in more dispassionate but still introspective terms in 1981, when she said the departure

> was inevitable, you see. What we have to do we have to do. I could no longer stay, so I had to leave, you see. I suppose you could say I wasn't up to the demands and everything, the life I had to live, there. But there was something else; that I came to a place of recognition of confusion that had to be solved. . . . It's just like painting; I waited patiently for . . . something like permission to leave. Because I certainly felt I should stay and do my work. But when I had completed a show for Los Angeles I suddenly felt that I could leave and then I did leave.[75]

These recollections of confusion and even desperation are exceptional. Much more typical is this 1996 explanation: "The very day that I heard they were going to tear down my loft, I also got a letter that gave me a $5,000 award for painting."[76] With this grant, from the National Endowment for the Arts, she took a bus to Detroit and headed for a Dodge dealership. "I picked out the liveliest salesman and said, 'here's a check for $5,000, what kind of truck can haul a camper?'"[77]

When she was later asked, "Were you aware that the art world considered you to have spent a decade in New York making masterful paintings?"

Martin replied, "Yes, I thought I had, too.... I thought I had already made them so I could leave."[78] A few days before she left, she appeared unannounced at Pace Gallery. Arne Glimcher recalls, "She had brought all her art materials she could carry—brushes, canvases, stretchers—and asked me to give them away to young artists."[79] She would make no paintings, by her account, for four-and-a-half years, although she did not entirely sever herself from friends and art-world acquaintances. Her isolation was shorter and more tempered than is implied by the biblical period of wandering—sometimes erroneously said to have lasted a full seven years—that has accrued to her myth. As always, the image she leaves is fractured.

— Chapter 6 —

SILENCE

"The scene changes to an empty room. Rimbaud has gone to Abyssinia to make his fortune in the slave trade. Wittgenstein, after a period as a village schoolteacher, has chosen menial work as a hospital orderly. Duchamp has turned to chess.... But the choice of permanent silence doesn't negate their work. On the contrary, it imparts retroactively an added power and authority to what was broken off—disavowal of the work becoming a new source of its validity." So writes Susan Sontag in "The Aesthetics of Silence," an essay of 1967, the year Martin went rogue. As if directing her thoughts squarely at Martin, Sontag continues, "Art is more than ever... an exercise in asceticism. Through it, the artist becomes purified—of himself and, eventually, of his art."[1]

The period of travel that followed Martin's departure from New York and the interruption to her painting career have acquired the status of myth. There is a fair amount of mystery about where she went and how she spent her time during those years. What is known is that for roughly the first year and a half, she was on the move, driving and camping in the Pacific Northwest, in both the United States and Canada. By the end of 1968, she had resettled. Even when she had no fixed address, her isolation was not complete; she maintained limited contact with some friends. "I am staying unsettled and trying not to talk for three years," she wrote at this time to Sam Wagstaff, a curator and collector she'd met in New York.

"I want to do it very much," she added. In another letter to Wagstaff, she reflected, in candid confusion:

> I don't understand anything about the whole business of painting and exhibiting. I enjoyed it more than I enjoyed anything else but there was also a "trying to do the right thing" a kind of "duty" about it. Also a paying of the price for that "error" that we do not know what it is. What we "owe." Now I do not owe anything or have to do anything. Fantastic but even more fantastic I do not think that there will be any more people in my life. With about thirty years to go [not a bad estimate; she was then in her late fifties and died at 92] that is very odd. Do not think that that is sad. It is not sad. Even sadness is not sad.[2]

Clearly, she struggled in these years to resolve creative–and social–impulses with the urgent need for internal peace. But she had definitely closed the door on the kind of involvement in a fervidly progressive urban art community that she had sustained for a decade at Coenties Slip.

As Sontag's catalogue of cultural saints-in-the-wilderness demonstrates, the prestige of artists who had chosen to drop out of mainstream society reached a high point by the late sixties. Accordingly, by 1973 Martin was being described as a mystic: "The verbal statements of Reinhardt and Martin are similar in nature to the self-contradictory phrases of mystics which couple unity and multiplicity, overcoming the barriers between the individual and the absolute," Lizzie Borden wrote in an article for *Artforum* that year.[3] Jill Johnston recalled, "it isn't altogether clear why she left new york and why she stopped painting but if you heard the story it's the sort of story you accept and understand without any explanations. leaving new york has become as much a ritual exodus as going to new york is a ritual initiation."[4]

But Martin's flight is not best seen as a statement of principled withdrawal for solitary meditation. She left New York in a state of considerable turmoil ("every day I suddenly felt I wanted to die"), with no clear sense of

where she was heading and no evident intention of sustaining her career. Everything about her period of wandering and resettling was—like the rest of her life, but more so—riven with contradictions and exceptions. Still, as her argument with John Cage's notion of silence implies, one thing she believed in deeply was the possibility of an absolute quiet, best sought in nature, and in 1967 she went in pursuit of it. Loneliness could be a terror, but the presence of others was at times worse. Most difficult of all was the clamor that arose within. It seems she wanted the noise to stop.

The toll Martin's psychological conflicts took is referred to with surprising candor throughout her recorded lectures and writing. On the other hand, her diagnosis—of paranoid schizophrenia—was not publicly disclosed during her lifetime, and the nature of her trouble was minimized, ignored, or misrepresented with surprising success. While soul-searching, introspection, was the creative source most reliably mined by Martin's abstract expressionist peers, the other, mostly younger artists with whom she was associated (voluntarily or otherwise) while in New York were looking to transcend the individual psyche's turbulence either through ethical and material idealism (Kelly and Reinhardt; the Minimalists) or by turning to the world of commercial imagery for their source material (the Pop Artists). Since Martin's death, and in the context of changing levels of social acceptance and understanding, it has become possible to read her statements about emotional trouble less as the solemn pronouncements of a beatific anchorite, warning of moral and psychological perils and pointing toward their transcendence from a position safely above the fray, and more as telegrams of urgent psychological peril.

The first hospitalization of which friends speak resulted, in the mid-1960s, from a break that occurred during a trip by freighter to India (much like the one she had discussed with Georgia O'Keeffe); it is generally described as a rather *Passage to India*-like episode of spiritual excursion gone awry. It has been said that Lenore Tawney traveled to India to take her home,[5] and also that Tawney paid for at least some of the costs of her hospitalizations.[6] In Jill Johnston's words, "once she took a freighter

around the world and someplace in india they took her off the boat and confined her in a hatch because she'd gone into a trance."⁷ David McIntosh, whom Martin met in 1971—they became enduring friends later in the decade—recalled, "She was one of several passengers on a freighter. She knew immediately"—or believed—"the other passengers disliked her, intended to exclude her." The tension caused her breakdown and led to amnesia. "She lost her memory, her sense of self. She was hospitalized there. When she recovered one of the doctors accompanied her back to New York. She spoke of his kindness."⁸

Kristina Wilson strikes a rather whimsical note in describing the incident in India, saying Martin sang Scottish ballads to the nurses before she remembered who she was.⁹ Pat Steir, who first met Martin in 1971 and visited her every summer for three decades, says that the India episode resulted from an "attack of conscience," which caused her to see that money was inconsequential, and so she gave away what she had.¹⁰ Like most of these reports, the version written with Martin's involvement is circumspect and wry: Benita Eisler's *New Yorker* profile records, "By 1964, Martin had managed to earn enough from two shows at the Elkon Gallery to plan a trip around the world, but she had barely arrived in Bombay when she got sick. She spent a month and a half in the hospital there and then came home. 'I didn't get to look around much,' she says dryly."¹¹

The 1967 episode in New York was quite serious. Robert Indiana recalls, "I happened to encounter Agnes on South Street and she simply walked past me and didn't even recognize me. Shortly thereafter she was committed to Bellevue."¹² At Bellevue, she was initially placed with severely disturbed patients. She was physically restrained, heavily sedated, and underwent electroconvulsive therapy (ECT—"shock treatment"). According to her friend Kristina Wilson, Martin had been found wandering and confused, and she "was put in a ward with violent patients. It was just awful, people screaming and so on. She stayed there for several days, and someone found a phone number in her pocket that was one of the Coenties

Slip artists. They rallied and had her moved to Presbyterian." Indiana says it was he, who, dismayed by the conditions at Bellevue, called an art-collecting psychiatrist with whom he was friendly, Dr. Arthur Carr, and that Carr arranged for the transfer; Ann Wilson recalled that Kelly was involved in this rescue as well.[13] Kristina Wilson reported that Martin said she had electroshock treatment at Bellevue more than 100 times, "and that when she got out she left New York for her health."[14] Donald Woodman, who met Martin in 1977, also states that ECT was administered to her at Bellevue; it was a routine procedure at the time for patients with her symptoms (and in fact has returned to favor for treating major depression, though it is now administered more humanely).[15]

A description of shock treatment at mid-century appears in Sylvia Plath's *The Bell Jar* (1963). Based on her own experience, Plath reported, "There was a brief silence, like an indrawn breath. Then something bent down and took hold of me and shook me like the end of the world. Wheeee-ee, it shrilled, through an air crackling with blue light and with each flash a great jolt struck me till I thought my bones would break and the sap fly out of me like a split plant."[16] It is a vivid account of the treatment's miseries, which some doctors sought to avoid.

Carr recalls his role in Martin's care: "Because of the influence I had at the time, I was able to have her transferred to Columbia Presbyterian Psychiatric Institute [at 168th Street in upper Manhattan]. She'd had a very difficult existence down at Coenties Slip." The conditions at Bellevue were both unpleasant and unsanitary: "I visited her at Bellevue with Bob Indiana, and a rat, or a mouse, ran across the floor." She was very grateful to Carr for the transfer, he says, which much improved her situation. "I would have the *New York Times* delivered to her every morning," Carr remembered, "and she had a good breakfast there. She felt like a very special person. And indeed she was. They treated her royally. Even getting food was difficult where she was living, down on the waterfront." To a question about whether ECT was part of the treatment at Columbia, Carr responded

with some alarm. "I don't think so. The Psychiatric Institute was a not a place that emphasized shock treatment. It was not," he added with evident discomfort, "pleasant to watch."[17]

There was a later hospitalization in Pueblo, Colorado, after Martin had again been found wandering and confused, and another in Santa Fe. Amnesia—not knowing who or where she was—was a component of these episodes; so was terror. Later in her life, Martin benefited from the development of less heavily sedating medications than, for instance, the Thorazine that was the most-prescribed antipsychotic when she was hospitalized in 1967. At the same time, her illness abated with age, which is often the case. Martin's benign term for her psychotic experiences, "trances," is belied by some of the states she evokes, at times, in her writing; similarly mundane is her report that these spells, short and long, were caused by overstimulation, as in the story she told, cheerfully, of conking out after lunch with O'Keeffe. On another occasion, she told Arne Glimcher, she was "in a perfect small church on Second Avenue in New York at Christmas time and hearing . . . the Messiah. After three notes, I zonked out—in a trance—I've been in many trances, you know. That's how they put me away in Bellevue."[18]

It may be relevant to Martin's reference points for this experience that "trance" is also the term used to describe Saint Teresa's ecstatic states. The chronology for a 1943 biography of the saint gives for 1539, "In July seriously ill, and in a trance for four days, when in her father's house. Paralysed for more than two years."[19] This hardly seems a pleasant condition, but in Teresa's own description, found in her signal teaching, the Prayer of Quiet, such trances left her "as it were, in a swoon, both inwardly and outwardly, so that the outward man (let me call it the 'body,' and then you will understand it better) does not wish to move, but rests, like one who has almost reached the end of his journey." Grave though this may still sound, Teresa insists that such states were blissful, because they transported her spiritually. When thus disposed, people like her "seem not to be in the world, and have no wish to see or hear anything but their God . . . Sometimes it

goes on for a day, or for two days, and we find ourselves—I mean those who experience this state—full of this joy without understanding the reason."[20]

While Martin never spoke of seeking (or finding) contact with God during her trances, Teresa's language resonates with hers in many ways. There are also parallels in Teresa's "Prayer of Quiet" to Martin's preference for laughing off intrusive thoughts, especially those that are distractingly intellectual: "When one of you finds herself in this sublime state of prayer, which, as I have already said, is most markedly supernatural, and the understanding (or to put it more clearly, the thought) wanders off after the most ridiculous things in the world, she should laugh at it and treat it as the silly thing it is . . . if you try to drag the understanding back by force, you lose your power over it."[21] The complicated mix of paralysis, self-forgetfulness, transcendence, and mirth provides a framework for considering Martin's psychological experience in non-medical terms that seem to have been attractive to her and her friends.

Yet there were more than a few people who knew how dire her situation sometimes was. Kristina Wilson and Donald Woodman both received desperate notes from Martin. To Wilson, she wrote, "I have tried existing and I do not like it. I have decided to give it up. Agnes."[22] And to Woodman, in the late 1970s, she wrote on a small piece of paper in shaky handwriting, "I think I am dying / Please call an ambulance to take me to Albuquerque / Crematorium immediately / if you find me dead / call Arnold as note on bank account directs."[23] Martin's writing contains testaments to deepest anguish, including at least one elliptical reference to suicide: ruminating on a favorite topic, she writes of a "little boy" who has an inspiration that "seems to be different but is really the same. One day perhaps he is vicious and mean and insufferable so is sent to his room. There he hates everyone thoroughly, wishes he could kill everyone in the world, decides to kill himself since he cannot and thinks everyone will be sorry. Thinks his parents do not deserve him, that they probably stole him somewhere etc. After many fantasies he becomes exhausted. Then his mind is suddenly cleared he is happy, transformed. The whole storm and all of the

evidence is forgotten."[24] It is hard to avoid reading this digressive tale, which appears in undated handwritten lecture notes, as autobiographical. A "Short Essay" Martin titled "Staleness," with equally suggestive hand-written emendations, reads:

Because I cannot see
Because I cannot know my [this possessive was inserted in ms.] desire
Because of burning and ashes
I am looking on my own death
Now in desperation and because I know suffering [the preceding five
words were struck through] I will help this one
that one
But there will be no help given
there will be hope and determination and no breathing.

(To be fair to Martin's breadth of vision, "Staleness" is paired with a limpid essay called "Freshness," which reads:

Especially when the morning air
is struck alive
Especially when the stream runs cool and the grass drinks
Especially in sweet sleep when small waves go back on themselves.
Clear shining trembling gay
Soft lifting serene
Alaighing [sic] thirst
Freshness enters.)[25]

The most acute of Martin's psychotic episodes, which included catatonia and amnesia, were widely scattered and short-lived. But for much of her adult life she experienced aural hallucinations, one of the commonest signs of schizophrenia Martin, and the friends to whom she talked about these internal voices, have generally emphasized that they had absolutely

no creative use for her and were completely distinct from what she called inspirations, or visions, which were her most reliable imaginative resource. David McIntosh says, "She never related the paintings to the voices. I cannot recall one instance in which the paintings had anything to do with the voices. The inspirations and the audible voices were different. She always said that every painter needed inspiration."[26] To Donald Woodman, she talked about "pushing back voices in her head to find the silence she needed, which was of paramount importance in her work."[27] If not disabling, they were often a considerable nuisance. Kristina Wilson says that when Martin was ill, "one hand wasn't aware of what the other was doing," and that she was "often pursued by demons," as when "beings came through the wall one night and stole her wallet."[28] On the other hand, the filmmaker Mary Lance remembers that Martin sometimes spoke of her inner voices as being useful forms of unconventional communication: having failed, uncharacteristically, to show up for a scheduled lunch, Martin explained to Lance, "You called me on the psychic telephone to tell me you'd broken your leg."[29] With equal matter-of-factness, Martin refers in lecture notes to "mental telepathy" which she equates with "super sensory abilities," and, in an unusual departure from grammatical logic, she continues, "I think you will see that if you give it a little time,—a scientific fact, shared by all the animals in varying degrees and one that in most people no longer functions."[30] When she was listening to voices other people couldn't hear, she evidently sensed a connection to other animals; it is a moving expression of the experience of hearing, and speaking, a language that—inverting linguistic function—isolated her from other people.

McIntosh's recollection of Martin's illness also reveals its bedeviling inconsistency. "I knew her when she had clear vision and disturbed vision," he says. (By "vision" he doesn't mean her image-producing inspirations—note the absence of an article, "vision" not "a vision"—but simply clarity of mind.) "Often the experiences were destructive and painful for her but some of the experiences with voices were jovial for her, and at times it made her very happy. She had pleasing, exhilarating conversations

with the voices. It seemed quite a good social life for her, although at other times they were malevolent and frightening." The voices' appearances "weren't frequent, they were episodic. Usually they accompanied periods of stress, from painting or her emotional situations, about which I didn't know." When asked if the voices were personified—if they had different characters—McIntosh replied, "Yes, they did," but they weren't persistent over time. "One voice which may have been active for three or four days would never reappear."[31]

Shortly after Woodman met Martin in 1977 and McIntosh reconnected with her—and following her resumption of art-making—she was visited by her old friend Ann Wilson and by Harmony Hammond, a younger artist. In 1978 all three took a road trip during which Martin was particularly garrulous. In recollections published together, both Wilson and Hammond record discussions of instructions delivered to her by imaginary guardians and scolds. Wrote Wilson, "Her voices told her that when she had worked too long she needed to take a trip . . . She said her voices tell her not to own property and to keep cutting back. The first thing she got rid of was obsessive thinking. Then she dropped the things that she did not like about herself. Agnes figures you keep cutting back until there is nothing there."[32] Hammond reported, "She explained that her voices would not let her own land. That it was dangerous to be secure. Just a few chickens. No dogs." Some of these admonitions are consistent with Martin's clear-headed commitments, as to material simplicity and a footloose life. But Hammond also remembered Martin saying that the hallucinations were not always easily accommodated or understood. "She had to do what her voices told her to do, even if it seemed wrong. And sometimes they were wrong."[33]

Donald Fineberg is a psychiatrist who treated Martin from 1985 to 2000 with talk therapy that for many years involved weekly sessions. By the time he met her, she had entered into a long period of relative stability, and she did not require hospitalization while under his care. He says that she came to him on a variety of medications—perhaps too much medication, in his view—and yet was remarkably productive. "What makes her unusual,"

Fineberg says, "is the depth and sensitivity with which she was able to make art in the face of a disorder that for many people would be devastating."[34] While her symptoms diminished in these years (and her medication was reduced), they did not entirely disappear. "She has a relationship, in her medicated state, to the voices, where she has what you might say is an observing ego—a capacity to look at them so as not to be overwhelmed by them. So they're voices, but they're not typical schizophrenic hallucinations. They're more like internal thoughts and meanderings. She never had, in my presence, or reported to me, a command hallucination which was idiosyncratic and bizarre—those are the signals of an acute, schizophrenic-like psychotic hallucination. But rather they would be more like, you would say, inner thoughts."[35]

But Martin's experience of the voices seems to have varied enormously[36]—likewise her feelings about psychiatric treatment. "My voices never allow me to take medication and I have no use for doctors—I've taken it sometimes but I've had to repent," she told Arne Glimcher;[37] clearly, that wasn't the whole story. And despite the stress placed by Martin and by her friends on the unbridgeable divide between the visions that nourished her art and the voices that impeded it, sometimes she said things that made that distinction seem hazy and even untenable. For a 1982 Whitney Museum of American Art acquisition form, she responded to a standard question about "the subject of this work, the ideas expressed in it"—it is a 1960 grid drawing, one of her earliest uses of the form—by writing:

All art work is made in obedience to the conscious mind. It is something like conscience it says do this or that and it also says when it has been done and when it has not been done. That is inspiration. Real art work is made by inspiration. . . . A real artist is lisening [sic], like Adam & Eve while they were in the garden, for his commands, and struggling to obey them accurately. He follows a path. This drawing was made on the path to more simplified grids. It is a wonderful expierience [sic] for me. Much moreso [sic] now than when I drew it.

In these few short sentences, she thoroughly blurs boundaries between inspiration and voice, voice and command, while suggesting that there is a personified Judeo-Christian God to whom the artist (at first like the innocent Adam and Eve, then simply "he") is listening, in considerable trepidation, and awaiting orders. She concludes by implying that the whole process of creation was more than a little harrowing; better for her to contemplate the finished image than put herself back in the process of creating it.

One of the subjects to which Martin returned most frequently in lectures, writing and interviews is the value of solitude. Just as often, she talked about its cost.

> Solitude and freedom are the same
> under every fallen leaf
> Others do not really exist in solitude, I do not exist
> no thinking of others even when they are there, no interruption
> a mystic and a solitary person are the same[38]

Thus she wrote in "The Untroubled Mind," lending support to those inclined to see her as a kind of Buddhist monk. Over and over she stressed the importance of working alone, without distraction—no partners or friends; not even dogs. "To discover the conscious mind in a world where intellect is held to be valuable requires solitude—quite a lot of solitude. We have been very strenuously conditioned against solitude," she wrote. "I suggest to artists that you take every opportunity of being alone, that you give up having pets and unnecessary companions."[39] The tone is of a calm, wise parent; it was directed at students and young artists and meant to convince them that only from the quiet that accompanies isolation can inspiration arise. And yet, and far more vividly, she spoke just as often of the devastation wrought by solitude. Sometimes these descriptions take on an allegorical quality, though the epic tone doesn't conceal the depth of feeling involved: "The solitary life is full of terrors.... Worse than the terror

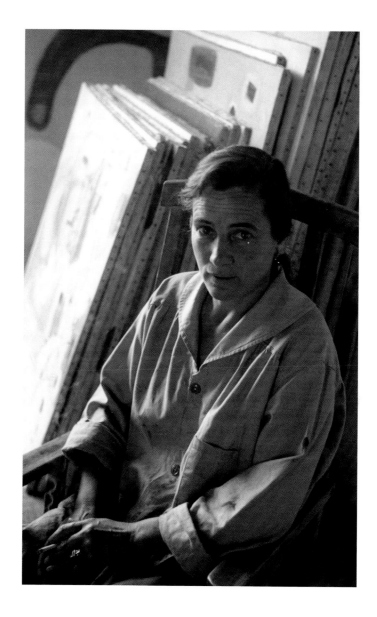

13
Mildred Tolbert. Agnes Martin in Taos, ca. 1953.
Courtesy Mildred Tolbert Archives, The Harwood Museum
of Art of the University of New Mexico, Taos

14

Untitled, 1959.

Oil on canvas, 24½ × 48 in.

Dia Art Foundation, New York

15 (ABOVE)
Harbor I, ca. 1959.
Oil on canvas, 49¾ × 40 in.
The Museum of Modern Art, New York.
Gift of Agnes Gund and Committee on
Painting and Sculpture Funds

———

16 (LEFT)
The Laws, 1958.
Boat spikes and oil paint on wood,
93½ × 18 × 2 in.
Private collection, London

17 (ABOVE)

The Spring, 1957.

Oil on canvas, 70 × 70 in.

Collection Fayez Sarofim

18 (BELOW)

Cow, 1960.

Oil on canvas, 69 × 69 in.

Private collection

19 (ABOVE)

Little Sister, 1962.

Oil, ink, and brass nails on canvas and wood; sheet: 9⅞ × 9¹¹/₁₆ in.

Solomon R. Guggenheim Museum, New York.

Gift, Andrew Powie Fuller and Geraldine Spreckels Fuller Collection

20 (OPPOSITE, TOP)

Untitled, 1960.

Black ink on paper; sheet: 11⅞ × 9⅜ in.

Solomon R. Guggenheim Museum, New York.

Gift, Andrew Powie Fuller and

Geraldine Spreckels Fuller Collection

21 (OPPOSITE, BOTTOM)

Mountain, 1960.

Ink and pencil on paper, 9⅜ × 11⅞ in.

The Museum of Modern Art, New York.

Ruth Vollmer Bequest

22–23

White Flower, 1960–62, and detail (opposite).

Oil on canvas, 71⅞ × 72 in.

Solomon R. Guggenheim Museum,

New York

24

Friendship, 1963.

Incised gold leaf and gesso on canvas, 75 × 75 in.

The Museum of Modern Art, New York.

Gift, Celeste and Armand P. Bartos

25

The Tree, 1964.

Oil and pencil on canvas, 72 × 72 in.

The Museum of Modern Art, New York.

Larry Aldrich Foundation Fund

26

Milk River, 1963.

Oil and colored pencil on canvas, 72 × 72 in.

Whitney Museum of American Art, New York.

Purchase with funds from

the Larry Aldrich Foundation Fund

27

Red Bird, 1964.

Colored ink and pencil on paper, 12¼ × 11⅞ in.

The Museum of Modern Art, New York.

Gift of Mrs. Bliss Parkinson

28 A-C
Gabriel, 1976.
16mm film;
total running time:
78 minutes.
Stills by Bill Jacobson,
Courtesy Pace Gallery

29 (ABOVE)
Untitled #17, 1974.
Gesso, acrylic, and pencil on canvas,
72 × 72 in.
Des Moines Art Center

––––––––––

30 (RIGHT)
Untitled, 1977.
Watercolor and graphite on paper,
image: 9 × 9 in.; sheet: 12 × 12 in.
Solomon R. Guggenheim
Museum, New York.
Gift, American Art Foundation

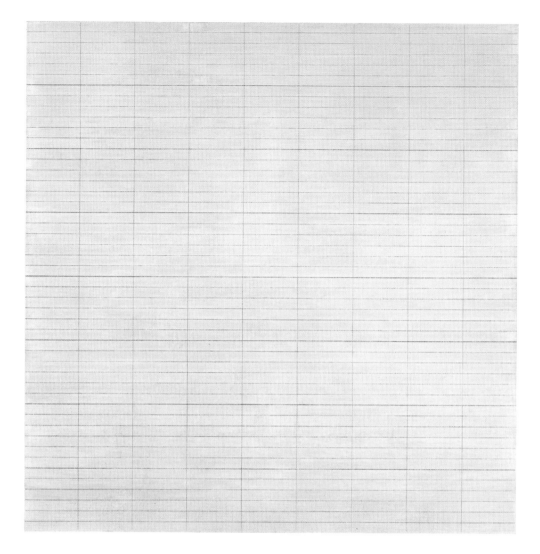

31

Untitled #11, 1977.

Graphite and gesso on canvas, 72 × 72 in.

Whitney Museum of American Art, New York.

Gift of The American Art Foundation

of fear is the Dragon. The Dragon really pounds through the inner streets shaking everything and breathing fire. The fire of his breath destroys and disintegrates everything.... The solitary person is in great danger from the Dragon because without an outside enemy the Dragon turns on the self. In fact, self-destructiveness is the first of human weaknesses.... I hope that it is quite plain that I am not moralizing, but simply describing some of the states of mind that are a hazard in solitude," she wrote in "On the Perfection Underlying Life."[40]

Indeed, panic, arising with or without cause, is another leitmotif. "Suddenly your heart beats and you're in a panic and you just feel afraid," she told Kate Horsfield in 1974.[41] The essay "On the Perfection Underlying Life" amplifies this:

Helplessness, even a mild state of helplessness, is extremely hard to bear. Moments of helplessness are moments of blindness. One feels as though something terrible has happened without knowing what it is. One feels as though one is in the outer darkness or as though one has made some terrible error—a fatal error. Our great help that we leaned on in the dark has deserted us and we are in a complete panic and we feel that we have got to have help. The panic of complete helplessness drives us to fantastic extremes, and feelings of mild helplessness drive us to a ridiculousness, We go from reading religious doctrine to changing our diet.

Thus, she told Arne Glimcher, she sometimes resorted to extreme food restrictions: only cheese, tomatoes, and walnuts one winter, just bananas and gelatin three years later.[42] Or, Martin continued in the essay, one goes "from absolute self-abasement or abandonment to every known and unknown fetish." At times like these, "The feeling of calamity and loss covers everything. We imagine that we are completely cut off and tremble with fear and dread." This description of utterly prostrating anxiety, and of lesser states of unhappiness, is remarkably clear and deeply affecting,

and it has been quoted to substantiate her "depressions"—a more familiar kind of psychological condition, and a less frightening diagnosis, than the schizophrenia from which she also suffered. But that is not where Martin ends this thought. She concludes, "But helplessness when fear and dread have run their course, as all passions do, is the most rewarding state of all."[43] She is consistent only in being contradictory—perhaps a symptom, but also an invaluable gift.

The potency of the fear Martin described is illuminated by evidence of her paranoia and her belief that success itself—its achievement and even its pursuit—could be mortally hazardous. Mark Rothko wasn't the only artist whose death she found suspicious, in her darker moments, and she did not think that one's enemies engaged only in incidents of vandalism or wallet-snatching. In the 1974 interview with Horsfield, which went rather far afield, Martin said:

Success is so little understood that we don't want it.... What we want is peace and quiet and uninterrupted time to do work. That's all we want. God knows, they killed Judy Garland, they killed Monroe. You see. Public demand made their lives so unlivable that they died of it. And so did Pollack [sic]. My God, the first American Expressionist. If they had just included Newman and Still and everything and not put it all on Pollack, he wouldn't have died. He was a strong guy, from the West out here, you know. But they killed him. I don't care if he did drive off the road. That's when I went to New York; the first thing that I asked Betty Parsons—she used to have all those artists—I said, "Why did they all die? Why?" When the European artists lived to a grand old age.... I'm only 62. Except for Albers and Still—and de Kooning, who doesn't count because he's drunk.... You see? We don't want it.[44]

This particular trait—profound suspicion, impervious to logical or emotional dissuasion—is perhaps the biggest challenge to sustained contact with other people. "Agnes has problems with paranoia," said Richard

Tuttle, one of her most enduring friends. "Through the paranoia, she will hurt people, cut them off, not see them for years.... 'I have no friends and you're one of them'" is a favorite statement.[45] Similarly, Bob Ellis, a faithful friend in her later years, recalled, "Occasionally she'd turn on people, if she didn't take her medications. She talked openly about it. One time she voluntarily put herself in a mental institution. She was aware of [her illness]. There was a line she didn't want to stray far from. She had her depressions, and she would have periods when she didn't paint.... She'd sit in her studio or at home in her rocking chair and wait."[46] Kristina Wilson remembers, "There was a niece she liked for a long time, then abruptly ended it. She'd get paranoid." And again, "She was close to my son, and when he had a daughter and named her Jade, she got furious, wouldn't talk to him or his wife or the daughter, because she thought that was a terrible name and the child would suffer by it. We didn't talk for a long time. That was very hurtful."[47]

Donald Woodman was another close friend for several years with whom she abruptly and categorically ceased contact. Martin's psychiatrist Donald Fineberg says that she referred to "Arnold [Glimcher] as her trusted friend and confidant and someone who couldn't be trusted, sometimes in the same consultations." As Fineberg explains, such discontinuous social reality is characteristic of Martin's illness. "Putting things in separate boxes is the ambivalence characteristic of psychotic ambivalence. A neurotic ambivalence is like uncertainty, I want this, but I want that... But psychotic ambivalence is things are in separate boxes. Agnes had that."[48] This kind of erratic behavior, so hard on friendships, is no better for professional associations. The fact that she maintained both is a triumph that pales only beside her ability to produce artwork in a remarkably sustained way.

It seems that the compartmentalization to which Martin was subject—and which, perhaps, helped her manage her world—was reflected in her relationships: friends and associates similarly often put the various disjunctive elements of her character in separate, non-communicating boxes. Not surprisingly, friends with emotional difficulties of their own

seem to have understood her trials best. One of her bonds with Chryssa may well have been that both suffered from mental illness. Reported Jill Johnston:

> another fairly safe thing to talk about is insanity since i suppose we would both agree that nobody knows anything about it except the insane. i think it was at the very end of the summer that i did go out again and agnes and thalia [Poons] were the ones who rescued me up in brewster where I abandoned my car and called them ... and didn't take the whole bottle of thorazine that agnes suggested I should but rather about 400 mcs or mgs or whatever they are. possibly agnes asked me what was wrong with me and I said I was afraid to die.[49]

But for most of her friends and associates, tact–and perhaps willed blindness–prevailed over active intervention. At Coenties Slip, Benita Eisler writes, "The conventions that governed their tight little community–respect for privacy, solitude, distance–served also to isolate and imprison [Martin] ... Moreover, the distance that she required–a larger 'envelope of private space' than was the norm on the Slip–allowed her rigid defense system to be taken as an objective state. Agnes was fine–until she wasn't. Then friends would be summoned. When it was over, nothing had happened."[50]

This snapshot of genteel reserve might be profitably contextualized by considering the crosswinds actively reshaping approaches to mental illness at the time. Just as attitudes about homosexuality were beginning to undergo radical change–and meeting ferocious resistance–so were cultural beliefs about psychological disturbance being upended. To summarize, as is necessary: psychiatric treatment from the end of the nineteenth century to the middle of the twentieth was bifurcated, with those most ill–and least wealthy–warehoused in increasingly large and ineffectual institutions.[51] Conditions were generally execrable: filthy, dehumanizing, and often dangerous. A notorious 1947 report noted patients tied to beds

with leather straps or even handcuffs tied to chains. Some were confined to bed because there wasn't enough clothing to go around. The many popular representations of mental institutions at mid-century ranged from a long, illustrated article in *Life* magazine called "Bedlam 1946" to the successful 1948 movie *Snake Pit*, for which Olivia de Haviland in the leading role was an Oscar nominee. As Edward Shorter writes, "In the first half of the twentieth century, psychiatry was caught in a dilemma. On the one hand, psychiatrists could warehouse their patients in vast bins in the hopes that they might recover spontaneously. On the other, they had psychoanalysis, a therapy suitable for the needs of wealthy people desiring self-insight, but not for real psychiatric illness."[52]

Inadequate although it was for treating the most seriously ill, Freudian psychoanalysis had, by the 1960s, reached the height of its influence.[53] But in the postwar period, biological research gained support as well. For schizophrenia, insulin shock therapy was developed in the middle 1930s, and it was in widespread use by the 1950s; so was electroconvulsive therapy, which was used for the first time in 1938.[54] By the 1950s, psychotropic drugs, beginning with Thorazine (chlorpromazine) in 1954, had been introduced, which dramatically alleviated psychotic symptoms. These drugs allowed public health services to relinquish their longstanding reliance on extended hospitalization, and as a result community alternatives appeared. In the 1980s a new class of drugs for depression, the SSRIs, of which Prozac was the first and best known, again revolutionized psychiatric practice.

It is hard to reconstruct Martin's early psychotic episodes; the first incidents of psychosis are often the most frightening. The options for treatment that would have been available in the early 1930s—if her illness, as is typical, first became apparent in early adulthood—would have been hospitalization hardly different from incarceration, including physical restraint and perhaps insulin shock therapy, a brutal remedy involving induced coma, along with, perhaps, some talk therapy. She was living at that time in Bellingham.

The symptoms that afflicted her had first been described by clinicians in 1809, and their reported incidence increased substantially during the course of the nineteenth century. The term "schizophrenia" wasn't introduced until 1908, when Zurich psychology professor Eugen Bleuler proposed it (to replace the earlier "dementia praecox," or premature dementia) and shifted the discussion from physical symptoms, such as catatonia, to psychological processes, such as the "splitting" of consciousness. Shorter writes, "The term schizophrenia was probably an unfortunate choice, for subsequent generations of physicians and nonphysicians alike would associate it with some kind of splitting or divided consciousness. In schizophrenia, nothing is split."[55] In the decades before effective medications were developed, psychological affliction was seen to be a question of degree rather than kind; the analysts whose thinking then predominated believed that dividing psychoses (characterized by a loss of contact with reality) categorically from neuroses (less acute disorders) was misguided. At the time that the National Institute of Mental Health was established, at mid-century, diagnostic criteria were still vague; "The category of schizophrenia, for example, was generally defined in terms of an inability to relate to the external world or to other human beings. The symptoms—depending on the form—were equally broad."[56]

Establishing parameters for schizophrenia remains a work in progress. On the NIMH website in 2013, it is defined as "a chronic, severe and disabling brain disorder that has affected people throughout history. People with the disorder may hear voices other people don't hear. They may believe other people are reading their minds, controlling their thoughts, or plotting to harm them. This can terrify people with the illness and make them withdrawn or extremely agitated. People with schizophrenia may not make sense when they talk. They may sit for hours without moving or talking. Sometimes people with schizophrenia seem perfectly fine until they talk about what they are really thinking." A few things are striking about this definition: one is that schizophrenia is defined as a brain disorder; indeed, that simple fact is accepted throughout the psychiatric community.

The NIMH goes on to explain that both genes and environment play a part in the illness's development; experience reshapes the brain, so an organic mental illness can be attributed in part to life events as well as to heritable traits. But it is now generally agreed that schizophrenia does not arise solely from patients' early childhood experiences or the short-comings of their first caregivers. Just as noteworthy in the NIMH's first, categorical statement is that everything after it is provisional: a person with schizophrenia *may* experience this or that symptom; delusional thoughts *can* be terrifying, and so on. Based in brain chemistry though it may be, schizophrenia remains hard to pin down.

In a somewhat more nuanced definition, psychiatrist Donald Goff explains, "Schizophrenia has traditionally been classified as a major psychotic disorder. The term *psychotic* denotes a loss of reality testing, which can occur as a result of delusional beliefs or hallucinatory perceptions, usually auditory or visual. The psychotic symptoms are the most dramatic and potentially dangerous features of this illness, but other symptoms may be even more disabling." Among them are disorganized thinking and behavior, and "inappropriate" affect. "A third symptom cluster includes the negative symptoms of apathy, social withdrawal, loss of emotional expressiveness, and poverty of thought and speech."[57] Patients with the third syndrome "are often particularly unresponsive to treatment." Fineberg says that Martin did not exhibit this "third symptom cluster," and stresses that her illness was atypical in many ways. It is also possible, however, to see her episodes (prior to his treatment) of social withdrawal, her voluntary restrictions of sensory pleasures, and the formalized nature of her conversation and her friendships, as just such negative symptoms; in fact psychiatrist Mark Epstein has suggested this possibility.[58] What seems beyond doubt is that Martin's case was atypical: she was an extraordinary artist with exceptional courage, intelligence, and determination; the magnitude of her success is only one proof of that. But it is easy to forget, in an age when emotional ailments are so widely acknowledged and diagnosed, that only approximately one percent of the American population has schizophrenia

(by contrast, more than a quarter of American adults are diagnosed with a mental disorder in any given year; depression and anxiety are the leading complaints). It is a serious and fairly uncommon problem.

For that reason, schizophrenia remains poorly understood by the general public; it was still more challenging to scientists, clinicians, and patients (and their friends) half a century ago. In a respected textbook published in 1966, the year before Martin's hospitalization in Bellevue, it was conceded, "the important questions of diagnosis, prognosis, etiology, and therapy are still unanswered.... is schizophrenia a group of ill-defined syndromes, or is it a true nosological entity? Is it a disease? A maladjustment? A way of life? Is the irrationality of schizophrenia transmitted by genes or by interpersonal relations? What are the best methods of treatment?"[59] Writing in 1997, Shorter admitted, "Why shocking the brain to the point of eliciting convulsions makes psychotic patients better is unclear. But it does. So does the dangerous procedure of putting them into prolonged comas."[60] Mark Epstein wonders if, in today's climate, Martin might have been considered to have bipolar or schizoaffective disorder because of how well she functioned between episodes, but he believes on balance her history is strongly suggestive of schizophrenia.[61] Goff raises the same issue of shifting diagnostic standards. The positive symptoms (hallucinations, catatonia) can appear in people with both conditions. But if these questions remain unanswered, the issues they raise are not as contentious as they were in the late 1960s, when psychoanalysis and neurobiology collided head on, and when Martin's illness reached the status of an emergency.

In keeping with a redirection of medical attention in the 1960s, there was a turn toward community-based psychiatric treatment centers that addressed social as well as psychological problems, often at the expense of the seriously ill.[62] But the most provocative attack against the conventional treatments of the time came from a vigorous if controversial and short-lived anti-psychiatry movement, arising both from within psychiatry and without, which challenged the very notion of mental illness as such. The position advanced by Thomas Szasz, an American psychiatrist, was the

most radical. Bitter and caustic, his epigrammatic diatribes, first launched in a book challengingly titled *The Myth of Mental Illness* (1960), were aimed at not only at the therapeutic system but also at those who sought (or were committed to) treatment. The book concludes with the resounding declaration, "There is no medical, moral, or legal justification for involuntary psychiatric interventions. They are crimes against humanity."[63] Denouncing psychiatric patients as self-involved, over-indulged malingerers, he claimed that people with psychosis suffer only from "righteous indignation and seeing oneself as a victim," and that (most) schizophrenia is a simply a "type of arrogance and immodesty."[64] These judgments, however vicious, struck a chord that resonated widely in the cultural community, if not among practicing psychotherapists. Szasz's pronouncement that "Today, particularly in the United States... nearly everyone is considered to some extent mentally ill,"[65] and his identification of a "Therapeutic State," in which there is the socially sanctioned establishment of faith in therapy, rather than in religion, anticipated, for instance, Christopher Lasch's *Culture of Narcissism*, Robert Hughes's *The Culture of Complaint*, and their many descendants.

Szasz's argument rested on the belief that mind and body were distinct, which ignored growing evidence—reflected in clinical practice—that psychiatric symptoms could be alleviated with medication. The same assumption underlay the writing of R. D. Laing, a British psychiatrist identified with the New Left and with a movement encouraging more equitable relations between psychiatrists and patients. Laing's *The Divided Self*, which also appeared in 1960, was a more traditional—and more sympathetic—combination of case histories and interpretive conclusions, but he too challenged the psychiatric establishment, writing that by its nature, "psychopathology perpetuates the very dualism that most psychopathologists wish to avoid and that is clearly false."[66] In Laing's view, maintaining fixed divisions between mental health and illness in general, and assuming in particular that schizophrenic behaviors are irredeemably meaningless, exacerbated the problems psychiatry was meant to relieve; moreover, it

was not innocent in this process, but culpable of abuse of power. Laing
has been criticized for romanticizing schizophrenia; while he recog-
nized the need for hospitalization in urgent cases, he believed that "the
cracked mind of the schizophrenic may let in light which does not enter
the intact minds of many sane people," and claimed, more provocatively,
"The schizophrenic is often making a fool of himself and the doctor. He
is playing at being mad."[67]

Laing's contention that psychosis was a sane response to an ailing
society had wide appeal, although most mental healthcare providers dis-
missed renegades like him and Szasz, who ultimately did little to change
to the course of therapeutic practice. Among other cultural figures whose
writing contributed to the anti-psychiatry movement in the 1960s was
Michel Foucault, whose influential *Madness and Civilization* (1961; 1965
in English) looked to the Enlightenment for the origin of cultural patterns
cleaving sanity from madness.[68] Just as mental illness was being termed a
cultural construct by Foucault, Laing, and Szasz, it was also being revealed
to reflect a range of biases. Yet sexism, however prevalent, was not at first
prominent among them. Although psychiatry might have been accused of
gross injustice for holding women solely accountable, as bad mothers, for
all manner of emotional distress, that charge was not a primary thrust of
the anti-psychiatry argument. Instead there was implicit, in much of the
attack on psychiatry, a belief that women patients were as much to blame
as their doctors, for being disposed to complaint and helplessness and
talking too much, particularly about themselves. There were exceptions;
perhaps surprisingly, Szasz recognized the plight of the "modern woman"
who feels herself "a domestic slave."[69] But the indictment of psychiatry for
sexism was taken further by a few rising feminists such as Phyllis Chesler,
whose sometimes imprecise but nonetheless forceful *Women and Madness*
(1972) charged a largely male psychiatric establishment with perpetuat-
ing prejudices that contributed to women's emotional crises. From the
nineteenth century forward, Chesler claimed, "most women in asylums
were not insane,"[70] but instead had simply flouted conventions. Law and

medicine were interchangeable resources, Chesler argued, for fathers and husbands looking to dispose of unruly women. Seeking artistic prerogative was, she wrote, seen as lunacy, as witness the treatment—and outcome—of creative but troubled women from Virginia Woolf to Sylvia Plath.[71]

Chesler, putting schizophrenia in quotation marks,[72] said that the label was often applied to women who simply didn't act feminine; she also suggested that hospitalization itself caused a gender role-shift. On the one hand, "Madness and asylums generally function as ... penalties for *being* 'female,' as well as for desiring or daring *not* to be"; on the other, "If asylums are where you go for being alienated from your sex role, then you might as well act out that alienation as much as possible."[73] While Chesler suggested that Laing went too far in equating madness with political or creative expression,[74] her focus on women as victims of a male psychiatric establishment comported with tenets of the anti-psychiatry movement. It also had parallels with the impulse toward alternative healing practices, including those that looked away from sexuality—from the body—altogether, with Zen meditation a popular example at the time.

Prominent among cultural figures who were sympathetic to the anti-psychiatry movement was Susan Sontag; her essay celebrating Antonin Artaud—whose mental illness resulted in long periods of hospitalization and was progressively debilitating—appeared in 1973. Sontag wrote approvingly of insanity as a route to expressive freedom: "Only a few situations in modern secular society seem sufficiently extreme and uncommunicative to have a chance of evading cooptation. Madness is one."[75] Conceding that "Artaud at no time in his life wholly got out from under the lash of madness," she argued nonetheless, "Psychiatry draws a clear line between art ... and symptomatology: the very boundary that Artaud contests." In Sontag's view, "Madness is the logical conclusion of the commitment to individuality when that commitment is pushed far enough."[76]

In popular culture, there is perhaps is no clearer expression of the belief that the inmates are saner than those running the asylums than Ken Kesey's 1962 novel *One Flew Over the Cuckoo's Nest*, and the 1975 movie Milos

Forman made from it. But there is reason to believe that people with serious disorders of thought and mood found such representations—and the anti-psychiatry movement that was their underpinning—both inaccurate and insulting. It has been reported, for instance, that Joanne Greenberg, author (as Hannah Green) of a fictionalized account of her struggle with schizophrenia called *I Never Promised You a Rose Garden* (1964; it, too, was made into a movie, in 1977), "hated the Kesey book. She later said, 'Creativity and mental illness are *opposites*, not complements. . . . I want to choose my perceptions. I don't want them to come out of some kind of unconscious soup. I want it to be something I choose to say, not something that says me.'"77

Without question, this was Martin's feeling as well. She never talked about madness as a creative resource; she seldom talked about it at all. And while it would be wrong to categorically deny any connection between her illness and her work, there is absolutely no reason to consider her work spontaneously cathartic or in any other way therapeutic. It was, instead, manifestly deliberate and meant to express universal rather than personal experience. Nonetheless, she was surely affected not only by the enormous burden of living with mental illness, but also by the badly fractured system of care available when she most needed it. Nor could she have been helped by the wildly conflicting ideas promoted in the culture at large—and the art community nearer at hand—about just what such illness was.

·

The conviction that a link exists between madness and creativity runs throughout the history of art. While making the connection generally involves celebrating access to ostensible reserves of imaginative freedom and emotional breadth, as with Byron, perhaps, or van Gogh, some arguments run in very different directions. One is presented in *Madness and Modernism* by psychiatrist and cultural historian Louis Sass. In his contention that schizophrenia inclines people toward the cerebral and the abstract rather than the "free play of desire,"78 Sass outlines a disposition in

which Martin's character as an artist is recognizable (although it should be noted that his views on "madness" are not widely shared; as Mark Epstein writes, "most schizophrenics can't think coherently"; they are concrete in their thinking but hardly cerebral or abstract[79]). It would in any event be grossly irresponsible to approach Martin's paintings as "schizophrenic." But suggestive comparisons can be made with other artists whose minds apparently moved along similar pathways. Among well-known artists whose schizophrenia is confirmed is a handful who made work that has interesting points of contact with Martin's. The highly structured and patterned paintings and drawings by Adolf Wölfli, for instance, are organized by rigid geometry and parallel lines that frame emblematic figures. Similarly, the figurative contents of Martín Ramírez's work—men on horseback, trains—are set into systems of parallel lines that impose a hypnotic rhythmic order. Martin's paintings, thoroughly sophisticated and historically conscious, and adamantly abstract, have in common with the work of Wölfli and Ramírez only a more subtle version of such order's ineffably engrossing appeal. The measured increments of Martin's grids (and, later, stripes) establish a rhythm that insinuates itself into one's perceptual field with a force that, while much quieter, is no less insistent than the untrained artists' imagery. A 2005 exhibition linking Martin with faith healers Emma Kunz and Hilma af Klint (of which more later) makes a similar comparison.

But perhaps a more productive comparison is with Yayoi Kusama, whose work and life have several striking parallels with Martin's. Born in 1929 in a provincial town west of Tokyo, Kusama came to the United States in 1957 (the year Martin settled at the seaport), having burned most of her Surrealist-influenced early works. She landed in Seattle, with an encouraging letter from Georgia O'Keeffe in her pocket, and, like Martin before her, was exposed to the city's Zen-influenced art community, still dominated by Morris Graves and Mark Tobey. Kusama soon headed to the East Coast and first exhibited her "Infinity Net" paintings in Boston in 1959; later that year, they were shown in her first solo New York exhibition, at Brata Gallery. These paintings, widely exhibited in the 1960s in New York, are

composed of short curved strokes of paint, most often white against a dark ground. Evoking loose crocheting when observed closely, they coalesce at a distance into shimmering expanses, oceanic in their largest iterations. Kusama has worked in a very wide range of mediums, including sculpture, installations, performance, film, fiction, and poetry as well as painting and works on paper, and in her sculptures particularly has employed repetitive gestures or forms related to those in the Infinity Net paintings. These canvases, which first gained wide attention for Kusama, remain among her best known, and they are closest in sensibility to Martin's work. Taking the form of what could be called cursive grids, Kusama's Infinity Nets form a link between conventional Surrealist "automatism" and Martin's paintings.

In 1961 Kusama moved to a studio one floor below Donald Judd's. Like Martin, Kusama received favorable critical attention from Judd, and from Dore Ashton, early on. And again like Martin, Kusama's residence in New York during the 1960s was marked by the challenges of being female and foreign, experiences that would figure explicitly in her work and that also contributed, as the spirit of the times grew more hectic, to "recurring bouts of depression and ill health."[80] Having briefly visited Japan in 1970, Kusama returned for good in 1973, and since 1977 has lived by choice in a psychiatric hospital close to her studio, even while achieving international renown and continuing to paint. By that time, she "had come to understand and explain her own work and obsessions as intrinsically linked to hallucinatory episodes during her childhood that resurfaced in later recurrent mental breakdowns," Frances Morris writes in a survey exhibition catalogue.[81]

Thus, in a 2002 autobiography she titled *Infinity Net*, Kusama wrote, "I often suffered episodes of severe neurosis. I would cover a canvas with nets, then continue painting them on the table, on the floor, and finally on my own body. As I repeated this process over and over again, the nets began to expand to infinity. I forgot about myself as they enveloped me." Waking one morning to find, she said, the nets stuck to the window and crawling onto her hands, Kusama was thrown into "the throes of a full-blown panic attack" and called an ambulance, "which rushed me to Bellevue Hospital.

Unfortunately this sort of thing began to happen with some regularity."[82] (It is not inconceivable that she and Martin crossed paths there.) Panic and its outcomes notwithstanding, Kusama saw fit to celebrate this unchecked proliferation of nets: in 1959, she "issued a manifesto stating that every-thing—myself, others, the entire universe—would be obliterated by white nets of nothingness connecting astronomical accumulations of dots."[83] Unlike Martin, Kusama attributed her motifs to her native landscape: "The scenery of the river bed behind our house, where I spent much of my disconsolate childhood, became the miraculous source of a vision: the hundreds of millions of white pebbles, each individually verifiable, really 'existed' there, drenched in the midsummer sun."[84] But her hold on the verifiable was weak. "I fluctuate between feelings of reality and unreality,"[85] she wrote. In sharpest distinction to Martin is Kusama's declaration, "Artists do not usually express their own psychological complexes directly, but I do use my complexes and fears as subjects."[86]

As Frances Morris observes, "Much of the writing on Kusama's work has followed the artist's lead in linking her motivation, her manner of working, the style of the work itself and its subject matter … to a psychological disor-der dating from childhood and related to memorable traumatic incidents in her early years," including "her mother's alleged violence towards her daughter."[87] In consequence, "Consideration of her working process as an artist is frequently diagnostic in character, particularly in relation to notions of proliferation, accumulation, repetition, and obliteration within the work."[88] The childhood hallucinations Kusama reports were primar-ily visual, though they included, for instance, "an endless sea of violets that 'spoke' to her."[89] Despite the artist's own willingness to talk about it, the nature of Kusama's illness is given only indistinct definition in crit-ical writing. According to Mignon Nixon, a psychoanalytically inclined art historian, "The dynamic of desire" Kusama's work enacts "is at once manic and melancholic, hyperbolically indiscriminate and depressively indifferent."[90] Juliet Mitchell, a psychoanalyst who writes often about art, claims, "Kusama looks at the world from an hallucinatory perspective" and

believes that "Kusama's many 'Infinity Net' paintings suggest that nets can provide protection from black holes."[91] But Mitchell rejects the idea that hallucinatory experience is emancipatory, arguing that the compulsive repetition of the Infinity Nets "marks a traumatic experience: the trauma has permeated the psychological protective barrier and exploded inside with an 'unbound' energy; what fragment is left of the shattered ego repeatedly tries to get hold of this wild energy and bind it."[92]

An intermittent extrovert whose flamboyant personality has often fueled her work, Kusama is in some ways the polar opposite of Martin, and the kind of psychoanalytic readings that Kusama has solicited would surely strike Martin as profoundly misguided and personally abhorrent. But the parallels remain, each body of work helping to illuminate the other.[93] For Martin, art is not born on gusts of irrepressible feeling. On the contrary, it is an expression of control, which is a source of calm and happiness. One senses that, for her, mental clarity was a moral imperative, an ethical guidepost. Her paintings were aimed at this goal. To the extent that Kusama's art was an invitation to probe her psychological recesses, Martin's work can be seen as a screen, shielding her from such scrutiny—baffling the curious—while also protecting her, as she made them, from unwanted and excessive stimulation. If it is possible to see her work as an ambience one enters, as into the ocean, or the landscape, it also functions as a lens through which she saw the world; it may be said to have clarified that world for her and organized it, making it both orderly and luminous; it surely does that for viewers.

Chapter 7

DEPARTURES

Within half a dozen years of leaving New York, Martin was painting and exhibiting, as well as writing and lecturing to rapt audiences. In Jill Johnston's vivid description of a talk at the Pasadena Art Museum in 1973:

> An overflow audience was reverent and expectant. She appeared very alone sitting on a chair in the middle of a stage, her hair now short to the ears and still brown, wearing a tangerine velveteen skirt to the floor and a white starched blouse flared at the elbows, so solemn and formal looking for a woman who joked a lot and laughed at herself and knew how to build houses and shoot a .22 and maintain her own vehicles.... All the while she spoke she was twisting a white handkerchief like worry beads in her lap. Her speech was a memorized piece of writing 4,000 words long.[1]

But there had been an interregnum of some length and significance. In the white pickup truck she'd bought in Detroit in 1967, Martin "drove around" (the vague term is hers, insistently) in the Pacific Northwest, Canada, and the American Southwest for eighteen months, circling areas where she'd grown up and sleeping in the camper the truck hauled. While on the road, she wrote to Sam Wagstaff, "I have been enjoying myself. Have

a canoe that I put on the lakes and some rivers. Sometimes camping out and packing." She was heading, she said, for the desert and Lake Powell in Utah. "Being alone and not talking I recommend," she wrote.[2]

In 1976, she again spoke of the solitary pleasures of this long road trip: "I went on a camping trip. I stayed in forest camps up north which could camp three thousand people. But there was nobody there. I was there alone. I enjoyed it. I had this problem, you see, and I had to have my mind to myself. When you're with other people, your mind isn't your own."[3] Speaking like the homestead-born pragmatist she was, Martin advised treating inner trouble through active, independent response: "Say that you have become aware of a sudden fear or something like that. Suddenly your heart beats and you're in a panic and you just feel afraid. Well, if you can put your whole mind on that fear, you cannot only understand it,… you recognize it. And once recognized, it no longer has the strength to disturb you."[4]

But looking back at her period of driving around a dozen years later, she was far less resolute. "A lot of people withdraw from society, as an experiment. So I thought I would withdraw and see how enlightening it would be. But I found out that it's not enlightening. I think that what you're supposed to do is stay in the midst of life."[5] Shortly after her wandering had ended, she'd written the summary assessment, "Asceticism is a mistake / sought out suffering is a mistake."[6] Walking, Zen-like, in sandals in the snow was not advisable. Neither did she consider the wilderness interlude a resource for her painting. Recalling the occasional snowfall in places where she had camped and the cold, she said she didn't mind it, being from Canada, and then hastened to add, "I didn't go out to go into nature [for my work]; I don't want anybody to think that. My work is anti-nature."[7] Even the unbroken solitude often attributed to this period (with Martin's blessing) is overstated. Lenore Tawney spent nearly two weeks with her, traveling to Big Sur in California and then to Flagstaff, Arizona, by way of Death Valley, and, perhaps most surprisingly, Las Vegas—Sin City seldom figures in the portrait drawn of Martin. Tawney went back East from

Flagstaff, but Martin went on to the Grand Canyon before concluding her travels in New Mexico.[8]

In Martin's initial recollection, the journey eventually just wound down of its own accord, its mission fulfilled. "Well ... finally, you see, I remembered New Mexico. I was there before, but I traveled a long way, as far as I could go, and in every direction."[9] But in subsequent (and repeated) retellings, her extended ramble ended more momentously. As she recalled it in 1987, "I drove around and drove around, and then I had a vision of an adobe brick. So I thought that must be New Mexico so I went back"; the memory made her laugh heartily.[10] In any case, the period of nomadism led Martin, in a counter-biblical narrative, back to the desert, this time for good. By 1968 she had surfaced in Cuba, a small town northwest of Santa Fe, where she stopped at a gas station café and asked its manager if he knew of any available land with a spring. She was looking to rent, not buy; her voices had told her not to own property.[11] The manager directed Martin to his wife's property on the remote Portales mesa, approximately six miles wide, eight long and one thousand feet in elevation. She secured a "lifetime" lease, at ten dollars a month, for fifty acres.

Portales overlooks a valley that runs along the foothills of the Sangre de Cristo Mountains to the west. It is a twenty-mile drive, over dirt roads, from the nearest highway. Cuba, the nearest town, was (and remains) isolated, poor, and lacking in visible history or charm. On the mesa, Martin—who was 56 when she settled there—had no telephone and no electricity; rainwater was collected for drinking, and water for other household needs was pumped from a well.[12] Her closest neighbor was six miles away. In the early months, Martin's efforts were directed entirely toward building, which absorbed both her energy and her avid interest. The first dwelling, apart from the camper, was made with adobe, using skills she had developed in Albuquerque in the 1940s.[13] Adobe is a natural choice in a region where dirt is more readily available than lumber, and it is also favored because it is both a good insulator and an excellent sound absorber. Assembled

brick by handmade brick into rectangular units laid in even courses, it is
a kind of physical equivalent to Martin's hand-ruled painting scaffolds.

It has further been noted, by Karen Schiff, that the mud that covers
the adobe bricks, inside and out, softens the surfaces and obscures the
underlying grid in a way that is comparable to the atmospheric effects of
Martin's paintings, when seen at a distance.[14] Martin's interest in building
with native materials also led her to use "logs they call vigas"; she cut
down trees with a chain saw, she said, and built "a very big log studio . . .
by myself because I lived so far away that by the time anybody got there
they'd have to go home."[15] She ultimately constructed five buildings.[16] (In
fact, it seems she had help with the studio from the young architect Bill
Katz, a friend of Robert Indiana, through whom they met.[17])

Protected on her mesa-top fastness, Martin soon began to make regular
contacts with old acquaintances and new ones and resumed traveling. As
early as April 1968 she was at Bennington College in Vermont with Betty
Parsons, for a memorial exhibition of Paul Feeley's work.[18] In 1971 she
traveled to Germany, at the invitation of Luitpold Domberger, to create
a suite of thirty screenprints, titled *On a Clear Day*, published in 1973 by
Robert Feldman's Parasol Press in New York. Exceptionally simple and
subtly luminous, the square grids, of varying internal proportions, are
delineated in dark gray ink. In a draft for the statement accompanying
the portfolio, Martin wrote, "these prints express innosense [sic] of mind.
If you can go with them and hold your mind as emty [sic] and tranquil
as they are and recognize your feelings at the same time you will realize
your full response to this work."[19] Like the portfolio's title, the statement
was an announcement of a break in the clouds: work had resumed, though
for several years it would follow digressive paths. When the prints were
shown at the Museum of Modern Art in 1973, curator Riva Castleman
wrote for the exhibition's press release, "[Martin] has sought to replace, by
means of mechanical application, the illusionary and irregular drawing
that detracted from the perfection she sought in her compositions," asking
the silkscreen workshop to cut stencils "without attempting to duplicate

her autographic line." Although consonant with esthetic preferences of the early 1970s, eliminating the autographic line was starkly at odds with Martin's previous work, and she did not repeat the experiment.

By the early 1970s Martin was also welcoming visitors, albeit on a selective basis. In 1971 the writer and curator Douglas Crimp contacted her for help in locating paintings for an exhibition he was organizing at a small gallery run by the School of Visual Arts in New York—it was Crimp's first curatorial effort and a first noncommercial solo show for Martin. After some time, she telephoned him and asked him to come and see her, and when he accepted, Crimp recalled, "I learned how far she'd had to drive to make that phone call." In his telling:

> We had a map of the mesa where Martin lived that she'd drawn and sent to me, but it wasn't at all detailed, and Pat [Steir, the painter, who was his traveling companion] and I found it very difficult to determine, in the dry desert landscape, what was a road and what wasn't.... Eventually we realized we had no idea where we were in relation to Martin's map, or even the way to get back off the mesa, and the sun was beginning to set. Then, as if from out of nowhere, Agnes Martin drove up in her pickup. As I recall, she showed little sympathy for our plight.[20]

They followed her to the "beautiful one-room adobe she'd built"; that night, Martin slept in her camper, "which seemed to serve as her bedroom, even though she had the house. I remember sleeping in a kind of log shed ... there was no sign yet of the studio she would build three years later in which to resume painting." And although the trip was fruitful and memorable, it was no easier socially than logistically. "Apart from Martin's shyness and her being unused to being around people," Crimp says, "her conversation was odd, gnomic—assertive and tentative at once."[21] Steir's memory of this initial trip—she became a regular visitor—included the bountiful meal of chicken and white wine that Martin prepared, and in her recollection the two women shared the one-room adobe house.

Ann Wilson visited shortly thereafter, in 1972, and later wrote, "After taking a bus from the airport to Cuba, I asked in a coffee shop where Agnes Martin lived. Two men said she was the woman who cleaned their bear skins for them, and they drove me in a truck down the road to a fence by a dry river bed."[22] Wilson's rather reverent account of the simple furnishings of Martin's home make mention of an old wood-burning, cast-iron stove used for baking muffins (as at the seaport), a bright orange hydraulic water pump, a wooden board with tools, a sewing machine, and a sink chest. Among the details Wilson noted are a few clearly intended to suggest connections to Martin's artwork: "Looking out the window Agnes built over her table. Four-over-four-over-four rectangles of glass. Pure cerulean with white clouds." Wilson observed, "Pine trees and sage scent. The room has whitewashed and plain adobe walls. The rough wooden cupboards are also whitewashed. Tree beams, with bark still on them, measure across the ceiling spaces. Black-and-white wide squares of checkered linoleum tile measure out the floor. There is a rocking chair, and the simple wooden benches that Agnes made."[23] Wilson also provided testimony to the sixty-year-old Martin's prodigious physical strength. "Agnes Martin wanted to lay stones in front of her adobe door. 'Big enough for two chairs, so I can sit outside in the evening,' she said." So Wilson and a friend "worked in the hot New Mexico sun on the roof of the world all one morning digging the clay and moving stones in place. We were then too tired to continue as the stones were very heavy. Agnes came out of the door and laughed at our result. We had not been able to make the stones lie flat. In a half hour she moved all the stones and leveled the earth and placed them exactly right."[24]

Jill Johnston made the pilgrimage the following year and soon after published a decidedly more picaresque account: after leaving Cuba, she and her travel mates, utterly confounded by the unmarked terrain, bumped along rutted dirt roads past "lots of gates and dry river beds and little forests.... there was not only a third gate but a fork... we had passed the half eaten carcass of a cow right along the side of the road... some part of my

head said we were going to die in the desert…i was about to die laughing
…i said we should turn back…so we did it again."[25] Of their conversation
on finally reaching Martin's home, Johnston recalled:

> she talked about animals having thoughts[26] and how she doesn't keep
> domestic ones any more, she doesn't want them around any more than
> people. What she keeps exactly is five vehicles in perfect working order
> and a beebee gun and a regular .22. not counting the small adobe in
> which she cooks and eats and possibly reads and undoubtedly muses,
> an open tall shedlike garage where she was parking her new shiny blue
> vw sports model, an outhouse, a tiny cave log room guest dwelling and
> a compost affair and she still sleeps in the dodge pickup or the pickup
> detached from the truck in which she lived for a couple of years riding
> all round the u.s. and canada till she found the proper mesa.[27]

But few were welcome on the mesa; the material rigors of her life (the
shiny new VW notwithstanding) were sufficiently demanding to discour-
age socializing—and art-making as well. And her initial projects, in this
period, largely departed from paint on canvas.

One of the detours Martin followed before recommitting herself to
painting led to the conception of a kind of earthwork, a then new form of
generally large-scale sculpture created directly in the landscape—evidence
that despite her seclusion, she had been keeping up with developments in
the art world. "I had an inspiration about a land thing—like Smithson," she
said. (Robert Smithson's best-known work, *Spiral Jetty*, was constructed in
1970; Martin had met him when he curated the 1966 Dwan gallery exhi-
bition, *10*. She also later mentioned Michael Heizer's work in connection
with her garden plan.) She continued:

> I thought I was going to build a garden. I mean, I was going to build an
> eight-foot wall, 40 yards square. It was going to be a Zen garden, or at
> least something like it, but with absolutely nothing alive in it. We have

a lot of interesting materials where I live. The mountains are volcanic, and there are a lot of different kinds of lava, some of it very light and very white. I was only going to let people in this construction one at a time, and if their response to the silence would be good, then I would have considered the structure successful. . . . But I haven't built this garden. I don't know if I will, because I can almost *see* what I'm going to do.[28]

Even though she didn't construct it—later she said the fear that it would be vandalized "took the starch out of me"[29]—this project confirms the depth of Martin's involvement, in this period, with building in indigenous materials, whether adobe dwellings or garden walls made of volcanic rock. It was not the last time that she'd entertain the idea of departing from painting in order to celebrate—if that is the right term for a project so parsimonious—the natural world with a directness she renounced in her primary medium. The many striking elements of this unrealized "garden" include the absence of living flora, the unyielding control such a structure would have permitted her, the silence and isolation it would have enforced for viewers, and, not least, the judgment Martin would have passed on each visitor's response. Having talked of entering a painting as one parted a curtain, or entered the ocean,[30] she envisioned a decidedly more arid version of such an experience. Yet for all its commitment to profound solitude, the equilateral garden—so evocative, even in Martin's sketchy description, of a LeWitt sculpture—suggests she was still thinking of her place in the cosmopolitan art world.

By the time of Ann Wilson's visit of 1972, Martin had also returned to paper, pencils, and paint. "There is a wire strung across the long wall on which hang two small watercolors done on thin paper," Wilson reported. "The first is of sixteen squares indented all around about a quarter-inch with cross spaces between them. The lines are penciled in and painted with a gray-white. The lines give the effect of seeming to be part of the fiber of the paper, or of emblems growing out of the grain . . . The second

watercolor presents twelve rectangles in a cross division of the paper, three rectangles per division. The paint surface is very apparent."[31]

Having tentatively resumed painting, on paper, Martin soon reengaged with the system by which art is exhibited and sold, and although she would always be wary of art dealers, museum directors, critics, and publishers, her membership in the art tribe would remain firm. In fact, Wilson's trip had been prompted by a key event in Martin's reentry into the art world. In 1973 Suzanne Delehanty, who had become director of the Institute of Contemporary Art at the University of Pennsylvania in Philadelphia two years earlier, presented a survey there of the work Martin had made between 1957 and 1967. Having seen and admired Martin's paintings in a number of places, including *Documenta V*, in 1972, Delehanty (like Crimp) approached Martin directly, and the artist agreed to cooperate with her. The exhibition included more than three dozen paintings (some quite small), nearly as many works on paper, and three constructions from the late 1950s. It proved to be a turning point, crucial in reviving interest in Martin's work: an opportunity for her both to open herself to critical and public response and, as she saw it, to set some aspects of her record straight.

Perhaps inevitably, it was preceded by a number of struggles, beginning with one over the nature of the exhibition catalogue, that generally non-negotiable exhibition accessory about which Martin was so leery. An undated letter from Martin to Delehanty begins, "I simply cannot come through with a biography I do not present my life only the work and perhaps thoughts that that are completely unhelpful as I explain in my notes." Evidently responding to a term Delehanty had introduced, Martin continued, "It is very discomforting thinking about 'the demand of the people.' I do not pay any attention to 'the demand' ever. 'The demand' can never be met I assure you. We must act according to inspiration." Martin did concede her age and birthplace, wrote that she learned to paint at Columbia (stretching the truth just a bit) and that she was "was happy to become an American citizen." She added, "I would prefer it if you did not list exhibitions but the names of collectors of course should be listed

and all those who help in any way."[32] Obviously, her reluctance to publish personal information had nothing to do with naiveté.

In further correspondence with Delehanty, Martin contended with other aspects of the written record to that point. She distanced herself from her paintings' titles, in part by attributing them to friends. For instance, she insisted, "All Lenore's titles are romantic not classic and a contradiction of the work. If I wrote a romantic title I fell by the wayside probably started Lenore on the wrong foot. If I come out for any reason it seems to me it should be to correct those titles." In an attempt to explain the titles of which she approved, she wrote, "You will probably think I am mad when I say that what makes my titles unromantic is that they represent experiences of the mind." And in a letter to Frank Kolbert, an art dealer and critic who had written about her work, Martin said, "This is a very sensitive criticism and I am grateful to you for writing it.... But the titles are not ironical. I do not think I am capable of irony. 'The Desert' is of the mind."

The correspondence with Delehanty also reveals Martin's disappointment with previous critics and commentators. (Writing on a photocopy of an early Dore Ashton review, Martin fumed, "this is completely inaccurate in every detail and in point of view please don't quote anything from it Environment and biography have nothing to do with inspired work.") Nothing made her angrier than a statement that had appeared over her name in press material for an exhibition at the Betty Parsons Gallery. It begins, "I paint out of certain experiences not mystical. I paint without representational object. I paint beauty without idealism, the new real beauty that needs very much to be defined by modern philosophers. (I consider idealism, mysticism and conventions interferences in occasions of real beauty.)" On a photocopy of this statement, Martin wrote, "I did not write this statement and it is not true. I do not paint or not paint what it says." And in a separate letter, she added: "This statement is the most quoted of my 'statements' and I did not write it and I hate every word. It was written by a fellow called Ray Izzbiki who pretended to write what I said but wrote instead his own thoughts. Please File."[33]

Martin struggled as well with Ann Wilson, whom Delehanty had asked to furnish a catalogue essay—or to extract from Martin a body of writing that would serve the same purpose; hence Wilson's visit to Cuba. Martin's anxiety ahead of her arrival is evident in a postcard she sent to Delehanty in April: "Forgive me for taking your time," Martin begins, "but please send me Ann's Wilson's [sic] phone number I am afraid she will come to see me without giving me enough notice and I am my house is very hard to find. I would like to meet her in Albuquerque airport. Agnes Martin." Subsequently, in an undated letter, she wrote gratefully to Delehanty, "I feel very fortunate in having had the opportunity of talking with Anne. We had a number of good interviews and I think the general theme is set. Thank-you. She asked me to send the notes that I write to myself once in a while and perhaps drawings etc." But in a subsequent letter to Wilson, also undated, she pleaded, "Dear Annie, Please don't say anything about why I do this and that like that bit about the horizontal line. It is crazy to say I paint from an image and then pull it to pieces." And finally, in a letter about the catalogue to Delehanty, "Is Ann on the job? If she fails you, surely Alloway could do it and would since he is investigating. I would still prefer Ann but she is not very dependable. Agnes."[34]

In the event, it was Lawrence Alloway, already familiar with Martin's work, who wrote the catalogue's critical essay. Wilson's unpublished essay, titled "Agnes Martin: The Essential Form, The Committed Life," is exceptionally rich with metaphor and insight; she compares the compositions of the grids to Chinese painting and its multiple focal points, and she says Martin's "diagrams" are "very like the relationship of rain to the ocean." Perhaps less amenably to Martin, Wilson also wrote, "The reason some people are drawn to Agnes Martin is because she had the vision to try to make a map of the proportions of the undistracted mind." And she concludes with an American Indian Shaman Song ("With the Zig Zag lightning flung over your head, come to us soaring...").[35]

By contrast, Alloway begins with a straightforward account of Martin's development. While noting that her square canvases anticipate Reinhardt's

black squares and also LeWitt's pencil drawings on walls, which he suggests "may be an extrapolation of Martin's incorporation of the pencil into painting." Alloway claims that her "repetitive forms . . . resemble stitching" and recall the "motifs on Indian textiles"[36]—connections that Martin had vigorously disputed. Alloway's short text also includes the assertion, "Both by inference from her imagery and from judging her titles we recognize a form of nature imagery," along with the slightly grudging admission, "There is reason, however, not to make too much of the nature metaphors."[37]

Despite Alloway's violations of Martin's strictures, she was overjoyed with the publication. "Dear Suzanne," she wrote, "If this catalogue is an accurate indication of the composition of the show—it is hard for me to wait to see it I thought your introduction just right and the choices beyond my hopes just right. . . . Very happy Agnes." And the formality of her relationship with Delehanty had completely evaporated. The sixty-one-year-old artist told the ICA director, then in her late twenties, "I beg you not to work too hard. I really am a bit afraid for you. Exhibiting is the hardest work in the world. I will be glad to hear that you are taking a bit of holiday. Quite a long one would be best. . . . Please be guided by me."

Martin also specified, with great care, what she would and wouldn't do in connection with the exhibition's reception, in January 1973. "Since Richard Tuttle has volunteered to help I will suggest that he stand in for me at the opening and protect you." Further, "I cannot talk informally to the students or anyone—but I could talk to the students—a formal talk that would last one hour. The subject would be: 'The Underlying Perfection in Life.' No social reception. I would come to the Inst of C. Art. Someone would show me the room in which I would speak then I would go to my hotel return to speak and return to the hotel. No interviews. We are well enough acquainted now so that you will understand I am sure and explain for me. Just say that I am a hermit."

The progression of these letters is illuminating and touching. Martin's warmth, her long experience as a teacher and her irrepressible maternal



inclinations are all apparent in her correspondence with Delehanty. Her anxiety about the exhibition opening (hardly unusual, except perhaps in its extremity) is handled with a firmness that is both funny and revealing. She knew exactly what to expect, and also just how to handle it. She even had an idea of how to exploit the persona with which she knew people identified her: "Just say that I am a hermit." (On the occasion of a lecture three years later, at Yale, she similarly said to her new dealer, Arne Glimcher, "No questions afterward. When I come down, just take my arm and make a beeline for the door."[38])

As Delehanty describes the lecture, which took place in February, Martin prevailed in every way. Arriving at the ICA in a Burberry raincoat, plaid Pendleton skirt and white shirt, stout and crop-haired, she presented herself as a plainspoken, conservatively dressed outlier to the notoriously fashion-conscious cultural elite. The spirit of the sixties still lingered on the college campus, but Martin did not indulge it. And by contrast with other women artists she admired, including O'Keeffe, so effectively glamorized by her husband Alfred Stieglitz, and her soon-to-be gallery mate at Pace Louise Nevelson, with her famously luxuriant eyelashes and furs, Martin declined the demeanor of a star. She sat in a chair and she read her talk to a capacity crowd of over two hundred.[39] Published later, the lecture began, solemnly, "The process of life is hidden from us. The meaning of suffering is held from us. And we are blind to life." But she quickly turned toward uplift: if pride is what blinds us, work helps us defeat it. With the pronouncement, "I will now speak directly to the art students present," she shifted to exhortation: "There is no halfway with art. We wake up thinking about it and we go to sleep thinking about it." While inspiration leads us, failure can't be avoided; artwork is very hard. Moments of joy help, and they should be stockpiled. "The function of art work is the stimulation of sensibilities, the renewal of memories of moments of perfection."[40]

A substantial portion of the lecture concerned the feeling of defeat, when all hope is lost. It is in this talk that Martin described "the panic of complete helplessness" that "drives us to fantastic extremes," and admitted,

"the solitary life is full of terrors." And she spoke of the "Dragon," worse than the terror of fear. He cannot be slain—"that is a medieval idea, I guess"—so we must become familiar with him "and hope that he sleeps. The way things are most of the time, is that he is awake and we are asleep. What we hope is the opposite."

Although the Dragon introduced a theme that revealed a good deal about Martin's interior life, it also can be understood as an allegory with universal application—which is precisely how it was read. In any case, much of the lecture is firmly dedicated to guiding the young: "Say to yourselves: I am going to work in order to see myself and free myself. I will have to be by myself almost all the time and it will be a quiet life," she urged near its conclusion. Rising to a rhapsodic final statement, Martin crafted a nautical metaphor: "For those who are visual minded I will say: there seems to be a fine ship at anchor. Fear is the anchor, convention is the chain, ghosts stalk the decks, the sails are filled with Pride and the ship does not move. But there are moments for all of us in which the anchor is weighed."[41]

With the presentation of such public lectures (including one at Cornell University in January 1972, one at the Pasadena Art Museum in 1973 when the ICA show traveled there, and one at Maharishi University in June 1976; Johnston writes that she gave six lectures in 1973 alone,[42] and there were several in the 1980s), Martin introduced a speaking voice that was augmented by occasionally published texts, including those that appeared in the ICA catalogue. (A selection of texts and lecture notes were published by Hatje Cantz in 1992.[43]) Thereafter, this voice forcibly intervened in the critical reception to her work and constituted, in the near-total absence of exhibition catalogues she enforced, a substantial part of the textual framework for her work. Looking back, she gave conflicting reports about her writing. In 1974, she responded with some annoyance to a question about whether she wrote every day: "I don't write at all. There's a girl making a catalog for me, Ann Wilson and . . . she asked me to send sketches and notes. Well, I don't really write notes very much."[44] Fifteen years later, when asked again about her writing, she said, "Oh, I was just staying sane.

I wrote a journal. . . . I think anybody who goes to live a solitary and sim-
ple life would naturally write a journal."[45] But on the same occasion she
said, of the fables that were published in the catalogue, that though they
came to her "all at once," she'd never written them down.[46] In 2013 Wilson
recalled their writing process to me: "I'd handwrite what she said. Then I
restructured it."[47] Additionally, Martin "had a whole pile of notebooks,"
which Wilson similarly "edited and restructured." Obviously, Martin had
mixed feelings, at best, about this process. Both Martin and Wilson signed
the ICA catalogue texts. (In the Hatje Cantz volume they are attributed
only to Martin.) And while Martin fretted over details, she nonetheless
approved and even embraced the publication. If in some passages it is
hard to disentangle Martin's words from Wilson's intervention, the tone
is generally consistent with later writing published by Martin alone and
surely revealing of her preoccupations at the time.[48]

The ICA catalogue's first text, "The Untroubled Mind" is a hybrid of
sermon, poetry, fable, and diary; printed in verse form, it wanders further,
and is less carefully worded and constructed, than the lecture. It is rife with
references to the Christianity that significantly shaped Martin's childhood
and reappeared in her reading of Christian and Old Testament figures
in her seaport years, but there are also invocations of classical thought,
Plato in particular, along with Asian art and spiritual systems. It is in "The
Untroubled Mind" that certain much-quoted phrases appear. A number of
them are koan-like: "beauty is unattached," or "look between the rain / the
drops are insular / try to remember before you were born."[49] Some in this
category apply directly to art: "The observer makes the painting." And some
provide uncharacteristically direct accounts of her compositional choices:

I saw the plains driving out of New Mexico and I thought the
plain had it
just the plane
If you draw a diagonal, that's loose at both ends
I don't like circles—too expanding

Martin also reflects in this text on her development:

> Painting is not about ideas or personal emotion
> When I was painting in New York I was not so clear about that
> Now I'm very clear that the object is freedom[50]

Among Martin's references to classical writers is her variation on Plato's allegory of the cave:

> Just follow what Plato has to say
> Classicists are people that look out with their back to the world.
> It represents something that isn't possible in the world
> More perfection than is possible in the world
> it's as unsubjective as possible

In a related passage, she contends,

> Plato says that all that exists are shadows.
> To a detached person the complication of the involved life
> is like chaos
> If you don't like the chaos you're a classicist
> If you like it you're a romanticist

Deliberately or not, she has, it seems, upended Plato's allegory. In the dialogue in question, Plato has Socrates say that we unfortunate mortals are imprisoned in a dark cave, chained at neck and feet so we face its rear wall, where we see only the shadows of the true world's inhabitants and artifacts, projected by a fire burning behind us. The light of day alone can grant life its fullness, and "is the cause of all that is correct and beautiful in anything."[51] Converting Plato's lightless cave to a realm of clarity and freedom, Martin infuses it with perfection, an inversion that may have

resulted from compounding Plato with Buddhism, as suggested by another passage in "The Untroubled Mind" that also urges turning away from the world: "When you get off the wheel you're looking out / You stand with your back to the turmoil." In Buddhism, the Wheel of Life is a series of concentric realms through which all beings progress in cycles of rebirth into increasingly enlightened forms of existence; one can step off it only in a state of transcendence. In either case, the point toward which Martin strove is the same: quiet, clarity, simplicity, and above all freedom from worldly entanglements.

"The Untroubled Mind" ranges broadly, from passages in which Martin speaks from a distant height of moral precepts and advantageous practices to others where she writes more frankly about her emotional experience. There is quite a bit concerning solitude: "Others do not really exist in solitude. I do not exist / no thinking of others even when they are there," she writes, describing a feeling that might resonate for many readers. More elliptically, she says,

> I, like the deer, looked
> finding less and less
> living is grazing
> memory is chewing cud
> wandering away from everything
> giving up everything
> not me anymore, any of it
> retired ego, wandering

Martin expresses her belief in inspiration when she writes, "Muses come and help me now. It exists in the mind / Before it's presented on paper it exists in the mind." Her claim that "it is a consolation even to plants and animals" is perplexing. And there are places where the writing becomes frankly irrational, such as,

A boy whenever he had a problem
he called this rock up out of the mud
he turned into a rock
he summoned a vision of quiet

Such passages can be read as flights of lyric symbolism, but they are also, perhaps, indicative of darker impulses. At the end of "The Untroubled Mind" is a prose paragraph that concludes on a note as arresting for its matter-of-factness as its poignancy: "Small children are taken to the park for social play; sent to nursery school and headstart. But the little child sitting alone, perhaps even neglected and forgotten, is the one open to inspiration and the development of sensibility." As in her passage about an unhappy little boy, Martin has abruptly descended from the podium to speak of palpable things she surely knows well: early education with its dubious advantages, on the one hand, and on the other a solitary child, neglected and forgotten, but spared utter misery by an inclination toward art.

The ICA catalogue includes two further texts. One is a pair of very brief "Willie Stories" that offer, in rather strenuously homespun language, two tales of a fictional man-child. References to classical myth, as well as to Christianity's God, devil, and angels, thread through both; Martin would later say that like the paintings, the fables just come into her mind, "absolutely from beginning to end."[52] In the first, Willie is dragged through the river of Lethe, then jumps into "the fire." After three days, having proved immune to its flames, "he walked right up to satan's office / and he signed up to be a devil." The second tale tells of Willie's fondness for his mother, replaced by love for his wife, which is surpassed by his love of his son. He beseeches God each time his affections shift to ensure that the new love survives unchallenged, which prompts a patient deity to instruct His angels,

"Take care of Willie."
And the angels said, "What are we going to do with
these human beings they all want the same thing

and want it changed?"

And God says, "Arrange it that way."[53]

It may be relevant to Martin's several Willie stories that Willa Cather, often called Willie by her family, wrote a short story for children called "Wee Winkie's Wanderings"—the reference is to the nursery rhyme "Wee Willie Winkie"—in which an intrepid and stubborn little girl decides that she would like to ride the mower with her father; when her mother denies her wish, Winkie declares her intention to run away. To the child's deep chagrin, her mother, in an ostensibly benevolent but plainly hurtful effort to teach her a lesson, urges her on. So the little girl sets out for a nearby mountain, "resolved that she would not speak . . . to a single living creature." The story ends happily, with Winkie restored to her mother; there are unmistakable parallels, though, to the unhappy relationship Martin had with her own mother.[54]

The last of the ICA catalogue texts is the "Parable of the Two Hearts." It begins, "Once there were two lovers that had equal hearts," who pursued each other and, with the help of the angels, "perceived each other," so that "their hearts melted into one." But finding themselves restless, they parted, one flying into the sky, the other into the sea. Ceaseless yearning for the spurned other ensued, stumping the angels (as did Willie). Luckily, however, "There's one thing that God is not able to endure— / a suffering heart," so he caused the two hearts to reunite in the form of sea water, which when it evaporates and then returns as rain "affects people and softens them. I painted a painting called *This Rain*." Ending on this unexpected note, the distinctly childlike parable offers itself as the subject of a Rothko-esque painting of 1960 in which a blue rectangle hovers over a warm white one; the ascription of meaning is utterly at odds with Martin's unyielding insistence that abstraction is a language devoid of narrative or indeed figurative reference.

It is possible to see again, in the "Parable of the Two Hearts," evidence of Martin's interest in Plato. In his *Symposium*, Plato ascribes to Aristophanes

a speech that explains, "our nature wasn't originally the same as it is now: ... there used to be three human genders," male, female and "a third, which was a combination of both the other two. Its name has survived, but the gender itself has died out. In those days, there was a distinct type of androgynous person," which "combined male and female; nowadays, however, only the word remains, and that counts as an insult." Originally such persons were singularly valued and powerful. So Zeus, after taking counsel with the other gods, decided to cut these androgynes in half, a brutal stroke. "It was their very essence that had been split in two, so each half missed its other half and tried to be with it," Plato wrote, in language strikingly echoed by Martin's. The sundered parts yearned for reunification, with a longing that Plato pointedly describes as by no means less powerful when the attraction is between those of the same sex: "Now, when someone who loves boys—or whatever his sexual preferences may be—actually meets his other half, it's an overwhelming experience. It's impossible to describe the affection, warmth, and love they feel for each other."[55] Like the passages from Gertrude Stein that are, it has been suggested, present off-frame in Martin's writing, Plato's *Symposium*, to which Martin may have been alluding, considers with great frankness (and considerable humor) a kind of desire that she firmly refused to publicly acknowledge. Its bearing on her painting may indeed be negligible, but it suggests the range of passions, and of inhibitions, that she negotiated with a remarkably steady hand—and no small measure of wit—throughout her career.

Martin's writing, and the public speaking that broadcast it, held an important but hard-to-define position in her creative life and in her personal one as well. By several accounts, the voice of her writing and public speaking, for all its formality, was not that different from the tone she took in social interaction. Though some old friends insist on her earthiness, she often defaulted to a form of personal exchange that could be confused with an internal monologue spoken aloud; in private as well as public speech, she projected both modesty and incontrovertibility. According

to her friend the artist Harmony Hammond, "you didn't have a conversa-
tion with Agnes, because she would hold forth,"[56] a description echoed by
other acquaintances. Jill Johnston offered a complementary perspective,
reporting, "she says she talks all the time when people come in order not
to know more than she wants to know."[57] As with her instructions to her
lecture hosts, she generally knew just what she was doing.

One senses that words often were, to Martin, as numinous as the mental
images that she called inspirations: her writing conducts a kind of charge
that is sometimes nearly independent of conventional meaning. And, as in
her painting, Martin's handwriting matters: the line that never ceases in her
painting is kept moving just as steadily in her correspondence, personal
musings, and public texts. The manuscripts, which are almost always on
lined notebook paper, often seem to be fair copies of discarded drafts; the
penmanship is careful and old-fashioned. Just as she never had a television
set, she apparently never saw a need for a typewriter (both, it might be
noted, are objectionably noisy). And like her paintings, her writing is as
effective at keeping people at bay as at drawing them in. If, as Delehanty
observes, "She wrote things out as a way to protect herself,"[58] it was a strat-
egy that served her not only for public speaking. It was also a procedure,
perhaps manual as well as mental, for organizing her thoughts. And it
expressed an impulse, which sometimes seems forcefully compelled, to
construct a comprehensively ordered world, to issue precepts for its ongo-
ing regulation and to speak in generalizations that preclude the emotional
give and take of ordinary conversation.

But Martin's writing has a wide-ranging erudition and wealth of met-
aphor that go far beyond compulsion; as with her painting, it would be
wrong to label it symptomatic, or cathartic. And like her proposed walled
garden, her involvement with text can be linked to contemporaneous
developments in art. Much of the writing by the Minimalists—Donald Judd,
Robert Morris—was, not altogether unlike Martin's, both imperiously pre-
scriptive and studiously impersonal. In both respects, such writing echoed

the ideas, and the style, of Reinhardt's implacable pronouncements. All these artists shared with Martin an aversion to art based in individual experience. At the time she began writing in earnest, the Conceptualists, too, were producing universalizing texts that sometimes tended toward arrogance, even if in their loftier reaches they were at least partly ironic. The latter is surely true of the first three of Sol LeWitt's famous "Sentences on Conceptual Art," published in 1969: "1. Conceptual artists are mystics rather than rationalists. 2. They leap to conclusions that logic cannot reach. 3. Rational judgments repeat rational judgments. Irrational judgments lead to new experience." And LeWitt's "Paragraphs on Conceptual Art," from 1967, include the statements, "This kind of art is not theoretical or illustrative of theories: it is intuitive, it is involved with all types of mental processes and it is purposeless."[59] LeWitt's aversion to rationality and his embrace of intuition both have clear affinities with Martin's thinking.

Similarly, the writings of Robert Smithson, with their omnivorous range of references and apocalyptic mood, create a kind of gothic sublime that can seem a dark mirror to Martin's texts. It is tempting to consider that Martin not only saw documentation of his *Spiral Jetty*, but read what he wrote of its creation, in 1972: "Slowly, we drew near to the lake ... upon which the sun poured down its crushing light. . . . Perception was heaving, the stomach turning, I was on a geologic fault that groaned within me. Between heat lightning and heat exhaustion the spiral curled into vaporization ... Surely the storm clouds massing would turn into a rain of blood."[60] A hallucinogenic rhapsody in contrast to Martin's mostly sober fugues, Smithson's writing nonetheless evokes, like hers, the willed submission to a natural environment that can be both transporting and—though Martin avoids saying so—annihilating.

Possibly, too, Martin had read Smithson's idiosyncratic texts before leaving New York. In a wonderfully digressive essay published in *Arts* in 1966, he wrote that each of Reinhardt's black paintings is "at once both memory and forgetfulness, a paradox of darkening time. The lines of his

grids are barely visible; they waver between the future and the past." It is tempting to imagine Reinhardt and Martin enjoying this article together. Its cosmological range would have appealed to her; its descriptions of Reinhardt's work would suit hers almost as well.

The importance of writing in Martin's work and life should not be over-stated, nor should the parallels between the younger artists' writing and hers. As much as any visual artist, she made work that resisted words. Yet with her writing and lecturing, Martin ventured to put her voice inside our heads.

In any case, writing was not the only departure Martin took from painting in the 1970s. She also produced one feature-length movie, *Gabriel*, in 1976, and embarked on a second that remained unfinished. As the unrealized Zen garden would have done, movies create an environment that embraces the viewer, with sound as well as imagery that unfolds over time; like the garden, too, *Gabriel* takes natural beauty as a subject (pl. 28 a-c). And although this film flies in the face of Martin's repeated injunctions against using landscape imagery in art, it shows her faithful to the representation of positive emotional states. It seems to have served other purposes as well, including practical ones. Following her 1975 show at Pace, she announced, "I went out to buy moving-picture equipment"; the Aeroflex she bought was, she said, the most expensive she could find—a choice made for tax purposes, she explained.[61] "I'll be making a movie. Of course, I'll never consider my movie making on the level with painting. But I'm making it in order to reach a large audience." It was to be about happiness and innocence. "I've never seen a movie or read a story that was absolutely free of any misery. And so, I thought I would make one. The whole thing is about a little boy who has a day of freedom." As with painting, she trusted her inspiration to guide her. "The materialist point of view is that there is technique and expertise in the making of something. But that is not so. And it's not how I work. If I'm going to make a movie about innocence and

happiness, then I have to have in my mind—free of distraction—innocence and happiness. And then, into my mind will come everything that I need to do," she said at the time.[62]

Shot in color, with no script and no storyboards, over a period of three months, *Gabriel* opens silently, at a beach. A child shortly appears (Martin said that he was really fourteen years old, but looked closer to eight[63]), and so does music, Bach's *Goldberg Variations*, which run intermittently throughout. At first the boy stands still, with his back to us, facing the ocean, and briefly the screen is organized in horizontal bands: the still beach, with the child anchoring it; the moving water beyond; the fixed horizon and sky above. Soon, the music stops and the boy trudges off through brush toward distant mountains; wind is audible as he leaves the frame. Thereafter, he will make his way up and down steep hillsides, through stands of trees and fields of flowers, and follow various waterways before finally returning to the ocean. Most of the time we see him from the back, a slender dark-haired child in a white T-shirt, shorts, and hiking boots. Focus is lost and regained as the camera closes in—framing nearly abstract shots of shallow water coursing over large stones, at first crystal clear, then turbulent and foamy—and pulls back. Along with the boy's progress and the flowing water, action is provided by the shifting sunlight, which dances on the water and dapples the trees; after periods of silence, the returning music is, each time, a gentle surprise. (One is reminded of the beat, in competitive swimming, alternating underwater quiet and the human noise audible when the swimmer's head is above water.) There are close-ups of pussy willows hanging over water, of big white blossoms blowing in the breeze, and then flowers in a variety of colors, of a waterfall churning. The sky is generally deep blue and cloudless.

In discussing *Gabriel*, Douglas Crimp quotes eminent filmmaker Jonas Mekas, who writes, "Agnes Martin is a great painter and whatever she does has an importance. Her film is no great cinema, that I have to state at the outset. But it is a very beautiful film"[64]—an assessment Crimp endorses. He notes Martin's lack of familiarity with film history and writes that the

view of nature she presents "is fairly commonplace ... if perfectly lovely. Nor does the film's structure have discernible sense." Nonetheless, he concludes, "the play of sound and silence feels right, and there are some truly exquisite sequences."[65] It is hard to argue with any of this (although Crimp perhaps overstates Martin's ignorance of independent films); in long stretches, *Gabriel* is both tedious and sentimental. At the same time, it has moments of great beauty, and the merit of offering insight into Martin's perceptual world.

Moreover Martin's stated ambition was not to reinvent nature photography or the art-house film (as it existed in the era before video art largely supplanted the genre), but to express a state of mind and to challenge conventions of taste. "At first, I made a film to protest the commercial film being negative, that they're always about deception and deceit—and violence,"[66] she explained. And she grew deeply involved, as she had in using adobe, with the physical aspects of the medium. "When I found out about the sensitivity of photography as a medium, it was very exciting!... I enjoyed everything about it," including editing.[67] Meeting the challenges of an unfamiliar process produced some tension: "I have two cameras and they were equally temperamental. And so I was worried about whether they were actually working or not. It's quite a strain."[68] And, as always, she submitted to advice that arose within. Harmony Hammond reports, "Explaining that *Gabriel* was about joy, Agnes described how she had no problem carrying the heavy camera equipment but when she began to shoot the wildflowers up close, her hands would begin this terrible shaking, and she couldn't figure out why or what was happening. Finally her voices showed her that she was trembling for joy because of the beautiful flowers."[69]

Its narrative and formal merits aside, *Gabriel* is of interest for exploring two themes about which Martin often spoke and wrote: children and music. From earliest adulthood, Martin had worked with young children, as a teacher and in other capacities. References to children recur, again and again, in her writing, lectures, and interviews; as already discussed,

they reveal an understanding of childhood that veers between astute understanding and unreasoning reverence. Several friends and associates, among them Arne Glimcher and Kristina Wilson, testify to Martin's interest in babies and young people, with whom she could be tender and alert, although sometimes she was less than ardent: "When people ask me if I'm not disappointed because I didn't get married and don't have children, I tell them I believe in reincarnation. I've been married a hundred times and I've had hundreds of children. This time I asked to be left alone."[70]

Clearly, Martin's concern with children was tied up with her pursuit of innocence; just as obviously, some of her observations are conflicted, as in the description, "Babies gurgle and laugh... reach out and touch people on the cheek... the baby is loving them in a very flirtatious way."[71] More often, babies and young people seem to have stood for a state of (unrealistically) quiet contemplativeness: "Our most perceptive state is in infancy, before social responsibility is put on us. Very young children can play in the dirt with a stick, without boredom, early morning until lunch. If you played in the dirt with a stick, you wouldn't last that long."[72] Some of her more idealizing statements sound suspiciously like recriminations, addressed retroactively to her imperfect self. "Children make a perfect response to life. They see everything as beautiful and perfect, often telling their parents how beautiful and wonderful they are. Children always love their parents with perfect love regardless of what the parents are like." But then, perhaps admitting a small note of self-forgiveness, she adds, "They have to learn to bear frustration which makes them seem unhappy at times."[73] The actual boy in *Gabriel*, of whom Martin spoke afterward with little affection, and whose dutiful march through the film lacks visible enthusiasm—for his surroundings or for the project into which he has been enlisted—is, in his inscrutability, the more available as a screen for these various attributions of childhood.

Less complicated—though not without conflict—was Martin's relationship to music, which she often called "the highest form of art." In her estimation, music was "the most abstract and the most effective. We make

about four times as much response to sound as we do to what we see."[74] Despite music's advantages, Martin claimed that visual art could approach its effects, as when she wrote, "Art work that is completely abstract, free from any expression of the environment, is like music and can be responded to in the same way. Our response to line and tone and color is the same as our response to sound and, like music, abstract art is thematic. It holds meaning for us that is beyond expression in words."[75]

If in *Gabriel* Martin exalts a rather literal kind of innocence–one that is unattainable for adults–she also celebrates an art form that she seems to have felt was beyond her reach: "I think musicians are a race apart,"[76] she once said, later adding that they attained a rare degree of triumph over pride. "The obedience of performing musicians is extremely sensitive and accurate. . . . I wish I could point out how authoritative art work is dependent on the obedient state of mind."[77] At the same time, her accounts of passing out (or entering "trances") while listening to music in church in earlier adulthood and, more generally, her pursuit of silence–sometimes to extremes–suggest that music could be overwhelming for Martin. She often said that she played music while painting and that Beethoven was a favorite, citing the Ninth Symphony–hardly a soothing composition. The far less turbulent Bach *Variations* that run through *Gabriel* are further modulated by being heard in alternation with the sounds of wind and water–which, even when barely audible, hold their own.

One further element of *Gabriel* worth noting is the movie's title. The bearer of glad tidings (the most important of course being the annunciation to Mary of Jesus's imminent birth), Gabriel is generally depicted as a graceful winged being, neither quite male nor female–Martin's preferred gender. And if the boy who performed in her movie was, in Martin's descriptions, something short of angelic, she said she named the film for a figure that "is beyond this world" in his innocence.[78] In the film, he does seem to stand for the delivery of good news: the perfectly ordered beauty of the earth, innocent of the messy arrangements of human affairs and immaculately conceived.

The next film project Martin undertook, to have been called *Captivity*, could hardly have been more different. A cross-cultural, trans-historical costume drama ripe with sex and violence, it was to be based on a tale of Genghis Khan. As Martin described its plot, when the Mongol ruler occupied northern China, "he saw this princess in a garden, and he said if they'd give him the princess as hostage that he wouldn't destroy Peking. And so they decide to give him the princess. And my movie was about when the sons of the generals went to go and pick up the princess and bring her back to Mongolia."[79] The logistical and technical challenges of filming this story were formidable. Martin said she traveled to Japan in search of Kabuki dancers to play the princess and her maid but didn't succeed. Instead, she hired dancers from the Japanese community in San Francisco, where there was a Kabuki theater. "In Japan," Martin reported, "The actors are all men. Even the women are men. But in San Francisco, they're all women. Even the men are women. I hired a woman and her daughter."[80]

Despite the greater congeniality, for Martin, of women performers, trouble arose. She complained of the lead performer's stubbornness—meaning, evidently, her refusal to submit to direction, instead insisting on the dance movements of the tradition in which she was trained. Neither could it have been easy to convince the cast, which included local Native Americans, to sleep in the tents meant to recreate Mongol encampments. In addition to the two lead women, there were apparently eight boys and eight horses. "To take a picture of [even] one horse is really a problem,"[81] Martin admitted. She worked one of the cameras herself, and she bought a cutting table; Donald Woodman, the photographer she'd met in 1977, worked the second camera and provided other technical support.[82] She had "an ancient Chinese garden" built and a cart to transport the prisoners. Much of the filming was done in New Mexico; final scenes were shot in Victoria, in British Columbia.

Notwithstanding the naiveté attributed to—or expressed in—*Gabriel*, Martin spoke knowledgably of film, and Kabuki, at around the time *Captivity* was in production. "Agnes talked about... the need for restrained or

ritualized expression of emotions" in Kabuki theater, Harmony Hammond remembered, "where the actors act out one emotion at a time to the audience rather than to each other. One can truly feel only one emotion at a time. Then she imitated the Kabuki sounds and the gestures of wailing and grief. She compared Fellini's *La Strada* with Kurosawa's film *Rashomon*, saying that Fellini missed the mark because he did not immediately and fully define the main character." They also joked about recent movies. "Speaking of *Star Wars*, Agnes said, 'You know something is wrong when a tin can gets the best actor of the year award.'" Hammond concluded, hesitantly, "As I understood it, Agnes's new film in progress represents the ritualized emotions of Kabuki. Something about a fence with a Kabuki dancer on one side and a Native American on the other."[83]

Martin's accounts of *Captivity*'s development, and its meaning, vary considerably. One is offhand and a little ribald: "I made it because I thought the Jemez Indians," whom she hired as actors, "looked like Moguls [*sic*]." When asked why she discarded it, Martin replied, "The woman got me down." Then she paused, and continued, "In the last scene, Genghis Khan rode in and I said to him, 'Do you think you could make a dance about romantic love?' And he said (laughing), 'Oh I think I could.' And so he danced. He was pretty good. (Pause) And so the princess fell for him, when he did this romantic dance. She married him and she had two sons and then they walked off into the sunset."[84] In this vein, she said the project was "really a kick."[85] But on a later occasion, she talked of the princess and the maid dancing expressions of "fear and terror… when the boys came to get 'em. And then the princess danced goodbye to her garden," as well as "homesickness and all kinds of nostalgia."[86] Hammond related, "To Agnes, it was about sorrow, fear, and acceptance, about love and fences… about two individuals on either side of a fence—about how we all are ultimately separate. Our joys and sorrows are separate."[87]

Arne Glimcher reports that when the film was under way, Martin told him it was to be "about surrender, the mental attitudes of surrender." The kidnapped princess "was afraid of Genghis Khan, but eventually

she married him and had two sons and went back to China." She added, "I'll stop my movie before that—I'll end it at the moment of surrender which is happiness. It's the same kind of happiness that's reached after the mind takes charge of an idea. The idea grows up and up until truth comes through the idea and dissolves it. It is the surrender of the intellect to fate. That's where the movie ends in surrender which equals happiness—no conflict, no irony."[88]

It's not easy to accept the emotional logic that connects the thoroughly reasonable terror and homesickness Martin ascribed to the princess and her maid, carried away by a rapacious despot, not only to surrender and acceptance but also to happiness. Just as perplexing is the parallel she draws between this experience and the submission of intellect to fate—a submission that she felt every artist must make. In any event, Martin herself ultimately decided the entire undertaking was a failure. It was never shown; she told friends she threw the completed footage into a dumpster. She said nothing about the issues it most obviously raised: of cross-dressing and gender ambiguity, of cultural conquest, violence against women, and power struggles between the sexes, and of her own quite stunning artistic ambition.

While Martin continued to speak in public and to write for both public and private purposes, the excursion from painting represented by these films (and the proposed garden) was never repeated. They can be considered experimental investigations of possible relationships with viewers—of the "response" that Martin deemed an essential aspect of any worthy painting. "Everybody's got their mind on artists and paintings. But it's the *response* to art that really matters," she said on one occasion.[89] Asked how much time she thought a viewer should spend with her work, she replied, laughing, "Just about one minute." When the surprised interviewer replied, "A minute?" Martin offered the seldom acknowledged truth, "Yeah, but a minute's quite a while."[90]

The question of reception, in the late sixties and early seventies, was being given considerable thought. Michael Fried's 1967 denunciation of

Minimalist sculpture for its "theatrical" relationship with the viewer inadvertently promoted interest in the ability of static, abstract art to induce a time-based experience. Other relevant, more-or-less contemporaneous formulations of visual response include Barnett Newman's bid for viewers to be absorbed by the painted field. Also pertinent is Sontag's distinction (in the essay, "The Aesthetics of Silence") between "Traditional art," which "invites a look," and "Art that is silent" which "engenders a stare" (that is, it allows "no release from attention").[91]

The egoless immersion in an undifferentiated, disembodied awareness that is promoted by Zen is another of the cultural options on offer at the time for thinking about looking.[92] All have some bearing on the engagement that Martin invited—an immoderate visual experience, an absorption by the work that is a kind of secular rapture, even if it only lasts sixty seconds. The experimentation with film can be seen as the trial of an alternative to painting that would prolong the encounter. And the writing, in this respect, serves not only as a set of instructions for students on how to go about making art, but also, and maybe especially, for viewers of all ages about how to see it.

By the middle 1970s Martin had constructed a thirty-five-by-thirty-five-foot studio and returned to painting on canvas, and apart from the kind of occasional fallow period that appears in most artists' careers, she continued to paint until the very end of her life; she had resumed painting by the time the films were made. In June of 1974, Arne Glimcher writes, she came into the Pace Gallery and "asked if we would show her work." He promptly agreed.[93] In September Glimcher, too, made the trip to Portales mesa, and he described the small, one-room house Martin had built there, "a water well, pump-handle sink, a black Naugahyde sofa, a table, kerosene lamp, and three chairs pushed against the wall next to a large window, the transversing wooden supports of which are filled with Agnes's harvest of ripening tomatoes." He remarked on the outdoor bathtub, filled from the pump in the morning and warmed by the sun during the day, and he noted

the split tree trunks, their bark left on, that supported the ceiling. On the wall he saw framed early-twentieth-century advertisements for Coca-Cola, featuring Gibson Girl models; when Martin caught Glimcher looking at them, she laughed.[94]

Despite her bold approach to Pace and deepening relationship with its director, she was hardly establishing herself in the heart of art-world society. She told Glimcher she had been isolated for the entire winter, eating preserved walnuts, hard cheese, and homegrown tomatoes. "That was her entire diet," he writes. Though Glimcher argues gamely that the choice was made so that "Not even the decision of planning a meal was allowed to distract her from the making of her paintings,"[95] clearly she was in a fairly fragile state, and she would remain so for some time. On another visit by Glimcher three years later, she was eating only Knox gelatin mixed with orange juice and bananas, living in her camper, without a working heater, in sub-zero weather. "I have absolutely no comfort now. But I don't want it," she told him.[96]

And yet, she was hard at work, and she was beginning to let people know it. Bob Ellis had seen Martin's ICA show when it went to Pasadena in 1973 and was "bowled over by it. It spoke to me. I got her address from the staff and wrote her a note, saying I'd seen her show, and would love to meet her. I got a postcard back saying 'don't come out, don't give my address to anyone, building a studio, Agnes.' I wrote back saying, 'when you're ready.' Didn't hear a thing for years. Then in the late seventies came a card: 'you can come up now.'" So Ellis, too, went up to Cuba, initiating a friendship that lasted until the end of Martin's life.[97]

"When you stop painting for a while, which I don't think is the least bit bad—I think it's a good thing to stop if you have to, work something out for a while—the painting goes on, if you want it to. But then when you start painting again, you have to sort of get conditioned, like an athlete. You have to get on this track, and stay on this track, and every interruption is bad," Martin said to Skowhegan students in 1987.[98] She spoke from experience. Her first years back at work seem to have been effortful. In a 1974

letter to Beatrice Mandelman, whom she had known since the 1940s in Taos, Martin disparages their mutual friend Mildred (Tolbert) Crews for not working hard enough and then goes on, "So I want to warn you. No use for you to begin unless you want to move through 'the field' get out in front and move on from there. You will have to make around 500 paintings. When I made my prints [*On a Clear Day*, 1973] I worked 3 months and made 500 paintings before I was even on the track... there has to be <u>pace</u> and a gradual working up to what you have to do. A fast pace.... It is <u>composition</u> like the musicians... This year I have painted over a hundred paintings none of them are any good." Among these old friends in Taos, Martin was beginning to distinguish herself as an international star, and she seemed at pains to dispel the aura (and the gossip) that that status provoked. To Mandelman's husband, Louis Ribak, she wrote, also in 1974, "I cannot abide 'wheeling and dealing'... I have been called brilliant, shrewd, strong, weak everything right down to an ass-licker and the truth is I have never done <u>anything</u>. I hope that they, the paintings somehow get to the right place I believe they do."[99]

Martin spent just under a decade on the Portales mesa. Looking back, she told Irving Sandler, "I decided to experiment with simple living; I went up on top of a mesa that is eight miles long and six miles wide and there was nobody up there and the nearest house was six miles away. There was no electricity and no telephones. I stayed up there for years and became as wise as a Chinese hermit. Then I decided that that is not a natural human way of living, to be so isolated, so I came back down."[100] In fact, the choice was not hers alone. Despite her "lifetime" lease on mesa property, Martin was told to leave in 1977, when one of its owners—the brother of the café manager's wife—decided he wanted it back. But the eviction, and return to a more convivial and active life, came at a good time.

Shortly before she left Cuba, Martin wrote me a letter. I had written to her because I was doing research for an undergraduate paper on her work, and as I recall (I didn't keep a copy of my letter), I sought answers to questions of intention. I asked whether there were artists and critics whom

she felt had been particularly perceptive with regard to her work. Undertaking the role of educator, she urged me away from intellect and toward true feelings, which she patiently distinguished from emotions. "The artist uses only the primary awareness because the intellect draws on knowledge from the past and leads us in a circle. The response in primary awareness is in <u>feeling</u>. The response to art is <u>feeling</u> not intellectual (knowledge) or emotional, love anger etc. but true feelings such as you would have at the beach—freedom, joy, gratitude, innosense [again this misspelling], harmony, content, the sublime, all <u>positive feeling</u>." Magnanimously, she allowed, "Words that represent our primary response are art. That is words that describe our positive feeling." She advised reading Walt Whitman and avoiding any reference to "conventional knowledge." Sensing academic inclinations in my letter, she warned again and again against mucking around in scholarly matters. "Ideas are the illusion. The concrete in life is not illusion. It is real. But ideas are not real. We simply make them up."

To explain her working method, she wrote, "I paint from an image that comes into my mind because I want it." Crossed out before the last word was "to see." She wanted it understood, clearly, that the desire itself was primary. And, in another clarification: "I first saw 'the desert.' I think everyone has this mental concept 'the desert.' The real desert is nothing like it."

She wrote of the significance to her of the Abstract Expressionists—Still, Rothko, Pollock, Newman—and said the most important thing about their work, and hers, "is that it presents an undefined amount of space, unlimited space, or spacelessness." Correcting an assumption I had made, she explained, "I do not have a personal touch in my work. The Chinese painters for example had a personal line that could be recognized. All my lines are measured and ruled and impersonal." She touched on the importance to her of music, notably in its reliance on silence: "In 'On a Clear Day' I wanted them to recognize the composition in scale as carrying the meaning. Just like in music the composition in silences and notes carries the meaning. But it was not recognized, but the response was made and that is enough."

Finally and categorically, she renounced spirituality. On the letter's penultimate page, she wrote, "There is no spiritual. There is the concrete and the abstract. The abstract is awareness that takes place in the mind free from environmental influence. Reasonless joy. It is life or reality 'passing through' the mind. But our primitive religious tendencies tend to call it God or Gods or the Supernatural. But our mental awareness is our real life and it operates also on the concrete level."

On the envelope Martin gave her return address as Cuba; it was postmarked Albuquerque, a long drive away. Like Douglas Crimp, I was unaware of the circumstances under which she was living. Nor did I then fully appreciate the generosity of this letter: the effort she undertook to set the record straight (even if some of her corrections were provisional) and, even more graciously, to encourage an eager but bewildered student.

------ Chapter 8 ------

BACK TO THE WORLD

A fter a brief period of transition following her departure from Cuba,[1] Martin settled in Galisteo, New Mexico, in 1978. She stayed for nearly fifteen years, her longest fixed residence. It was during this period that Martin achieved financial security for the first time, and although she would always maintain a life of material simplicity, the visibility, critical acclaim, and market success her work drew by the 1980s relieved her of the hardships she had so often faced before. The isolation that she had sought, and also suffered from, on the Portales mesa was mitigated in Galisteo as well.

A half-hour drive from Santa Fe, it was a quiet little town when Martin arrived, but it grew into a livelier—if still ruggedly rural and small—community over the next decade.[2] During her years there, Martin had regular contact with her old friend Richard Tuttle and his wife, the poet Mei-Mei Berssenbrugge, who have long had a residence in Abiquiú. Martin's neighbors in Galisteo eventually included the artist and writer Harmony Hammond (resident since 1984) and cultural historian Lucy Lippard (who has lived most of the year there since 1992). The artists Bruce Nauman and Susan Rothenberg moved to Galisteo in 1989. Flora and Sidney Biddle, well-known art patrons, acquired a home nearby in 1990 and became good friends of Martin. The painter Pat Steir, who had accompanied Douglas

Crimp on his 1971 trip to Cuba, continued to visit Martin regularly in Galisteo. Ann Wilson remained a friend and reliable visitor as well.

Though the artists who chose to live in this rural New Mexico outpost were, generally speaking, looking to escape the professionally driven social obligations and other distractions of major cultural centers, Galisteo's small art community was convivial, its members meeting causally at each other's homes and also at such local events as church socials.[3] Hammond reports, "at parties Agnes never got up and danced, but she thoroughly enjoyed herself." Flora Biddle says Martin liked her Martinis;[4] Donald Woodman (the photographer who had helped her with the Genghis Khan film) said her drink was sherry.[5] And increasingly, over the years, Hammond recalls, younger women artists came to Martin on "pilgrimages," to pay homage.[6] In Lippard's words, by the end of the eighties, Martin had become "a real queen bee."[7]

Her growing international celebrity notwithstanding, Martin remained devoted to the particular pleasures, physical as well as social, of the New Mexico environment she'd long since adopted. The landscape around Galisteo, a basin ringed by mountains, is not as dramatically rugged as the Portales mesa, but it shares the crystalline air characteristic of the Southwest (and of Saskatchewan) and the dramatic changes of light that turn mountains vivid shades of ocher, red, and purple. The home Martin built there was on a three-acre property owned by Woodman: Martin told him she'd pay him $200 per month in perpetuity for the Galisteo property, where Woodman was living as well. For a couple of weeks, both slept in Martin's camper, until, he says, she threw him out.[8] The camper in which she stayed she later covered in adobe—to the amusement of many—while Woodman moved into a tipi close by. Having been trained as an architect, he helped Martin build a studio; they also built a pump house and dug by hand a trench for electrical cable, which was three feet deep and several hundred feet long. "We had an unspoken competition to see who could live the most Spartan lifestyle," Woodman says. "She was tough." Her

disregard for amenities endured; she lived without electricity for some years in Galisteo.

After a time, Martin give up the camper for a proper house on the insistence of a Santa Fe therapist she was then seeing, and she and Woodman built a long, narrow residence of rammed earth with a metal shed roof. It contained a bedroom, sitting room, kitchen, bathroom, and mechanical room. They also built a studio.[9] Visiting toward the end of Martin's residence there, the critic Klaus Kertess described a 15-by-60-foot living space and a 20-by-40-foot studio; the trailer was stuccoed with red earth.[10] Again, there was nothing remarkable about the home or its immediate surroundings; the landscape is scrubby, the site lacking in drama. By 1984, Martin and Woodman had had a falling out (though later they reconciled), and she bought the Galisteo property from him, her early instruction from inner voices notwithstanding.

Martin told Hammond that, at nearly seventy, she could no longer do the physical work—moving rocks, chopping wood, building stretchers—that she had done earlier, but her determination and spirit of independence remained daunting. More conspicuous than cladding her camper in adobe was her alteration of the course of the Galisteo Creek, which, when it swelled with summer rains, ate into the fifty-foot-high cliff on which Martin's house stood. Without permission from the Army Corps of Engineers, she hired earth-moving equipment and laborers to redirect the water through adjacent ranch property and to build a large berm protecting hers.

Still devoted in these years to swimming—which she ultimately supported more as a patron than a participant—she built a pool near her house for local children, but filled it in when "someone irked her." She kept a garden and ate what she grew. Her home's spare furnishings were, as always, chosen without regard for style—evidently, friends say, from mass-market mail-order catalogues. And although she kept up, to some extent, with trends in contemporary art, her associates don't often recall seeing art books or magazines in her house. For most, a visit was a fairly formal occasion: guests sat at the kitchen table, where there were two chairs, one—as

always—a rocker. However much she enjoyed a party, Martin's preferred social engagement was still one-to-one conversation.

Visitors were not welcome in the studio while she was working. When favored people were allowed to enter to see completed paintings, they found a studio carefully prepared for quiet contemplation: "You clean and arrange your studio in a way that will forward a quiet state of mind," she wrote in lecture notes. "This cautious care of atmosphere is <u>really</u> needed to show respect for the work. Respect for art work and everything connected with it, one's own and that of everyone else <u>must be maintained</u> and <u>forwarded</u>. No disrespect careless or ego selfishness must be allowed to interfere."[11] And despite certain lapses, she continued to observe the dictates of internal authorities. "Her voices would not let her have certain things, and told her what not to do: yes to pick-up trucks, no," for now, "to chickens," for example.[12]

Settled though she was, Martin remained restless, and she traveled often while living in Galisteo, the trips ranging from hiking in the local mountains to excursions to the Monterey coast and further. She generally referred to the wilderness travel as solitary, but sometimes she had company: after Woodman was ejected from the camper but before he moved into the tipi, he accompanied Martin on a six-week trip up the Mackenzie River in Canada. A massive and largely unpeopled waterway that flows north to the Arctic from the Northwest Territories above Alberta and British Columbia, it is North America's second-longest river, and it was a magnet for Martin. As Woodman recorded in a diary he kept of the trip, Martin called the journey "her life's work" and a "goal since childhood."

Martin's version, as told to Ann Wilson, was, "Her voices told her that when she had worked too long she needed to take a trip. She told us about her sailboat on the Mackenzie River in northwest Canada, and how when she boats on the Mackenzie, she goes where there is no help, where she is beyond the reach of human beings."[13] At least on this occasion there was help, and the boat had a motor. Martin and Woodman set out for the Northwest Territories in May 1978, traveling in a Jeep Scout pulling

an 18-foot flat-bottomed aluminum motorboat. There was still ice on the river when they entered it, and the trip would remain throughout cold and wet, exhilarating and tiresome, challenging in the extreme, and spectacularly beautiful. Woodman's diary begins, "15 May 1978. On the road to Cheyenne Wyoming: the start of a trip to the Mackenzie River to cast our lives to fate to give up all fears of the unknown." They stare at the stars, and Martin warns, "You won't find the answers out there." But, she adds, "Little children before they are conditioned can show you how we are supposed to be."

Three days and 500 miles later, they are both "giddy, and the jokes are weird." On May 19, Woodman writes, "Today's talk was a tirade on the Hippies and how each of us should do what we want that we will all pay for our mistakes—justice reigns." A cold May 22 finds Martin "walking around bundled up like an Eskimo" and engaging in games of introspective analysis. "I am struggling with my mental thoughts," Woodman writes. "I took her other psychological test of completing the drawings of 6 squares given her by Robert Indiana . . . We talked of how you have to find your own karma—work in life's natural direction." And in another entry on the same day, "Agnes is spending much time talking to me of methods to work on yourself. . . . The idea of going down the Mackenzie to go over the edge of civilization so as to show yourself that you do not cling to life - you do not hold on to anything. You seek the truth you move through life you do not desire for anything but to seek truth."

As they travel north, "the sun sets sideways along the northwest horizon" at the end of 16-hour days. Martin talks about God and goodness, joy, truth, happiness, innocence; also the Devil and sadness, lies, conceit, and pride. And she tells stories: there is a variant on the Willie story in which he cuts a deal with Satan, this time taking a permanent job ferrying people to hell; there is also a version of "two hearts that are the same."[14] On June 2 they "talk of art and how to respond to people who say of abstract art that anyone can do it; the fear that such talk raises." The next day, Woodman writes, "I wonder if I will be able to keep my trust in Agnes—I must

trust myself only … we got drunk tonight on the sherry she can be very unusual–strange." Woodman documents moments of bracing grandeur and physical challenge he shared with the then sixty-six-year-old artist:

> 6 June … the sky and water were one–and the reflections like flying through the air but on water. … We landed in a heavy rain–it literally pelted us with lightning and thunder … it lasted but a few minutes but the confusion was total we beached, secured the boat and put up tents in the woods on the muskeg and then a fire to dry out both of us were totally wet. … a lynx eyes us from 100 feet away are we the first humans to meet his eye this close? How far away are we from other people??

On the other hand, Woodman writes with increasing heat about Martin's demands–and also about her visual sensitivity. By June 10, nearly a month into their journey, he is admitting, "I guess part of the thing with traveling with and being with Agnes is to listen to her all the time and not to complain nor say please I wish quiet but to listen to everything unrelenting at times." The day before, he had written, "Agnes sees in such subtle colors I see in colors and black and white." And yet, "sometimes I want to curse and shout out what I see and hear from you is noise or contradictions to what is 'truth' - is it respect that I show her or is it the battle to maintain sanity in this experience?"

For all its rigors, the Mackenzie River trip was broken up by occasional stops for Chinese food or a popular movie; Martin held no doctrinaire beliefs about what constituted a proper wilderness excursion. In the following two decades, she traveled widely with David McIntosh, under less demanding conditions. Often, these journeys–like her earlier one to India, as well as the trip with Woodman–involved water. McIntosh and Martin went together to the Panama Canal, first flying to Florida, then proceeding by boat. Other destinations included Alaska, the Orinoco in Venezuela, and the Mediterranean. Among overland trips was a two-week tour of Morocco; they also drove through Scotland, where they visited

Skye, Martin's ancestral home. She told McIntosh her forebears had been whalers and said she felt at home in Skye, although she made no effort to look for family.

"Agnes said at the end of her life that the ship voyage through Norway was her favorite," McIntosh recollects. Lasting more than two weeks, it included Denmark, the Faroe Islands, and the Norwegian coast; again, she almost reached the Arctic.[15] Later in her life she enjoyed being a guest on the yacht of Michael Ovitz, a client of Pace Gallery.[16] Her happily remembered childhood in British Columbia and the equally strong connection she felt to her riverside residence at the New York City seaport provided anchors for a lifelong love of water that, with characteristic discipline, she abjured by spending most of her adult life in the desert. Some of Martin's travels with McIntosh were work-related. They went to Amsterdam, to see her show at the Stedelijk in 1991. In the catalogue for that show, Marja Bloem says Martin was then well known in Europe, as much for her writing as for her paintings.[17] The same year, Bloem joined them in Wiesbaden for the ceremony at which the city awarded Martin the Alexej von Jawlensky Prize. And Martin continued to lecture, although not as widely.

While the Galisteo years were a period of relative stability for Martin, in her physical circumstances and personal life, she was not entirely free from turmoil. She was hospitalized at least twice, in Colorado and at the psychiatric ward at Saint Vincent's in Santa Fe. It was at around this time that Martin wrote to Woodman of her fear that she was dying. Donald Fineberg began treating her in 1985, and gradually, from that point, her symptoms decreased; at the same time, the available medications—which she would continue to take—improved, and the rhythms of her life became more regular. Her painting—with some notable exceptions—grew progressively more luminous and calm.

•

The simplest way to distinguish the paintings Martin had begun making when she resumed work in the early 1970s from those of the New York period is that the grids gave way—with some initial hesitation—to broad

stripes. Occasionally (particularly at first) the stripes are vertical but more often they are horizontal. Sometimes interrupted by a single perpendicular line or two, the initial stripe paintings are often painted in translucent, near-primary tones of red and blue. There were also paintings of the mid-1970s (when she was living in the heatless camper) in shades of gray.

One painting of 1974 (private collection) comprises a trio of vertical bands, the middle element blue, the others red, each separated by narrow strips of white; as in other canvases of this time, an even thinner strip crosses the composition horizontally, suggesting the vestigial axis of a grid. In another work of the same year, narrower red and blue bands alternate, all of equal width (pl. 29). The use of primaries, the American-flag palette, and the simplicity of the organizing schemes all seem to announce a new visual language. Applied in multiple layers of highly diluted acrylic paint, the bands are illuminated from behind by the white of the ground, which she applied in multiple, generally individually sanded, layers. By 1975 the red has grown warmer, to a very pale shade of adobe, and patterns have grown more complex. There are paintings employing red alone and also ones of pale blue alternating with lemon yellow. The minutely calibrated balance between cool and warm, shape and line, internal variation and overall image, and the increasing variety of hue—the subtly yellowed reds, the sun-warmed blues—begin to suggest the breadth of expression this new vocabulary would make possible.

Sometimes the painted bands are evenly spaced and equivalent; more often, there is a fairly complicated rhythm of alternating widths, although always governed by a measured beat. Because the patterns of stripes repeat from top to bottom rather than mirroring each other from the midline, the paintings seem to have a new directional force, rather than being fully self-contained (they may have a broad band at the top, say, and a narrow one at the bottom). Penciled lines, almost always readily visible on close inspection, continue to rule the canvases' divisions. The 6-foot square remained her paintings' unvarying dimensions until the last decade of her life, when they were reduced to 5 feet on a side.

As before, Martin continued to work on paper as well, often in ink or pencil and watercolor, her favored dimensions ranging between 9-inch and 12-inch squares. In one drawing of 1977 (pl. 30), broad bands of watery blue and red fade to white by imperceptible degrees before reaching their penciled border, a horizon drawn at the center in the faintest line of graphite; they seem clouds of color-imbued atmosphere. The vellum-like paper on which this and many other such drawings were made is not absorbent and so not generally favored by watercolorists because of the difficulty it presents in controlling the paint. Another drawing of the same year features blue and yellow lateral stripes, lucid and hushed, the color saturation as uniform as it is delicate. The consummate control of these drawings serves mostly to make skill invisible; the artist's hand, while always visible, never falters.

Soon after the colored bands appeared, Martin began to construct images in shades of black and white, painted with acrylic washes or diluted India ink, sometimes over slightly gravelly surfaces; in some of these, the grid returns. In one such painting, *Untitled #11*, 1977 (pl. 31), a grid of elongated horizontal rectangles is penciled on a matte gray ground. Fairly assertive and even a little glittery, like mica in a city sidewalk, the black penciled lines become heavier at regular intervals, creating secondary horizontal rectangles within the grid. The washy ground, of very diluted ink, picks up the weave of the canvas and its imperfections. The whole is cool, wintry, lightless. In another India-ink-washed painting of 1977 (*Untitled #5*; Doris and Donald Fisher Collection, San Francisco), the canvas is divided into a series of windowpanes, each vertical rectangle defined by doubled pencil lines; this is as close to a depiction of mullions as Martin came. A third in this 1977 series (*Untitled #14*; Solomon R. Guggenheim Museum, New York) is divided into wide rectangles, five across and roughly two dozen in a column. Cloudy and a little dour, it is marked, again, with a scatter of dark spots where the slightly gritty surface has picked up ink: it could be the negative for a photograph of a night sky, the stars sucked into darkness and darkness itself lost to lightless shadow.

Gray paintings appeared often in the eighties as well. In *Untitled #9,* 1984 (Metropolitan Museum of Art, New York), diluted ink was sponged or wiped across the surface, which was probably prepared with a medium that had some sand in it. The effect is, distantly, of seawater washing across a beach, in regular laps, gray and chill. In a related painting of the same year, *Untitled No. 11* (pl. 34), with a similarly scumbled surface grayed by lateral washes of watered-down ink and divided by penciled lines into eighteen horizontal bands, there is a fair amount of incident in the wash, which, seen closely, appears to gather and fall like water running over a rock face. There are also paintings, from the eighties in particular, that are executed with gray acrylic paint rather than ink wash, in warm, velvety shades brushed on in horizontal bands of various widths.

But by the end of the 1970s, Martin had created, as well, compositions that sang with light, achieving a sometimes ecstatic radiance. *The Islands,* 1979, in the collection of the Whitney Museum, is a cycle of a dozen such paintings, one of four suites Martin made (the others are at the Harwood Museum in Taos; Dia:Beacon, in Beacon, New York; and in the Ovitz family collection, a promised gift to the Museum of Modern Art, New York). In its scope and ambition, the Whitney's cycle is reminiscent (perhaps deliberately) of the Rothko Chapel in Houston (which opened in 1971), Barnett Newman's *Stations of the Cross* (painted between 1958 and 1966), and Cy Twombly's *Fifty Days at Iliam* (1978). Majestic and, seen together in a dedicated room, faintly ecclesiastic, each painting of *The Islands* (a title Martin had used before) is composed of horizontal bands of warm white or cool white, sometimes verging on yellow or blue. They vary from five broad bands to a dozen; sometimes the bands are separated by single penciled lines, more often by a narrow strip of white that is defined by lines above and below. The color distinctions in these paintings are evanescent. Up close, the whispered color tends to disappear; it only coalesces at a distance, ranging from the pale bluish white of old-fashioned skim milk to the glaring white zenith of a sun-bleached sky at midday, and then to the solid indoor white of linens and bandages, soothing and warm.

The patterns of painted bands vary from complex, syncopated rhythms to steady regular beats; in one or two paintings, there is the implication of overlapping louvers, light seeping under them, and with it the merest implication of weight and volume. The penciled lines variously resonate, like plucked strings, like wires held taut and still, or like the traces of simple calculation that they are. And, as always, one reads them as one would a line of text–or an unspoken thought. The final composition, of six bands, the second from the top and the bottom one dense and creamy, the others thinner, has a conclusive force, as of the striking of a tonic chord. As a whole, the cycle has the uncanny ability to cleanse the air and purify sight. Perhaps significantly, these paintings (and others of this family) are even harder to reproduce than the grids of the sixties. Firsthand viewing, in real time (and lots of it), is imperative.

Of the work that emerged after Martin's retreat from painting, it could be said that the urban grid gave way, gradually but conclusively, to a rural vision of open expanses and to sunlit shades of desert, rock, and sky (although, as always, she would resist such associations to the landscape). It could also be said that drawing had given way to painting as the work's disciplinary basis. Or that voice had ceded to vision: instead of ceaseless, sometimes querulous lines of rumination, the post-New York paintings offer more purely retinal and sensual prospects, distilled experiences of unshadowed light. But the penciled line never disappeared entirely from Martin's work. Sometimes vanishingly faint, it always lurks behind the painted bands, and is increasingly like the always-present–if only implicit–guiding lines of a musical score.

And as before, the surface is minutely considered, so the presence of the artist's hand, and of her relationship to the canvas, is easily sensed when you stand in front of it. You feel very strongly that when she painted, Martin saw nothing else: the field of painting was her field of vision. But it is also somehow evident, perhaps from the clarity and resolution of each painting, that she had seen it before its execution, as an inspiration, and had obediently undertaken to produce it as a painted image. The truth

of this may be only notional, and unconvincing without the support of her writing, but it presents itself as a powerful lens through which to see Martin's work.

•

With Martin's resumption of painting, critical attention grew and shifted. The Philadelphia ICA exhibition that opened in January 1973 had generated a great deal of favorable criticism, suggesting a pent-up interest. Because the exhibition preceded Martin's return to full-time painting, it brought renewed attention to her grids, now positioned in an altered context. In the years since her work had first been shown and reviewed, the effort to place it within the contending stylistic, ideological, and social categories of the 1960s had given way to a near consensus that she was, in her work as in her person, a committed outlier, fundamentally at odds with the conceptual and material bases of Minimalism. With this round of responses, hair-splitting distinctions between varieties of spare abstraction were largely abandoned—replaced, in part, by equally scholastic disputes over varieties of the sublime. The shift depended, in no small part, on the new availability of the artist's spoken and written thoughts. A special section on Martin in the April 1973 issue of *Artforum* included a text by Martin, "Reflections,"[18] which was "transcribed and edited" by Lizzie Borden (who also contributed the article about Martin's early work cited earlier[19]). It is the text that begins, "I'd like to talk about the perfection underlying life when the mind is covered over with perfection and the heart is filled with delight but I wish not to deny the rest." Also in this issue of *Artforum* was an article by Alloway,[20] who covered some of the same ground he'd explored in the ICA catalogue essay; he wrote about Martin that year for *Studio International* as well.[21] In *Art News*, Carter Ratcliff pursued the new typology, contending that she was not a classicist but a romantic and invoking Edmund Burke's distinction between the balanced compositions of classicism and the "artificial infinite" of romantic pictorial construction, which instead yields the sublime. Ratcliff, too, quotes the artist to support his views.[22]

Writing in *Art in America*, Peter Schjeldahl, like others, cited the artist's texts, which he found strikingly modest.[23] Schjeldahl proclaimed, moreover, "the issue of her connection to Minimalism, once seemingly important, now seems hardly worth mentioning except to be dismissed." On the other hand, in a profile for *Vogue*, Barbara Rose argued, somewhat reluctantly, that Martin's paintings "share sufficient stylistic characteristics with Minimal art" to be seen within its context, although Rose also noted that, "like Rothko and Newman, Martin uses light as a metaphor for spiritual radiance" and that "her work is a very contemporary expression of the classical spirit," at once surprisingly sophisticated and "oddly sensual."[24] Rose, too, quotes Martin's statements. In the *New York Times*, the notoriously dyspeptic Hilton Kramer pronounced Martin's paintings a "remarkable achievement," finding "nothing clamorous in her style. Nor is there any personal mythology or media celebrity to focus attention on what she has accomplished"–this despite the growing renown of both Martin's work and her character. (Rose asserted the artist had "shocked the art world by closing her studio at precisely the moment her works began to achieve widespread recognition.") Kramer, like Schjeldahl, argued that the association of Martin's work with Minimalism was misleading. Instead, he praised what he termed "an intimism of the spiritual life, at once mystical and relaxed."[25]

Three years later, two simultaneous New York shows, one of new work, at Pace, and the other of work from the sixties, at Elkon, elicited a stronger shift toward lyrical descriptive language, this in order to embrace the new, post-New York paintings. In another review for the *New York Times*, a downright rhapsodic Kramer noted in the older work, especially, "the quality of religious utterance, almost a form of prayer"–a phrase that gained considerable currency–and found that the paintings of the seventies introduced a palette for which the word "color" was "too colorful and sensuous, too worldly and theatrical ... for what is there," a distilled essence that "we experience as light."[26] Thomas Hess, writing for *New York* magazine, allied Martin with nineteenth-century American Luminist painters, famed for

their depictions of preternaturally still, jewel-like landscapes. Hess heard
a mystical note as well, writing that in contrast to the grids, "as calculated
as a Swiss watch," Martin's new paintings "have an informal look—like a
God-made desertscape or a man-made inspiration."²⁷ In a 1978 review of
an exhibition of watercolors, John Ashbery compared Martin to Northwest
artists Still, Cage, and Tobey, and noted as well the "new luminosity" of
the work that followed her "dry period." But, borrowing from Norman O.
Brown, he also described, with uncanny sympathy, the "whispered speech"
of Martin's watercolors, which struck him as "almost distressingly pow-
erful." Ashbery compared the attention her work requires to listening to
"the whispered sequences of Webern's music, where one can hear and
distinguish seemingly for the first time a B-flat from an A-sharp."²⁸

With Donald Kuspit's 1982 review of a show at Pace of colored stripe
paintings, the effort to discriminate among variants of sublimity pro-
ceeded apace. Borrowing a distinction drawn by Kant, Kuspit compared
the "dynamic" sublime, which he said characterizes Martin's work, to the
mathematical.²⁹ In a 1987 feature article, Thomas McEvilley countered
with an ascription of "the abstract sublime, with its constant shifting back
and forth between ontological and epistemological terms, between pure
being and pure consciousness." A scholar of world religions as well as of
classical thought, McEvilley found both Taoist and numerological bases for
Martin's work, counting the number of vertical and horizontal lines in the
early grids, and also in the later striped compositions, and observing that
"the works tend to cluster around the simple ratios 1:2, 2:3, and 3:4, which
have long been viewed as creative and dynamic.... Pythagoras found that
in music they make up the three so-called 'perfect' intervals." In affirming
the affinity of Martin's painting with music, McEvilley lends weight to the
contention that Kant's "mathematical sublime" (rather than the "dynamic
sublime" for which Kuspit argued) stood close to the heart of her work.³⁰
Holland Cotter's review of a 1989 exhibition of gray paintings found, in
the ineluctable evidence of Martin's hand, "a signature without an ego"
and argued, "it is hard to think of any other painting today that makes

self-identity and self-abnegation so nearly one thing." More distinctively, Cotter was among the very few writers who detected profound darkness in Martin's sensibility, observing that the work's formalism was "as much about desperation as about a deity."[31]

While Martin continued to avoid contact with critics and neither endorsed nor opposed their interpretations, she was not disengaged from the decisions determining how—and where—her work was shown. In an undated note to Arne Glimcher, whose Pace gallery had opened a SoHo branch in 1990 (it closed in 2000), Martin wrote:

> I have only one worry in the world! It is that my paintings will show downtown and fail there. They will fail because they are non-aggressive—they are not even outgoing—in a competitive environment, with big displays of aggressive artwork.... The competitive environment is made by the huge audience of mostly young (ambitious) painters that are "making" the "scene." The "art scene" is really a lot of words put out by journalists. With its changing trends it bears very little relation to ART... I particularly do not want to be on the art scene. If you come on with the scene you go off with the scene.... I am deeply concerned about this. What I want is ... just a little room, just a few paintings, contemplated quietly. Unaggressive paintings.*

The asterisk from the last leads to "for unaggressive collectors." Martin concludes by writing, "hoping you agree with me."[32] She was surely right. The brash expressionism, on the one hand, and photo-based postmodern imagery, on the other, that were then predominant in SoHo galleries would have provided a much less supportive context than the quieter precincts of East Fifty-seventh Street that she preferred. She kept her distance, in New Mexico, but she also kept a sharp lookout for her painting's best prospects.

For all the close attention paid by critics to Martin's work in the 1970s and '80s, many observers remained stubbornly fixed on the paintings of her New York decade and on the visual mechanics of the grid, which by

the early 1980s she had abandoned almost entirely. This focus was supported by Martin's inclusion in such exhibitions as *Grids* (January–March 1972), organized by Lucy Lippard for the Institute of Contemporary Art in Philadelphia and preceding by a year the Martin survey that Delehanty assembled. Lippard's show had represented a broad spectrum: Ad Reinhardt and Ellsworth Kelly were included; so were such younger artists as Eva Hesse, Joan Snyder, Merrill Wagner, Mary Heilmann, and Dona Nelson–"perhaps by coincidence perhaps not," Lippard wrote, "many of the artists who have drawn a particularly unique interpretation from the grid's precise strains are women." Also shown was work by (among others) Carl Andre, Jasper Johns, Alfred Jensen, Sol LeWitt, Robert Ryman, and Andy Warhol. Lippard's catalogue essay began: "The grid *per se* is of absolutely no importance to any of the artists in this exhibition," providing only an "armature" for various means and ends. Indeed, Lippard embraced the arbitrariness of her chosen aggregation, since the very idea of a unifying critical rubric seemed to her suspiciously authoritarian. Although she did offer that "the grid is music paper for color, idea, state of mind," and that "its perfection is temptingly despoilable," she mostly let the artists speak for themselves. Ad Reinhardt was quoted as having said, "If you want to be left with nothing, you can't have nothing to begin with." LeWitt perhaps spoke best for Lippard's own interests at the time when he said, "To work with a plan that is pre-set is one way of avoiding subjectivity." Martin's own writing doesn't appear in this essay, but Lippard notes, "Agnes Martin's channels of nuance ... are the legendary examples of an unrepetitive use of a repetitive medium."[33]

If Lippard deliberately refrained from theorizing about the grid, whether in particular instances or as a generic form, Rosalind Krauss dived in deep, and in two highly influential essays of the late seventies and early eighties illustrated her ideas with Martin's work. "Grids," written in 1978 and first published in *October* 9 (1979),[34] begins by arguing that the grid, emblem par excellence of modernity, installs a barrier between vision and language, and also between art and reality: it is, Krauss writes, "what art

looks like when it turns its back on nature," creating an order "of pure relationship." While the orthogonals of perspective-based painting map space, the grid, "if it maps anything . . . maps the surface of the painting itself." This is a straightforward statement of formalism. But from Mondrian and Malevich to Reinhardt, Krauss continued, painters who have availed themselves of grids have invoked spirituality, initiating a dramatic opposition of spirit and matter. "The grid's mythic power is that it makes us able to think we are dealing with materialism (or sometimes science, or logic) while at the same time it provides us with a release into belief (or illusion, or fiction)," she maintained. "The work of Reinhardt or Agnes Martin would be instances of this power." In other words, the grid is a myth in the structuralist sense, in that it allows two contrary views "to be held in some kind of para-logical suspension."

At the same time, Krauss suggested, psychoanalysis helps us see that the grid allows a contradiction to be sustained "in the consciousness of modernism, or rather its unconscious, as something repressed." She went back to the late nineteenth century, with its pioneering studies of light and of the physiology of perception, to find grids in both neo-impressionism (in its scientism) and symbolism (insofar as windows were a favorite metaphor), and summarized, "I do not think it is an exaggeration to say that behind every twentieth-century grid there lies—like a trauma that must be repressed—a symbolist window parading in the guise of a treatise on optics." Introducing yet another opposition, she contended that, in centrifugal fashion, the grid is sometimes "an introjection of the boundaries of the world into the interior of the work." Martin's work, she says, falls into this category, in which the surface tends to be dematerialized.

In conclusion, Krauss proclaims, "Because of its bivalent structure (and history) the grid is fully, even cheerfully, schizophrenic." In defending the application of clinical terms to a cultural phenomenon (the grid), Krauss explained that she was tracking a symptom across a range of instances, rather than scripting a narrative that develops over time. It goes without saying that Krauss's use of the term "schizophrenic" in connection with

Martin's work entailed not the slightest implication that there was a link between the artist's painting and her mental illness (of which Krauss was almost certainly unaware). But it also suggests the freedom with which psychoanalytic formulations and diagnostic terms have been applied, by Krauss and others, to art clearly not motivated by the internal, emotional experiences for which those terms were coined. On the contrary, psychoanalysis, for Krauss, was a sharp tool for separating woolly-headed introspection, and its proponents, from scholarly investigation of the patterns of cultural production.

Like "Grids," Krauss's "The Originality of the Avant-Garde," first published two years later, opens with an image of one of Martin's grids from the mid-1960s. In another wide-ranging consideration of the grid, as an emblem of novelty "that is constantly being paradoxically rediscovered," Krauss contended that some artists became caught in the grid's meshes, such that "their work virtually ceases to develop and becomes involved, instead, in repetition. Exemplary artists in this respect are Mondrian, Albers, Reinhardt, and Agnes Martin."[35] This despite the fact that Martin's work had, by 1978, turned toward striped compositions. These essays had already helped consolidate understanding of Martin's work as enduringly grid-based when, a dozen years later, Krauss revisited it, in her catalogue essay for the 1992 retrospective at the Whitney Museum—the artist's first major solo museum exhibition.

Organized by Barbara Haskell (who had been curator at the Pasadena Museum of Art when the ICA show traveled there), it was among the most significant exhibitions of Martin's career. Besides presenting work from the 1960s, it afforded audiences an opportunity to see little-known early assemblages, biomorphic abstractions, and black and gray paintings, as well as the color-suffused striped compositions she had been creating since the middle 1970s. The catalogue included an essay by Haskell that treated Martin's development with great sensitivity, discussing her writing and beliefs, tracing the outlines of her early life, noting the art communities in which she participated, and considering the full range of her work in

relationship to these shaping influences. Another powerful essay, by Anna Chave, discussed Martin's work in relationship to her Abstract Expressionist peers and considered the gender politics (of which more later) that framed its reception. The catalogue also included some examples of Martin's writing, among them her views on the response to art, on humility, and on the question of what is real.

But it is Krauss's essay in this volume that is most often cited in subsequent criticism.[36] It begins ingratiatingly ("Do you remember the hilarity, as a child..."), by way of introducing a discussion of the film *Gabriel* and the problem of nature imagery in Martin's work generally. Soon, however, Krauss delivers a sharp slap to complacent readers ("In the exceedingly superficial and repetitive literature on Agnes Martin..."), alighting on the "arresting exception" of an early article by the little-known Kasha Linville, which observes (as have many writers, before and since[37]) the distinct experiences Martin's paintings offer from different viewing distances. In a bravura performance of criticism, Krauss designates three such experiences—the close reading of "facture and drawing"; the crucial middle-distance view from which "the paintings go atmospheric"; and the last, most distant one in which they become opaque shapes—proceeding from these positions to the formulation, by the theorist Hubert Damisch, of the bracketed term /cloud/. Krauss paraphrases this /cloud/ as an entity that doesn't fit into a given system, but defines it nonetheless. An optical mechanism developed by the Renaissance master Brunelleschi, along with a classificatory system shaped by the late nineteenth-century art historian Alois Riegl, are called into play to place Martin's work as both an exemplar of classicism and of formlessness (a mode of art-making, associated with Georges Bataille, that Krauss has explored extensively elsewhere). Notably, Krauss concludes by characterizing not a specific painting by Martin, or even a body of her work, but rather "the grid," which in Krauss's essay still stands for Martin's entire oeuvre.

For her part, Martin, who was eighty when the Whitney exhibition opened, demonstrated little interest in the critical maneuvers of the time.

She was, naturally, enormously gratified by the recognition the exhibition offered, and photographs of her at the opening reception—shaking hands with Chuck Close, standing beside Jill Johnston, Barbara Haskell, and Arne Glimcher—show her happy if a little distracted; as always, she negotiated the art world's social events from a careful distance. (David McIntosh, who accompanied Martin to New York, recalled that Flora and Sidney Biddle gave a big dinner party in her honor, which, McIntosh said, she enjoyed immensely.)

Once again, the critical response was largely favorable.[38] At the same time, a number of writers noted, not always happily, the growing importance of her character. Deborah Solomon disparaged "her image as a guru of female self-reliance," while allowing, "Fortunately, Ms. Martin is far more subtle as a painter than as a cult figure."[39] On the other hand, Kay Larson observed, respectfully, Martin's "evident sympathy with Asian meditation and the mind-set that produces it," while wondering why she wasn't a "bigger star."[40] But as early as 1979, John Perreault had complained, in a review of an exhibition at Pace, "There's an Agnes Martin mystique and it annoys me," a mystique he attributed to her age, endurance, discipline, and withdrawal to New Mexico. Such skepticism should be seen against the growing importance, by this time, of cultural and political reckoning in the visual arts: by 1992, art that took no social position had become suspect.

That condition was a long time in the making. In the late 1960s and early '70s, many artists had turned away from conventional disciplines (painting, sculpture) toward performance, film and video, installation, free-standing work in non-traditional mediums (including those associated with craft), and various forms of art-based activism. In many cases, artists who made these choices were impelled by feminist politics. Martin's forays into film and, at least imaginatively, into earthwork suggest that she was aware of this sea change and interested in testing its waters—although her acknowledged guideposts were mostly works by men. By the eighties, photo-based work that examined the social and sexual codes operating in commercial

imagery had gained ascendance, work that again was strongly driven by women (though this attribution is not always credited). At the same time, painting was also back in play by the eighties, but the favored mode, given a boost by the newly open exchange of artists across international borders, was figurative, expressionistic, big and brash; women were much less prominent in this cohort. (It was, perhaps, this bold, large-scale painting that Martin had in mind when she wrote to Arne Glimcher asking that her work not be shown in SoHo.) Female abstractionists—whether roughly of Martin's generation, such as Joan Mitchell and Lee Krasner, or of slightly later ones, like Anne Truitt, Jo Baer, and Mary Heilmann—struggled to achieve anything close to the visibility of such painters as Brice Marden, Sol LeWitt, Robert Ryman, and their elders, including the notable survivor among Martin's peers, Ellsworth Kelly. The male artists included in Lippard's *Grids* show of twenty years earlier continued to draw more notice than the women. Such disparities would be addressed only slowly and never completely. The nineties would see an even more polarizing emphasis on gender (and racial, and cultural) identity politics, mostly expressed as before in mediums other than painting and sculpture.

Perreault had situated Martin in this developing lineage when he wrote, in his 1979 review, "The rise of the women's movement enhanced Martin's status, for women artists, with some justification, could look to her as an example, a role model." To his mind, such attribution was false: "Martin's use of the grid is sometimes proposed as feminist. Is this because the horizontals and verticals resemble the warp and weft of weaving, which is considered women's work? I think this is nonsense."[41] Martin, of course, was in full agreement. In any case, she did not even see herself as a woman, much less as a feminist—as she had long ago revealed in her comment to Jill Johnston, who'd ventured the thought that Martin might have had a bigger reputation if she was not a woman, and "she shot back i'm not a woman and i don't care about reputations."[42] Later, she would say to Mary Lance that Johnston (who was herself openly gay) had got many things right but was wrong when she said that she (Martin) was a lesbian.[43] Having

left New York before the feminist efforts of the late sixties and early seventies transformed the art world's sexual politics, Martin may have found it easier to dismiss the movement than if she had remained there. Regardless, her rejection of gender identification was adamant and, in her later life, sometimes successful enough to fool strangers, as is illustrated in Arne Glimcher's anecdote of a visit to a restaurant in Albuquerque, where she happily accepted being addressed as a man.[44]

In her catalogue essay for the Whitney survey,[45] Anna Chave had ventured—more or less alone among critics to that point—to consider Martin's place among female peers. "Unlike the handful of other female artists who succeeded in attaining some prominence before the gains won by the feminist movement in the 1970s," Chave wrote, "Martin was hardly ever termed, and therefore marginalized as, a 'woman artist.' Nor would the burgeoning women's movement rush to enfold her as one of its own, as it did with other older female artists such as Alice Neel, Louise Bourgeois, or Georgia O'Keeffe." This was despite, Chave notes, Martin's early and consistent support by female critics. Indeed, she argues, Martin's "astonishing" critical success may have made her later embrace by feminists seem unnecessary, Perreault's assessment notwithstanding. Moreover, the choice of plane geometry and of painting discouraged feminist solidarity: "Martin has been tacitly viewed by some feminists as a kind of sellout, in other words, an artist who used a paradigmatically masculine vocabulary in order to pass as one of the boys, that is, as a mainstream modernist." Nonetheless, Chave saw Martin's work as a deliberate effort to undermine authority, and in so doing, to engage—at least implicitly—in an anti-patriarchal effort: "It was not merely in her use of the grid, but in the way she composed those grids, that Martin implemented her critique of power," Chave wrote. Borrowing the artist's vocabulary, she argued, "Martin's interest in using rectangles and squares to visualize the defeat of aggression by mildness put her conspicuously at odds with her Minimalist peers," such as Judd and Carl Andre. Widely seen as "quiet, self-effacing, devout, and de-sexualized," Martin kept her "unconventional" private life "in the

shadows" and hence exuded "a kind of egolessness" that set her "apart from her male peers."

Perhaps not surprisingly, Martin didn't endorse this reading.[46] In an interview conducted at around the time of her show at the Whitney, she pronounced, "The women's movement failed. They"—note the pronoun—"aren't any more free than they ever were." She reported not the slightest discrimination against herself or women artists of her acquaintance, although she did admit one difference: "Men artists can get married and go right on being artists. Women artists who get married don't have a chance." Art, Martin went on, shouldn't have a gender. "I'm for keeping the field of art as it is, neither masculine nor feminine."[47] Nonetheless, in her 1987 lecture to students at the Skowhegan School, Martin had encouraged young women in particular, and—anomalously—she made a clear statement of her understanding that women faced particular obstacles. "By questioning your own mind it is possible to have absolutely original thoughts," she promised, but cautioned, "Your conditioning has taught you to identify with others—their emotions and their needs. I urge you to look to yourself. In our convention it is particularly difficult for women." And a decade later, she said to Mary Lance, "I'd like to say to women painters that they can get married and have their children and when the children are independent, that they still have years and years to paint—if they live as long as I do, anyway."[48] But to Michael Auping, in an interview of around the same time, she insisted, "My art has never been about politics or form. I'm not a feminist the way some people describe it."[49] Finally, when asked in a 1999 interview, "Have you ever thought of yourself as a feminist?" she replied, "No, no, no."[50] Clearly, she wanted this question disposed of, conclusively.

As she grew older, and perhaps less cautious, Martin also made clear her impatience with the whole noisome business of social injustice and the activism that resists it. Harmony Hammond considers Martin to have been "right wing" and recalls Martin referring dismissively to "those women, the Indians, the poor, that feminist thing." According to Hammond, Martin was

against abortion; she believed sex was degradation;[51] she did not identify as a woman. And she found some confirmation for her attitudes in her heterogeneous local community; Hammond reports that people stood and cheered when Martin said, in a 1989 talk at the Museum of Fine Arts in Santa Fe, "The political world is a structure conceived and agreed to by us but it is not reality," and further, "the political is a negation of life."[52] While elsewhere in the art world increasingly thorny debates over theory and politics prevailed, Martin sustained a commitment to policing the boundaries between art and everything else.

This is not to say that she spurned social obligations on either a personal or community level. When she became wealthy, she sought out ways to share her bounty, from significant acts of philanthropy to taking people out for lunch. Her acts of non-material generosity were just as important in sustaining the many deeply loyal friendships she continued to have. Some of her social judgments seem to have become crude. At best they were careless. But if she was against the women's movement, and political engagement of any kind, it was because she was against anything that stood in the way of maintaining an innocent, untroubled mind.

—— Chapter 9 ——

CONTOURS REDRAWN

Soon after the Whitney show opened, Martin moved back to Taos, where she remained for her final dozen years. The retrospective—and others at the Stedelijk Museum in Amsterdam (1991) and the Serpentine Gallery in London (1993)—along with the 1992 publication of her writings by Hatje Cantz, had brought a new degree of visibility, which may have spurred her move. So might have her advancing age. In Taos her daily regimen was simple: she lived in a retirement residence, painted at a studio in town, and lunched, almost daily, with a friend or acquaintance.

In the many interviews she gave in her last years, a few themes are repeated, including her rather vexed relationship to music and the importance to her of friends, reading and, always most necessary, work. To Rosamund Bernier, in a 1992 interview for *Vogue*, Martin reported that she still did not have a TV. "She enjoys music," wrote Bernier, "Beethoven symphonies, above all—but rarely listens to it. 'Too stimulating,' she says." And when she was asked whether she read in the evening alone, she answered, "I don't read nonfiction. Big thinkers stick to your mind, prey upon you, and bring destruction. I prefer detective stories." Which ones, Bernier wondered? "The same as everyone else, Agatha Christie," Martin replied.[1]

In another interview the following year, she again explained her reading habits: "If you read non-fiction like philosophy, history and all that,

it sticks on your mind and preys on your mind. The next day when you try to get inspiration you think of the ancient Greeks or whomever. So what you have to read is what will go through the mind, in one ear and out the other. For me that's detective stories. As soon as it's solved it's gone." Confirming that Christie's detective novels were her favorite, she said, "I read them over and over. As soon as I forget who done it, I read it again. I don't get any value out of reading them, so there is no use going on about it," she added, a warning reminiscent of her injunction against citing Zen teachings and other spiritual texts in explaining her work or her character. On the overstimulation caused by music, she explained, rather confoundingly, "I only listen to Beethoven. But he makes me so joyful that I weep. I play some Bach everyday. It keeps me balanced." And on sociability, Martin offered, "I think we are herd animals. We have to do a certain amount of talking and being together. I have lots of friends here and know other artists"; among those she mentioned were Bruce Nauman and Susan Rothenberg, and Richard Tuttle.[2]

Her friends were well aware of her interests. Tony Huston says he took Martin on drives in her last years, often playing Beethoven on the car stereo. When a chamber group traveled to Taos he arranged for them to play a Beethoven string quartet for her in a private performance at the home of Taos residents Happy and Ken Price. Huston said she sat amid them "like a mountain, and beamed."[3] Suzanne Delehanty, who visited Martin at Taos, noted her well-kept studio and her regular lunches, taken at the Taos Inn; as did other friends, she remarked that Martin enjoyed a cocktail—with Delehanty it was a margarita—and a good steak.[4] Those who still considered her an ascetic might have been surprised to learn that her appetites were, as ever, hearty.

In a telephone conversation in 1997, Martin told Holland Cotter of the *New York Times* that her retirement home was "perfect for me. We each have a small house of our own. People come to clean and to wash my clothes. I don't have to think about anything but painting." Cotter reported that she rose early and drove herself the half-mile to her studio. "There

she works steadily from 8:30 to 11:30. By noon, she's at lunch at a favorite restaurant. She spends afternoons reading at home. 'I don't read nonfiction because it sticks in the mind. I have to keep my mind free for painting. I read mystery stories. In one ear and out the other. I like Agatha Christie best. I've read her so many times I practically know the words by heart." (It seems her answers to reporters' questions were equally well rehearsed.) "By 8 pm," Cotter wrote, "she's usually asleep."[5] An interview seven years later again reprised these themes, although her day seemed to have shortened a bit.[6] But it was noted that among the rare breaks in her schedule was a one-day trip to attend the opening of a gallery featuring her work at the Dia Art Foundation's then new home in Beacon, New York.

In other words, the contradictions of Martin's life remained fairly breathtaking. Jetting, when the occasion demanded, between the little insular community of Taos and the cosmopolitan world where her work had become nearly universally esteemed, Martin had constructed a life in reliable equilibrium. Although not without its moments of stress, and of exhilaration, it was kept on an even keel by a routine of her own careful devising, for which Agatha Christie (whom she'd been reading in Galisteo too; a visitor spotted a Christie novel on her bookshelf there[7]) provided, like Bach, manageably stimulating background music—and, at the risk of flouting Martin's prohibition, some telling comparisons with her own habits and preferences. Organized around elegantly constructed systems of perfect and rather stringent logic, Christie's stories celebrate propriety and measured fun; there is drinking and sociability; the characters are psychologically one-dimensional; the moral codes simple. In the early twenty-first century, for someone who had been newly adult when the classic mysteries first gained popularity, they would have been deeply nostalgic. The violence that is at their heart is routine and, by later standards, bloodless. Bad (or questionable, or simply uninteresting) people are dispatched, without much fuss. The smart ones live and prosper. Anger, fear, and death—the last in extravagant abundance—are all shown to be eminently manageable.

The establishment of permanent galleries featuring her work at Dia:Beacon was not the only honor bestowed on Martin in her later years. In 1997 she was awarded the Golden Lion for Lifetime Achievement at the Venice Biennale. David McIntosh recalls how pleased she was to receive a National Medal of Arts award, the following year, during the Clinton administration. Martin traveled to Washington, D.C., to accept it, and she met the President and First Lady. McIntosh says she liked Hillary Clinton in particular. Martin "appreciated her personality," he remembers, while adding that Martin always claimed she did not support women just for the sake of supporting women's rights. Although it was sometimes said that she never followed the news (her opposition to political involvement supports the assumption), McIntosh recalls that she enjoyed reading the newspaper in the Plaza del Retiro every morning, and while she "wasn't involved much in politics, she did support"–perhaps not surprisingly–"both Clintons."[8] She kept a photograph of herself with the President in her bedroom, along with a photograph of some local children, and a very few decorative objects: a stamped tin crucifix, a locally made textile hanging. (As ever, stylish and comfortable domesticity was not her concern.) In Taos, too, Martin was a celebrity. Harmony Hammond was among the guests at a dinner celebrating Martin's ninetieth birthday, in 2002, when Martin shared the dais with other local artists, among them Richard Tuttle, and representatives of the Pace Gallery, including Arne Glimcher and executive vice-president Peter Boris. Martin, Hammond recalls, "was wearing a corsage, and one of her custom-made velvet outfits. Agnes Martin canvas bags were given out. The mayor of Taos proclaimed it Agnes Martin week. Her name was in lights on the hotel in town." A conference was held on the occasion, and "she went to every talk."[9]

Among the others on the dais was Bob Ellis, then the director of the Harwood Museum in Taos. Ellis had a standing weekly lunch engagement with Martin in these Taos years, which bespeaks a friendship he explains with disarming simplicity: "So many people approached her in awe. I didn't do that." Indeed, his reminiscences about Martin are refreshingly

frank. "Occasionally," he says, "she'd turn on people, if she didn't take her medications. She talked openly about it. She had her depressions, and periods when she didn't paint." At the same time, she was subject, still, to all the ordinary emotional experiences of a working artist, including jealousy and—that cardinal sin, for Martin—pride. "Agnes had an ego," Ellis says, "despite her philosophy. She used the word envious of Rothko and Twombly."

Along with routine feelings and prosaic events, their conversation sometimes turned to spiritual matters. Ellis, who points out that the Bible is full of people who heard voices, has consulted oracles for his own spiritual purposes and recalls talking with Martin about receptivity to such sources. On occasion, he says, she would make "spiritual ratings of people. We went to lunch one time and as we sat down she said, let's check your spiritual rating. Her head went to one side, her eyes glazed over, she twitched a little, and she came out with a number, and then she said, 'wow, that's higher than what I thought it would be.'" The unselfconsciousness with which she approached this evaluation, seemingly made with no more fuss than measuring a person's feet for shoes, is striking. It was in a similar spirit that she told Ellis she had been on the planet many times before, as men as well as women, and also as children. She liked to sit in silence, he reports. And she didn't like to be touched.[10]

The easy transition Ellis conveys between Martin's references to states of communion—whether spiritual or social—and of isolation is also striking. It seems she never stopped negotiating between engagement and withdrawal, although in her later years the two conditions seemed less starkly opposed. In a 1993 interview, she said, "I've always meditated a bit. It's a pleasant experience. I don't meditate for hours, just twenty minutes twice a day. A lot of days I don't do it twice." When asked about her technique, she replied, with characteristic matter-of-factness, "I just gradually learned to stop thinking. It doesn't help to try to shut it off forcefully." Similarly, she admitted to having relaxed her standards for suppressing

vanity. When asked if egolessness was her goal in meditating, she answered, "No. It's not possible to be egoless in this world. It's ego that makes us what we are."[11]

Bob Ellis's friendship with Martin was of considerable benefit to the Harwood. Long a shoestring operation, it had started as a cultural center, not a museum, and was taken over by the University of New Mexico in the 1930s, not long before Martin arrived at the Field School there. By the early nineties the university was looking to leave Taos, but couldn't shut the museum and deaccession its collection because of the terms of the founding gift. "We started to show local artists—Larry Bell, Kenny Price—and were always scrounging for shows that wouldn't cost much money," Ellis says. "One day I said to Agnes, if you ever want to show some paintings before they go to New York, we'd be happy to show them. This was around 1994," Ellis continued. "She had just finished ten paintings—she'd recently been to Greece, and they were blue and white. She said, you can show seven of them. Right now.' So we did." The gallery designated for the exhibition was square, "but we built additional walls spanning the corners to make it octagonal, so each painting would have a wall. Agnes came. I brought a rocking chair in, and she sat in it while we hung the paintings. She said, the Whitney doesn't let me do this. I had an epiphany that if she would give us the paintings we would build a gallery. No one had ever asked. She said yes." With Arne Glimcher's agreement (and some negotiation over which paintings would be part of the gift), the donation was made, and a permanent gallery built, with an octagonal floor plan and an oculus in the center of the ceiling that admits natural light. A cluster of Minimalist seats, designed by Donald Judd, sits at the center (pl. 36). According to Ellis, "Peter Boris [of Pace Gallery] and his wife offered to donate the Judd benches. Unfortunately he sent color samples to Agnes, in red, green, brown, and ocher. Agnes wanted one of each. I had to fight that with Agnes. I told her they'd clash. She said, the paintings will hold their own. I had to practically tell lies to convince her" to accept a single

color (ocher). "Afterward, I went to pick her up for lunch, and she climbed in the car and said, well, I lost that. She didn't like to lose."[12] Nor did she care to refine her taste in furnishings.

In her later years Martin exercised her will less by her stubbornness than by her generosity—her always anonymous philanthropy extended to support for two parks in Taos and a public swimming pool there as well as a substantial financial gift to the Harwood—though hardheadedness persisted. In 2000, when she was nearing 90, she was asked if she still drove much. "Oh yes," she answered. "It's so easy to drive my car. When I first got it, I drove for six hours. Up to Questa, Red River, Eagle Nest, then I went down to Cimarron, Canyon, Springer, and then came back to Ocate, then Mora, and then I came home. In one day. I drove it to see if I'd get tired. Everybody tells me I'm too old to drive. So I checked to see if I'd get tired, but I didn't." And then, replying to a question bearing on her interest in other artists, she said that when she was in Los Angeles, where she had gone to see a show of her own work, she also went to a David Hockney exhibition that included the big painting *Grand Canyon*, which she pronounced "a knockout." Laughing a little, as she so often did in interviews, she added, "You just wonder how he can ever make so many colors look so good."[13] The year before she died Martin was still driving, in what Lillian Ross, writing for the *New Yorker*, described as a "spotless" E320 Mercedes. "I don't eat supper," Martin told Ross, nor did she listen to the radio or watch television. But she was still listening to music; this time, she said it was Beethoven's Ninth. "Beethoven is really *about* something," she said to Ross. And then, as if to clarify, "I go to sleep when it gets dark, get up when it's light. Like a chicken. Let's go to lunch."[14]

•

Martin's delight in Hockney's rainbow palette bespeaks the same joy she took in the range of color choices available for the Harwood gallery seating. Her own work's color spectrum remained narrow, although some liberties were ultimately taken there too. The Harwood paintings are, as

Ellis observed, executed exclusively in various shades of Mediterranean blue and white, all powerfully sun-bleached. Shortly before making them, as Ellis noted, Martin traveled to Greece, a trip that Suzanne Delehanty says was particularly important, because of the artist's commitment to classicism. At the same time, the filmmaker Mary Lance says that in her late eighties, Martin admitted she was influenced by the blue sky of Taos. And she also said, "I was brought up on the ocean and I tried to convince myself that I like the mountains as much as the ocean, but I don't. I like the ocean better."[15] Both bracing ocean air and the sharp light of the Taos high-desert landscape can be felt in these seven Harwood paintings, all made in 1993 or '94, and all in her late, 5-foot-square format. The octagonal shape of the room in which they hang encourages the viewer to experience them as a group, and the oculus admits unifying light, but the paintings themselves do not produce, together, the sense of an environment, nor even of a specified sequence. Despite their shared palette and compositional elements—horizontal bands of varying width and pattern—each requires dedicated, individual face-to-face contemplation: a lunch for two.

A few have the rhythm of slow ocean waves, with broad bands of pale blue alternating with white, edge to edge across the canvases. The penciled lines that rule the divisions are sometimes scarcely visible and, in other cases, more insistent. In some, the whites seem pure oxygen and the blues crystalline, while in others there is a heavier, heat-struck atmosphere, and the blues range from radiant and liquid to nearly lightless. In one, the blue goes quite flat, almost gray, like water on an overcast day. There are lively, even agitated canvases—with narrow stripes, more saturated colors and visibly brushy paint application—and quieter ones. In *Playing*, a strong illusion of volume is created where bands of blue are bordered below with shadow-like strips of darker blue, and above with narrow strips of bright white, which—as in a couple of paintings in *The Islands* series at the Whitney Museum—creates the impression of substantial horizontal louvers, their top edges here sharply illuminated. The titles of the other paintings are unabashed declarations of purpose: *Lovely Life, Love, Friendship,*

Perfect Day, Ordinary Happiness, and, inevitably, *Innocence,* this last a calm composition in which there are six even, broad bands of blue so pale and hushed they nearly register as white. The experiences identified by some of these names (*Lovely Life, Perfect Day*), and by other titles like them attached to many later works, can be dismissed as naive. Believing in the possibility of realizing such experiences in images is the hard work of a long lifetime.

A related series of eight paintings, in the collection of Dia Art Foundation and on semi-permanent display in its Beacon, New York, facility, is dated 1999 and titled, as a group, *Innocent Love* (pl. 37). These 5-foot squares, all again composed of horizontal bands, add yellow and a pale orange to the dyad of blue and white. The fourth work in this series is banded at the center with a heraldic pair of stripes, one orange and the other a surprisingly electric blue; the whispery yellow ground that these stripes cross is a luminous wonder (especially lit by shifting daylight admitted from overhead, as it is, again, at the skylit Dia:Beacon). Sometimes the blue is watery, like satin ribbon. Several of the bands are broad enough to constitute fields; in one case, two such areas of blue create a quite breathtaking sense of open, cloudless sky. The final canvas brings together pale red, yellow, and blue bands, two of each, all the same width, in a sunset spectrum that is unabashedly simple and almost absurdly beautiful.

Other late paintings experiment further with colors new to Martin's work. Still opposed to depicting the landscape, she remained, as ever, an ardent observer of her natural environs, and her descriptions of them are, as before, easily tied to her work, as when she said of Taos, in 2000, "It's still a little town. You can be in the scenery right on the edge of town." Unlike regions where "the mountains are jammed up together... here you have mountain, plain, mountain, plain. It's a great experience of space."[16] It's also a great account of the rhythm of much of her late work, the palette of which began to change with the turn of the century. A group of paintings exhibited at Pace in April of 2000, all dated that year, introduce a range of greens; a fairly saturated orange appears as well. In *Innocence,* pale

forest-green bands course across a creamy white ground. Mossy greens also appear in *Everyday Happiness* and *Love*. In *Happy Holiday*, single green stripes appear at top and bottom; between are pale orange stripes alternating with white, but an unusual calculation results in a striking asymmetry, with white bordering green at the bottom and, at the top, orange with green. The Christmassy combination of reddish orange with piney green hints at an explanation of the painting's title, but it may be more easily explained by Martin's 1973 statement, "Although helplessness is the most important state of mind the holiday state of mind is the most efficacious for artists: 'Free and easy wandering' it is called by the Chinese sage Chuang Tzu."[17] *Infant Response to Love* combines nursery shades of very pale yellow and baby blue, in pairs of bands each separated by white. Buttery yellow stripes appear in others of these paintings, along with pale red-oranges.

Over the next few years, anomalies multiplied and old motifs reappeared. Vertical stripes return after 2000, as do the occasional intersection of vertical and horizontal. In *Untitled #3* of 2003, the top half of the canvas supports a fine grid, hearkening back to earlier paintings; below is a solid field of pale greenish yellow. *Untitled #22* of 2002 features two blue vertical stripes at the margins and a field of very warm off-white between them; this wall-eyed composition, a kind of inside-out Barnett Newman, creates the sense of a field too big to see at once. *Benevolence*, 2001, features six yellow bands separated by narrower white ones, the color so pale it disappears as you approach. *Gratitude*, 2001, presents a deep, fresco-like orange field at the center, paired with white; light pea-green stripes appear on either side. Pale orange bands, bordered and separated by white, constitute *I Love the Whole World*, 2001. The quiet ecstasy of these paintings is as plain as their titles.

Not all of Martin's late paintings are buoyant. There are a number of late paintings that employ black or shades of gray. Most of these are untitled; they represent states of mind Martin chose not to name. Among them is a vertically striped gray canvas, *Untitled #4*, 2002, a baleful planked wall.

Untitled #17, 2002, is banded at the top with a washy gray that is repeated in two squares at its bottom corners. The field in which they float is of the very densest black, the matte paint apparently both brushed and knifed on, with a ruthless, rather frenzied determination in which it is not hard to discern something like terror. In *Untitled #21* of 2001 there are also two squares, this time black against a gold-toned ground; a gray band runs horizontally beneath the tops of the squares: darkness held in balance against radiance. A black trapezoid looms in the center of *Homage to Life*, 2003, floating in a field of grainy gray like the pitch-dark shadow of a New Mexico mesa. In *Untitled #1*, 2003, two equilateral triangles sit side by side, precisely spanning the canvas, each topped by a yellow point. Again black as tar, they suggest the ghosts of mountains or, more whimsically, pencil tops. In one of Martin's last paintings, *Untitled*, 2004 (pl. 38), two black squares float on a pale gray ground, one rising up on the left toward a pair of bands, yellow and royal blue, that run across the top edge. The second square drifts toward the bottom, but doesn't reach as close as the other to the canvas's edges. In the context of Martin's oeuvre as a whole, the asymmetry of this composition and its unfamiliar forms and colors have the pull of an incipient narrative.

The reintroduction of floating geometric elements, not seen in Martin's work since the 1950s, suggests retrospection and also, maybe, a ferociously determined effort to look into the future: to picture the black door through which she would soon be going. Perhaps, as she sometimes said, she expected to return—reentering, even more speculatively, through one of the paired abysses she pictured. But of course such literal (and admittedly reductive) symbolism was anathema to her. In any case, as other late paintings indicate, she may have expected only the most transcendent radiance. What seems likeliest is that she considered the alternatives, actively, and fought to conquer sometimes harrowing fear with clear-eyed curiosity.

Among the notes that the filmmaker Mary Lance took during her conversations with Martin is the transcription of a poem she spoke. It reads:

My old eyes and the fields looking back
Praying in the summer sun
Speaking the low hum of stretched out time
My old eyes tell me the long happening of it.

In this late-life conversation between vision and thought, the volume of internal speech has been lowered. It is time that has accomplished this attenuation, which seems to have brought peace and the joyful states named in the light-suffused later paintings. Martin had told Bob Ellis that even when she was living in Cuba she would come up to Taos to write talks, and it is clear she continued to find sustenance in the landscape there with its surrounding mountains, the majestic Taos Mountain preeminent among them.

Martin's last, unexpected work is a slightly wobbly line drawing in ink of a small, unremarkable potted plant (pl. 39). It is 3½ inches high. Here is the rose whose beauty does not die with it, the simple, humble face of nature, unsublimated and nonetheless perfect. She had resisted descriptive representation for decades, and at the last, in an image that looks like a blind contour drawing—she seems to have been looking at the potted plant, not the paper—the struggle that she (like Ellsworth Kelly) had long waged against the lure of the glorious natural world is resolved to a single, delicately meandering line.

•

Martin died on December 16, 2004, at 92, of congestive heart failure. She'd been in sharply declining health for six months, during which time she had ceased to work. With her passing, new aspects of her life came under consideration. And along with the opening of new perspectives, a certain fractiousness arose, starting with the circumstances of her burial. Her old friend Kristina Wilson reports, "on her deathbed, I asked if she'd like to be buried in a park she'd created—she'd planted oak trees there—north of

Taos on the Rio Grande. She was very weak and wasn't able to talk but she beamed and nodded. I asked if she'd sign a statement to that effect, and she barely scribbled her name. Then she said something barely audible to the nurse, who understood her to mean she wanted it notarized."[18]

In Arne Glimcher's telling, Martin had said she wanted to be buried next to the gallery at the Harwood where her paintings are installed; he notes that New Mexico prohibits burial on government land, and that the museum and its property are owned by University of New Mexico, a state institution. Hence, he says, the cloak-and-dagger nature of the interment that transpired, under an apricot tree beside the museum. The concerned parties waited for the spring thaw, and at midnight under a full moon Glimcher, David McIntosh, Bob Ellis, and Derek Martin, her nephew, all

scaled the adobe walls of the garden with a ladder. David had brought a shovel and Agnes's ashes, and we cleared the earth of last fall's apricot leaves and dug a deep hole among the roots of the tree. David had also brought a Japanese bowl with a gold leaf lining to receive her ashes. The sky was clear and just before we placed the ashes in the bowl its gold lining reflected the moon. With handfuls of ashes we took turns putting Agnes to rest underneath the tree. We covered the grave with earth, replaced the fallen leaves and covered our tracks.[19]

As these conflicting accounts hint, it was not clear until she was gone how vigorously, and how successfully, Martin had constrained discussions of both her life and work, not just by inhibiting catalogues but also by eliciting pledges of silence from friends. In the decade following her death, her paintings and her persona began to be framed in contexts that significantly challenged previous understandings. In 2004 the first of three exhibitions surveying Martin's career opened at Dia:Beacon. A long-term installation of Martin's work now occupies several galleries at the big, spare museum in a riverfront town north of New York City. On the face of it, this presentation, at an institution sometimes called the high church of

Minimalism, consolidates Martin's position within the pantheon of late twentieth-century abstractionists, while emphasizing her important link to the generation that succeeded her—and from which she had made such strong efforts to distance herself. But it is not simply by its association with Minimalism that Dia's support for Martin complicates the understanding of her work. As Anna Chave has pointed out, "church" applies to Dia as more than a figure of speech;[20] its founders, Heiner Friedrich and Philippa de Menil (later Fariha Friedrich), are adherents of Sufism (Islamic mysticism), a sect that "has tended to value an aniconic and 'contemplative' visual art that 'expresses above all a state of the soul that is open toward the interior, toward an encounter with the Divine Presence.'" In Islamic art generally speaking, and more specifically within Sufi poetry, beauty, Chave writes, "is considered of the essence, as beauty is tantamount to the 'face of God.'"[21] These priorities are strikingly close to Martin's, even if the specific practice of Sufism was foreign to her. If the Dia foundation "ensured a fuller development of a spiritualized and epic chapter to the Minimalist story than would otherwise have been possible,"[22] then its support for Martin has confirmed that her work will continue to be seen through a screen of ideas and associations, from Minimalism to mysticism, from which—despite her early affiliations—she also took pains to distance herself.

The Friedrichs were hardly alone, in the 1970s, in their devotion to esoteric spiritual practices and an art of transcendent experience. Chave cites founding Minimalist Robert Morris, who wrote in 2000, "Minimalist art at its zenith in the sixties was a kind of religious art. Unfrocked, perhaps, but religious nevertheless." In Minimalism, "that old-time religion of Puritanism and transcendentalism grafted to Deweyan pragmatism's aesthetics of wholeness achieves its full blown ideological synthesis."[23] (Again, these references perfectly describe the range of ideas that shaped Martin's sensibility early on.) And the early twentieth century's links between various spiritual regimens and geometric abstraction, never entirely lost to sight, were reinforced by the ambitious—and, admittedly, unevenly received—1986 exhibition *The Spiritual in Art: Abstract Painting 1890–1985*

at the Los Angeles County Museum of Art. Its omnivorous catalogue refers to many of the spiritually inclined artists with whom Martin had had contact, from the Transcendental Painting Group formed in Taos in 1938 to Martin's friends Reinhardt, Kelly, and Nauman.

Martin was not included in *The Spiritual in Art*. But it provided the art-world debut for Hilma af Klint, who, along with Emma Kunz,[24] joined Martin in a notable 2005 exhibition at the Drawing Center in New York, "3X Abstraction: New Methods of Drawing," which provided a quite radical repositioning of her work. Af Klint (Swedish, 1862–1944) and Kunz (Swiss, 1892–1963) were both healers as well as artists and considered their drawings and paintings tools of their spiritual, diagnostic, and therapeutic practices. Little known in the upper reaches of the art world during her lifetime, af Klint in 1892 formed a group with four other women called The Five; they engaged in weekly séances during which automatic drawings were made as early as 1896. Highly influenced by mystical ideas that had wide credence at the time, they believed their drawings and watercolors could "lead the viewer into other levels of awareness . . . through glimpses of the fourth-dimensional."[25] Af Klint's compositions, organized around concentric circles and other geometric figures and executed in symbolically significant colors, can be said to be among the very first examples of non-figurative abstraction—although perhaps the term should be qualified to reflect that these images were *about* something: they referred to a system of belief.

Similarly obscure, Kunz by 1910 had begun to experiment with telepathy and prophecy and had taken up radiesthesia, the practice of divining with a pendulum. In single sessions with patients that could last more than twenty-four hours, Kunz traced on graph paper the tracks of a swinging pendulum, with which she claimed to channel "external forces."[26] The drawings provided the basis for diagnoses; they also served to locate the patients' lifelines and aid meditation.[27] Her drawings can, again, be called remarkable early examples of geometric abstraction. Their multitudes of radiating and parallel lines, inscribed within various geometric

figures—stars and circles, primarily—establish vibratory fields meant to engage the viewer on every level of perception. But even more than af Klint, Kunz considered her drawings to be inseparable from a psychological and spiritual regimen.

Catherine de Zegher, the exhibition's curator, states in a catalogue essay that the three women are connected primarily by their commitment to geometric abstraction, but they also, she wrote, share "a concern for art as a transformative project related to therapeutic precepts for living, their drawings often inducing restorative feeling and healing." Alike, de Zegher argued, in pursuing "a rational model of perfection" and also "an emotional model of relinquishment (the renouncing of egotism)," the three artists were, she said, similar in their lives and characters as much as in their work. "Not only do their drawings . . . relate the substantial to the immaterial and invisible, but the solitary humble lives the women led also manifest significant affinities," de Zegher contended. "Living in seclusion, af Klint, Kunz, and Martin shared a remarkable work ethic aimed at achieving (self-) knowledge through assiduous diligence and contemplative reflection"; using drawing as "the sages" do, they offered "an opening to a plane of bliss." Their shared Protestant background is noted, as is the extensive writing that each produced, and also that "Each renounced marriage, disciples and society." In short, "The work of af Klint, Kunz, and Martin flows from the intuitive perception of force fields that cannot be seen. Their unique contribution is to give concrete form to their own bodily and spiritual experiences."[28]

Perhaps it goes without saying, by now, that almost none of this is quite true of Martin. While she could be said to have pursued a "rational model of perfection," nothing could be further from her intention than that art should serve a "therapeutic precept for living." Some of the other contributors to the exhibition's catalogue distance themselves from de Zegher's stance. Sounding a little wary, Richard Tuttle writes, in a short text dated the day Martin died, "She was a person and a painter who knew that a reality based in art also has to be based in life. For this reason, you find

her on the mid-path, no easy journey, where she has little patience for spook, witchcraft, agendas, etc." While he seems equivocal at best about whether the spiritual practices of af Klint and Kunz—and by extension, the work produced in their service—are relevant to Martin, Tuttle endorses—if, again, a little murkily—another important notion that is implicit in the exhibition: "If one read her paintings, one would find a feminine to enjoy, one which could be identified from having been able to recognize it in feminine animals, previously."[29] In a less elliptical statement, de Zegher reports that (presumably in the course of preparing this exhibition and its catalogue), "Richard Tuttle came to me to tell me that Martin had said to him in a conversation: 'You will never know what abstraction is unless you ask the women.'"[30]

Whether there is something specifically female (if not feminist) in Martin's work is a question taken up in the catalogue by Griselda Pollock, a feminist scholar who like Rosalind Krauss is committed to bringing psychoanalytic theory to bear on her subject.[31] But Pollock is diverted from an interpretative trail whose signposts are Freud, Lacan, Kristeva, and Barthes by a visit to Martin in Taos in 1995. The account Pollock provides of their conversation is amusing: "'How long does it take to make a painting?' I asked. 'Three hours or so,' she replied. This surprised me. I had imagined that each painting was the product of a lengthy, contemplative process.... 'Why do you want to make another?' I then asked. 'I have a dream,' she says. 'A dream?' The Freudian is immediately intrigued. 'And what do you dream.' Was I hoping for the revelation of the iconographic meaning of the paintings of Agnes Martin? She replied, 'I dream another grid.'"[32] One has to take this with a grain of salt—Martin wasn't then painting grids, and there are no other references, in interviews, to dreams as creative sources. Still, one gets a clear picture, sketched with self-deprecating charm by Pollock, of a painter fully competent to deflect the most determined of exegetes.

Ultimately, the most significant boundary reconfigured by the Drawing Center show was not between the material and the spiritual but between

two draftswomen not trained in academic or professional art programs nor affiliated with mainstream art institutions and one who was. Martin is alone, in this grouping, in her formal training, art-historical knowledge and cultural sophistication. The overriding of this distinction presaged a trend that has since flourished. Moreover, to associate Martin with artists who could be called "outsiders" was to exploit a fuzziness the art world accepts—as does the broader culture—concerning the distinctions between eccentricity and illness. While there had been publicly available evidence for years, primarily in her own writing, that she suffered from profound emotional disturbances, it was only after Martin's death that changing social norms began to enable a somewhat less-guarded acknowledgment of her difficulties. In 2011 the Dia Foundation published a book of essays about Martin in which Douglas Crimp wrote that, while he didn't doubt that freedom, innocence, happiness, and perfection were Martin's subject, "surely it is the turmoil away from which Martin turned … that constitutes the tension so many of us see in her paintings."[33] Arne Glimcher's 2012 book announces her illness at the outset: "Agnes had always suffered from schizophrenia and from time to time required hospitalization."[34] In Jill Johnston's obituary for Martin, she wrote, "I had not known her very long when she told me about her 'trance' states, clinically called catatonia."[35]

A similar shift has loosened discussion of Martin's romantic life. At a 2012 symposium at the Harwood museum honoring Martin on the centenary of her birth, her longtime friend Kristina Wilson, a Taos resident, said publicly for the first time that they were lovers in the 1950s;[36] she recalled having met Martin at Columbia sometime around 1950. "I was in a design class," Wilson said, and "there was someone painting at an easel at the back of the class. She introduced herself."[37] They met again a few years later in Taos and remained friends until the end of Martin's life—one of the very few relationships that Martin sustained for so long. Kristina Wilson's brief presentation, which included a frank discussion of Martin's mental illness, was delivered, with considerable hesitation, as a video-recorded statement; she was present to take questions after the

recording was shown. Her reluctance was understandable; many Martin supporters in the audience were dismayed at the revelation, evidently less because of homophobia than because of a perceived violation of the artist's privacy, eight years after her death. Wilson said at the time that she struggled "with whether I was betraying her, by talking about her illness, and our affair."[38]

But others had already broached this issue too. In 2004, Anna Chave wrote, "Martin's fixation on 'innocence' assumes other overtones in the context of a society that systematically pathologized and criminalized her sexual orientation,"[39] and contended that although Martin rejected physical passion, her paintings' "extraordinary sparseness and reticence" might be seen to "quietly inscrib[e] a form of feminine and lesbian identity willfully aligned with, yet willfully apart from, masculine norms." Martin's inclusion in Jonathan Katz and David Ward's widely discussed 2010 exhibition, *Hide/Seek: Difference and Desire in American Portraiture*, was a conspicuous bid for her identification as an admitted lesbian; she was represented by a very early portrait of a woman shown nude from the waist up (pl. 6), which Katz claimed was an expression of same-sex desire.[40] In a separate, recent essay that expands on the theme of Martin's sexuality, Katz describes what he believes to have been the openly gay community of Coenties Slip and states that Lenore Tawney was Martin's "partner."[41] Most provocatively, Katz believes that Martin meant her work to be a call for solidarity and a gesture of support: "Martin never understood her picture making as mere aesthetic activity but always saw it as a kind of social service," insofar as it invited others to recall their own "free moments."[42] The portrait of Martin as a healer is thereby given another turn.

All of these claims have been disputed, often by using Martin's own words, as when she said to Mary Lance, "Jill Johnston wrote that I'm a lesbian but I am not." But, again, Martin is not an infallible narrator of her own story. And the many artists who reflect her influence, with and without explicit acknowledgement, continue to broaden the narrative. Martin's influence can be felt in the work of peers who shared exhibitions with her in

their lifetimes—from LeWitt (1928–2007), whose work was restricted to rec-tilinear abstraction only early in his career, to Eva Hesse (1936–1970), whose grid-based works were also confined to a limited but nonetheless crucial body of work—and also in that of such younger artists as Hanne Darboven, whose concern was with the marking of time; Mary Heilmann, who is far freer than Martin with color and pattern; Jennifer Bartlett, who gained rec-ognition with epic cycles of imagery inscribed on gridded, baked enamel tiles; and Ellen Gallagher, who gave a sharp edge of racial politics to very Martin-like stripes. In an exhibition review of 2014, the painter Dan Walsh is quoted as saying, "My joke early on about how to describe myself was 'Philip Guston paints an Agnes Martin'"[43]; indeed a zesty fusion, Walsh's paintings now are color-soaked, fat-brushed, Indian-influenced geometries that mate prayer rugs and paintings. And as part of a belated recognition that modernism's adherents and their descendants were not exclusively Western, certain realignments have been made in major exhibitions, so that at *Documenta 12*, the regular international roundup, Martin's work was paired with delicate ink-on-paper and also graphite linear abstractions, photographs, and diary pages by Nasreen Mohamedi (1937–1990). Born in India, to which she returned in the early 1960s, Mohamedi studied in London and Paris, but the eastern spiritual influences that her peers in the United States were grasping at from a distance were her birthright. At the same time, a melancholy verging on despair, which Mohamedi records in her diary in nearly illegibly micrographic lines of urgent inner thought, reflects an inclination to explore states of turmoil with a candor that seems affiliated with the twentieth-century West.

Some of the most fervent homages to Martin arise from those most at odds with her spirit. The German artist Jutta Koether's public presentation on Martin, at Dia's New York City venue in 2013,[44] began with a projected image of the slightly mad-looking pencil calculations that Martin made when translating an image received by inspiration into a painting—repro-ductions of such calculations serve as endpapers in Arne Glimcher's book, which was a touchstone for Koether's talk. At the outset, she explained that

what interested her in Martin's work was "a logical process haunted by psychosis." As if to illustrate, Koether passed around to the audience a number of her own small paintings, the various bruised-looking grids going hand to hand with an undiscriminating intimacy—and a lack of concern for the work's physical safety—that would have horrified Martin. Koether documented projects she had organized to honor Martin's work in which drawings were created collaboratively (although Martin never had so much as a studio assistant), explaining that her effort at "reenacting another artist's practice" was akin to "entry into a mirror stage." Along with this reference to Lacan, she also cited Jacques Derrida's deconstructionism, and his concept of the "Double Session" in particular. Yet, Koether said, "What I learned from Agnes Martin is that there is in painting a dimension beyond the discursive." At the conclusion of her lecture-cum-performance, Koether undertook a wild but straight-faced dance with a champagne-bottle-shaped cardboard partner, swirling to big-band music, which, Glimcher writes, Martin loved.

Nothing if not passionate, Koether's presentation drew a large, rapt audience—to each of whom, it is safe to say, Martin meant something altogether different. Martin's writing as well as her work remains enormously compelling for students; she is revered for her metaphysical insights (her demurrals about mysticism notwithstanding) and as an exemplar of steadfastness in the face of obscurity and poverty. The fact that she was in her middle forties before she began making the paintings she felt were resolved, and in her fifties by the time she received recognition for them, has continued to give struggling artists hope.

So does her amply manifest independence—and her many contradictions. The way Martin lived, the way she dressed and ate, socialized and spent her private time, the way she furnished her homes and traveled, conformed to no one's notion of high style. She didn't wear black, she wasn't svelte or soignée. While she never owned a television (or a computer), neither did she live off the grid in a way that meets the favored standards of self-sacrificing austerity. She loved fancy cars and ocean liners. She liked

32 (ABOVE)
Donald Woodman. Agnes Martin
in New Mexico, 1988.
Courtesy the photographer

33 (BELOW)
Donald Woodman. Agnes Martin's home
and studio, Galisteo, New Mexico, 1979.
Courtesy the photographer

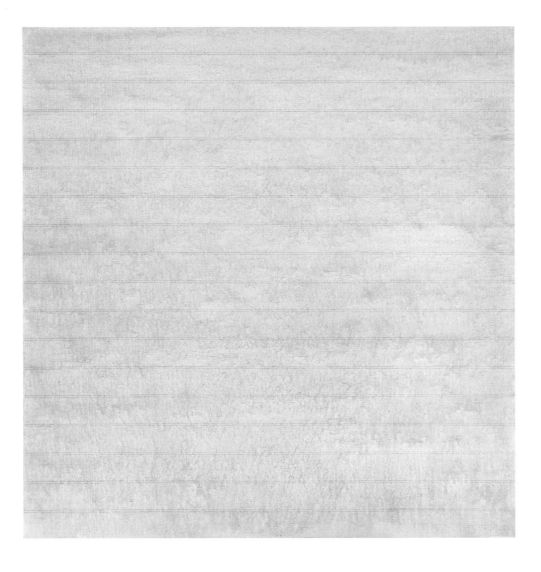

34

Untitled No. 11, 1984.
Acrylic, gesso, and pencil on linen, 72⅛ × 72⅛ in.
Hirshhorn Museum and Sculpture Garden,
Smithsonian Institution, Washington, D.C.

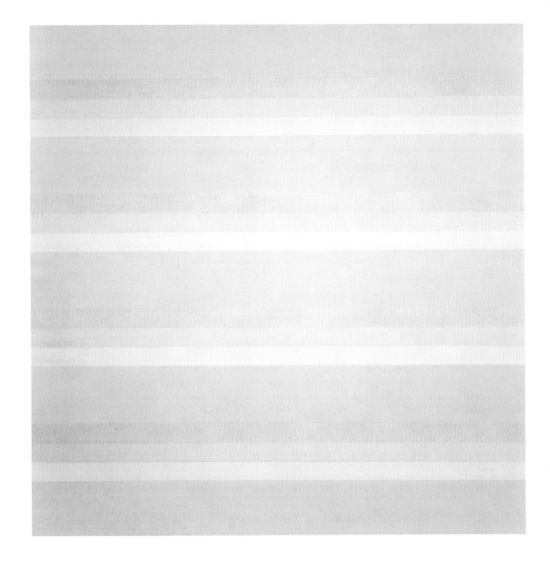

35
Untitled #2, 1992.
Acrylic and graphite on linen, 72 × 72 in.
Private collection

36

Tina Larkin. Agnes Martin Gallery,
The Harwood Museum of Art, 1994.
Courtesy of The Harwood Museum of Art
of the University of New Mexico, Taos

Happiness (panel four of eight in the series *Innocent Love*), 1999.
Acrylic and graphite on canvas, 60 × 60 in.
Dia Art Foundation, New York

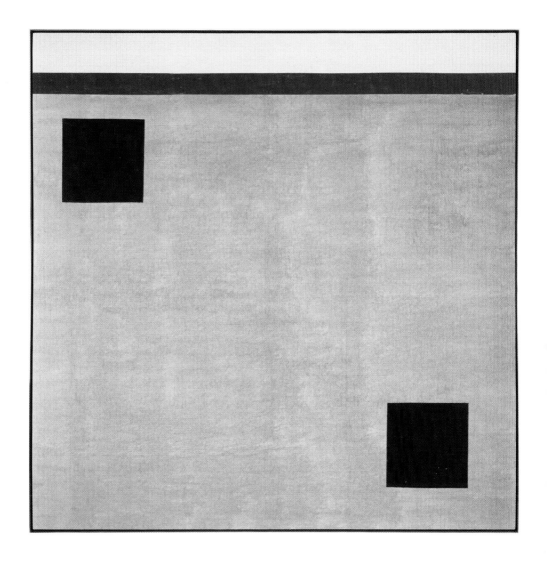

38
Untitled, 2004.
Acrylic on canvas, 60 × 60 in.
Private collection

39
Untitled, 2004.
Ink on paper, 3½ × 2¾ in.
Private collection

being honored. She valued humility above all else. She was at once a consummate insider and a lifelong outsider, a devoted student of Zen and Christian mysticism, and a sworn skeptic. She was of sound mind at times (and to the extent that such a state can be defined), and at times she was not. Her most reliable testimony remains her majestic work.

Painting, for Martin, was the expression of a state of mind, just as it was for the Abstract Expressionists. She did not believe that it puts one in contact with unseen forces, even less that it cures one's ills. While her reliance on inspiration can be usefully compared with the solicitation of subconscious—or trans-conscious—sources, and thereby with automatist drawing exercises, she opposed any suggestion that her inspirations derived from a place of either psychic conflict or spiritual authority. Inspiration was simply the channel on which she received her vision—her orders for paintings, one at a time. She resisted anything that distracted from focus on the visual experience her art offered. And that experience, which she was not shy of naming Joy, or Love, or Innocence, is of a kind encountered rarely. As riven with contradictions as the artist herself, it was born as thought, transcribed by hand, and addressed with fervent intimacy to everyone.

COMPOSURE

Almost all artists, I think, sometimes feel that their integrity and credibility rest on beliefs that are frail as a spider web; this may be particularly true of abstractionists. Martin spoke over and over of doubt, of accepting it and using its lessons to move forward. "I want particularly to talk to those who recognize all of their failures and feel inadequate and defeated, to those who feel insufficient—short of what is expected or needed," she said. "I would like somehow to explain that these feelings are the natural state of mind of the artist, that a sense of disappointment and defeat is the essential state of mind for creative work."[1] She also wrote, "helplessness, when fear and dread have run their course, as all passions do, is the most rewarding state of all."[2] And she told an interviewer, "There's a lot of failure. I've said that the ability to recognize failure is the most important talent of an artist."[3]

In the face of such rampant dread, helplessness, and failure, the resolution she sought might best be called composure: it is a quality recognized equally in the arrangement of lines and color on canvas (that is, in composition), of tone and measure in music (again, composition), and of heart and mind in human experience. Martin believed that all living things share the capacity for such harmony; the lines she drew mapped a transit of power that fuels happiness, beauty, and innocence—and danger as well. In seeking to express the vibrancy and joy inherent to animate

beings, she also strove to regulate an energy that was not always easy to tame. Sometimes she was unable to control these currents, and they overwhelmed her; sometimes they fizzled and went dead. Such struggle may be common among artists, but Martin waged it with special vigor.

The sense of doubt of which Martin so often spoke can threaten viewers as well. Lawrence Alloway strikes a plaintive note in his 1966 essay "Systemic Painting" when he writes, "What is missing from the formalist approach to painting is a serious desire to study meanings beyond the purely visual configuration." He is impatient with writers who find emotional expression in the work, noting drily, "this 'sometimes-I'm-happy, sometimes-I'm blue' interpretation is less than one hopes for."[4] Yet his solution, to look at fixed formal systems as distinctive fingerprints of artists' intentions, doesn't take us much farther. Similarly, William Seitz, after hailing the advent of a brand-new art form based on enlisting perceptions that take place between cornea and brain, wondered in print, "can such works, that refer to nothing outside themselves, replace with psychic effectiveness the content that has been abandoned?"[5]

In the decades since these critics wrote, particularly the past few, notions of faith that were once banned and ascriptions of analogy and metaphor, of biography and self-expression, have returned in force to discussions of abstraction. Yet many critics of Martin's work have continued to argue that its meaning relies wholly on the shifting experience yielded by viewing it from near and far, without really explaining why that is noteworthy. Doesn't Impressionism, too, demand that we come close then step back? Doesn't Rembrandt? The famous *Landscape with the Fall of Icarus*, associated with Pieter Bruegel the Elder, depends on it, as a kind of metaphysical joke.

Such questions and quibbles are probably inevitable. Our position, as viewers, can hardly be more secure than that of artists. And no ardent admirer of abstract painting can avoid moments when, for whatever reason, the current of energy breaks. Martin's *The Tree* (1964), in the Museum of Modern Art, New York, was the first of her paintings I encountered.

I was a teenager, and it has stayed with me ever since. Returning to it when I began writing this book, I found it static and coldly white. It was a dismaying moment; I sat on a bench with pad and pen in hand and saw nothing but pencil lines and paint. Was it the lighting? A recent cleaning? Did *The Tree* have bad company on the walls that day, or–a more selfish thought–in the gallery, with its noisy throngs of careless viewers? Martin believed firmly that her work was dependent on the observer's response, and I was failing it. And to Martin it was no minor painting. Describing it when it was acquired by MoMA, the year after it was completed, she said, "When I first made a grid I happened to be thinking of the innocence of trees and then this grid came into my mind and I thought it represented innocence, and I still do, and so I painted it and then I was satisfied. I thought, this is my vision."

On a subsequent viewing, *The Tree* came back to life for me. It was again an image of nature sublimated into the radiance of geometry. Like the majestic pump that a big tree is, sucking water from the earth and moving it toward sunlight, the painting once more seemed to breathe visibly, with its biaxial double-stroke of inspiration and exhalation. A painting can create an updraft and take you with it. It can also be a buffer for the kind of shattering, screaming beauty that may swallow you whole, as I believe Martin often felt her sensorium threatened to do. The business of response is a delicate, willed operation, a deep but unstable joy even when it succeeds.

The relationship between an artist and a writer, or an artist and a viewer, is complicated. In her letter to me, Martin implored, "Write your true response instead of stirring around in knowledge or quoting responses made by others (the past) and your thesis will be effective because it will be the truth. Only the truth is effective. All ideas are false. They are conjecture. False because by the time you have them they are the past and false besides!" Although I've tried to honor the spirit of her advice, I haven't been entirely faithful to her injunction. And naturally she, too, was full of ideas, produced and acquired by her singularly complicated and hungry

mind. If it is not easy to assemble a cohesive, comprehensive story of Martin's life, neither is it simple to explain why it should matter.

She herself was perfectly clear that biography is meaningless. "Almost everyone believes that art is from the experience of the artist meaning the intellectually grasped experience. They believe that it is affected by where you live and what you do. But one's 'biography,' character, abilities, knowledge all of that has nothing to do with art work. Inspiration is the beginning the middle and the end."[6] She went further. "I want to repeat: there are no valid thoughts about art. If your sensibilities are awake you will respond. It will be a pleasant experience recalling happy times. You must see that no talking will help and that no defence is necessary and that you must not answer your critics. But most important you must have no contact with them."[7]

This can give a critic and biographer pause. Indeed, there are no lurking symbolic images in her paintings begging for interpretation in light of her varied life experiences. But visual art, by its nature, does not reduce to words. I believe that, insofar as words are part of the current of her thought, they hum along the lines of her painting. More than anything else, Martin's work brings her particular spirit into clearer focus. The work is, of course, also the reason we care to make that spirit's acquaintance, and it is our invitation. Incomplete (as she insisted) without us, the paintings are the extension of a hand, an opening to understanding, and the expression of an optimistic conviction that such an understanding, as intimate and powerfully transformative as it is impersonal, can be achieved.

ENDNOTES

Introduction

1. Ann Wilson, "Agnes Martin: The Essential Form: The Committed Life," *Art International / The Lugano Review*, December 15, 1974, 50.
2. Undated letter to Suzanne Delehanty, in Institute of Contemporary Art Archive, Rare Books and Manuscripts, Annenberg Library, University of Pennsylvania, Philadelphia.
3. See Jonathan Katz, "Hide/Seek: Difference and Desire in American Portraiture," in Katz and David Ward, *Hide/Seek: Difference and Desire in American Portraiture* (Washington, D.C.: Smithsonian Institution, 2010), 45.
4. Rosamund Bernier, "Drawing the Line," *Vogue*, November 1992, 306, 360.
5. Mary Lance, unpublished transcript of *Agnes Martin: With My Back to the World*, produced and directed by Mary Lance, 2003.
6. Michael Cunningham, *By Nightfall* (New York: Picador, 2010), 183.
7. Susan Sontag, "The Aesthetics of Silence," in *Styles of Radical Will* (New York: Farrar, Straus and Giroux, 1976), 32.
8. Conversation with Richard Tuttle, June 8, 2013.

Chapter 1

1. Suzan Campbell, "Interview with Agnes Martin, May 15, 1989," transcript, Archives of American Art, Smithsonian Institution, Washington, D.C., p. 1.
2. Susan Conly, *Prairie Views from Eye Hill* (Macklin: Macklin History Book Society, 1992), 3.
3. Jack Stabler and Rose Olfert, "One Hundred Years of Evolution in the Rural Economy," in ed. Jene Porter, *Perspectives of Saskatchewan*, (Winnipeg: University of Manitoba Press, 2009), 127, 129.
4. John Archer, *Saskatchewan: A History* (Saskatoon: Western Producer Prairie Books, 1980), 148.
5. Archer, *Saskatchewan*, 134.
6. Susan Conly in conversation with the author, October 18, 2014.
7. Jenny Attiyeh, unpublished interview. In this recollection, Martin explains, "We really had a peculiar family, because my younger brother was brilliant and then my older brother wasn't, and then my mother and my sister were below average, I think, in intelligence. He and I were brilliant, and they were dumb."
8. "Do you have any recollection of Macklin, or do your memories begin in Vancouver?" Campbell asked her. "No, I don't remember Macklin," she replied. Campbell, "Interview," 2.
9. Mary Lance, producer and director, *Agnes Martin: With My Back to the World* (Corrales, New Mexico: New Deal Films, 2003).
10. Archer, *Saskatchewan*, 148.
11. Wallace Stegner, *Wolf Willow* (New York: Penguin Books, 2000), 6–8.
12. Benita Eisler, "Profile: Life Lines," *The New Yorker*, January 25, 1993, p. 72.
13. Donald Woodman, by phone to the author, October 31, 2011.
14. Conly, *Prairie Views from Eye Hill*, 496.
15. Bruce Russell, conversation with the author, October 16, 2014.
16. In 1922 the properties were still in the Martin name; by 1930 title had transferred. By then, the family had long since moved. Saskatchewan homestead files: http://sab.minisisinc.com/sabmin/scripts/mwimain.dll/144/HOMESTEADS?-DIRECTSEARCH. Trying to decipher homestead records, with their arcane legal terms, offers a good sense of what the Cree and others faced in negotiating the terms of Treaty 6.

17. Stabler and Olfert, *Perspectives of Saskatchewan*, 131.

18. As in Campbell, "The Interview," 2, where she said she was three years old when she left.

19. This information from Bruce Russell, in a conversation with the author, October 19, 2014.

20. Benita Eisler, "Profile: Life Lines," *The New Yorker*, January 25, 1993, 72.

21. Joan Simon, "Perfection Is in the Mind: An Interview with Agnes Martin," *Art in America* 84, no. 5 (May 1996): 87.

22. Eisler, "Life Lines," 72.

23. Arne Glimcher, *Agnes Martin: Paintings, Writings, Remembrances* (London and New York: Phaidon, 2012), 106.

24. Jill Johnston, "Agnes Martin: Surrender & Solitude," in *Admission Accomplished: The Lesbian Nation Years (1970-75)* (London: Serpent's Tail, 1998), 301.

25. Lance, *Agnes Martin: With My Back to the World*.

26. David McIntosh, by phone to the author, January 31, 2013.

27. Arne Glimcher, *Agnes Martin: Paintings, Writings, Remembrances*, 104.

28. Eisler, "Life Lines," 72.

29. Ibid.

30. Martin continued, "I started young, too young to get into trouble. I didn't menstruate till I was about 16 and a half, and so I never got pregnant or anything, but I just, … I didn't care what they thought." Jenny Attiyeh, unpublished interview with Agnes Martin.

31. Harmony Hammond, "Meetings with Agnes Martin," in Aline Chapman Brandauer with Harmony Hammond and Ann Wilson, *Agnes Martin: Works on Paper* (Sante Fe: Museum of Fine Arts, Museum of New Mexico, 1998), 40.

32. Jenny Attiyeh, unpublished interview with Agnes Martin.

33. Ann Wilson, "Meetings with Agnes Martin," in *Agnes Martin: Works on Paper*, 22.

34. "Stars of Eastern Swim World Too Good for Coasters," *The Vancouver Sun*, July 19, 1932, 10; and "Swim Team is Selected," *Saskatoon Star-Phoenix*, July 19, 1932, 11.

35. Lance, *Agnes Martin: With My Back to the World*.

36. Unpublished interview with Judith Kendall and Bill Davis, February 2, 1999.

37. Leanne Shapton, *Swimming Studies* (London and New York: Blue Rider Press, 2012), 33.

38. Ibid., 188.

39. Eisler, "Life Lines," 73.

40. The first is from Mary Lance, ibid; the second from Bob Ellis, interview with the author, October 15, 2012.

41. Bob Ellis, interview with the author, October 15, 2012.

42. Tony Huston, by phone to the author, July 17, 2014. Not yet born at the time of Martin's employment by his family, Tony Huston was introduced to Martin in Taos by Bob Ellis; Martin told Huston that she'd worked for his father.

43. Campbell, "Interview," 2.

44. Tom Collins, "Agnes Martin Reflects on Art and Life," *Geronimo* 2, no. 1 (January 1999), accessed online: http://taos-webb.com/geronimo/january99/visualart.html (via Internet Archive).

45. On college entrance tests, she received a C+ in general aptitude for higher education. Her other entrance grades were undistinguished: Cs and Ds in spelling, math, and history, and two Fs, in English usage and, oddly enough, in penmanship. (Throughout her adulthood, she would write copiously, in longhand; the manuscripts and letters are executed in what recommends itself, by contemporary standards, as graceful and blameless script.)

46. Annie Dillard, *The Living* (New York: Harper Perennial, 1993), 3-4.

47. On her second application to Teachers College, she listed, under Record of Employment, three schools in Washington (Country School, Livingston School and Burley School) at which she'd taught "all grades 1-6." Document courtesy of Teachers College registrar's office.

48. McIntosh, phone interview, January 31, 2013.

49. Kristina Wilson, "A Contribution to a Further Understanding of Agnes Martin," at symposium accompanying *Agnes Martin: Before the Grid*, Harwood Museum of Art, March 24, 2012.

50. From a conversation with the historian Bruce Russell, October 19, 2014.

51. William C. Seitz, *Mark Tobey* (New York: The Museum of Modern Art, 1962), 27.

52. Kay Larson, *Where the Heart Beats: John Cage, Zen Buddhism, and the Inner Life of Artists* (New York: Penguin, 2012), 81.

53. Ibid., 69.

Chapter 2

1. Simon, "Perfection Is in the Mind," 87. Similarly, Martin said to Suzan Campbell, "I asked what was the best university in the country and somebody told me Columbia, so I went to Columbia." Campbell, "The Interview," 3.

2. Transcript, Washington State Normal School, Bellingham. Courtesy registrar's office.

3. Mary Lance, in conversation with the author, October 15, 2012; Bob Ellis confirms that she was at USC.

4. Thomas B. Hess, *Barnett Newman* (New York: Walker & Co., 1969), 10. Undeterred, Newman worked as a substitute teacher for $7.50 per day in New York City public high schools in the periods 1931-35 and 1933-39. From 1939-45, he worked two days a week at an adult art school, earning $15 per week.

5. Merle Curti, "The Schools and the Defense," *Teachers College Record* 43, no. 1 (1942): 21-23.

6. L. A. Cremin, David A. Shannon and Mary Evelyn Townsend, *A History of Teachers College, Columbia University* (New York: Columbia University Press, 1954), 188-89.

7. Orientation in Current School Practices; Educational Psychology; Teacher Preparation and Supervision in Fine Arts; Educational Foundations; Ind. Arts for Intermediate Grades.

8. Elise Ruffini and Harriet Knapp, *New Art Education: Book 9* (Sandusky: American Crayon Company / Dallas: Practical Drawing Company, 1947).

9. Arthur Young, "Art Education in Our Culture," in ed. Young, *This is Art Education 1951 Yearbook* (Kutztown, Pa.: State Teachers College / National Art Education Association), 15. Young cites, timorously but diligently, the wealth of diversity brought by various immigrants, in an odd list that begins with the Japanese and includes Swedes, Finns, Hollanders, Africans, Irish, but not French. "And even the most cursory knowledge of the arts in our culture provides evidence of the great contributions of the Jew. The Negro has likewise done much to change our musical idioms." Young, "Art Education in Our Culture," 25.

10. Ibid.

11. Cremin, Shannon and Townsend, *History of Teachers College*, 45.

12. Dewey, *Art as Experience* (New York: Perigee, 1980), 4-5.

13. Ibid., 81.

14. Ibid., 100.

15. Ibid., 74.

16. Ibid., 48.

17. Lippard, *Ad Reinhardt* (New York: Harry N. Abrams, 1981), 44.

18. Simon, "Perfection Is in the Mind," 87.

19. Collins, "Agnes Martin Reflects on Art and Life."

20. Arne Glimcher, *Agnes Martin: Paintings, Writings, Remembrances*, 106.

21. McIntosh, phone interview, January 31, 2013.

22. Simon, "Perfection Is in the Mind," 88.

23. Campbell, "The Interview," 5. Again, "My mother was a great disciplinarian–and I may have inherited some of that." Bernier, "Drawing the Line," 306.

24. David McIntosh, phone interview, January 31, 2013.

25. Campbell, "The Interview," 7.

26. David Witt, *Modernists in Taos: From Dasburg to Martin* (Santa Fe: Red Crane Books, 2002), 151.

27. Campbell, "The Interview," 5.

28. Earl Stroh, "Notes on Watching Art in New Mexico 1947-1989," *Voices in New Mexico Art* (Santa Fe: Museum of Fine Arts, Museum of New Mexico, 1996), 33.

29. *Taoseño and Taos Review*, August 7, 1947. Quoted in David Witt, *Modernists in Taos*, 151. Witt speculates the writer could have been either Mabel Dodge Luhan or Rebecca James, both of whom wrote for the paper.

30. Simon, "Perfection Is in the Mind," 88.

31. Joanna Weber, "Making Space for the Sacred: The Agnes Martin Gallery in Taos, New Mexico," unpublished draft essay.

32. Rosamund Bernier, "Drawing the Line," 306.

33. Wise, brave, stoic and quietly passionate (though of course celibate), Cather's French archbishop spends most of his life happily exiled in a place where outliers have for centuries seemed particularly at home. It is hard not to see him as a paradigm for the equally mythologized persona by which Martin would come to be known.

34. Ed. Lois Palken Rudnick, *Intimate Memories: The Autobiography of Mabel Dodge Luhan* (Santa Fe: Sunstone Press, 2008), 192. She asked Cather to read it before its publication.

35. Maurice Tuchman, "Hidden Meanings in Abstract Art," in ed. Tuchman, *The Spiritual in Art: Abstract Painting 1890-1985* (Los Angeles: Los Angeles County Museum of Art / New York: Abbeville Press, 1986), 43.

36. Witt notes, "While most Taos Modernists identified themselves as leftists, Bisttram, like Agnes Martin at a later time, was at the same time politically conservative and of a mystical bent. He traveled effectively through all parts of the artistic and political continuum, at home with both right-wing businessmen and bohemian artists." Witt, *Modernists in Taos*, 67.

37. Eastern thought also flourished in California. In the 1940s, the British-born Gordon Onslow Ford, native Austrian Wolfgang Paalen, and American Lee Mullican founded the Dynaton group, "a West Coast alternative to Abstract Expressionism [that] was characterized by a central attention to Zen, the *I Ching*, and the tarot." Automatism was important for all three, and in particular for Onslow Ford, who later enthused, "automatism was a luminous word . . . synonymous with the spirit of creation." Tuchman, "Hidden Meanings," 49.

38. Conversation by phone with the author, March 25, 2014.

39. Sharyn Udall, "Spirituality in the Art of 20th Century New Mexico," *Voices in New Mexico Art* (Santa Fe: Museum of Fine Arts, Museum of New Mexico, 1996), 40.

40. As cited in Dore Ashton, *About Mark Rothko* (New York: Oxford University Press, 1983), 69.

41. Quoted in Udall, "Spirituality in the Art of 20th Century New Mexico," 42.

42. Ibid.

43. David Witt, interview with the author, October 19, 2012.

44. Ibid.

45. Eisler, "Life Lines," 73.

46. O'Keeffe attended Teachers College's 1915 summer program in South Carolina, where she studied with Arthur Dow, a modernist who had been to Japan and was thus doubly influential. There is no indication that Martin had met O'Keeffe before attending Teachers College, but she may have known that the older painter, already a prominent figure, had preceded her to the school.

47. Collins, "Agnes Martin Reflects on Art and Life."

48. Ibid. Their friendship was sufficiently sustained that Juan Hamilton, O'Keeffe's companion and assistant, visited Martin after O'Keeffe died in 1986.

49. Lance, *Agnes Martin: With My Back to the World.*

50. Tiffany Bell and Jina Brenneman, preface, *Agnes Martin: Before the Grid* (Taos: The Harwood Museum of Art of the University of New Mexico, 2012), 4-5.

51. Eisler, "Life Lines," 74.

52. It is identified on the Harwood checklist as oil on canvas, although Martin scholar Christina Rosenberger believes that, like other early works, it was painted with encaustic, as she explained in a gallery talk on March 24, 2012, at the Harwood Museum. The painting is reproduced in *Agnes Martin: Before the Grid,* 44.

53. Mary Lance, interview with the author, October 15, 2012.

54. Lizzie Borden, "Agnes Martin: Early Work," *Artforum,* April 1973, 41.

55. Enrollment in 1951-52 was roughly 6,500. Cremin, Shannon and Townsend, *History of Teachers College,* 201.

56. Larson, *Where the Heart Beats,* 229. The subjects were: "The Development of Buddhist Philosophy in China," "Kegon (Hua-yen) Philosophy," and "Kegon Philosophy and Zen Mysticism."

57. Ibid., 223.

58. Witt, *Modernists in Taos,* 152.

59. Robert Goff, "Agnes Martin: In Taos, New Mexico," *Western Interiors and Design Magazine,* July–August 2003, 86

60. David Witt interview with Agnes Martin, Galisteo, New Mexico, April 7, 1987 (unpublished).

61. Interview conducted by Douglas Dreishpoon for the Mandelman Ribak Archive, June 24, 2000, author's transcription.

62. Campbell, "The Interview," 9.

63. Dreishpoon interview, June 24, 2000, Mandelman-Ribak Archive.

64. Ibid.

65. Mildred Tolbert, unpublished manuscript.

66. Witt interview April 7, 1987.

67. Bell and Brenneman, *Agnes Martin: Before the Grid,* 5.

68. Campbell, "The Interview," 8.

69. Quoted in David Witt, "Agnes Martin's Enigmatic Grids," *Taos Magazine* 7, no. 4 (July 1990): 8-9.

70. Borden, "Early Work," 42.

71. Campbell, "The Interview," 8.

Chapter 3

1. Stephanie Barron, "Giving Art History the Slip," *Art in America* 62, no. 2 (March-April 1974): 80.

2. Joseph Mitchell, "Up in the Old Hotel," *The Bottom of the Harbor* (London: Jonathan Cape, 2000), 8.

3. Mildred Glimcher, *Coenties Slip* (New York: Pace Gallery, 1993), 12.

4. Jack Youngerman, conversation by phone with the author, October 3, 2012.

5. Ibid.

6. When the building it occupied was torn down and the Institute relocated, an office tower was built that would ultimately house the first off-site branch of the Whitney Museum; an exhibition of Coenties Slip artists was held at the branch in 1974; another was held at Pace Gallery in SoHo in 1993, coinciding with Martin's retrospective at the Whitney Museum uptown.

7. Charles Hinman, interview with the author, October 6, 2012.

8. Ann Wilson, interview by phone with the author, January 10, 2013.

9. Faye Hammel, "Bohemia on the Waterfront," *Cue,* March 22, 1958, 16-17.

10. Campbell, "The Interview," 14.

11. Eisler, "Life Lines," 75.

12. Simon, "Perfection Is in the Mind," 88.

13. Irving Sandler, "Agnes Martin Interviewed by Irving Sandler," *Art Monthly,* September 1993, 9.

14. Robert Indiana, conversation by phone with the author, August 11, 2013.

15. E. C. Goossen, *Ellsworth Kelly* (New York: Museum of Modern Art, 1973), 49.

16. Ann Wilson, "Meetings with Agnes Martin," 19.

17. Eisler, "Life Lines," 75.

18. Mildred Glimcher, *Coenties Slip*, 13.

19. Ibid., 10.

20. Campbell, "The Interview," 14.

21. Simon, "Perfection Is in the Mind," 88.

22. Eisler, "Life Lines," 75.

23. From a 1963 interview with Henry Geldzahler, quoted in Barron, "Giving Art History the Slip," 84.

24. David Hayes, "Agnes Martin: Lines in the Desert," *Saturday Night*, December 1997, 83.

25. Eisler, "Life Lines," 75.

26. Ibid., 78.

27. Youngerman, phone interview with the author, October 3, 2012.

28. Witt, interview with the author, October 19, 2012.

29. Larson, *Where the Heart Beats*, 209.

30. Paul Cummings, interview with Lenore Tawney, June 23, 1971, transcription, Archives of American Art, Smithsonian Institution, Washington, D.C., p. 12

31. The Guggenheim Museum's acquisition record for *White Flower* (1960) says it is a gift of Lenore Tawney, although it is credited as anonymous.

32. Kristina Wilson, interview with the author, October 20, 2012. Wilson added, "I don't believe they had an intimate relationship."

33. Paul Cummings, interview with Lenore Tawney, June 23, 1971, transcription, Archives of American Art, Smithsonian Institution, Washington, D.C., p. 9.

34. Paul Smith, "A Tribute to Lenore," in *Lenore Tawney: A Retrospective* (New York: American Craft Museum, 1990), 21.

35. Paul Cummings, interview with Lenore Tawney, 17.

36. Ibid., 27.

37. Eisler, "Life Lines," 76.

38. *Lenore Tawney* (New York: Staten Island Museum, 1961).

39. Facsimile handwritten note, insert in Arne Glimcher, *Agnes Martin: Paintings, Writings, Remembrances*, between pages 124 and 125.

40. Simon, "Perfection Is in the Mind," 88.

41. Chryssa, whose last name was Vardea-Mavromichali, died on December 23, 2013. An obituary in the *New York Times*, published a month later, noted, "her death, which was reported in the Greek press, was not widely publicized outside the country. Perhaps fittingly for an artist whose work centered on enigma, the place of her death could not be confirmed; the Greek news media reported that she was buried in Athens." Margalit Fox, "Chryssa, 79, Artist Who Saw Neon's Potential as a Medium," *New York Times*, January 18, 2014, A28.

42. Barbara Rose in *Chryssa: Cycladic Books 1957-62* (Athens: Nicholas P. Goulandris Foundation / Museum of Cylcadic Art, 1997), 13.

43. Rose, *Chryssa*, 17.

44. Sam Hunter, *Chryssa* (New York: Harry N. Abrams, 1974), 5.

45. Pierre Restany, *Chryssa* (New York: Harry N. Abrams, 1977), 25.

46. Ursula von Rydingsvard, by phone with the author, June 3, 2013.

47. Chryssa, comments transcribed by Annelliesse Popescu in e-mail to the author, November 26, 2012.

48. Pat Steir, interview with the author, November 28, 2011.

49. Von Rydingsvard, by phone to the author, June 3, 2013.

50. Annelliesse Popescu, by e-mail to the author, November 26, 2012.

51. Von Rydingsvard, by phone to the author, June 3, 2013.

52. Chryssa, as transcribed by Popsecu in e-mail to the author.

53. Hunter, *Chryssa*, 9.

54. Chryssa, as transcribed by Popescu in e-mail to the author.

55. Arne Glimcher, *Agnes Martin: Paintings, Writings, Remembrances*, 8

56. Paul Cummings, "Interview with Betty Parsons," June 4 and 9, 1969, transcription, Archives of American Art, Washington, D.C., n.p.

57. Jack Tilton, by phone to author, September 10, 2012.

58. Ann Wilson, by phone to the author, January 10, 2013.

59. Mildred Glimcher, *Coenties Slip*, 12.

60. Martin to Suzanne Delehanty, undated letter, Institute of Contemporary Art Archives, Annenberg Library, University of Pennsylvania, Philadelphia.

61. See Christina Bryan Rosenberger, "A Sophisticated Economy of Means: Agnes Martin's Materiality," in ed. Lynne Cooke, Karen Kelley and Barbara Schröder, *Agnes Martin* (New York: Dia Art Foundation / New Haven and London: Yale University Press, 2011), 110.

62. Martin, "Reflections," in ed. Dieter Schwarz, *Agnes Martin: Writings/Schriften* (Ostfildern-Ruit: Hatje Cantz, 2005), 32.

63. Martin, "The Still and Silent in Art," in *Writings*, 89.

64. Martin, "The Untroubled Mind," in *Writings*, 36.

65. Object records, Museum of Modern Art, New York.

66. Lawrence Alloway, "Agnes Martin," *Artforum*, April 1973, 34.

67. The original Guggenheim Museum acquisition record and the label from the Elkon gallery on the work's stretcher both give the work's date as 1962. The last correspondence on the issue in the Guggenheim object file, from Lisa Dennison to Michael Govan, by e-mail on April 6, 2004, concludes: "Vivian Barnett says 'When the picture came here early in 1963 it was dated 1962, but we later determined that it had been painted in 1960.' Unfortunately there is nothing in our file that indicates the reason for this earlier date." Guggenheim object records.

68. Completed in 1958, the Mies van der Rohe tower was, perhaps apocryphally, meant to subliminally suggest—this was the dawn of corporate image manipulation—Seagram's gold-brown whiskey. Its exterior glass was gridded by bronze-toned I-beams.

69. The work, in the collection of the Museum of Modern Art, has water damage that would be very difficult to repair, and it is seldom shown.

70. Campbell, "The Interview," 11.

71. Interview with Douglas Dreishpoon, June 24, 2000, Mandelman-Ribak Archive.

Chapter 4

1. A connection between Martin's inspiration and automatism has been remarked by Suzanne Hudson, who writes, "her privileging of involuntary transmission represents a familiar stance, which is reminiscent of Surrealist automatism.... Yet where these artists willfully mined the unconscious, Martin understood herself transitively; she was a sort of conduit, receiving directions for creation from afar." Hudson, "Agnes Martin, On a Clear Day," in *Agnes Martin* (New York: Dia Art Foundation, 2011), 121. I have previously made the point as well, in "Agnes Martin: L'oeil intérieur," *Art Presse*, October 1999, 28–33, and "Off the Grid: Louise Bourgeois's Recent Drawings," *art US* 7 (March–April 2005): 18–21.

2. "When it comes, I see it completely in color.... MA: But your early paintings don't have color. AM: No they didn't. There was no color in the inspiration in those days. So I didn't put any color in the paintings." "Interview with Michael Auping" in *Agnes Martin, Richard Tuttle* (Fort Worth: Modern Art Museum of Fort Worth, 1998), 6–7.

3. "Interview with Michael Auping," 7.

4. Campbell, "Interview," 17.

5. Martin, "Lecture at Cornell University," in *Writings*, 61.

6. Martin, "What We Do Not See If We Do Not See," in *Writings*, 115.

7. John Gruen, "Agnes Martin: 'Everything, everything is about feeling ... feeling and recognition,'" *Art News*, September 1976, 94.

8. Martin, "Beauty Is the Mystery of Life," in *Writings*, 154.

9. Sandler, "Agnes Martin Interviewed," 5.

10. Martin, "Lecture at Cornell University," in *Writings*, 61–62.

11. Lecture at Skowhegan School of Painting and Sculpture, 1987, transcription by the author.

12. Simon, "Perfection Is in the Mind," p. 85.

13. In response to a question from the audience after delivering the lecture "Beauty Is the Mystery of Life" at the Museum of Fine Arts, Santa Fe, in April 1989, transcribed in *El Palacio* 6 (Fall/Winter 1989): 22.

14. It began: "SURREALISM, n. Pure psychic automatism by whose means it is intended to express, verbally, or in writing, or in any other manner, the actual functioning of thought. Dictation of thought, in the absence of all control by reason and outside of all aesthetic or moral preoccupations. | ENCYCLOPEDIA. *Philosophy*. Surrealism is based on the belief in the superior reality of certain forms of associations hitherto neglected, in the omnipotence of dream, in the disinterested play of thought. It tends to ruin, once and for all, all other psychic mechanisms ad to replace them in solving the main problems of life." In ed. Marcel Jean, *The Autobiography of Surrealism* (New York: Viking, 1980), 123.

15. Yve-Alain Bois, "Ellsworth Kelly in France: Anti-composition in its Many Guises," in Bois, Jack Cowart, and Alfred Pacquement, *Ellsworth Kelly: The Years in France 1948-1954* (Munich: Prestel / Washington, D.C.: National Gallery of Art, 1992), 16.

16. Goossen, *Ellsworth Kelly*, 19.

17. Jack Cowart, "Method and Motif: Ellsworth Kelly's 'Chance' Grids and His Development of Color Panel Paintings, 1948-1951," in *Ellsworth Kelly: The Years in France 1948-1954*, 39.

18. Madeleine Grynsztejn, *Ellsworth Kelly in San Francisco* (San Francisco Museum of Art, 2002), 11. In this "allover randomized grid," the palette is based on papers from a Parisian stationery store.

19. *Colors for a Large Wall*, 1951, Bois writes, is the last important work to make room for chance and, for that matter, for the principle of the modular grid. In Paris, Kelly was understood to be a descendent of Mondrian and of Malevich, of their rigorous forms of geometric abstraction based in fundamentally utopian visions. Bois believes instead that Kelly relied on "de-automatization," which he equates with the Modernist de-familiarization meant to refresh perception of ordinary

sights; on "already-made" compositions that he links to Duchamp's ready-mades; and on indexical imagery, claiming that the monochrome panels which followed Kelly's grids, and with which he was occupied while living in the seaport, are "an index of color as such" (*Ellsworth Kelly: The Years in France 1948-1954*, 28). In making these connections, Bois establishes a lineage that consolidates Kelly's direct relationship to the various abstractionists who followed him, and to arguments made on their behalf. It is, however, clear that Kelly actively pursued classically Surrealist automatist strategies, including the "scribbling" Bois disdains, though it is also clear (as Bois notes) that he did so, not in order to deepen his access to interior states, as the Surrealists did, but to elude the expression of personal inclination.

20. Reinhardt shared with Martin a less-than-privileged background. Like Mark Rothko, who went to Yale but dropped out after two years, Reinhardt had a complicated Ivy League education. Reinhardt was close to Rothko, and also Barnett Newman, in the late 1940s and early '50s. Both artists were important to Martin.
21. Simon, "Perfection Is in the Mind," 85.
22. Lippard, *Ad Reinhardt*, 51.
23. Barbara Rose, editor, *Art as Art: The Selected Writings of Ad Reinhardt*, (New York: Viking Press, 1975), 48-49.
24. Ibid., 24.
25. For instance, Barnett Newman wrote, "I believe that here in America, some of us, free from the weight of European culture, are finding the answer, by completely denying that art has any concern with the problem of beauty and where to find it. ... We are reasserting man's natural desire for the exalted, for a concern with our relationship to the absolute emotions. ... We are freeing ourselves of the impediments of memory, association, nostalgia, legend, myth, or what have you." Barnett Newman, "The Sublime Is Now," reprinted in part in ed. Charles Harrison and Paul Wood, *Art in Theory* (Oxford, U.K., and Cambridge, Mass.: Blackwell, 1992), 574.
26. Dore Ashton, *About Rothko* (New York: Oxford University Press, 1983), 70.
27. Sandler, "Agnes Martin Interviewed," 12.
28. Rose, *Art as Art*, 51-52.
29. Lippard, *Ad Reinhardt*, 93.
30. Ibid., 109.
31. Michael Corris, *Ad Reinhardt* (London: Reaktion Books, 2008), 97.
32. Ibid., 164
33. Rose, *Art as Art*, 58.
34. Corris, *Ad Reinhardt*, 99.
35. Ibid., 124.
36. Campbell, "The Interview," 17.
37. Sandler, "Agnes Martin Interviewed," 5.
38. Corris, *Ad Reinhardt*, 87.
39. Lippard, *Ad Reinhardt*, 93.
40. St. Teresa of Avila, *The Way of Perfection* (New York: Image Book, 1964), 5-6.
41. One priest who was sympathetic nonetheless warned, "Imaginary or bodily visions are those which are most doubtful, and should in no wise be desired, and if they come undesired still they should be shunned as much as possible." But, he went on, "if the visions continue after all this is done, and if the soul derives good from them, and if they do not lead to vanity but to deeper humility ... there is no reason then for avoiding them." Benedict Zimmerman, Introduction, *The Life of St. Teresa of Jesus*, trans. David Lewis (Westminster: Newman Book Shop, 1943), xxiii.
42. Martin, "What is Real," in *Writings*, 98.
43. Abraham Heschel, *The Prophets* (New York: Perennial Classics, 2001), 192.
44. Ibid., 194.
45. Along with Merce Cunningham, Cage—in Paris to meet with Pierre Boulez—appeared at the hotel where Kelly was staying. "I was just beginning to do abstract painting and John and Merce were the first people from New York that had some kind of authority and enthusiasm. And they gave me a great feeling that I was doing something that could be important." Larson, *Where the Heart Beats*, 405.
46. Corris, *Ad Reinhardt*, 87.
47. To Irving Sandler, Martin explained that she was acquainted with Cage, but "I don't agree with him." One of her arguments was with his notion of silence, which he insisted was never absolute. Martin didn't disagree about nature's aural richness, but rather about how it is experienced: "When you walk into a forest there are all kinds of sounds but you feel as though you have stepped into silence. I believe that is silence." Moreover, she continued, "John Cage believed in chance, and I very strongly disagree." Sandler, "Agnes Martin Interviewed," 5.
48. Johnston, "Agnes Martin: Surrender & Solitude," 304-5.
49. Martin, lecture at Skowhegan School, 1987, transcription by the author.
50. Quoted in Jacquelynn Baas, *Smile of the Buddha: Eastern Philosophy and Western Art from Monet to Today* (Berkeley: University of California Press, 2005), 215.
51. Holland Cotter, "Like Her Paintings," *New York Times*, January 19, 1997, 45.

52. David McIntosh, phone interview with the author, January 31, 2013.

53. Rick Smith, proprietor, Brodsky Bookshop, Taos, conversation with the author, March 25, 2012.

54. Daisetz Suzuki, "Lectures on Zen Buddhism," in Suzuki, Erich Fromm, and Richard De Martino, *Zen Buddhism and Psychoanalysis* (New York: Harper Colophon, 1960), 3.

55. Zen teaches that each of the earth's beings is to be allowed the language in which it speaks, dogs as well as flowers, as is demonstrated by "a classic anecdote" offered by Jung, who also became one of Zen's more important spokespersons in the West: "A monk once asked the master, 'Has a dog Buddhist nature, too?', whereupon the master answered 'Wu.' As Suzuki remarks, this 'Wu' means quite simply 'Wu,' obviously just what the dog himself would have said in answer to the question." Suzuki, *An Introduction to Zen Buddhism* (New York: Evergreen Black Cat, 1964), 20.

56. Martin, "The Untroubled Mind," in *Writings*, 35.

57. Martin, "Beauty Is the Mystery of Life," in *Writings*, 153.

58. Baas, *Smile of the Buddha*, 11.

59. John Cage, *Silence: Lectures and Writings by John Cage* (Middletown, Conn.: Wesleyan University Press, 1973), 116.

60. Martin, Skowhegan lecture, 1987, transcription by the author.

61. Suzuki, *An Introduction to Zen Buddhism*, 41.

62. Martin, "The Still and Silent in Art," in *Writings*, 90.

63. Baas, *Smile of the Buddha*, 58.

64. Suzuki, *An Introduction to Zen Buddhism*, 119.

65. Ibid., 64.

66. Ibid., 38.

67. Trans. Witter Bynner, *The Way of Life According to Lao Tzu* (New York: Perigee, 1994), 16.

68. Martin rarely used the term fate, and when she did, it was to describe a rather harsh form of justice: "When we see someone who has been poor all his life we think that he has been deprived but in reality he was unable to want more than he had. His lack of potential for life limited his life. He lacked energy, zest and gratitude. / *Fate is kind.* / At every moment we are presented with happiness, the sublime, absolute perfection. We are unable to grasp it due to the pull of death, commonly known as weakness. / *Fate is kind*" (italics Martin's). Martin, "The Current of the River of Life Moves Us," in *Writings*, 139. This notion of fate seems to have little connection to her inspirations, although they might also be called fated.

69. Cage, *Silence*, 57.

70. Ibid., 111.

71. Ann Wilson, interview by phone with the author, January 20, 2013.

72. Jonathan Katz, "Agnes Martin and the Sexuality of Abstraction," in *Agnes Martin* (Dia Art Foundation, 2011), 177. Said Cage, "I was never psychoanalyzed, I'll tell you how it happened, I always had a chip on my shoulder about psychoanalysis. I knew the remark of Rilke to a friend of his who wanted him to be psychoanalyzed. Rilke said, 'I'm sure they would remove my devils, but I fear they would offend my angels'" (*Silence*, 127). The idea that psychiatric treatment spelled the end of creativity was by Cage's time a canard, but obviously the prospect seemed noxious. One thinks of a Zen parable cited by Cage, of a master who admonished a supplicant to "cast out from you your power of hearing and sight; forget what you have in common with things; cultivate a grand similarity with the chaos of the plastic ether; unloose your mind; set your spirit free; be still as if you had no soul" and, above all (this is the advice with which the master begins), "neglect your body" (*Silence*, 55). Personal history and physical attractiveness found no expression in Cage's work or thinking, and the same was certainly true for Martin.

73. Baas, *Smile of the Buddha*, 215.

74. Martin, Skowhegan lecture, 1987, transcription by the author.

75. Bynner, *The Way of Life According to Lao Tzu*, 31.

76. Barbara Haskell, phone conversation with the author, June 3, 2013.

77. Cage, *Silence*, 40.

78. Brendan Prendeville, "The Meanings of Acts: Agnes Martin and the Making of Americans," *Oxford Art Journal* 31, no. 1 (2008): 72.

79. Jonathan Katz writes that the painting *Cow*, in addition to referring (as he also believes) to Zen Oxherding pictures, also points to Stein's erotic poetry, where "the term cow is a repeated motif. . . . Two poems in particular, *Lifting Belly* (1915) and *As a Wife Has a Cow—A Love Story* (1926), both feature the word 'cow' in numerous specifically lesbian contexts [and] . . . are among the most erotically charged lesbian literature of the first half of the twentieth century." He concludes, "Strange as it may sound, in Martin's own pictorial private language, Zen meditation and lesbian orgasm merge under the sign 'cow,' as different facets of a similar transcendent impulse." Katz, "Agnes Martin and the Sexuality of Abstraction," 189. The claim strains credibility, or at least available evidence.

80. Prendeville, "The Meanings of Acts," 69.

81. Barbara Rose, "ABC Art," in ed. Gregory Battcock, *Minimal Art: A Critical Anthology* (New York: Dutton, 1968), 286.

82. Cage, *Silence*, 108.

83. Indiana's *The Figure Five*, 1963, looks back to a 1928 precisionist painting by Charles Demuth, itself an homage to a nocturnal, urban poem by Williams that begins: "Among the rain / and lights / I saw the figure 5 / in gold / on a red / firetruck."

84. Barbara Haskell, "Robert Indiana: The American Dream," in ed. Haskell, *Robert Indiana: Beyond Love* (New York: Whitney Museum of American Art, 2013), 23.

85. Born in 1903, Jensen had a complicated upbringing and, like Martin, was a late starter as an artist; his first one-person show was in 1952 in New York, where Mark Rothko was among his close friends.

86. Roughly half of the 43 objects shown were Tawney's; other artists represented included Alice Adams, Sheila Hicks, and Claire Zeisler. Helping to define a field still nascent in 1963, all were to become major textile artists.

87. Kathleen Nugent Mangan et al., *Lenore Tawney: A Retrospective* (New York: American Craft Museum, 1990), 41.

88. Barron, "Giving Art History the Slip," 82.

89. Futurist and visual poetry have been invoked in discussing this work, which has also been compared to paintings by Jasper Johns (his *Newspaper*, 1957, for instance). Restany, *Chryssa*, 35-36.

90. Ibid., 63.

91. It is tempting to read romantic disruption into this history. In discussing Chryssa's focus on one letter at a time in her various wall-works and sculptures of this period, Restany singles out "A, for example, which one finds at all levels of Chryssa's work: A for Analysis, A for America, A for Advertisement, the inverted A of the Arrows, the A that is the structural basis of the Gates, the A in Automat. We see it once again in a monumental piece executed between 1970 and 1973: *Construction A*." Restany, *Chryssa*, 89. He says nothing of A for Agnes, though one can't help wondering at its conspicuous absence.

92. Ibid., 18.

93. Chryssa's neon work anticipates the language-based, plugged-in contributions to the 1970 exhibition *Information* at MoMA (which included such work by Joseph Kosuth, Robert Barry, Mel Bochner, and others), and it looks beyond to neon works by Bruce Nauman and his peers. It is also relevant to Chryssa's work that Al Held was making enormous, letter-based abstract paintings at this time.

94. Hunter, *Chryssa*, 9.

95. Briony Fer, "Drawing Drawing: Agnes Martin's Infinity," in ed. Carol Armstrong and Catherine de Zegher, *Women Artists at the Millennium* (Cambridge, Mass.: MIT Press, 2006), 178.

96. Walter Ong, *Orality and Literacy: The Technologizing of the Word* (London and New York: Routledge, 1988), 39.

97. It has also recently been argued that writing by hand, a waning discipline, is associated with the development of cognitive ability not matched by keyboarding. "When we write, a unique neural circuit is automatically activated," according to psychologist Stanislas Dehaene. In Maria Konikova, "What's Lost as Handwriting Fades," *New York Times*, June 3, 2014, D1 & 4-5.

98. Indeed, even in the eleventh century, a prominent monk apparently "seems to think of composing in writing as 'dictation to himself.'" And while the biblical languages, Aramaic and Hebrew, "do not differentiate between the act of reading and the act of speaking; they name both with the same word," it is also the case that "The classic phrase *scripta manet, verba volat*—which has come to mean, in our time, 'what is written remains, what is spoken vanishes into air'—used to express the exact opposite; it was coined in praise of the word said out loud, which has wings and can fly, as compared to the silent word on the page, which is motionless, dead." Alberto Manguel, *A History of Reading* (New York: Viking, 1996), 43, 45.

99. Manguel, *A History of Reading*, 50.

100. Vilém Flusser, *Does Writing Have a Future?* (Minneapolis: University of Minnesota Press, 2011), 31.

Chapter 5

1. Corris wrote, "Younger artists tended to acknowledge their affinity to the reductive qualities of the 'black' paintings but seemed to be able to disregard the contradictory implications that Reinhardt's manifestos may have held for their own work. One thinks of the delicately inflected monochromes of Agnes Martin ... with their strong commitment to the project of creating an image that maps on the artist's experience of landscape." *Ad Reinhardt*, 119. Corris wasn't quite right about her commitment to the landscape either.

2. Lee Hall, *Betty Parsons* (New York: Harry N. Abrams, 1991), 74.

3. Barron, "Giving Art History the Slip," 82.

4. Hall, *Betty Parsons*, 89.

5. Ibid., 102.

6. Youngerman, interview by phone with the author, October 2012.

7. Sally Eauclaire, "'All My Paintings Are About Happiness and Innocence': An Interview with Agnes Martin," *Southwest Profile* 16, no. 2 (May/June/July 1993): 17.

8. Youngerman, by phone to the author, October 3, 2012.

9. Eisler, "Life Lines," 76.

10. Sandler, "Agnes Martin Interviewed," 9.

11. To Suzanne Delehanty, undated, Institute of Contemporary Art Archive, Annenberg Library, University of Pennsylvania.
12. Sandler, "Agnes Martin Interviewed," 9.
13. Eisler, "Life Lines," 77.
14. Betty Parsons papers, Archives of American Art, Smithsonian Institution, Washington, D.C.
15. Eauclaire, "'All My Paintings Are About Happiness and Innocence,'" 17.
16. Eisler, "Life Lines," 77.
17. In response to a question from the audience after delivering the lecture "Beauty Is the Mystery of Life" at the Museum of Fine Arts, Santa Fe, in April 1989, transcribed in *El Palacio* 6 (Fall/Winter 1989): 22.
18. Campbell, "The Interview," 15.
19. It may have helped Martin to secure a new gallery that she was included, in early 1961, in the exhibition *Six American Abstract Painters* at Arthur Tooth & Sons Gallery, in London; the other artists—Kelly, Reinhardt, Leon Polk Smith, Sidney Wolfson, and Alexander Liberman—were all also represented by Parsons. The catalogue essay was by Lawrence Alloway.
20. Dore Ashton, *New York Times*, December 6, 1958, 26.
21. Dore Ashton, *New York Times*, December 29, 1959, 23.
22. Lawrence Campbell, "Reviews and Previews: Agnes Martin," *Art News*, January 1960, 16.
23. Donald Judd, "Exhibition at Robert Elkon," *Arts*, February 1963, 48.
24. Judd, "Exhibition at Robert Elkon," *Arts*, January 1964, 33-34.
25. Barbara Rose, "New York Letter," *Art International*, January 1964, 53.
26. Jill Johnston, "Exhibition at Robert Elkon," *Art News*, April 1965, 10.
27. Johnston, "Agnes Martin: Surrender & Solitude," 292-93.
28. Ann Wilson, "Linear Webs," *Art and Artists* 1, no. 7 (October 1966): 46.
29. Ibid., 47.
30. Ibid., 47. Also, "These paintings achieve that classic beauty which requires a disciplined vision."
31. Ibid.
32. Ibid., 48-49.
33. William Seitz, *The Responsive Eye* (New York: Museum of Modern Art, 1963), 5.
34. Ibid., 8.
35. Ibid., 9.
36. Ibid., 16.
37. Thomas Crow, *The Rise of the Sixties: American and European Art in the Era of Dissent* (New York: Harry N. Abrams, 1996), 114.
38. In the essay's only reference to Martin, Alloway remarks that Kelly, Reinhardt, and Leon Polk Smith "have been ratified by the work of younger artists." Alloway continues, "These three artists demonstrate an unexpected reconciliation of geometric art, as structural precision, and recent American painting, as colorist intensity. They showed at Betty Parsons Gallery and her adjunct Section Eleven, 1958-61, along with Alexander Liberman, Agnes Martin, and Sidney Wolfson. It is to this first phase of nonexpressionistic New York painting that the term Hard Edge applies." Lawrence Alloway, "Systemic Painting," reprinted in ed. Gregory Battcock, *Minimal Art: A Critical Anthology* (New York: Dutton, 1968), 38, 39.
39. Alloway, "Systemic Painting," 52.
40. Michael Fried, "Art and Objecthood," in ed. Battcock, *Minimal Art*, 135.
41. Annette Michelson, "Agnes Martin: Recent Paintings," *Artforum*, January 1967, 47.
42. Jane Livingston, "Exhibition at Nicholas Wilder Gallery," *Artforum*, December 1967, 62.
43. Lucy Lippard, "Homage to the Square," *Art in America* 55, no. 4 (July-August 1967): 50.
44. Ibid., 56.
45. Ibid., 54.
46. Ibid., 57.
47. Ibid., 54.
48. Sandler, "Agnes Martin Interviewed," 11.
49. Gruen, "Agnes Martin: 'Everything, everything is about feeling,'" 94.
50. To Douglas Dreishpoon June 24, 2000, Mandelman-Ribak Archive.
51. Quoted in Corris, *Ad Reinhardt*, 121.
52. Michelson, "Agnes Martin: Recent Paintings," *Artforum*, January 1967, 47.
53. Corris, *Ad Reinhardt*, 131.
54. Johnston, "Agnes Martin: Surrender & Solitude," 298.
55. Mildred Glimcher, *Coenties Slip*, 15.
56. Thomas Hess, "You can hang it in the hall," *Art News*, April 1965, 41.
57. Ibid., 42.

58. Ibid., 50.
59. Ibid., 49–50.
60. Donald Woodman, by phone to the author, October 31, 2011.
61. Lee Seldes, updated version, *The Legacy of Mark Rothko* (Boston: Da Capo Press, 1996), 94.
62. Reinhardt, "Chronology," reprinted in *Artforum*, October 1967, 47.
63. Campbell, "The Interview," 24.
64. Kate Horsfield, "On Art and Artists: Agnes Martin," *Profile* 1, no. 2 (March 1981): 6–7.
65. Sandler, "Agnes Martin Interviewed," 9.
66. It probably did not escape Martin's attention that Arne (then Arnold) Glimcher, president of Pace Gallery, had testified for the prosecution; "He gave a two-day lecture on Rothko's durability and importance. He spoke of art in terms of investment. When an artist dies, he said, this creates a 'finite commodity, where there once existed an open-ended one.'" Seldes, *The Legacy of Mark Rothko*, 216. By the time Martin read this book, Glimcher was her dealer; his testimony could have given cause for both confidence and a certain wariness; his testimony to Rothko's stature, cited in the legal judgment, was of material help to the prosecution. When the case was finally settled, in 1978, Rothko's eldest child, Kate, chose Pace to represent her father's estate.
67. "On August 26 [1970], with no warning, Mell died.... Mell's death shocked her friends; she was only forty-eight and, except for heavy drinking, was in apparent good health. Despite her sudden and premature demise, the medical examiner performed no autopsy." Seldes, 120. On March 26, 1973, "sculptor Louise Bourgeois discovered that her husband Robert Goldwater had died in his sleep. He was sixty-five years old and in apparent good health.... With Goldwater gone, there was no one left who would further enlighten Harrow [Assistant Attorney General for Trusts and Estates, representing the prosecution] about the foundation or about the three-way conflicts of interests" of the trustees who, Seldes writes, were in Marlborough's pocket. *The Legacy of Mark Rothko*, 175.
68. Seldes, *The Legacy of Mark Rothko*, 309.
69. Gruen, "Agnes Martin: 'Everything, everything is about feeling,'" 93.
70. Johnston, "Agnes Martin: Surrender & Solitude," 297.
71. Ibid., 301.
72. Simon, "Perfection Is in the Mind," 89.
73. Judith Kendall and William Davis, unpublished interview with Agnes Martin, February 2, 1999.
74. Maurice Poirier and Jane Necol, "The '60s in Abstract: 13 Statements and an Essay," *Art in America* 71, no. 9 (October 1983): 132.
75. Horsfield, "On Art and Artists," 9.
76. Simon, "Perfection Is in the Mind," 89.
77. Denise Spranger, "Center of Attention," *The Taos News: Tempo Magazine*, March 21–27, 2002, 22.
78. Campbell, "The Interview," 20.
79. Eisler, "Life Lines," 80.

Chapter 6
1. Sontag, "The Aesthetics of Silence," 6.
2. Samuel Wagstaff papers, Archives of American Art, Smithsonian Institution, Washington, D.C.
3. Borden, "Early Work," 43.
4. Johnston, "Agnes Martin: Surrender & Solitude," 293.
5. Ann Wilson, "Agnes Martin and Coenties Slip," in Harwood Museum symposium, March 24, 2012.
6. Ann Wilson, by phone to the author, January 10, 2013.
7. Johnston, "Agnes Martin: Surrender & Solitude," 305.
8. David McIntosh, by phone to the author, January 31, 2013.
9. Kristina Wilson, interview with the author, October 20, 2012.
10. Pat Steir, interview with the author, November 28, 2011.
11. Eisler, "Life Lines," 78–79.
12. Robert Indiana, by phone to the author, August 11, 2013. He continued, "I went to visit her there and saw that a mouse sat under her chair—I wasn't impressed with the conditions at Bellevue so I called Arthur Carr, and he transferred her to a private institution called Psychiatric Institute, connected with New York University. It was in Northwestern part of Manhattan and was a more pleasant accommodation. She was at Bellevue for a very short time and got very little treatment there. It was one of the sad parts of Coenties Slip: everyone else had achieved a measure of success and Agnes became ill and had to leave."
13. Ann Wilson, Harwood Museum symposium, March 24, 2012.
14. Kristina Wilson, interview with the author, October 20, 2012.
15. Woodman, by phone to the author, October 31, 2011.
16. Quoted in Phyllis Chesler, *Women and Madness* (1972; New York: Palgrave, 2005), 73.

17. Arthur Carr, interview with the author, September 28, 2013.
18. Arne Glimcher, *Agnes Martin: Paintings, Writings, Remembrances*, 102.
19. *The Life of St. Teresa of Jesus*, trans. Lewis, xxxvii.
20. Teresa of Avila, "Prayer of Quiet," Christian Classics Ethereal Library, *Way of Perfection*, Chapter 31. Accessed online: www.ccel.org/ccel/teresa/way.i.xxxvii.html.
21. Ibid.
22. Kristina Wilson, in Harwood Museum symposium, March 24, 2012.
23. Unpublished letter, undated, from Agnes Martin to Donald Woodman
24. Page 7 of untitled lecture in facsimile manuscript, insert between pages 16 and 17 of Arne Glimcher, *Agnes Martin: Paintings, Writings, Remembrances*.
25. Undated, in Institute of Contemporary Art Archive, Annenberg Library, University of Pennsylvania, Philadelphia. Published versions, with variants, in *Writings*, 19.
26. David McIntosh, conversation with the author, January 31, 2013
27. Donald Woodman by phone to the author, October 31, 2011. Woodman says that he got a call from a state psychiatric hospital in Pueblo, Colorado, saying she'd been arrested in Colorado Springs and committed. When she came back to New Mexico, she entered therapy with a woman who insisted, as a condition of their work, that Martin move out of the camper; the rammed earth house was built at this time. Also at this time she was put on fairly heavy medication. Subsequently, she was hospitalized at St. Vincent's in Santa Fe, prior to entering treatment with Donald Fineberg.
28. Kristina Wilson, in Harwood Museum symposium, March 24, 2012.
29. Mary Lance, conversation with the author, October 15, 2012.
30. Undated lecture notes, pp. 17–18, facsimile insert between pages 16 and 17 of Arne Glimcher, *Agnes Martin: Paintings, Writings, Remembrances*.
31. McIntosh, conversation with the author, January 31, 2013.
32. Ann Wilson in *Agnes Martin: Works on Paper*, 27.
33. Harmony Hammond in *Agnes Martin: Works on Paper*, 37
34. Donald Fineberg, conversation by phone with the author, November 3, 2011.
35. Fineberg, interview with the author, October 17, 2012.
36. She was not alone in this ambivalence; many people with schizophrenia have conflicted feelings about such voices. For instance, the mathematician John Nash replied, when asked why he stopped taking anti-psychotic medication, "If I take drugs I stop hearing the voices." Sylvia Nasar, *A Beautiful Mind*, (New York: Simon and Schuster Paperbacks, 1998), 321. On the other hand, Nash's biographer reports, "while … Nash often referred to pleasant aspects of the delusional state, it seems clear that these waking dreams were extremely unpleasant, full of anxiety and dread," 326.
37. Arne Glimcher, *Agnes Martin: Paintings, Writings, Remembrances*, 106.
38. Martin, "The Untroubled Mind," in *Writings*, 42.
39. Martin, "What We Do Not See If We Do Not See," in *Writings*, 117.
40. Martin, "On the Perfection Underlying Life," in *Writings*, 71-72.
41. Horsfield, "On Art and Artists," 5.
42. Arne Glimcher, *Agnes Martin: Paintings, Writings, Remembrances*, 69.
43. Martin, "On the Perfection Underlying Life," in *Writings*, 70-71.
44. Horsfield, "On Art and Artists," 12.
45. Eisler, "Life Lines," 82.
46. Bob Ellis, interview with the author, October 15, 2012.
47. Similarly, "She was very close to David McIntosh. On a picnic he somehow offended her and she threw him out of her life. They didn't see each other for five years. He moved out of Taos, to Dixon. When they re-established contact, it was like mother and son—he wheeled her around in a wheelbarrow." Kristina Wilson, interview with the author, October 20, 2012.
48. Fineberg, interview with the author, October 17, 2012.
49. Johnston, "Agnes Martin: Surrender & Solitude," 300.
50. Eisler, "Life Lines," 79.
51. They grew from clinics and spas that catered to the anxious and sad, and offered dubious treatments whose efficacy, such as it was, had depended on sympathetic practitioners. Consequent reliance on "the healing power of the human voice" soon translated to wide belief in the talking cure, and in the first decade of the twentieth century psychotherapy spread rapidly in the United States (as well as in Western Europe). Thus Freud's psychoanalytic methods, and his disciples, arrived in the United States at a propitious time. They sustained interest, among psychiatrists, in disorders of everyday life at the expense of psychoses, and in the first half of the twentieth century psychiatric practice shifted decisively from the asylum, where it had been directed, to the private office, while research into the biological underpinning of serious mental illness indeed, into its effective treatment languished.
52. Shorter, *A History of Psychiatry*, 190.

53. Ibid., 180. Among the obstacles at mid-century to the development of alternative therapies for mental illness, according to Shorter, was "The Nazi association of mental debility with genetic defect," which made biological psychiatry "inadmissible for many years after 1945." *A History of Psychiatry*, 99.

54. In state hospitals before the war, Dr. Robert Garber reported, doctors "treated all patients with the tools that were available. Colonic irrigation was still used." So were strains of malaria and typhoid, injected to induce fever. Insulin shock therapy was common. "We did it to take the starch out of disturbed patients." In a typical hospital, in Trenton, New Jersey, "There was a toilet and a sink and a drain in the middle of the floor so that if a patient, say, smeared feces around the room, we could hose it down." Nasar, *A Beautiful Mind*, 294.

55. Shorter, *A History of Psychiatry*, 61–62, 108. Louis Sass writes that schizophrenia was "not conceptualized as a diagnostic category until the 1890s," though it "quickly became psychiatry's central preoccupation." Louis Sass, *Madness and Modernism*, (New York: Basic Books, 1998), 13.

56. Gerald N. Grob, *The Mad Among Us: A History of the Care of America's Mentally Ill* (New York: Free Press, 1994), 216.

57. Donald Goff, "A 23-Year-Old Man with Schizophrenia," *Journal of the American Medical Association*, June 26, 2002, 3251.

58. Mark Epstein, e-mail to the author, July 19, 2014.

59. Grob, *The Mad Among Us*, 276.

60. Shorter, *A History of Psychiatry*, 207–8.

61. Epstein, e-mail to the author, July 16, 2014.

62. "The broadening of the boundaries of the mental health system characteristic of he 1960s and later was thus accompanied by a diffusion of responsibility toward the most severely impaired persons," writes Grob (*The Mad Among Us*, 268). Established in the 1970s, these centers got off to a shaky start, and were fatally undermined by the fiscal and social priorities of the 1980s, when the homeless mentally ill became a nationwide sign of failed healthcare policy.

63. Szasz, *The Myth of Mental Illness: Foundations of a Theory of Personal Conduct* (New York: Harper & Row, 1974), 259, 267–68.

64. Thomas Szasz, *The Second Sin* (Garden City: Anchor Press, 1973), 103.

65. Ibid., 95.

66. R. D. Laing, *The Divided Self* (Harmondsworth, U.K., and Baltimore: Penguin, 1969), 24.

67. Ibid., 164.

68. Early in the next decade, Gilles Deleuze and Felix Guattari began a series of investigations that further undermined the tenets of psychoanalysis.

69. Szasz, *Second Sin*, 93.

70. Chesler, *Women and Madness*, 62. It is Chesler, among others, who developed the goddess myth as a positive alternative to the mythical figures—Oedipus, most notably—that Freud offered, consistent with her belief that mental illness is a cultural phenomenon.

71. Shortly after Chesler's book appeared, Sandra Gilbert and Susan Gubar published *Madwoman in the Attic* (1979), an influential work of literary criticism that explored the recurrence of "madness" as a sign, or stigma, for transgressive female characters.

72. Chesler, *Women and Madness*, 110.

73. Ibid., 76, 115.

74. Ibid., 164, 155.

75. Susan Sontag, "Artaud," in ed. Sontag, *Antonin Artaud: Selected Writings* (New York: Farrar, Straus and Giroux, 1976), xiv.

76. Ibid., liv–lv.

77. Shorter, *A History of Psychiatry*, 277.

78. Louis Sass, *Madness and Modernism* (New York: Basic Books, 1992).

79. Epstein, e-mail to the author, July 16, 2014.

80. Rachel Taylor, "*Kusama's Self-Obliteration* and the Rise of Happenings 1967–1973," in ed. Frances Morris, *Yayoi Kusama* (London: Tate Modern and New York: Whitney Museum of American Art, 2012), 117.

81. Frances Morris, Introduction, *Yayoi Kusama*, 14.

82. Yayoi Kusama, *Infinity Net: The Autobiography of Yayoi Kusama*, trans. Ralph McCarthy (Chicago: University of Chicago Press, 2011), 20.

83. Ibid., 23.

84. Ibid., 26.

85. Ibid., 57.

86. Ibid., 47.

87. Morris, Introduction, *Yayoi Kusama*, 14. In this, too, there were echoes of Martin's experience. According to Fineberg, Martin reported that "She had psychotic fantasies about sexual abuse by her mother when she was an infant . . . I say psychotic because she was certain of abuse that happened in the first year of her life, but could not possibly be remembered." Fineberg, e-mail to the author, August 12, 2013. Others also say that Martin spoke of a more than ordinarily

difficult relationship with her mother; filmmaker Mary Lance, for instance, wrote that Martin spoke of "some kind of abuse—maybe not physical but emotional." Lance, interview with the author, October 15, 2012.

88. Morris, Introduction, *Yayoi Kusuma*, 15.

89. Taylor, "Early Years: 1929-57," *Yayoi Kusama*, 17.

90. Mignon Nixon, "Infinity Politics," in *Yayoi Kusama*, 180-81.

91. Juliet Mitchell, "Portrait of the Artist as a Young Flower," in *Yayoi Kusama*, 194.

92. Ibid., 197.

93. The connection has become evident; for instance, in recent years, works by the two artists have been hung next to each other at the Metropolitan Museum of Art in New York.

Chapter 7

1. Jill Johnston, "Agnes Martin, 1912-2004," *Art in America* 93, no. 3 (March 2005): 41.

2. Samuel Wagstaff papers, Archives of American Art, Smithsonian Institution, Washington, D.C.

3. Gruen, "Agnes Martin: 'Everything, everything is about feeling,'" 93.

4. Horsfield, "On Art and Artists," 5.

5. Campbell, "The Interview," 18.

6. Martin, "Untroubled Mind," in *Agnes Martin* (Philadelphia: Institute of Contemporary Art, 1973), reprinted in *Writings*, 36.

7. Horsfield, "On Art and Artists," 9.

8. Eisler, "Life Lines," 80.

9. Gruen, "Agnes Martin: 'Everything, everything is about feeling,'" 93.

10. David Witt, interview with Agnes Martin, April 7, 1987, transcript by the author. She told the same story to Suzan Campbell in 1989; see "The Interview," 18.

11. Hammond, "Meetings with Agnes Martin," 37.

12. Eisler, "Life Lines," 81.

13. "When I was in Albuquerque, see, I built a house. I was teaching in the university, so I said to my students, 'You all need experience laying adobe.' (Laughing.) So they all came, 15 and 20 at a time, and we built this house. We built it in four weekends. Well, I had poured the foundation before. But the house on the mesa I built with all native materials. And then I built a studio out of logs. And by the time I had built the studio, four and a half years had passed." Collins, "Agnes Martin Reflects on Art and Life."

14. Karen Schiff, "In/Substantial Constructions in Paint and Adobe: Agnes Martin," December 2005 (unpublished).

15. Campbell, "The Interview," 19.

16. Simon, "Perfection Is in the Mind," 123.

17. Suzanne Delehanty, interview with the author, October 19, 2012.

18. Benita Eisler, "Life Lines," 80. Lee Hall says this trip was in November 1969—"She and Agnes Martin visited Bennington early in November for a party with Helen Feeley and an exhibition of Paul Feeley's work at Bennington College," (*Betty Parsons*, 139)—but that is not when the Feeley show took place. Both Parsons and Tawney lost touch with Martin soon after she left New York, at least temporarily. In a June 1971 interview, Tawney said that Martin "quit painting about four years ago and went out to New Mexico. I saw her once after that, I was with her for twelve days in her camper traveling around but now I don't see her, I don't write, I don't have any contact at all" (Paul Cummings, "Interview," Archives of American Art, Smithsonian Institute, Washington, D.C., p. 24). On October 21, 1975, Parsons wrote, "Dear Agnes, I hear news about you from time to time and often wish I were somewhere near to get it directly from you. ... Let me know if you ever come to NY. And we will have a big celebration together! Love, [this carbon of the typed original has no signature]" Betty Parsons Papers, Archives American Art, Smithsonian Institute, Washington, D.C.

19. Institute of Contemporary Art Archive, Annenberg Library, University of Pennsylvania, Philadelphia.

20. Douglas Crimp, "Back to the Turmoil," in *Agnes Martin* (Dia Art Foundation), 64.

21. Crimp, "Back to the Turmoil," 64-65.

22. Ann Wilson, "Meetings with Agnes Martin," 20.

23. Ibid., 21.

24. Ann Wilson, unpublished essay for Institute of Contemporary Art catalogue, ICA Archive, Annenberg Library, University of Pennsylvania, Philadelphia.

25. Johnston, "Agnes Martin: Surrender & Solitude," 294-95.

26. Along similar lines, Arne Glimcher records that on a 1977 trip, as they were driving from Cuba to the airport in Santa Fe, a cow was separated from the herd and Martin stopped to talk to it, saying, "'Go back with the herd now—get—you hear me?' We continue and she says, 'Cows that leave the herd just sit and, finally, die. There's nothing wrong with them, but they die. Cows have social problems.'" Arne Glimcher, *Agnes Martin: Paintings, Writings, Remembrances*, 100.

27. Johnston, "Agnes Martin: Surrender & Solitude," 258-59.

28. Gruen, "Agnes Martin: 'Everything, everything is about feeling,'" 93.

29. Campbell, "The Interview," 25.
30. In Ann Wilson, "Linear Webs": "Nature is like parting a curtain, you go into it"; "You wouldn't think of form by the ocean."
31. Ann Wilson, "Meetings with Agnes Martin," 21.
32. Institute of Contemporary Art Archive, Annenberg Library, University of Pennsylvania, Philadelphia.
33. Ibid.
34. Ibid.
35. Ann Wilson, unpublished essay, Institute of Contemporary Art Archive, Annenberg Library, University of Pennsylvania, Philadelphia.
36. Lawrence Alloway, "Agnes Martin," in *Agnes Martin* (Philadelphia: Institute of Contemporary Art, 1976 reprint of 1973 catalogue), 12.
37. Ibid., 10.
38. Arne Glimcher, *Agnes Martin: Paintings, Writings, Remembrances*, 80.
39. Delehanty, interview with the author, October 9, 2012.
40. Martin, "On the Perfection Underlying Life," in *Writings*, 69.
41. Ibid., 70–74.
42. Johnston, "Agnes Martin: Surrender & Solitude," 291.
43. Ed. Dieter Schwarz, *Agnes Martin: Writings/Schriften* (Ostfildern-Ruit: Haatje Cantz, 1992).
44. Horsfield, "On Art and Artists," 9.
45. Campbell, "The Interview," 22.
46. Ibid., 26.
47. Ann Wilson, by phone to the author, January 10, 2013.
48. They arrived at the Institute of Contemporary Art as a typed manuscript, which Martin amended, with such handwritten marginal statements as, "Annie misunderstood me here I do not even know what Romanesque means," in reference to a line that was deleted: "You can't make the effort to be Romanesque before nature." ICA Archive, Annenberg Library, University of Pennsylvania, Philadelphia.
49. Here too Martin was amending the text as Wilson had submitted it. Beside the passage "Someone said all human emotion is an idea / Well ideas we can handle," Martin, having crossed out the second line, wrote "Painting is not about ideas or personal emotion." Institute of Contemporary Art Archive, Annenberg Library, University of Pennsylvania, Philadelphia.
50. "The Untroubled Mind" is contained in the ICA catalogue, *Agnes Martin* (Philadelphia: Institute of Contemporary Art, 1973), 17–24. See also *Flash Art* 41 (June 1973): 6–8. It is reprinted in *Writings*, 35–44, with the final section in a separate section as "Lecture at Cornell University," 61–62.
51. Plato, *The Republic*, trans. C. D. C. Reeve (Indianapolis and Cambridge: Hackett, 2004), 211.
52. Campbell, "The Interview," 26–27.
53. In a later, somewhat less shapely telling of Willie's story, Martin provided the protagonist with four sisters and a mother who "all told him what to do. And he said, believe me, when I grow up, I'm gonna do what I want to do." Nevertheless, "he met a fair maiden, married her and it wasn't long before she was telling him that he had to make sacrifices for his children. So he started complaining… from morning until night. The angels looked down and thought, what he needs is to go to the flames." Willie put up a fight, and he almost succeeded in drowning the devils in the river Lethe, but they managed to drag him to a flaming mountain, where he saw the damned, blistered and sweating. As in the first version, Willie responded by jumping "right into the flames," and, after three days of immolation, he emerged intact and presented himself at "the devil's office," seeking employment. "See you have to figure that out," Martin concluded this rendition, told to the filmmaker Mary Lance. When Lance turned the question of the tale's meaning back to its teller, Martin offered this explanation: "It means that if you complain, the best thing is to be exposed to the flames." Mary Lance, unpublished transcript of interviews for *Agnes Martin: With My Back to the World*.
54. Cather's story appeared in an article marking the writer's centenary in the same June 1973 issue of *Vogue* that featured a profile of Martin by Barbara Rose; both were clipped and saved by Betty Parsons. The first of Martin's Willie stories had appeared earlier in the year, so she would have to have seen Cather's Winkie tale prior to this publication for the influence to be possible. It was first published in 1896. Betty Parsons Papers, Archives of American Art.
55. Plato, *The Symposium*, trans. Robin Waterfield (Oxford and New York: Oxford University Press, 1998), 24–30.
56. Hammond, interview with the author, October 19, 2012.
57. Johnston, "Agnes Martin: Surrender & Solitude," 298.
58. Delehanty, interview with the author, October 9, 2012.
59. Reprinted in *Sol LeWitt* (New York: Museum of Modern Art, 1978), 166–68.
60. Robert Smithson, "The Spiral Jetty," in *The Writings of Robert Smithson: Essays with Illustrations*, edited by Nancy Holt (New York: New York University Press, 1979), 111–13.
61. "I bought the most expensive Aeroflex camera. I was going to take it off my taxes (laughs) so I might as well get the best." Collins, "Agnes Martin Reflects on Art & Life."

62. Gruen, "Agnes Martin: 'Everything, everything is about feeling,'" 94.
63. Campbell, "The Interview," 30.
64. Crimp, "Back to the Turmoil," 70.
65. Ibid., 73–74.
66. Campbell, "The Interview," 29.
67. Horsfield, "On Art and Artists," 14.
68. Ibid., 14–15.
69. Hammond, "Meetings with Agnes Martin," 36.
70. Spranger, "Center of Attention," 22.
71. Lance, transcript of interviews for *Agnes Martin: With My Back to the World*.
72. Horsfield, "On Art and Artists," 4.
73. Martin, "What We Do Not See If We Do Not See," in *Writings*, 119.
74. Lance transcript. On another occasion, she upped the ante, estimating that "the response to music is about ten times the response to visual arts. People make a fantastic response to music. Every note affects them." Campbell, "The Interview," 29.
75. Ed. Nancy Tousley, *Prints: Bochner, LeWitt, Mangold, Marden, Martin, Renouf, Rockburne, Ryman* (Toronto: Art Gallery of Ontario, 1975), 37.
76. Eauclaire, "'All My Paintings Are About Happiness and Innocence,'" 17.
77. Martin, "What is Real," in *Writings*, 98.
78. Simon, "Perfection Is in the Mind," 124.
79. Collins, "Agnes Martin Reflects on Art and Life."
80. Ibid.
81. Ibid.
82. Donald Woodman, by phone to the author, October 31, 2011.
83. Hammond, "Meetings with Agnes Martin," 36. Ann Wilson also spoke of Martin's interest in foreign films, including Fellini's *Juliet of the Spirits* and *Amarcord*. Ann Wilson, by phone to the author, January 10, 2013.
84. Collins, "Agnes Martin Reflects on Art and Life."
85. Ibid.
86. Lance, transcript, *Agnes Martin: With My Back to the World*.
87. Hammond, "Meetings with Agnes Martin," 36.
88. Arne Glimcher, *Agnes Martin: Paintings, Writings, Remembrances*, 88-89.
89. Mark Stevens, "Thin Gray Line," *Vanity Fair*, March 1989, 51.
90. Campbell, "The Interview," 35.
91. Sontag, "The Aesthetics of Silence," 16.
92. There is, too, the schizophrenic "stare," described by Louis Sass as the unmistakable marker of a deeply dissociated state.
93. Arne Glimcher, *Agnes Martin: Paintings, Writings, Remembrances*, 64.
94. Ibid., 68.
95. Ibid., 69.
96. Ibid., 92.
97. Ellis, interview with the author, October 15, 2012. Ellis was accompanied by Van Deren Coke, who photographed the studio; sadly, the photographs "didn't turn out."
98. Martin, Skowhegan lecture, 1987, transcription by the author. On a more upbeat note, she also advised the students, "It is better to go to the beach and think about painting than it is to be painting and thinking about going to the beach"—advice that was met with grateful laughter, in which she happily joined.
99. Mandelman-Ribak Archive, Taos.
100. Sandler, "Agnes Martin Interviewed," 11.

Chapter 8

1. Harmony Hammond says she spent this period in Corrales, Mary Lance says she was in Albuquerque.
2. The most recent census puts the population at around 250, of which a third is Hispanic and less than one percent Native American. Median income is below the state's average; real-estate values much above. Guided tours of local artists' studios are available: its proximity to Santa Fe and association with well-known artists are raising its profile, though not the number of residents.
3. Delehanty, interview with the author, October 9, 2012.
4. Flora Biddle, to the author, April 12, 2012.
5. Woodman, unpublished journal, 1978.
6. Hammond, interview with the author, October 19, 2012.
7. Lippard, interview with the author, October 18, 2012.
8. Woodman, by phone to the author, October 31, 2011.

9. Built without footings, the studio was converted into a guesthouse by subsequent owners. Woodman had purchased the land for $22,500; in 2011 it was on the market for $1.2 million.

10. Klaus Kertess, "A Sense of Wonder," *Elle Décor*, December 1992-January 1993, 24.

11. Undated lecture notes, pp. 33-34, facsimile insert between pages 16 and 17 of Arne Glimcher, *Agnes Martin: Paintings, Writings, Remembrances.*

12. Hammond, interview with the author, October 19, 2012.

13. Ann Wilson, "Meetings with Agnes Martin," 27.

14. Extracts from Woodman's unpublished journal, 1978:
 a man marries a beautiful wife he has always been bossed by his brothers and sisters. They have children so his wife tells him to go out and work to support her & the kids he refuses—after a time of this god sends down the angels to take him to Hell for not being responsible. They drag him off fighting he almost drowns them in the river styx. They get him to the first level of fire he jumps in an does not come out even though they beg and plead he stays 3 days and then comes out and asks to see satan goes to see satan & asks for a job taking people to hell he gets it and stays on forever.
 "Two Hearts that are the same."
 Two people who love each other –first one person the other then vice versa. The angels see this and say that it can't go on. The 2 realize their mutual love and embrace each other so strongly that their 2 hearts become one and they jump over a lovers leap when they go off into the spirit world the one heart which is two goes also—but it beats in slight disharmony the only place where it can live is by the sea where they is only sea and sky—disharmony still exist so the heart breaks in two and one ½ goes to the sky the other to the sea—they are both still and God sees this and tells the angels take both hearts and form them into water. So now they are very happy for they bring joy each time it rains.

15. McIntosh, by phone to the author, January 31, 2013.

16. Interview with Pat Steir, November 28, 2011.

17. Marja Bloem, "An Awareness of Perfection," in *Agnes Martin: Paintings and Drawings 1974-1990* (Amsterdam: Stedelijk Museum, 1991), 32.

18. Martin, "Reflections," *Artforum*, April 1973, 38.

19. Borden's article "Agnes Martin: Early Work" is cited in chapter 2.

20. Alloway, "Agnes Martin," *Artforum*, April 1973. He took pains to distance Martin from her peers on Coenties Slip (including Reinhardt) as well as from the painters producing the "opticality" promoted by Clement Greenberg (whose ideas had until recently been favored in *Artforum*). Alloway found connections instead to Mondrian's "Plus and Minus" paintings, which "combine a comparable degree of formalization in the signifier without losing contact with a signified scene"—for Mondrian, piers and ocean; for Martin, the New Mexican desert. And once more, Alloway detected echoes in Martin's paintings of craft and textiles.

21. Alloway, "*Formlessness breaking down form*: the paintings of Agnes Martin," *Studio International*, February 1973, 61-63. He again spoke of the work as creating "a veil, a shadow, a bloom," and quoted the artist (and Ann Wilson) in a confirmation of Martin's classicism.

22. Carter Ratcliff, "Agnes Martin and the 'artificial infinite,'" *Art News*, May 1973, 26-27.

23. "One is struck, in Martin's statements no less than in her paintings, by the modesty and transparency of tone, the absence of rhetoric." Peter Schjeldahl, "Agnes Martin at the Institute of Contemporary Art," *Art in America* 61, no. 3 (May-June 1973): 110.

24. Barbara Rose, "Pioneer Spirit," *Vogue*, June 1973, 157.

25. Hilton Kramer, "An Intimist of the Grid," *New York Times*, March 18, 1973, 23.

26. Hilton Kramer, "An Art That's Almost Prayer," *New York Times*, May 16, 1976, 31. Similarly, David Bourdon, in writing about the two shows for the *Village Voice* (May 17, 1976), 111, observed that "the recent canvases," composed of bands that are sometimes irregularly spaced, "are, by her standards at least, unusually coloristic and painterly," and "shot through with a milky white light that gives them an almost mystical radiance."

27. Thomas Hess, "Fresh-Air Fiends." *New York*, May 31, 1976, p. 65

28. John Ashbery, "Art," *New York*, April 17, 1978, 88. For a show at the Arts Council of Great Britain, in London in 1977, Dore Ashton wrote a catalogue essay in which a similar metaphor is applied: "Martin frequently laid down a delicate tone . . . that served much as the continuo serves in music. Above this continuo lifts the rhythmic melody, in which the very close harmonies are sometimes as indistinguishable to the eye." Dore Ashton, *Agnes Martin: Paintings and Drawings 1957-1975* (London, Arts Council of Great Britain, 1977), 11.

29. Kuspit, who also wrote of Martin's new work that it used color as if "excavated . . . achieving its first visibility in consciousness." Donald B. Kuspit, "Agnes Martin at Pace," *Art in America* 70, no. 1 (January 1982): 139.

30. Thomas McEvilley, "Grey Geese Descending," *Artforum*, Summer 1987, 94.

31. Holland Cotter, "Agnes Martin at Pace," *Art in America* 77, no. 4 (April 1989): 257.

32. Facsimile letter, insert between pages 136 and 137 of Arne Glimcher, *Agnes Martin: Paintings, Writings, Remembrances.*

33. Lucy Lippard, "Top to Bottom, Left to Right," *Grids* (Philadelphia: Institute of Contemporary Art, 1972), unpaginated.

34. Rosalind Krauss, "Grids," reprinted in *The Originality of the Avant-Garde and Other Modernist Myths* (Cambridge, Mass. and London: MIT Press, 1986), 8-22.

35. Rosalind Krauss, "The Originality of the Avant-Garde," reprinted in the *Originality of the Avant-Garde and Other Modernist Myths*.

36. Rosalind Krauss, "The /Cloud/," in ed. Barbara Haskell, *Agnes Martin* (New York: Whitney Museum of American Art, 1992), 155–65.

37. For example, Thomas McEvilley wrote, "When Martin's grids disappear as one backs away from the painting, they disappear, as it were, into the otherwise formless ground, where they reside always in a kind of latency, giving the ground an appearance of floating vibrancy, of light-filled potentiality, of invisible but active force. Thus grids are intensifications of the meaning that the ground itself has in art." "Grey Geese Descending," 96.

38. For instance, Klaus Kertess, like McEvilley, attended to the mathematics that govern Martin's stripes, noting that the 72-inch-square canvases, which she'd been using since the 1960s, were divisible "by almost every digit–2,3,4,6,8,9–[which] permits Martin to set an endless variety of regular rhythms resonating across her planes." Kertess, "A Sense of Wonder," 24. Peter Schjeldahl compared her late work unfavorably to the early paintings: "Beauty emerges slowly in a viewer's experience of Martin's best paintings and drawings, those from the 1960s... and the later 70s," finding that "Since 1980 or so Martin has been profligate with effects of beauty," but allowed, "The meaning of her best art... may be termed 'spiritual,'" not because it blurs the mind to "dreamy sublimity," but because "When perusing a good Martin, your eyes are sharpened." Peter Schjeldahl, "Martin Eyes," *Village Voice*, November 24, 1992, 100.

39. Deborah Solomon, "The Pleasure of Self-Denial," *Wall Street Journal*, November 11, 1992, A9.

40. Kay Larson, "Solitary Refinement," *New York*, November 23, 1992, 74.

41. John Perreault, "Martin-ized, Or the Zen of Drawing Blanks," *Soho Weekly News*, October 11, 1979, 42.

42. Johnston, "Agnes Martin: Surrender & Solitude," 300.

43. Lance, interview with the author, October 15, 2012.

44. Arne Glimcher, *Agnes Martin: Paintings, Writings, Remembrances*, 119

45. Anna Chave, "Agnes Martin: 'Humility, The Beautiful Daughter.... All of Her Ways Are Empty,'" in ed. Haskell, *Agnes Martin*, 131–53.

46. Eisler, "Life Lines," 82. Of course, she had long since expressed her irritation at criticism which, in linking her paintings to weaving, also implicitly connected it to women's work, as in Alloway's repeated references to textiles.

47. Ibid.

48. Lance, unpublished transcript of interviews for *Agnes Martin: With My Back to the World*.

49. "Interview with Michael Auping," *Agnes Martin, Richard Tuttle*, n.p.

50. Collins, "Agnes Martin Reflects on Art and Life."

51. In this respect, comments Martin made in an unpublished, late interview may be relevant: "I think that human beings' idea of love is just terrible... I don't see how they can be so wrong. That they think that the genital reaction of making love is love, I just think that's fantastic! It's 15 minutes of physical abrasion.... Love is really when you are no longer responding genitally, then you are able to be aware of love... I don't think that the sexual response is normal. I think that procreation is normal.... Making love is a destructive attack.... After you make love, you're just so dumb." Jenny Attiyeh, unpublished interview, undated, Dia archive. Similarly, to Douglas Dreishpoon in an interview conducted in 2000: "I paint innocent love like the babies. I think a baby is pure love... You notice how happy the baby is? Just gurgling and spitting. Well I don't think that making love is that enjoyable. [laughs] So the [recent] paintings are about love and innocence and happiness." Mandelman-Ribak Archive.

52. Martin, "The Current of Life Moves Us," in *Writings*, 137–38.

Chapter 9

1. Bernier, "Drawing the Line," 306.

2. Eauclaire, "'All My Paintings Are About Happiness and Innocence,'" 16–17.

3. Tony Huston, by phone to author, July 17, 2014.

4. Suzanne Delehanty, interview with the author, October 9, 2012.

5. Holland Cotter, "Like Her Paintings, Quiet, Unchanging and Revered," *New York Times*, January 19, 1997, 45.

6. Goff, "Agnes Martin: In Taos, New Mexico," 82.

7. John Bentley Mays, "Martin Demystified," *Canadian Art*, Fall 1992, 46.

8. David McIntosh to the author. Arthur Carr similarly referred to her daily reading of the *New York Times* in the 1960s.

9. Harmony Hammond, interview with the author, October 19, 2012.

10. Bob Ellis, interview with the author, October 15, 2012.

11. Eauclaire, "'All My Paintings Are About Happiness and Innocence,'" 16.

12. Ellis, interview with the author, October 15, 2012.

13. Collins, "Agnes Martin Reflects on Art and Life."

14. Lillian Ross, "Taos Postcard: Lunch with Agnes," *The New Yorker*, July 14 & 21, 2003, 34.

15. Lance, unpublished transcript of interview for *Agnes Martin: With My Back to the World*.

16. Interview with Douglas Dreishpoon, June 24, 2000, Mandelman-Ribak Archive.

17. "On the Perfection Underlying Life," in *Writings*, 71.

18. Kristina Wilson, interview with the author, October 20, 2012.

19. Arne Glimcher, *Agnes Martin: Paintings, Writings, Remembrances*, 6–7.

20. Anna Chave, "Revaluing Minimalism: Patronage, Aura, and Place," *Art Bulletin* 90, no. 3 (September 2008): 472.

21. Ibid., 470.

22. Ibid., 479–80.

23. Ibid., 479.

24. Similarly tied to renewed interest in spiritualism, the first exhibition of Emma Kunz's drawings took place in 1973, ten years after her death, at the Aargauer Kunsthaus in Aarau, Switzerland.

25. Catherine de Zegher, "Abstract," in ed. de Zegher and Hendel Teicher, *3X Abstraction: New Methods of Drawing, Hilma af Klint, Emma Kunz, Agnes Martin* (New York: Drawing Center / New Haven: Yale University Press, 2005), 26.

26. Ibid., 29.

27. More dedicated than af Klint to providing care, Kunz also offered herbs to her patients along with her other healing arts.

28. De Zegher, "Abstract," 24.

29. Richard Tuttle, "Agnes Martin and Abstractionism by Women," in *3X Abstraction*, 155.

30. De Zegher, "Abstract," 36.

31. Pollock, "Agnes Dreaming: Dreaming Agnes," 180.

32. Ibid., 164.

33. Crimp, "Back to the Turmoil," 68.

34. Arne Glimcher, *Agnes Martin: Paintings, Writings, Remembrances*, 9.

35. Johnston, "Agnes Martin: 1912–2004," 42.

36. Kristina Wilson, "A Contribution to a Further Understanding of Agnes Martin," symposium accompanying *Agnes Martin: Before the Grid*, Harwood Museum of Art, Taos, March 24, 2012.

37. Kristina Wilson, interview with the author, October 20, 2012.

38. Kristina Wilson, "A Contribution to a Further Understanding of Agnes Martin."

39. Anna Chave, *Agnes Martin: On and Off the Grid* (Ann Arbor: University of Michigan Museum of Art, 2004) accompanying *Agnes Martin: The Islands* (November 20, 2004–February 15, 2005), n.p.

40. Jonathan Katz, "Hide/Seek: Difference and Desire in American Portraiture," in Katz and David Ward, *Hide/Seek: Difference and Desire in American Portraiture* (Washington, D.C.: National Portrait Gallery, Smithsonian Books, 2010), 45.

41. Katz, "Agnes Martin and the Sexuality of Abstraction," 176.

42. Ibid., 192–93.

43. Barry Schwabsky, "Dan Walsh," *Artforum*, January 2014, 208. At the same time, many prominent artists still misidentify Martin. Writing in 2012, the painter and writer Peter Halley argued that "the ruling ethos of contemporary art" until 1980 valued truth to materials and process, and that it "reached its apogee with artists like Agnes Martin and Donald Judd, with Minimalism," this despite her adamant demurrals. "100 Years: Sensibility of the Times, Revisited," *Art in America* 100, no. 11 (December 2012), 164.

44. It was one in a series of artists' talks on artists represented in the Dia Art Foundation's collection.

Epilogue

1. Martin, "On the Perfection Underlying Life," in *Writings*, 68.

2. Ibid., 71.

3. Sandler, "Agnes Martin Interviewed," 9.

4. Alloway, "Systemic Painting," in ed. Battcock, *Minimal Art*, 51.

5. Seitz, *The Responsive Eye*, 43.

6. Undated lecture notes, pp. 13–14, facsimile insert between pages 16 and 17 of Arne Glimcher, *Agnes Martin: Paintings, Writings, Remembrances*.

7. Ibid., pp. 26–27.

SELECTED BIBLIOGRAPHY

3x Abstraction: New Methods of Drawing: Hilma af Klint, Emma Kunz and Agnes Martin (exh. cat.). Catherine de Zegher and Hendel Teicher, eds. New York: The Drawing Center, 2005.

Agnes Martin (exh. cat.). Texts by Lawrence Alloway and Agnes Martin with Ann Wilson. Philadelphia: Institute of Contemporary Art, University of Pennsylvania, 1973.

Agnes Martin: Paintings and Drawing 1957-1975 (exh. cat.). Texts by Dore Ashton and Agnes Martin with Ann Wilson. London: Arts Council of Great Britain, 1977.

Agnes Martin: Paintings and Drawings, 1974-1990 (exh. cat.). Texts by Marja Bloem, Erich Franz, Mark Stevens and Ann Wilson. Amsterdam: Stedelijk Museum, 1991.

Agnes Martin (exh. cat.). Texts by Barbara Haskell, Anna Chave and Rosalind Krauss. New York: Whitney Museum of American Art, 1992.

Agnes Martin (exh. cat.). Texts by Carmen Alborch, María de Corral and Barbara Haskell. Madrid: Museo Nacional Centro de Arte Reina Sofía, 1993.

Agnes Martin: Paintings and Drawings 1977-1991 (exh. cat.). Interview by Irving Sandler, text by Agnes Martin. London: Serpentine Gallery, 1993.

Agnes Martin (exh. cat.). Texts by Lawrence Rinder and Cindy Richmond. Regina: MacKenzie Art Gallery, 1995.

Agnes Martin, Richard Tuttle (exh. cat.). Fort Worth: Modern Art Museum, Texas, 1998. Text by Michael Auping.

Agnes Martin: Works on Paper (exh. cat.). Aline Brandauer, ed.; texts by Harmony Hammond and Ann Wilson. Santa Fe: Museum of Fine Arts, Museum of New Mexico, 1998.

Agnes Martin, Paintings and Writings (exh. cat.). Texts by Arne Glimcher and Agnes Martin. New York: PaceWildenstein, 2000.

Agnes Martin: The Nineties and Beyond (exh. cat.). Text by Ned Rifkin. Houston: Menil Collection, 2002.

Agnes Martin: On and Off the Grid (exhibition brochure). Text by Anna Chave. Ann Arbor, Michigan: The University of Michigan Museum of Art, 2003.

Agnes Martin: Before the Grid (exh. cat.). Tiffany Bell and Jina Brenneman, eds. Taos; The Harwood Museum of Art of the University of New Mexico, 2012.

Alloway, Lawrence. "Agnes Martin." *Artforum* 11, no. 8 (April 1973), pp. 32-37.

———. "Formlessness Breaking Down Form: The Paintings of Agnes Martin." *Studio International* 185, no. 952 (February 1973), pp. 61-63.

Ashbery, John. "Art." *New York*, April 17, 1978, pp. 87-88.

Ashton, Dore. "Premiere Exhibition for Agnes Martin." *New York Times*, December 6, 1958. p. 26.

———. "Art Drawn from Nature." *New York Times*, December 29, 1959, p. 23.

Auping, Michael. "Interview with Agnes Martin." *Transcript* 3, no. 2 (1997), 83-86.

Baas, Jacquelynn. *Smile of the Buddha: Eastern Philosophy and Western Art from Monet to Today*. Berkeley: University of California Press, 2005, pp. 213-19.

Bernier, Rosamond. "Drawing the Line." *Vogue*, November 1992, pp. 304-7, 360.

Blumenthal, Lynn and Kate Horsfield. *Agnes Martin 1974: An Interview*. Video recording. Chicago: Video Data Bank, 1974. Transcribed in *Profile: Agnes Martin* vol. 1, no. 2, March 1981. Borden, Lizzie. "Early Work." *Artforum* 11, no. 8 (April 1973), pp. 39-44.

Brendeville, Brendan. "The Meanings of Acts: Agnes Martin and the Making of Americans." *Oxford Art Journal* 31, no. 1 (March 2008), pp. 51-73.

Brenson, Michael. "Agnes Martin." *New York Times*, January 25, 1985, p. C24.

Campbell, Suzan. Interview with Agnes Martin, May 15, 1989. Transcript, Archives of American Art, Smithsonian Institution, Washington, D.C.

Chadwick, Whitney. *Women, Art, and Society*. Thames & Hudson World of Art. London: Thames & Hudson, 2007, pp. 331, 332; no. 200, illustrated.

Coates, Robert. "The Art Galleries: Variations on Themes." *New Yorker*, October 14, 1961, pp. 202-204, 207.

Collins, Tom. "Agnes Martin Reflects on Art & Life." *Taos Geronimo* (January 1999), pp. 11, 13-15.

Cooke, Lynne, Karen Kelley, and Barbara Schröder, eds. *Agnes Martin*. New York and New Haven: Dia Art Foundation; Yale University Press, 2011.

Cotter, Holland. "Agnes Martin: All the Way to Heaven." *Art in America* 81, no 4 (April 1993), pp. 88–97, 149.

———. "Like Her Paintings, Quiet, Unchanging, Revered." *New York Times*, January 19, 1997, Arts & Leisure section, p. 1, 45.

———. "Profiles: Agnes Martin." *Art Journal*, Fall 1998, 77–80.

Crimp, Douglas. "New York Letter." *Art International* 17, no. 4 (April 1973), pp. 57–59, 102–3.

Drathen, Doris von. "Chords of Silence: Agnes Martin." In *Vortex of Silence: Proposition for an Art Criticism beyond Aesthetic Categories*. Milan: Charta, 2004, pp. 209–218.

Eisler, Benita. "Profiles: Life Lines." *New Yorker*, January 25, 1993, pp. 70–83.

Fer, Briony. "Drawing Drawing: Agnes Martin's Infinity." In *Women Artists at the Millennium*. Carol Armstrong and Catherine de Zegher, eds. Cambridge, Mass.: MIT Press, 2006, pp. 169–187.

Glimcher, Arne. *Agnes Martin: Paintings, Writings, Remembrances*. London and New York: Phaidon, 2012.

Glimcher, Mildred. *Indiana, Kelly, Martin, Rosenquist, Youngerman at Coenties Slip* (exh. cat.). New York: The Pace Gallery, 1993.

Goff, Robert. "Agnes Martin: In Taos, New Mexico." *Western Interiors and Design Magazine*, July/August 2003, pp. 82–87.

Grids grids grids grids grids grids grids grids (exh. cat.). Text by Lucy Lippard. Philadelphia, Institute of Contemporary Art, University of Pennsylvania, 1972.

Gruen, John. "Anges Martin: 'Everything, everything is about feeling... feeling and recognition.'" *Art News* 75, no. 7 (Sept. 1976), pp. 91–94.

Hide/Seek: Difference and Desire in American Portraiture (exh. cat.). Texts by Jonathan Katz and David Ward. Washington, D.C.: Smithsonian Institution, 2010.

Illumination: The Paintings of Georgia O'Keeffe, Agnes Pelton, Agnes Martin, and Florence Pierce (exh. cat.). Texts by Karen Moss et al. Newport Beach, Calif.: Orange County Museum of Art, 2009.

Johnston, Jill. "Reviews and Previews: Agnes Martin." *Art News* 64, no. 4. (April 1965), p. 10.

———. "Surrender & Solitude." *Village Voice*, September 13, 1973, pp. 30, 32–33.

———. "Agnes Martin: 1912–2004." *Art in America* 93, no. 3 (March 2005), pp. 41, 43.

Judd, Donald. "Exhibition at Robert Elkon." *Arts Magazine* 37, no. 5 (Feburary 1963), p. 48.

———. "In the Galleries: Agnes Martin." *Arts Magazine* 38, no. 4 (January 1964), pp. 33–34.

Kertess, Klaus. "A Sense of Wonder." *Elle Décor*, December 1992/January 1993, pp. 20–24.

Kozloff, Max. "Art." *Nation*, November 14, 1966, pp. 524–26.

Kramer, Hilton. "An Intimist of the Grid." *New York Times*, March 18, 1973, p. 23

———. "An Art That's Almost Prayer." *New York Times*, May 16, 1976, p. 31

Krauss, Rosalind. "Grids" and "The Originality of the Avant-Garde," in *The Originaltiy of the Avant-Garde and Other Modernist Myths*. Cambridge, Mass.: MIT Press, 1986.

Lance, Mary. *Agnes Martin: With My Back to the World*. DVD. New Deal Films, 2003.

Linville, Kasha. "Agnes Martin: An Appreciation." *Artforum* 9, no. 10 (June 1971), pp. 72–73.

Lippard, Lucy. "Homage to the Square." *Art in America* 55, no. 4 (July/August 1967), p. 55.

———. "The Silent Art." *Art in America* 55, no. 1 (January/February 1967), p. 61

Livingston, Jane. "Los Angeles: Agnes Martin." *Artforum* 6, no. 4 (December 1967), p. 62.

Martin, Agnes. *Agnes Martin: Writings*. Schwarz, Dieter, ed. Ostfildern-Ruit: Hatje Cantz, 1992.

———. "Beauty Is the Mystery of Life." In *Uncontrollable Beauty; Toward a New Aesthetics*. Bill Beckley and David Shapiro, eds. New York: Allworth Press; School of Visual Arts, 1998, pp. 399–402.

———. *Lenore Tawney*. Additional text by James Coggin. New York: Staten Island Museum, 1961.

Mays, John Bentley. "Martin Demystified." *Canadian Art* 92 (Fall 1992), pp. 44–49.

McEvilley, Thomas. "'Grey Geese Descending': The Art of Agnes Martin." *Artforum* 25, no. 10 (Summer 1987), pp. 94–99.

Michelson, Annette. "Agnes Martin: Recent Paintings." *Artforum* 5, no. 5 (January 1967), pp. 46–47.

Perreault, John. "Martin-ized, or the Zen of Drawing Blanks." *Soho Weekly News*, October 11, 1979, p. 42.

Princenthal, Nancy. "Agnes Martin: l'Oeil Intérieur." *Art Press*, October 1992, pp. 28–33.

Ratcliff, Carter. "Agnes Martin and the 'Artificial Infinite.'" *Art News* 72 (May 1973), pp. 26–27.

The Responsive Eye (exh. cat.). Text by William Seitz. New York: The Museum of Modern Art, 1965: pl. 74.

Rose, Barbara. "New York Letter." *Art International* 7, no. 10 (January 1964), p. 66.

Rose, Barbara. "Pioneer Spirit." *Vogue*, June 1973, pp. 114–15, 157.

Sandler, Irving. "Agnes Martin Interview." *Art Monthly* no. 169 (September 1993), pp. 3–11.

Schiff, Karen. "Agnes Martin, Under New Auspices." *Art Journal* 71, no. 3 (Fall 2012), pp. 121–25.

Schjeldahl, Peter. "Philadelphia: Agnes Martin at the Institute of Contemporary Art." *Art in America* 61, no. 3 (May/June 1973), p. 244.

Shiff, Richard. "Reviews: 'Agnes Martin: The Nineties and Beyond.'" *Artforum* 40, no. 8 (April 2002), p. 131.

Simon, Joan. "Perfection is in the Mind: An Interview with Agnes Martin." *Art in America* 84, no. 5 (May 1996), pp. 82–89, 124.

Systemic Painting (exhibition catalogue). Text by Lawrence Alloway. New York: Solomon R. Guggenheim Museum, 1966.

Wilson, Ann. "Linear Webs." *Art and Artists* 1, no. 7 (October 1966), pp. 46–49.

Witt, David. *Modernists in Taos: From Dasburg to Martin*. Santa Fe: Red Crane Books, 2002.

INDEX

ACKNOWLEDGMENTS

I am enormously grateful for the information and insights so generously provided to me, in interviews and phone conversations, by artists who knew Martin including, at Coenties Slip, Jack Youngerman, Ann Wilson, Robert Indiana, Charles Hinman and Chryssa (assisted by Annelliesse Popescu); among Martin's fellow artists and other friends in New Mexico, I spoke with Harmony Hammond, Donald Woodman, David McIntosh, Mary Lance, Tony Huston and Kristina Wilson. The curators, art historians and writers Suzanne Delehanty, Bob Ellis, David Witt, Barbara Haskell and Lucy Lippard all offered their memories. Additional friends who contributed recollections include Pat Steir and Flora Biddle. Much gratitude is also due Drs. Donald Fineberg, Arthur Carr and Donald Goff.

Mark Epstein and Anna Chave each read portions of the manuscript, and I am indebted to them for their valuable advice. Others who kindly offered information and help of various kinds include Karen Schiff, Jack Tilton, Christina Bryan Rosenberger, Tiffany Bell, Rita Reinhardt, Ursula von Rydingsvard, Sandra Green and Sandra Ammann. I would like to acknowledge the assistance, at the Pace Gallery, of Arne Glimcher, Milly Glimcher and Jon Mason. Jessica Holmes contributed research at a crucial moment, as did my son, Milo LeDoux. I thank the School of Visual Arts, in New York, for a travel grant. And I am very fortunate that Anthony Kiendl, director of the MacKenzie Art Gallery in Saskatchewan, offered me the opportunity to visit Regina, where I had the benefit of talking with scholar Bruce Russell, and Macklin, where we spoke with local historians Darlene Kidd and Susan Conly. The Museum of Modern Art, New York, the Solomon R. Guggenheim Museum, the Hirshhorn Museum, the Metropolitan Museum of Art, the Whitney Museum of American Art and the Harwood Museum of Art provided welcome access to their collections and records. So did the Archive of the Institute of Contemporary Art in Philadelphia, held at the Annenberg Library of the University of Pennsylvania; the Archives of American Art, Smithsonian Institution, Washington, D.C. and the Mandelman-Ribak Foundation archive, in Taos. I greatly appreciate all the help provided by my wonderful editor Christopher Lyon, of Lyon Artbooks, and, at Thames & Hudson, Christopher Sweet and the indefatigable Elizabeth Keene. Most of all, I thank my husband Joseph LeDoux, without whose unstinting support I would not have made it to the finish line.